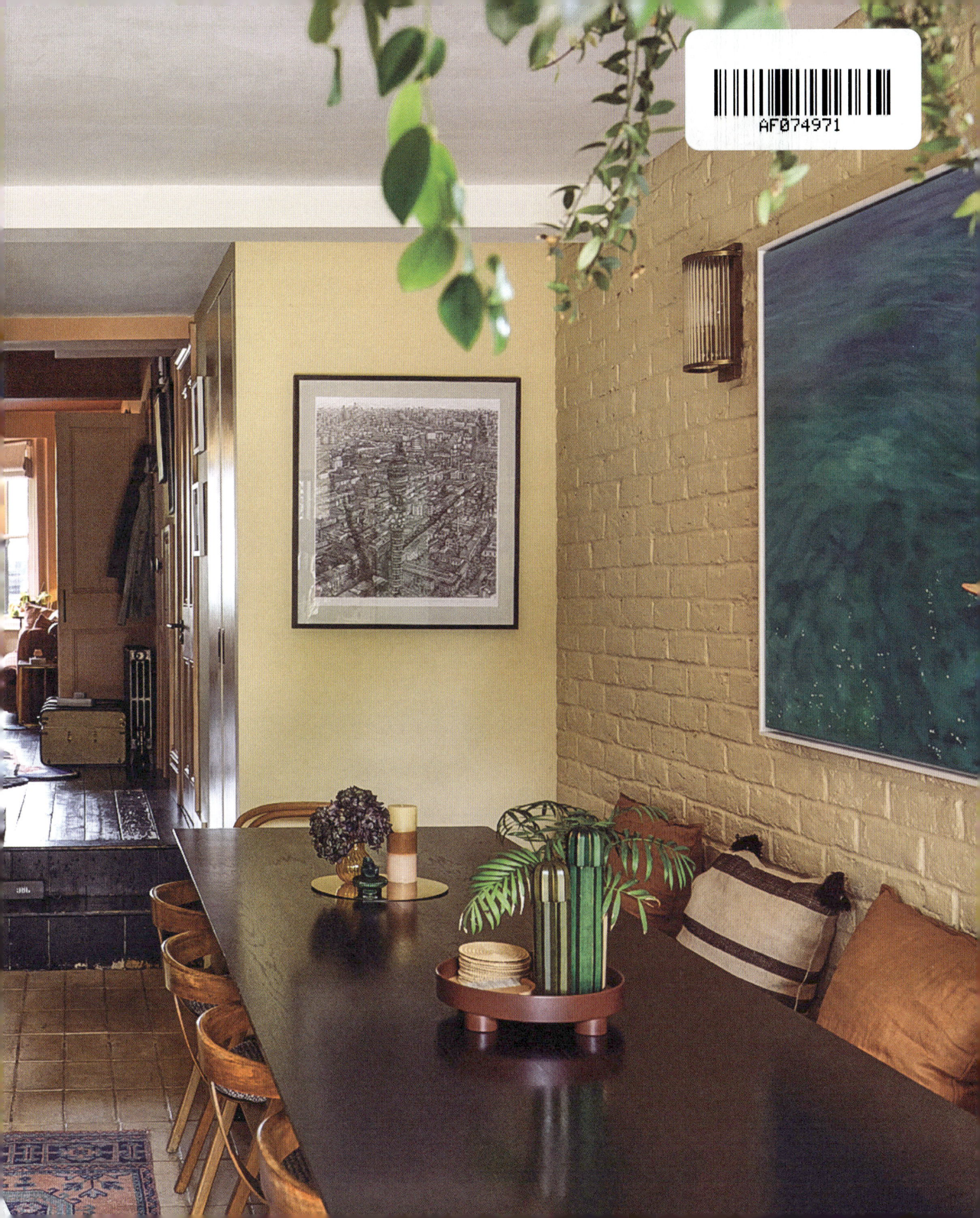

COLOURFUL HOMES *for the Soul*

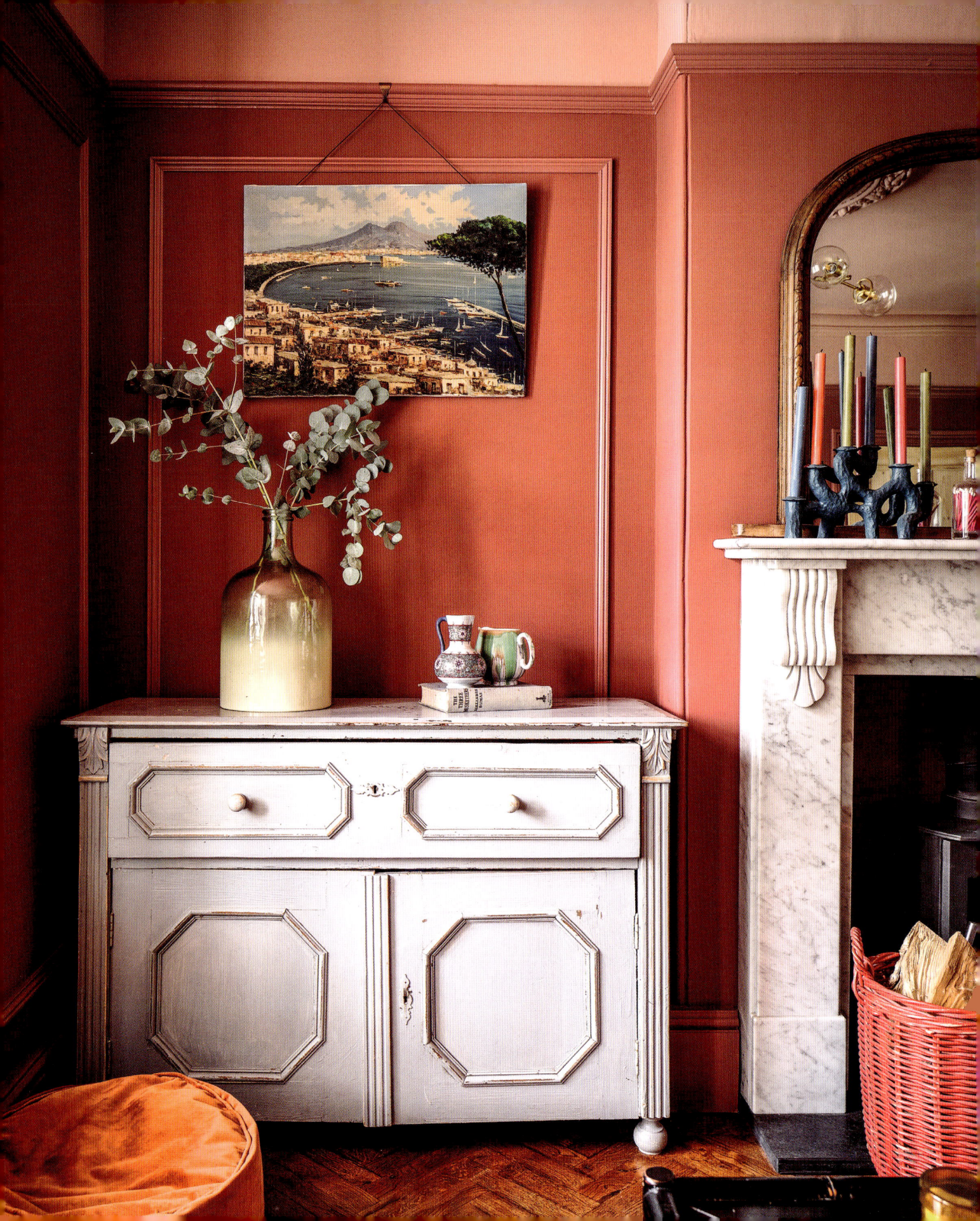

COLOURFUL HOMES *for the Soul*

BRIGHT IDEAS FOR SUSTAINABLE HOMES

SARA BIRD &
DAN DUCHARS of
The CONTENTed Nest

RYLAND PETERS & SMALL

For Dorothy

Senior designer Toni Kay
Editor Sophie Devlin
Location research Jess Walton
Head of production Patricia Harrington
Senior commissioning editor Annabel Morgan
Creative director Leslie Harrington

First published in 2025 by
Ryland Peters & Small
20-21 Jockey's Fields,
London WC1R 4BW
and

1452 Davis Bugg Road
Warrenton, NC 27589
www.rylandpeters.com
email: euregulations@rylandpeters.com
Text copyright © The CONTENTed Nest 2025
Design and photography copyright
© Ryland Peters & Small 2025
10 9 8 7 6 5 4 3 2 1

UK ISBN 978-1-78879-652-1
US ISBN 978-1-78879-654-5

The authors' moral rights have been asserted. All rights reserved. No part of this publication may be reproduced, stored in a retrieval system or transmitted in any form or by any means, electronic, mechanical, photocopying or otherwise, without the prior permission of the publisher.

A CIP record for this book is available from the British Library.

Library of Congress CIP data has been applied for.

Printed and bound in China.
The authorised representative in the EEA is Authorised Rep Compliance Ltd., Ground Floor, 71 Lower Baggot Street, Dublin, D02 P593, Ireland
www.arccompliance.com

FSC MIX Paper | Supporting responsible forestry FSC® C106563

CONTENTS

Introduction	6
COLOUR CHEMISTRY	**10**
Colour Theory	12
Colour Application	18
Colour Finishes	22
Colour & Light	26
Colour & Sustainability	30
Colour & Wellbeing	34
THE HOMES	**38**
Natural	**40**
Grand Romance	42
Come Together	54
Open House	66
Minimal	**80**
Peaceful Palette	82
Tonal Touch	94
Light & Shade	106
Maximal	**118**
Life in Colour	120
Playful Paintbox	132
Zest for Life	146
Accents	**160**
Inner Rebel	162
Colourful Care	176
Flying Colours	190
Sources	202
Picture Credits	204
Business Credits	205
Index	206
Acknowledgements	208

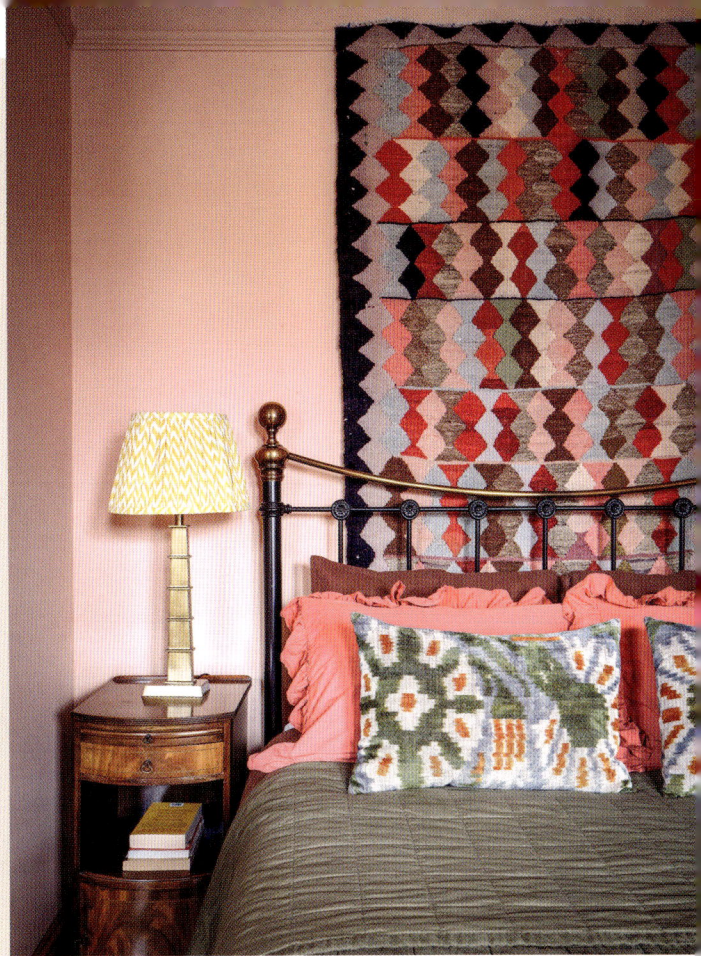

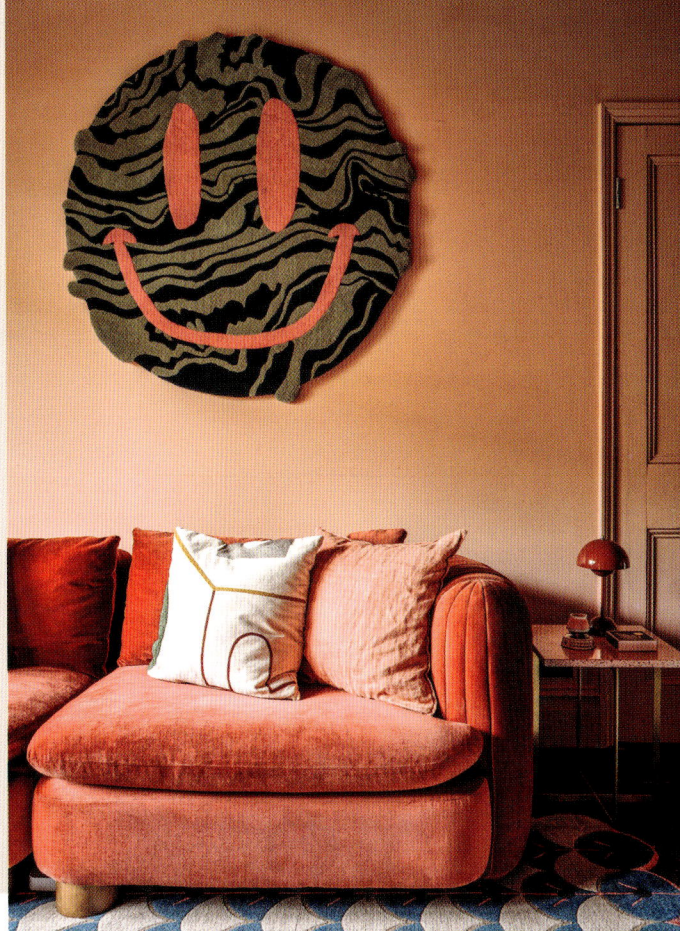

INTRODUCTION

Colour brings a sense of identity to our homes. Choosing the perfect palette from an array of pigments is a way to channel our creativity and visually enhance our living spaces. Highlight architectural features, create the illusion of space and light or make a bold statement with clever uses of colour on every surface. Even the simplicity of pure white walls can provide a blank canvas for self-expression.

There is another side to colour, too: its effect on the psyche. It can evoke emotion and get under our skin, making us feel free, adventurous, passionate and everything else. Colour is a global language, yet its expression is both individual and communal. It conveys culture and heritage, makes us mindful of our ecosystem and can even alert us to danger and promote healthy choices. Working creatively with colour also presents us with a chance to be resourceful, using natural plant-based pigments and dyes or finding ways to upcycle and reuse existing materials.

In this book, we share how to be inventive with colour in the home; how to explore the full spectrum of shades and make sustainable choices. We break down the art and science of combining colours and visit 12 real homes filled with imaginative and practical ideas. These inspiring interiors express their owners' true selves, revealing how colour can enhance not just our decor but also our wellbeing.

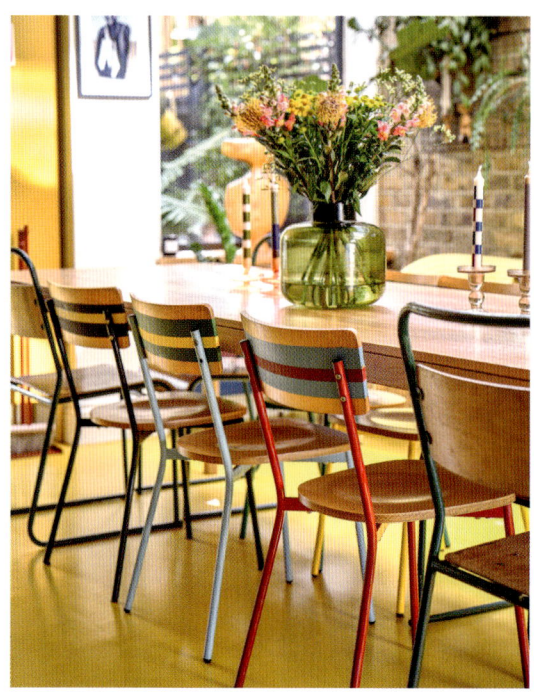

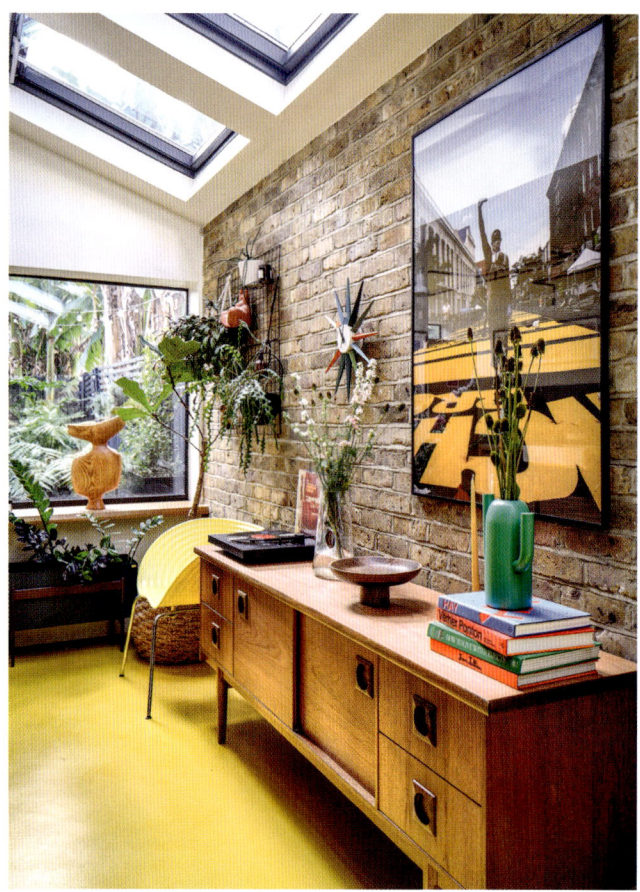

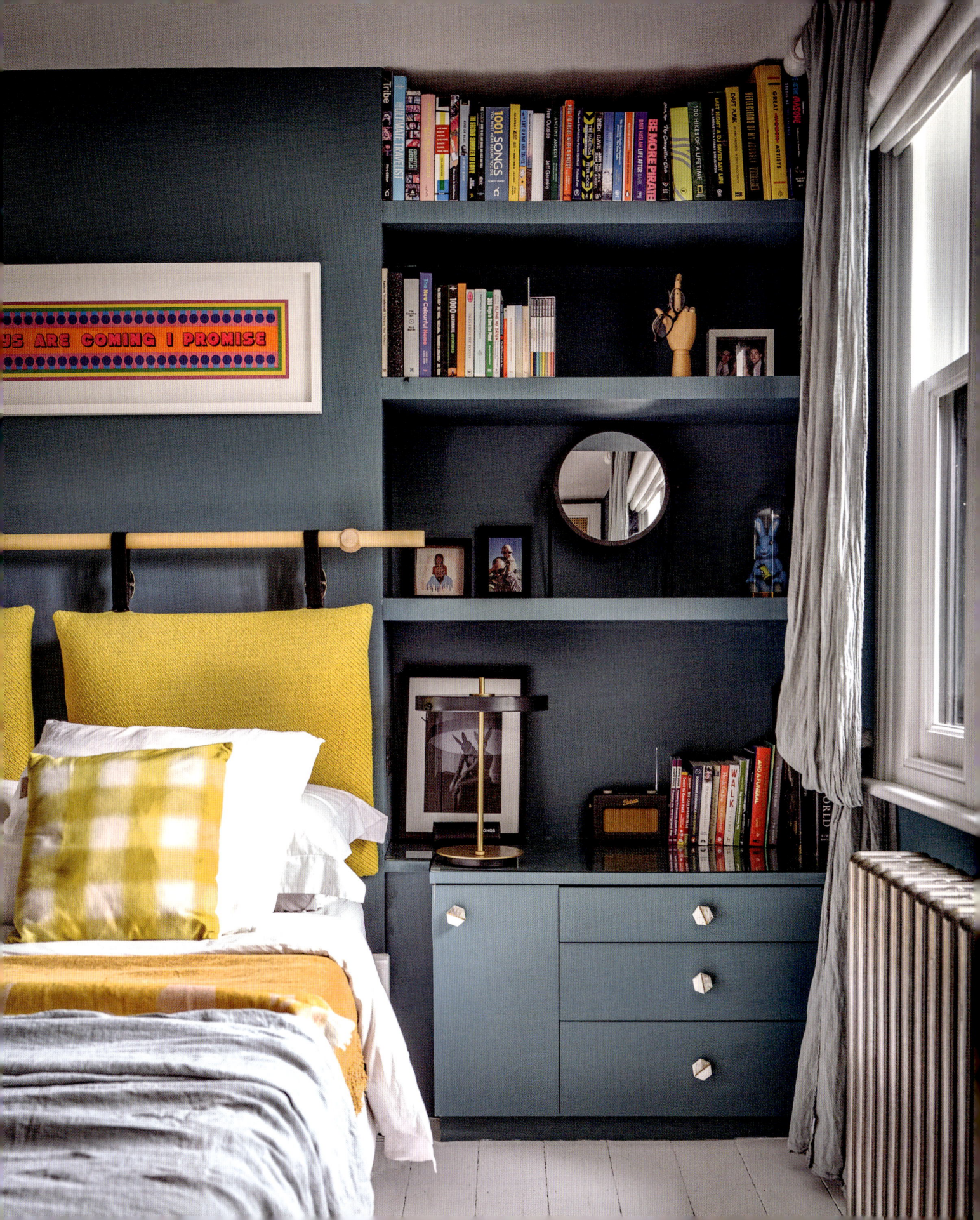

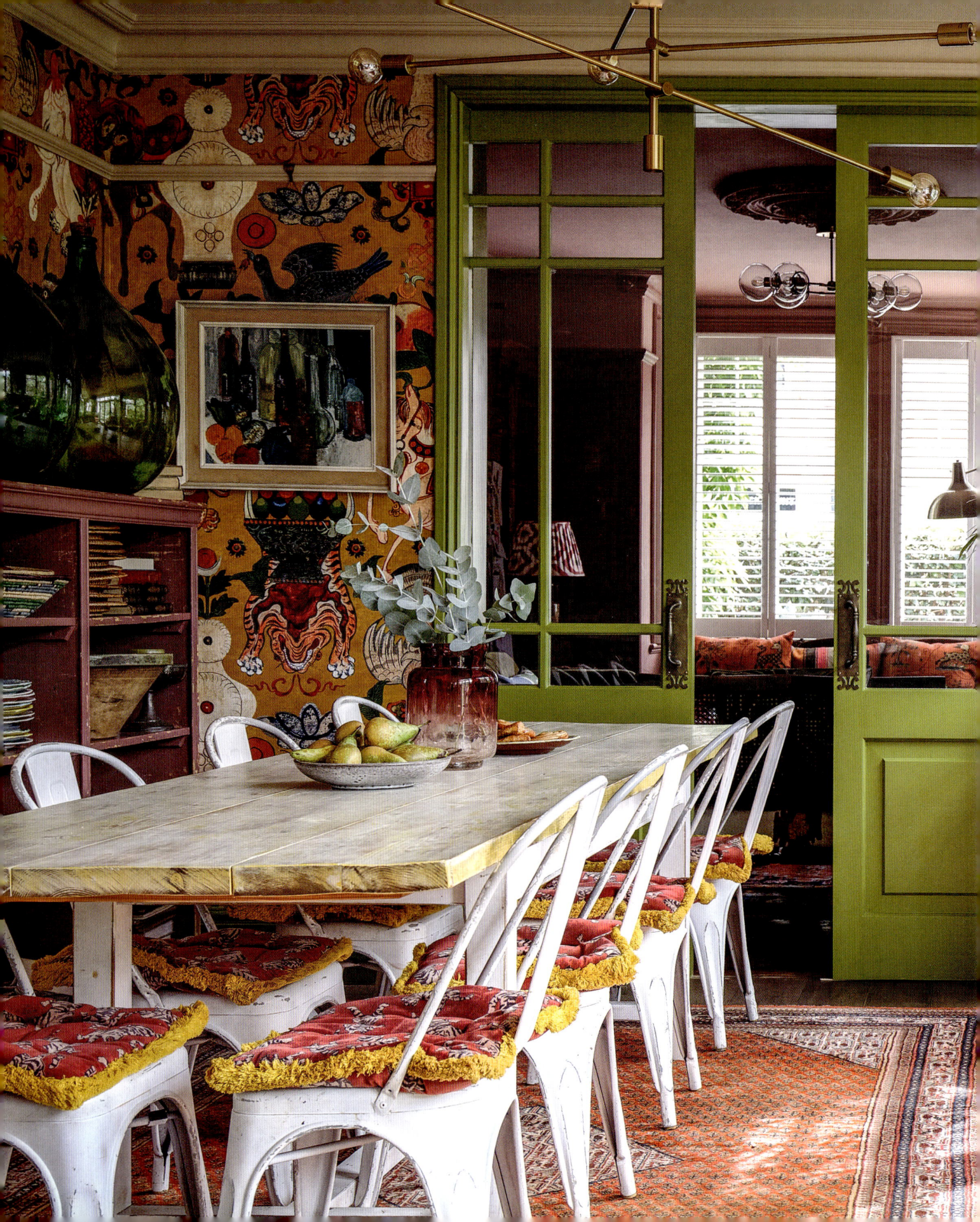

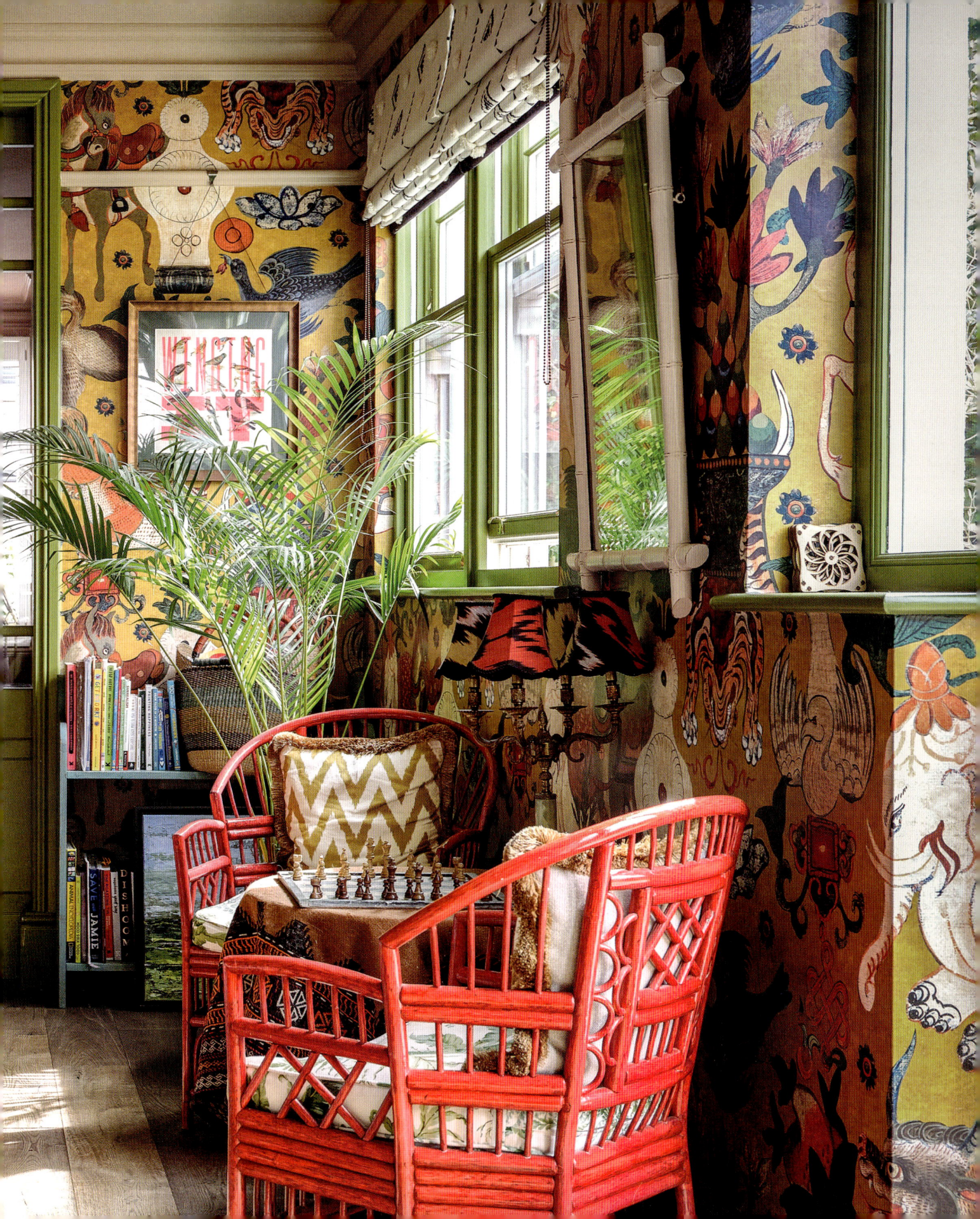

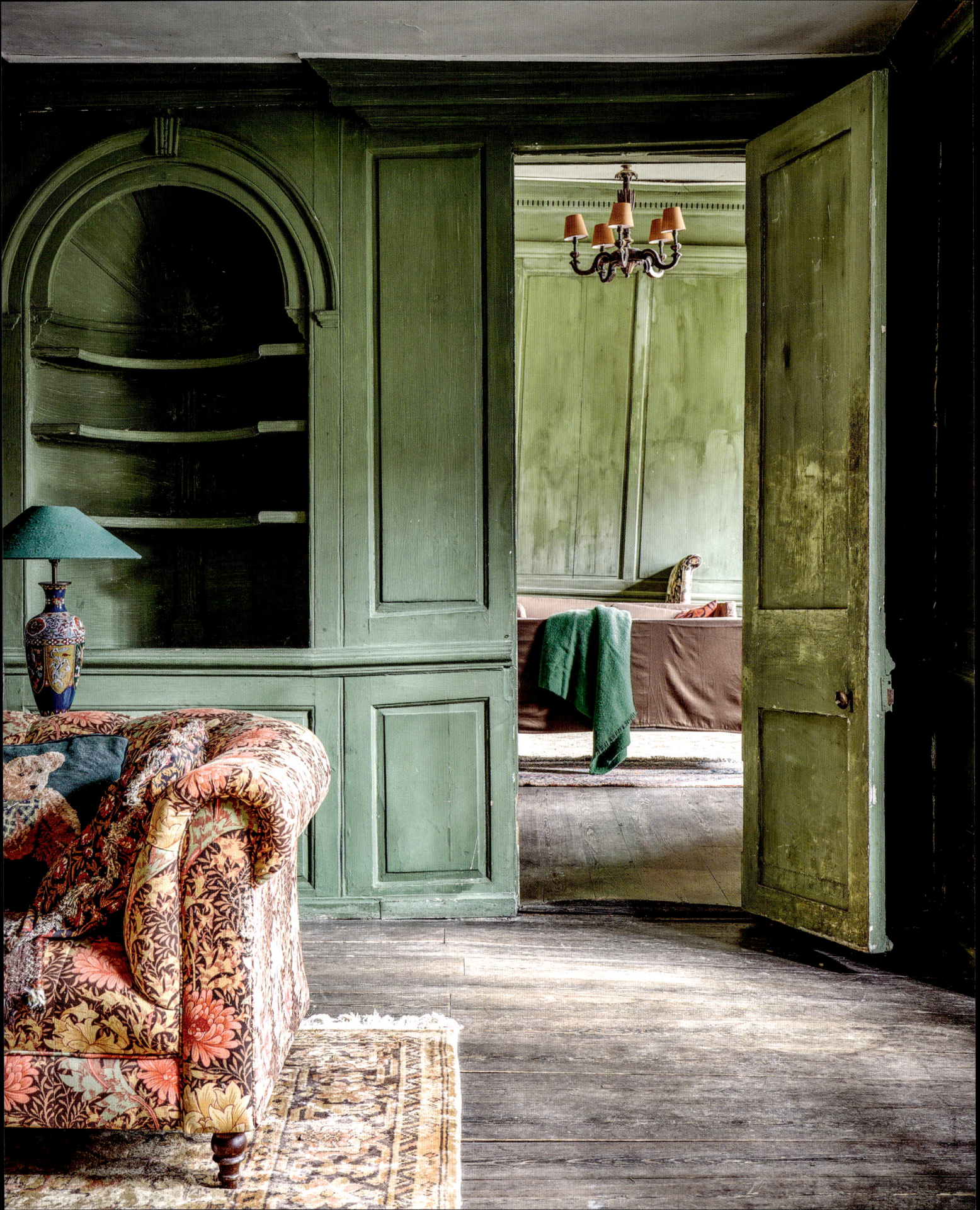

1
COLOUR CHEMISTRY

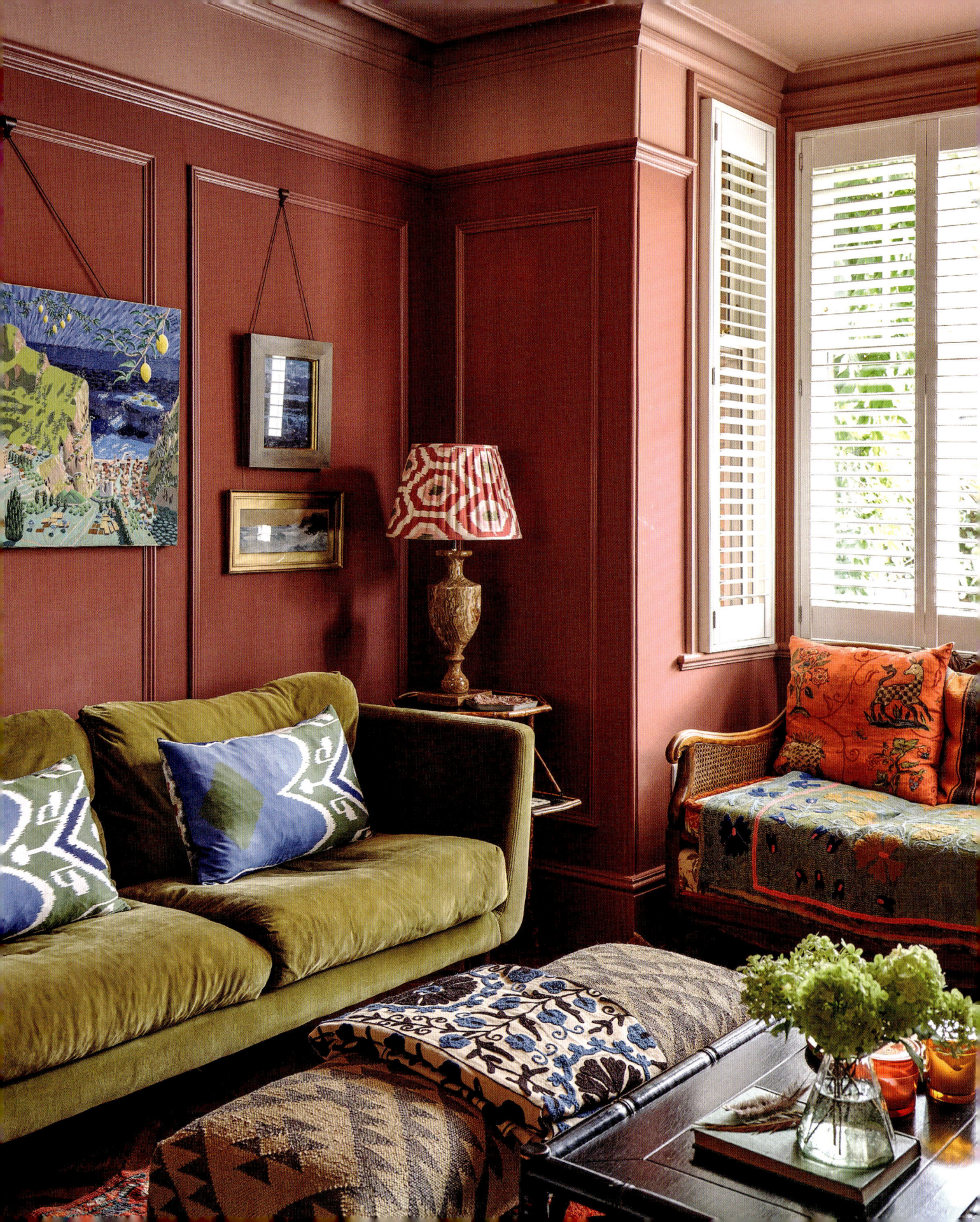

COLOUR THEORY

Inviting colour into our homes enables us to create personal spaces and share imaginative ideas. Favourite shades are always a go-to when conjuring up a scheme, but there is also a more scientific way to determine which hues will harmonize well together based on colour theory.

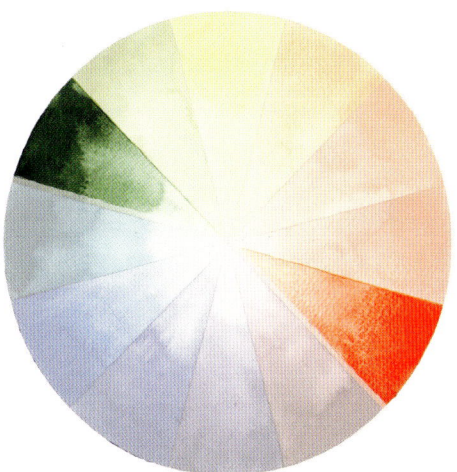

The colour wheel

The colour wheel is a practical tool that will help you build confidence when using colour in your home. It is a diagram that organizes hues according to their relationship with one another. In its basic form it features 12 colours. Three of these are primary shades: red, yellow and blue. In between them are the three secondary colours, each made by combining two of the primary colours: orange (red and yellow), green (yellow and blue) and violet (blue and red). The remaining six tertiary colours, made by combining one primary and one secondary colour, follow on as yellow-orange, yellow-green and so on. Finally, within the wheel the chroma, or the scale of pigment intensity, can be seen to reduce towards the centre of the wheel as the shades become less saturated.

Shades that are close to one another may be described as tonal, harmonious or analogous. When used side by side in an interiors scheme, they offer simple and subtle variations for a harmonious effect.

Complementary colours are opposing shades on the wheel, such as green and red. Together they provide the greatest possible contrast in hue, which is often useful for making particular features stand out.

Monochrome is usually a term used for a palette of black, white and shades of grey. However, it can also be applied to any combination of darker and lighter shades of the same base colour. Often associated with classical interiors, monochromatic looks can deliver a spectrum of schemes from the modest to the dramatic.

Complementary colours

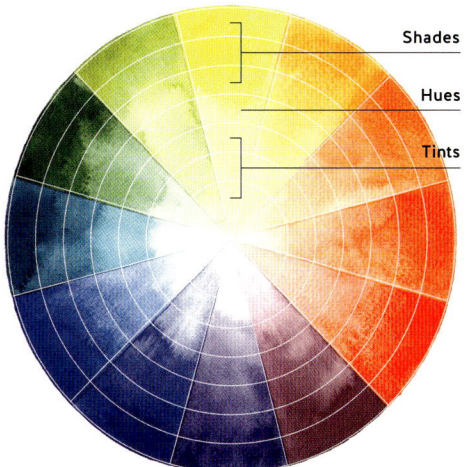

Tints, hues and shades

TAILOR-MADE TONES
Creating the perfect palette for an interior scheme is all about balance and harmony, as in this vibrant living room (opposite). The colour wheel is a useful reference tool, as it demonstrates how different hues, tints and shades relate to one another (right). It may inspire you to experiment with new combinations that were not previously on your radar, from complementary contrasts to subtle variations on a single colour.

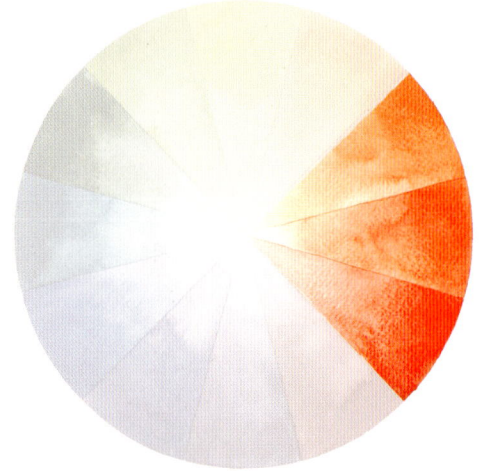

Orange and red tonal scheme

CLOSE FRIENDS

One recipe for a harmonious room is to select tonal colours from a segment of the colour wheel (above). In this hallway, a hue from the original floor tiles provided inspiration for a colour-drenched scheme in shades of red (opposite).

BUILDING A PALETTE

These rooms demonstrate that a scheme with a broad range of colours can still feel cohesive, as long as you begin by establishing the overall mood of the space. A tiled splashback and painted cabinetry in muted brights hold court in a kitchen, with hotch-potch pigments on display in plants and books (above). And in a designer's home in Sweden, a neutral paint colour is a grounding backdrop for a sunflower painting and an eclectic group of collected objects (right).

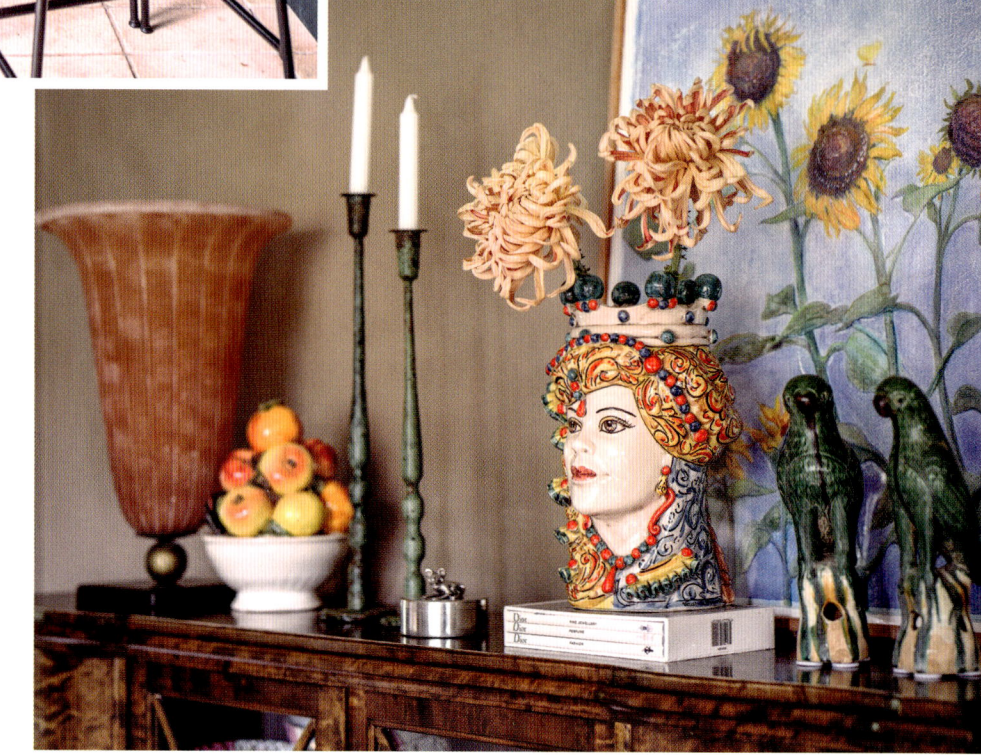

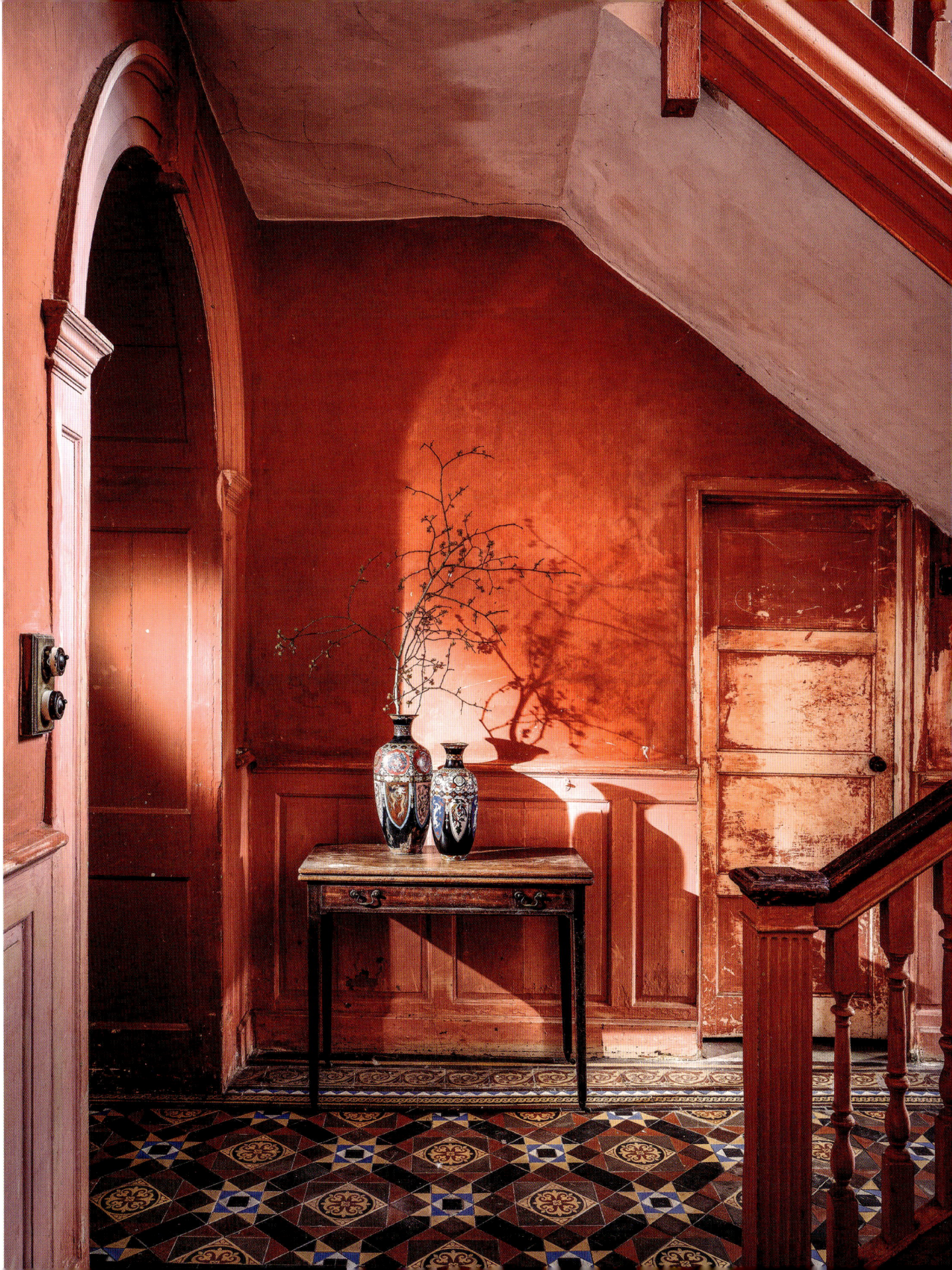

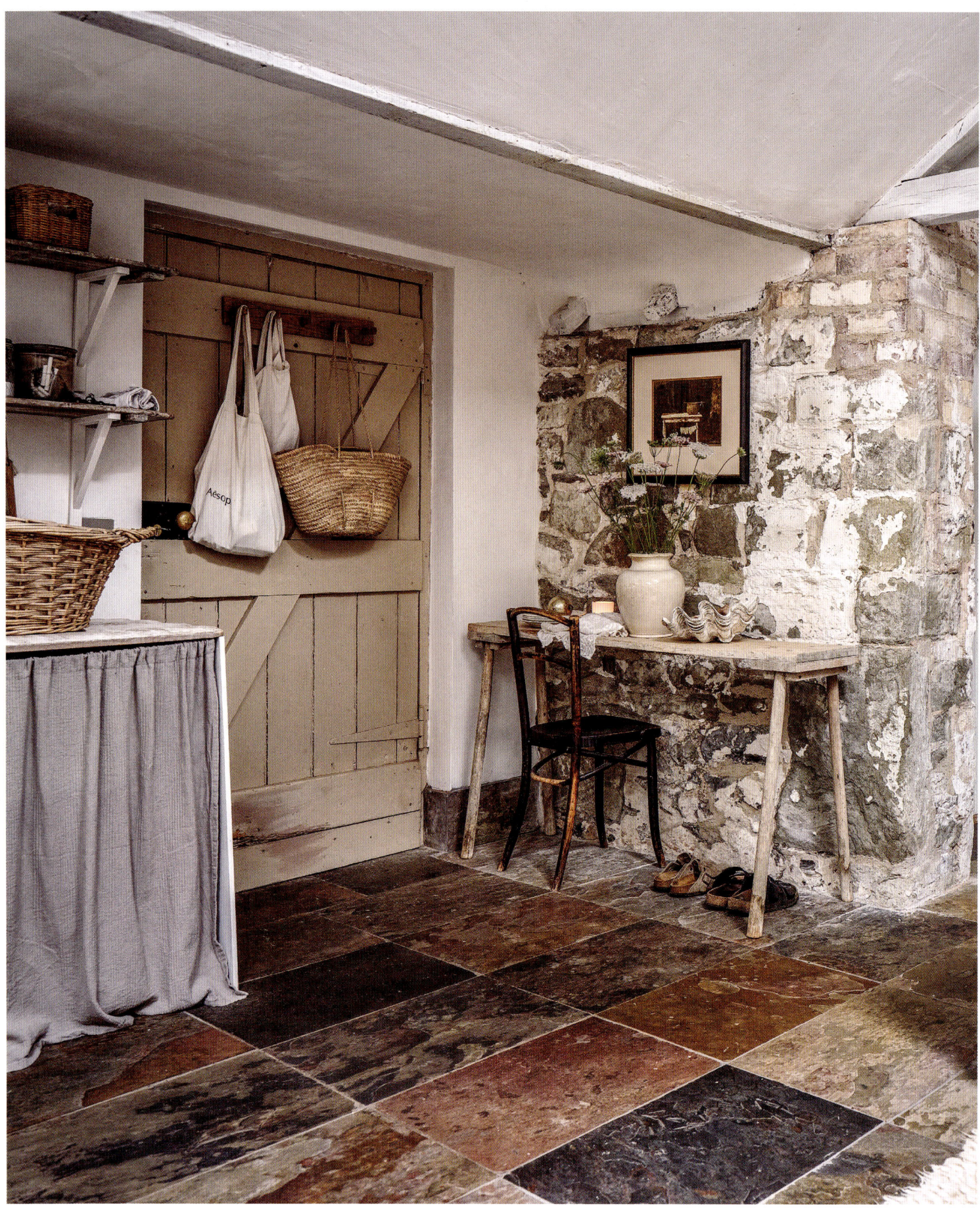

PERFECT HARMONY

Neutral schemes are most effective when built up in layers of tone and texture. Natural materials reveal an inherent warmth and depth. Different surfaces provide textural contrast. In these rooms, soft fabrics, glossy glazes and weathered stone all contribute their unique qualities to create a calming atmosphere (opposite and right).

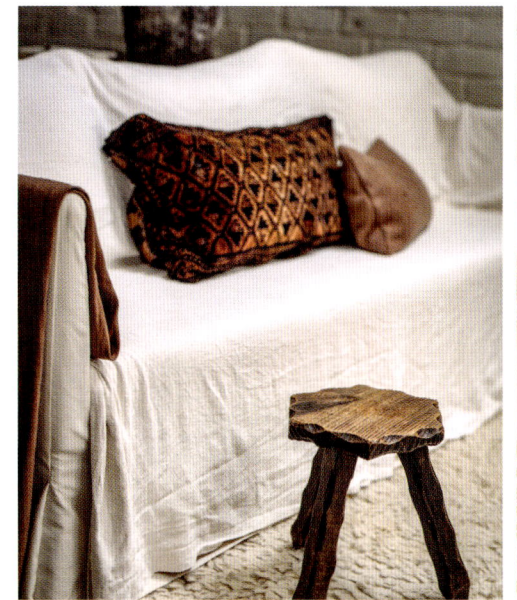

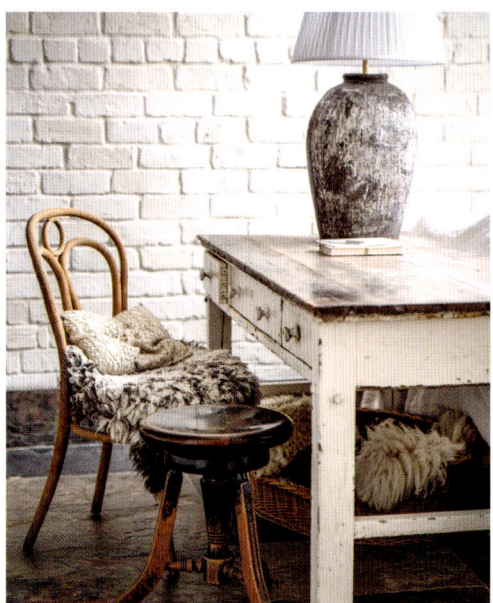

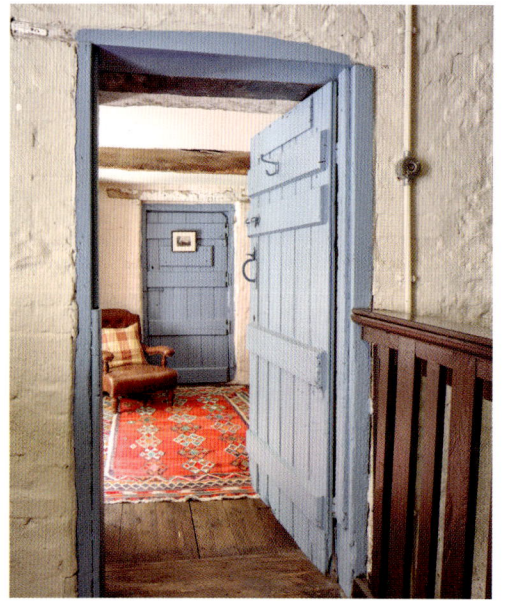

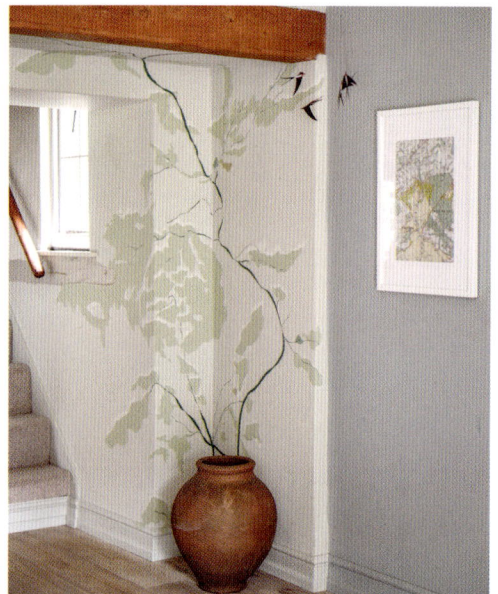

COLOUR APPLICATION

There are many ways to use colour and considering how to apply a shade can elevate a scheme to achieve so much more. By using different tones in specific areas and considering how they relate to one another, it is possible to trick the eye into seeing a larger space, to establish zones within an open layout or to highlight particular features.

Classical decorating guides on colour in the home suggest a way to form a balanced scheme is with a trio of dominant, secondary and accent hues, often with a fixed ratio of 60%, 30% and 10% respectively. However, it is possible to throw away the design rulebook and create a very different and more personalized look.

A simple treatment is to choose to decorate with one shade and use it throughout on everything, so that walls, floors, ceilings and furnishings carry the same hue across all their surfaces. This is known as colour drenching. It is the most cohesive way to create a scheme and can be an all-encompassing experience, adding great impact to a room. Sometimes subtle shade differences can be introduced in a tonal or ombré effect.

An alternative for larger rooms is to use colour blocking, in which a zone or shape is marked out on a surface. Using this treatment can bring order, mark a change of pace or divide an area into sections. It is the perfect way to delineate larger spaces that need to have different functions, and may allow you to introduce a bold colour without using it across a large surface area. Later in this book, the chapter on Accents (pages 160–201) explores several homes that make innovative use of colour-blocking techniques.

LEADING THE WAY
In these rooms, creative applications of colour guide from one room or storey to the next, point to elements of interest or even serve as works of art (this page and opposite). Some of these tricks are used frequently in the wider world to influence how we move in public spaces, whether on the road or through a department store. Bringing them into the home creates a dynamic sense of movement.

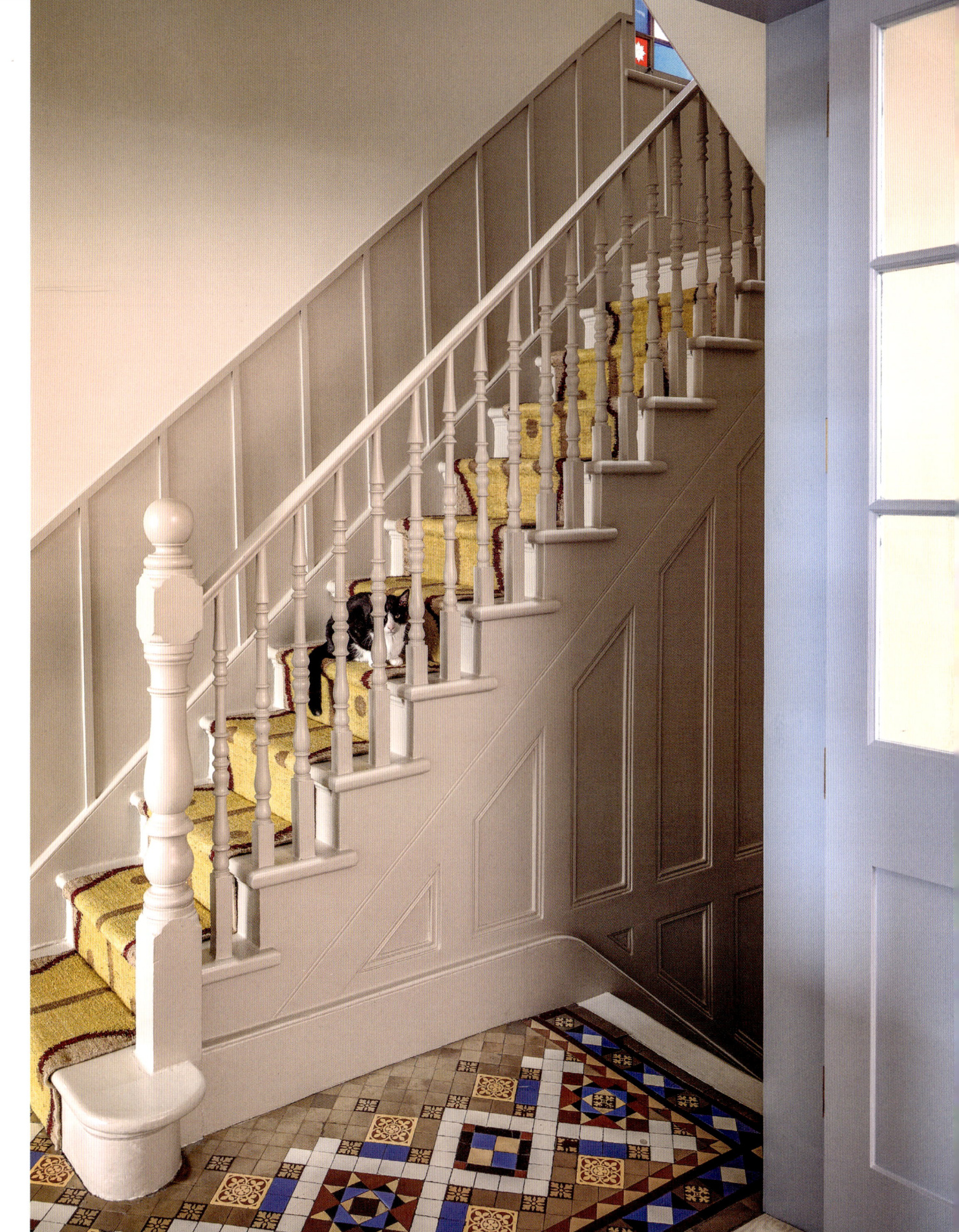

DRAW THE EYE

As well as guiding our footsteps, colour can direct our attention towards or away from particular elements of a room. It may gloss over less attractive details so that they diminish out of sight or highlight points of interest. This living room makes a feature of the old wooden beams, while a three-dimensional mural unites the full range of pastel hues seen in the decor (above). And in a bedroom, a pale blue doorway frames the entrance to an ensuite painted in playful shades of pink (left).

When choosing which colour to apply where, remember that colours manipulate the eye by advancing or receding. Light and cool tones recede, making them seem farther away from the eye, whereas darker and warmer ones advance towards us. When used as the main colour in a scheme, cool whites, blues and greys create a sense of space, while warmer reds, yellows and browns make a room feel small and cosy. The same illusion makes a white ceiling appear higher than it is, while a deeper hue on the far wall of a long, narrow room will bring it forward and suggest more even proportions. For more information about how colour interacts with light in the home, see pages 26–29.

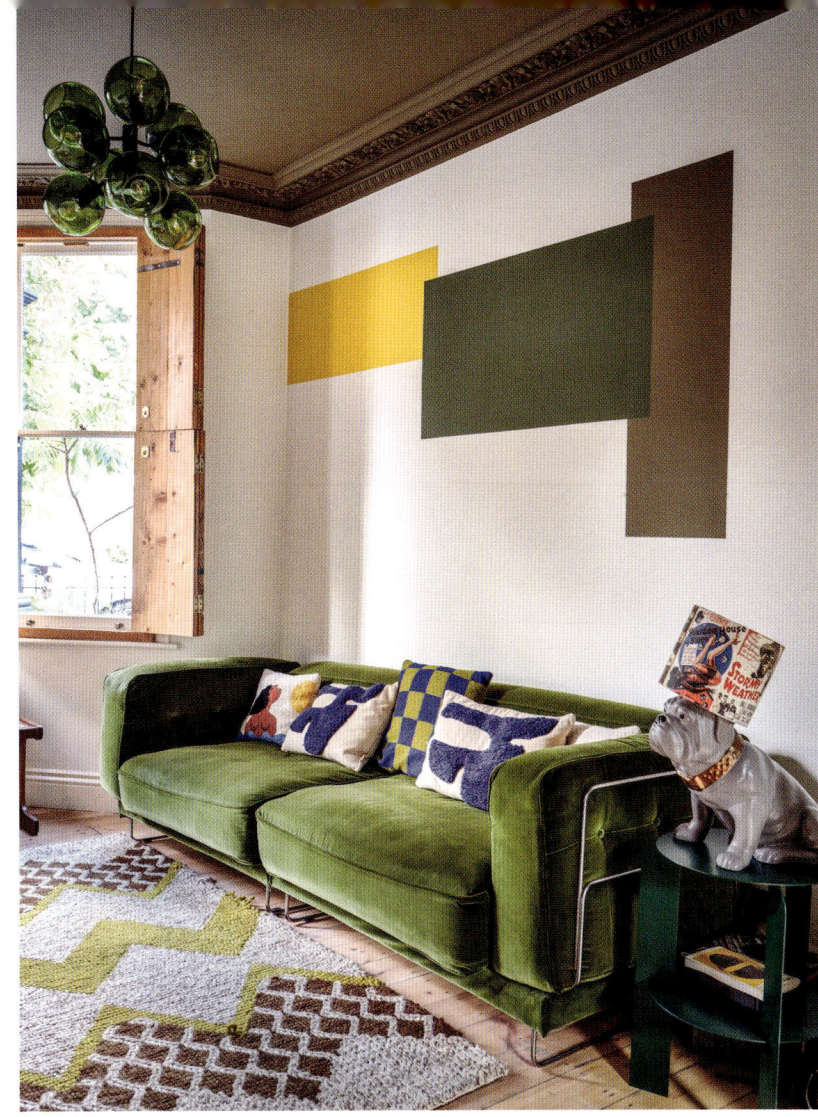

BUILDING BLOCKS

Large areas of colour are a clever way to shape a scheme. They can designate certain activities or act as hover points to anchor a room (above). Alternatively, a midway division of hues can help to ground the floor and raise the height of the ceiling, as in this green and white bedroom (left).

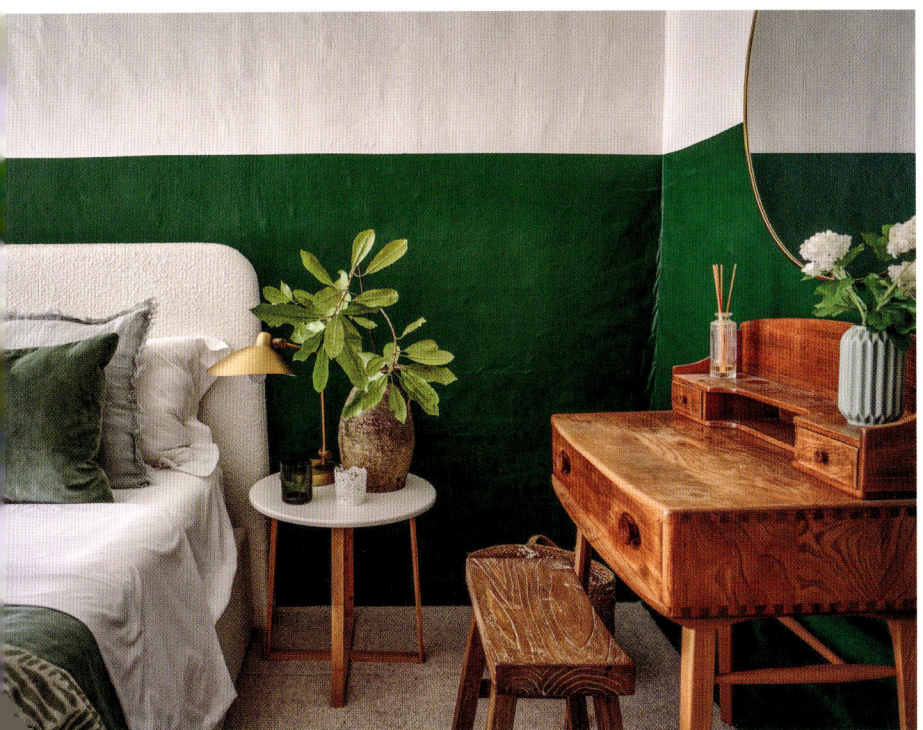

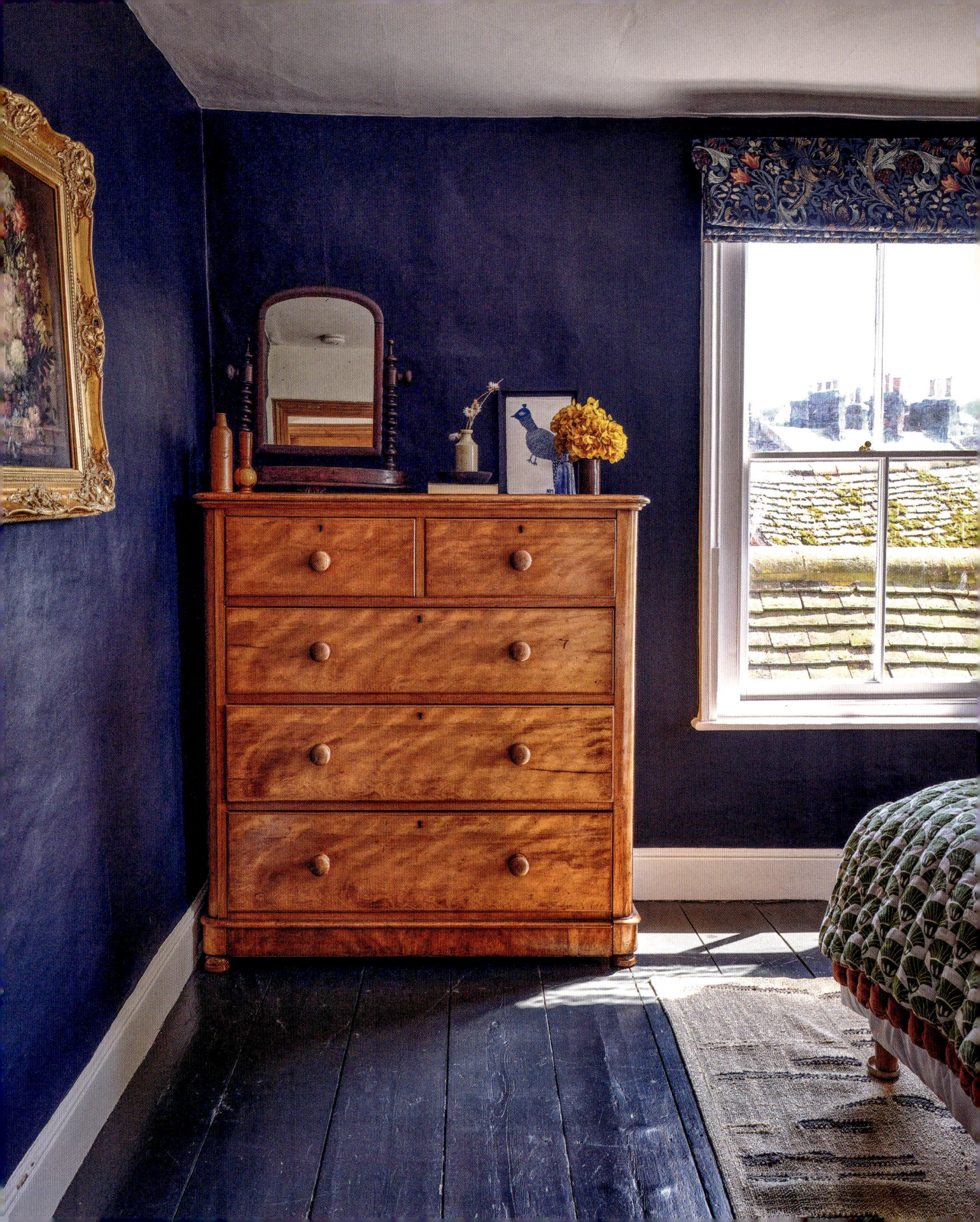

COLOUR FINISHES

The texture and quality of a surface, especially a painted one, can greatly affect how it is seen and how we react, connect and feel about a shade. The finish can make a surface porous or watertight depending on its seal or look dense or buffed subject to its sheen. In the paint industry, shine is measured according to how specific angles of light reflect back from a painted surface. The higher the percentage, the higher the gloss value.

Matt or flat finishes offer a powdery texture. On one hand they look soft and sometimes feel warm to touch with a tactile quality, yet they can supress and diminish a light source. It is a delicate surface, with a sheen of up to 10%, and while they do soften imperfections, they are prone to scuffs or marking and should be saved for low-traffic areas. Generally interior matt paint recipes are water based with modern ultimate matt finishes taking inspiration from plasterwork. They bring a chalky feel that can stimulate a feeling of calm.

Eggshell reveals a gently buffed feel. With a sheen level of around 20%, it is usually the finish of choice for interior woodwork, trims and skirting/baseboards. The low shine level does have other decorative benefits and is a refined option for deservingly darker wall palettes. The deeper shades absorb more light than paler hues and bring a sophisticated patina to a space.

Satin, satinwood and pearl finishes deliver a mid-sheen note of around 30–35%. They are the best choice for flooring on account of their durability. Although not waterproof, they can handle humidity, so they are also ideal for use in kitchens, bathrooms and utility/laundry rooms.

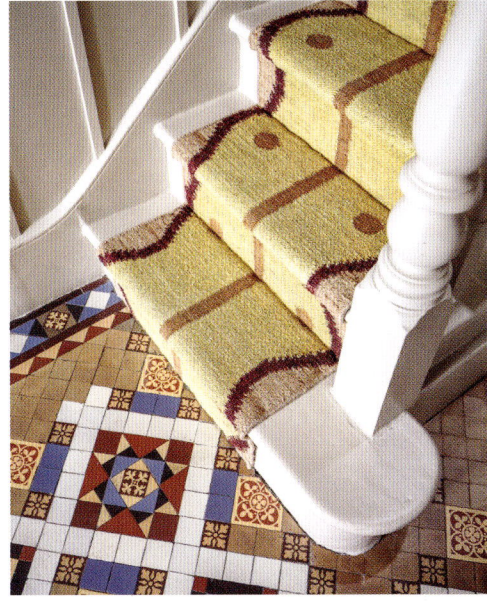

FINISHING TOUCH
It is always worth making sure that you have chosen the right type of paint for every application in your home (opposite and right). Powdery matt pigments disguise surface irregularities with a velvety touch. Gloss paint maximizes the reflective nature of a material, which can help illuminate a space. Distressed details age beautifully over time. And light sheens lift a room with a refined brightening polish.

You can use satin paint to pick out skirting/baseboards and other trims such as dado/chair rails for a smart, smooth finish.

Semi-gloss at around 60%, and *gloss* at 85% or more, are the most reflective and water repellent. Saved for high-traffic and the latter additionally for exterior use, they are trickier to use than other paints, take longer to dry off and often leave brush marks. Despite this there is a rise in popularity of use of semi-gloss and even gloss on walls and woodwork/trim for leading-edge looks and resistance to wear and tear. Use to add a polished and smooth feel on banisters and internal doors or gloss underfoot on a bathroom floor. If you are feeling bold and have immensely smooth surfaces and perfect painting skills, go for a dark dramatic gloss on a backdrop for a premium polished patina.

A last word on paints is reserved for their *application and appearance*. Various decorative paint effects can be used to bring a unique and crafted look. Watered-down washes, visible brushstrokes, stippling, scrunching and distressing can all add character and can take a room from looking box-fresh to timeworn in an instant.

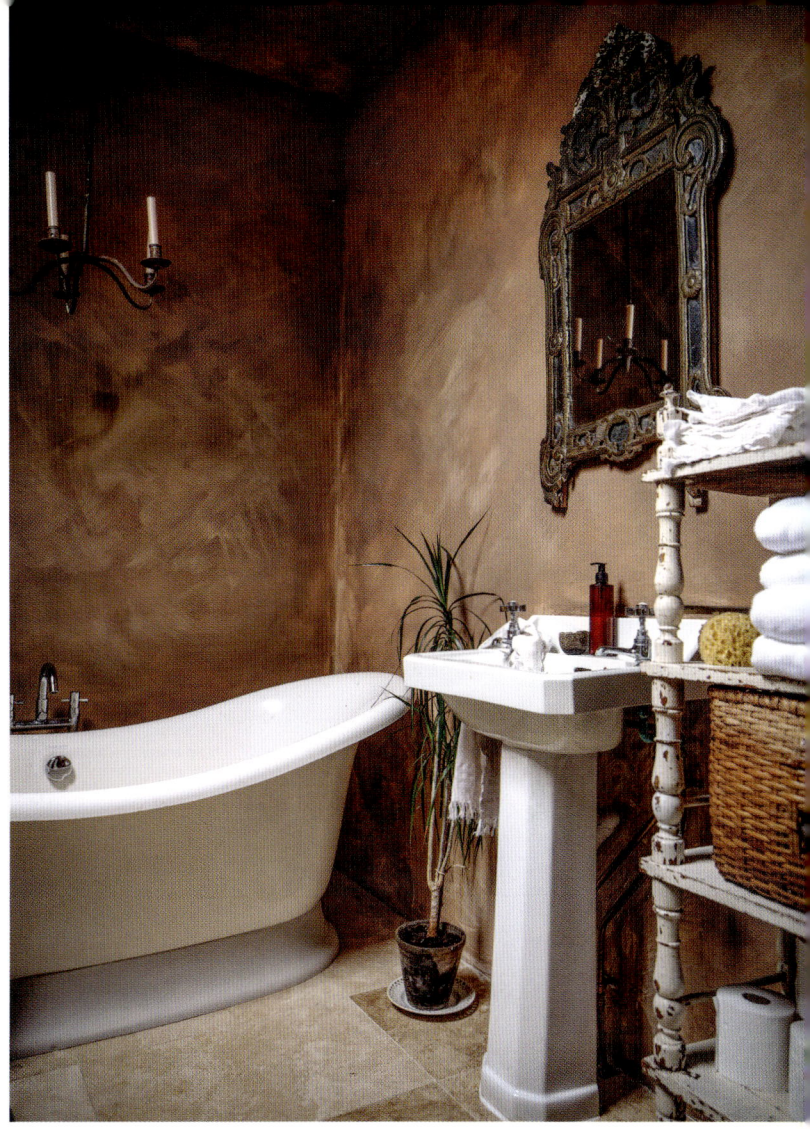

FULL STEAM AHEAD
Kitchen walls particularly benefit from higher sheen finishes because of the high humidity (opposite). Most matt paints are not able to withstand such close proximity to water and steam, whereas glossier paints repel liquids and have greater longevity.

MAKE IT LAST
For a softer effect in the bathroom, consider tadelakt, a traditional plaster finish from Morocco (above). Soap is buffed into the surface of the lime-based plaster to make it water-resistant. High-traffic areas such as entrances also need appropriate finishes, for example the wipeable gloss paint in this hallway (right).

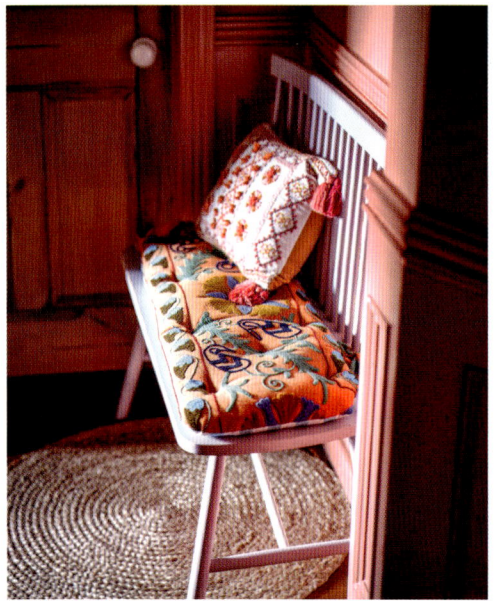

COLOUR & LIGHT

It is well known that different light can significantly alter how colours appear to us. The hour of the day, sun orientation, time of year and interaction between natural and artificial light all shape how colours are perceived, shifting their temperature and in turn influencing the mood of the space.

Lighting can be soft and subtle or have high contrast. Natural daylight tends to look and feel warmer because of the sun's rays even when it is not blazing into a room. However, it is affected by the climate and season and can make a room feel very different depending on the weather. Artificial lighting is easier to control, but it is generally cooler and can look harsh. Electric light that is too even and lacking in contrast will impede atmospheric qualities, making a room look bland and sterile. In a brightly illuminated room, regardless of the light source, it is often safest to use warm-toned neutrals as the foundation of the scheme and then build from there. Conversely, if a room is very gloomy and dull, embrace the mood from the beginning and build on the drama with dark decor.

To get the best out of a chosen colour scheme, consider the room's orientation in relation to the points of the compass, as this will determine the brightness and quality of the light it receives. A general rule in the northern hemisphere is to use cooler shades from the blue-green half of the spectrum in a south-facing room and those from the red-orange half if the room faces north. In the southern hemisphere, the reverse is true. East- and west-facing rooms are easier to work with, but remember that the sunlight is likely to be more intense in either the morning or the afternoon.

GET THE GLOW
Inviting the natural light inside to share a space has mood-enhancing benefits and allows gloss and matt finishes to reveal their own distinct qualities (left and opposite). Choose flat and muted variances for a soft and subtle shade change. Alternatively, reflective options reveal sharper and harder lines, which are useful in dark corners or to create dramatic contrasts.

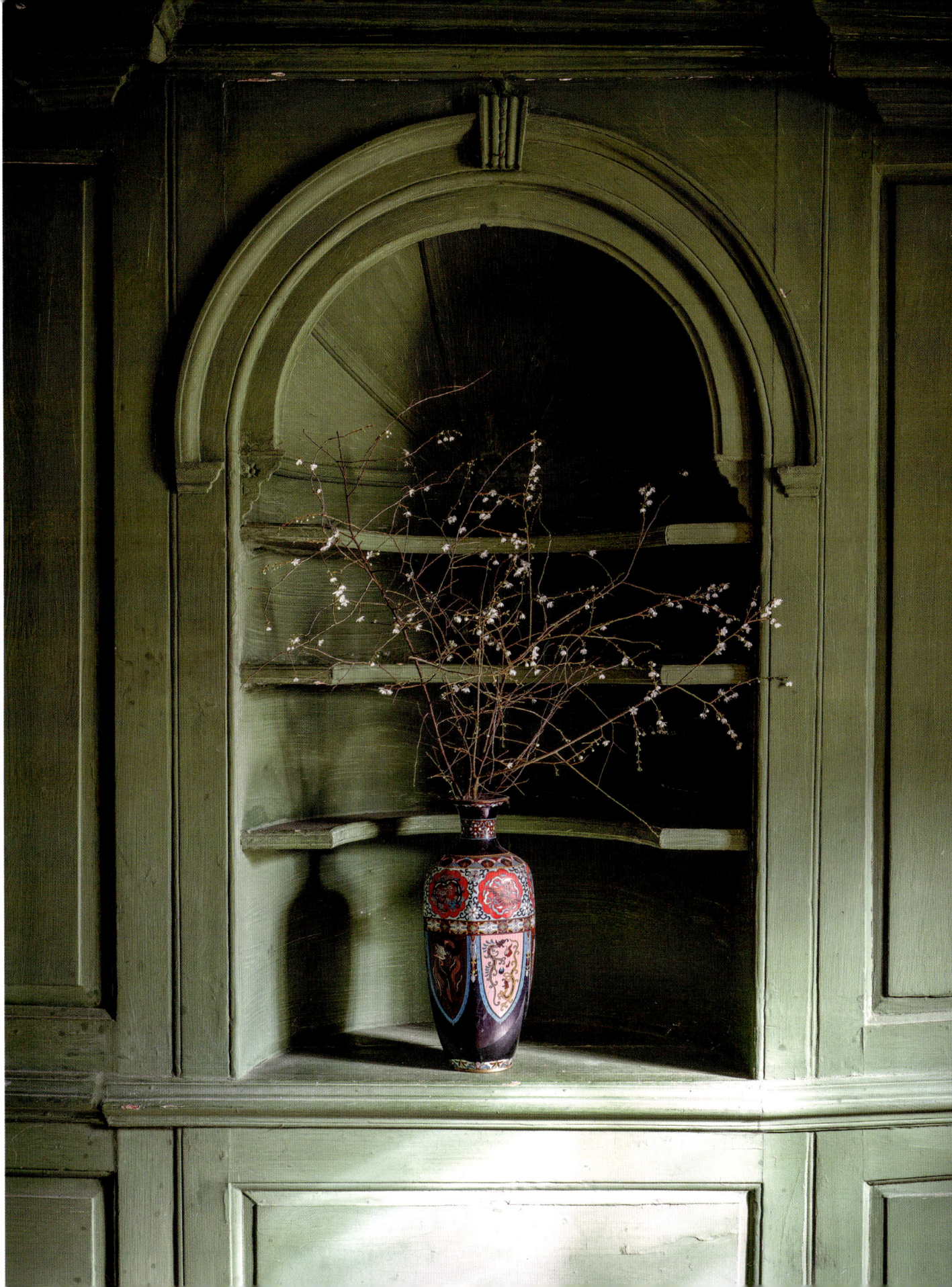

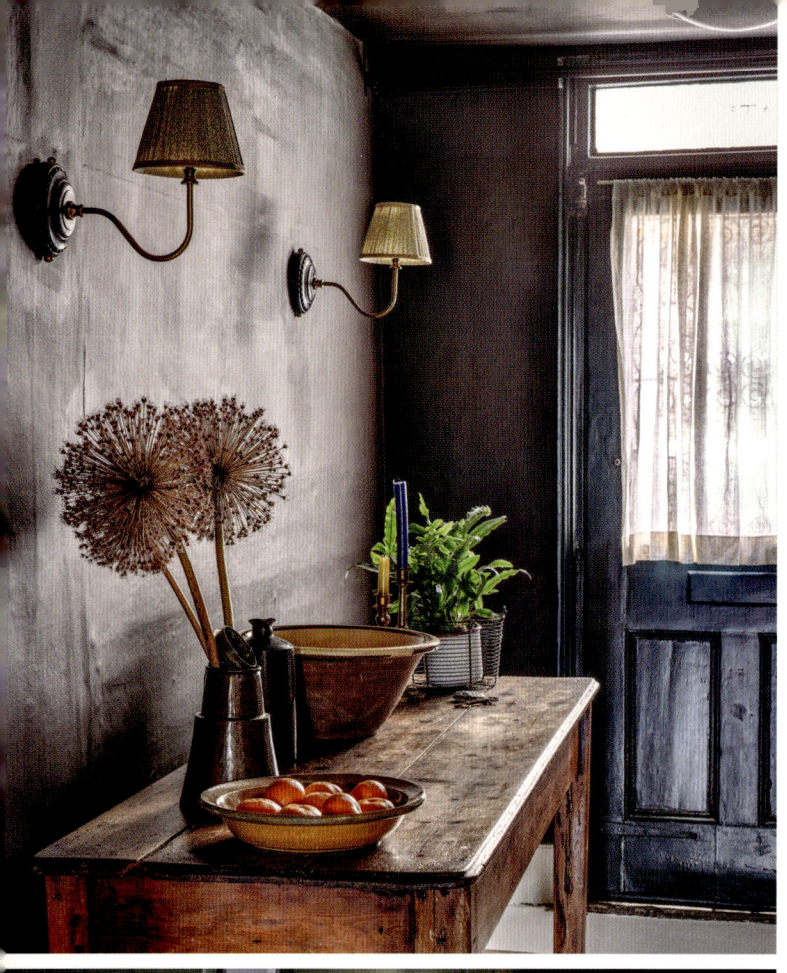
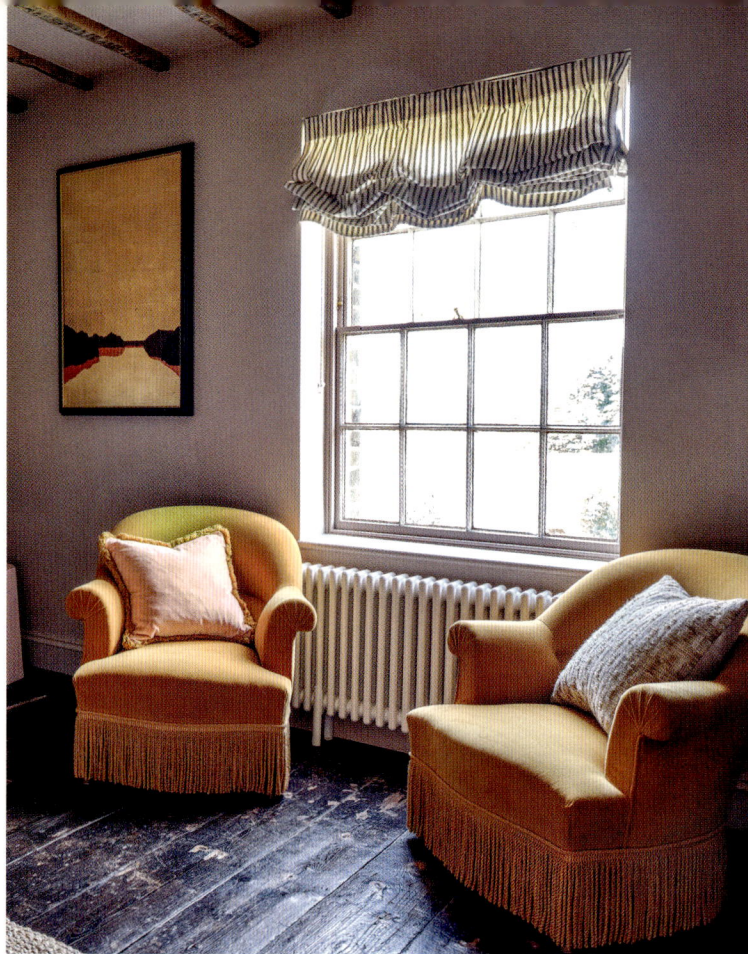
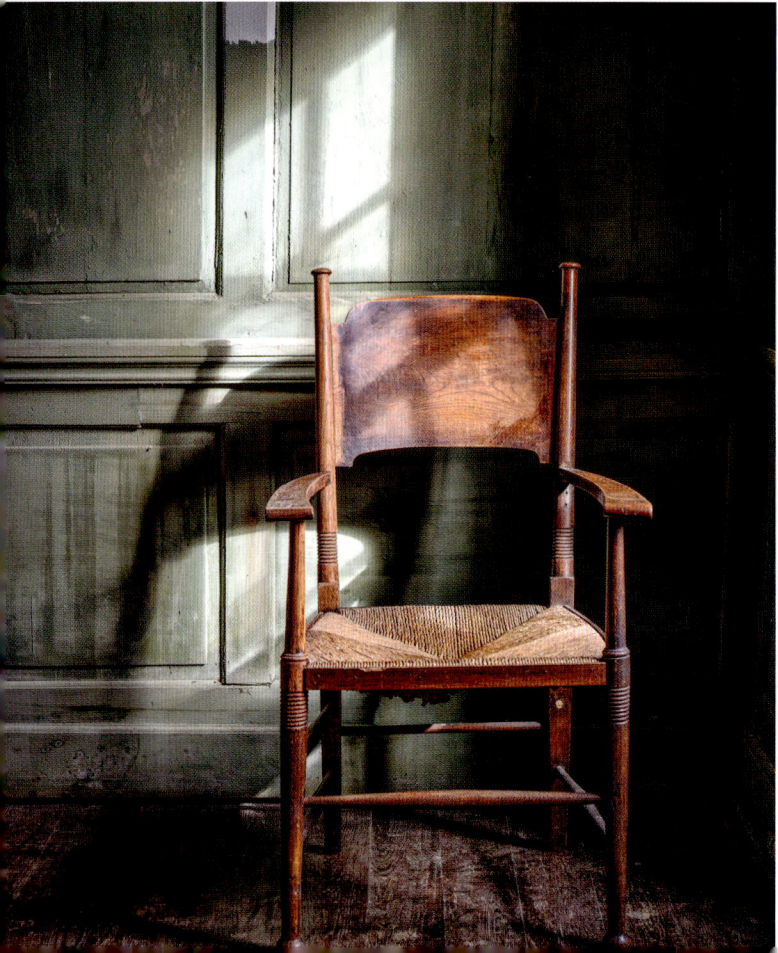
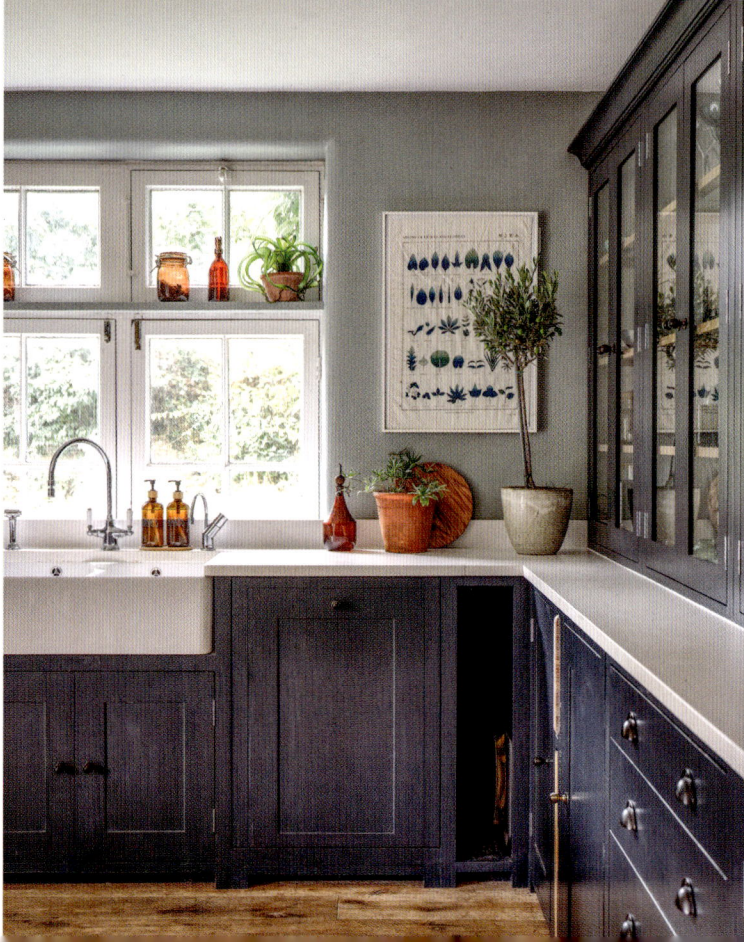

Light and darkness have a wonderful exchange with colour and create much of the ambience within a room. Brightly lit spaces feel positive and optimistic, while shadows can bring allure and intensity. Pops of colour can be highlighted with spotlights, room corners dimmed and signature shades enhanced after hours. Many rooms in today's homes are used throughout the day and into the night, so versatile colours that can adapt to changes in light are essential. Darker hues retain their chroma better and have superior atmospheric qualities than lighter shades, which may fade to grey unless brightly lit. Before choosing a paint shade, always paint a swatch on the wall and view it in situ at different hours of the day.

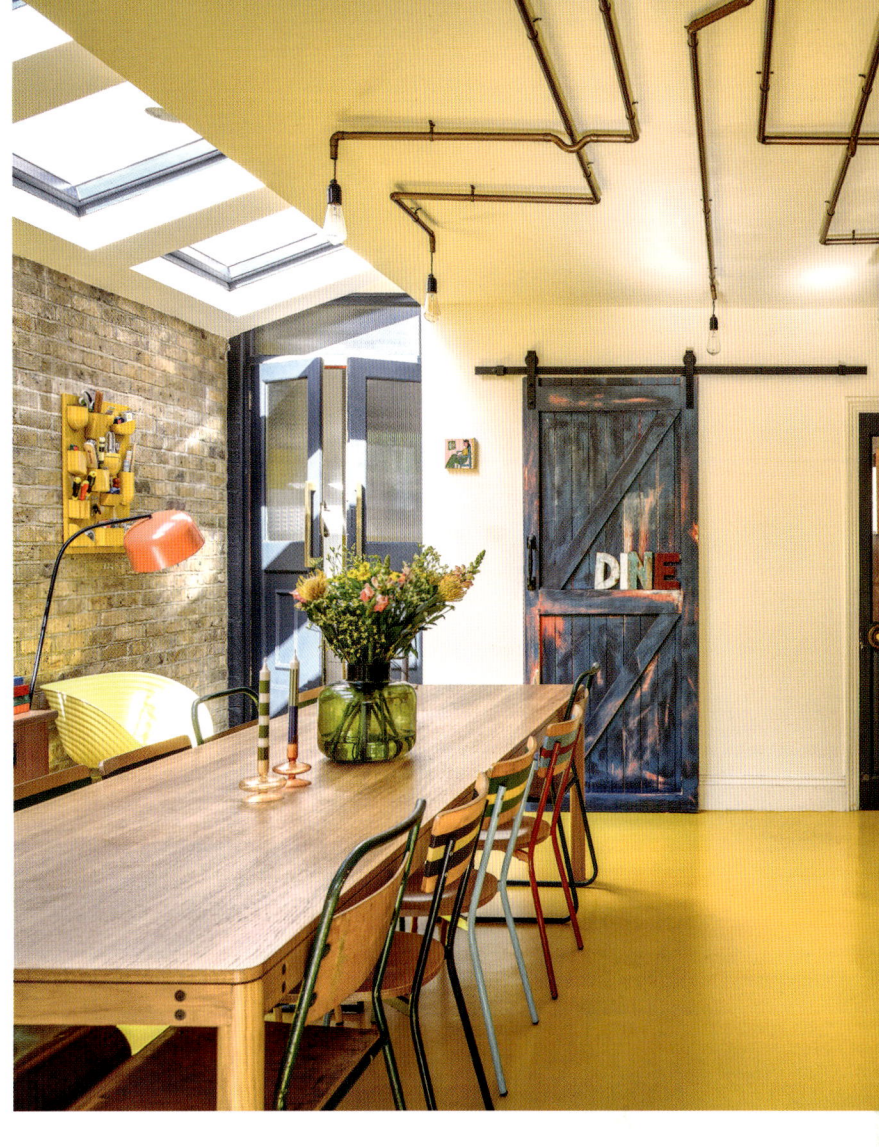

LIGHT AND SHADE
Illuminating a colour brings a pigment change as the hue interacts with the light (opposite and left). Natural daylight adds warmth, whereas artificial light has a cooling effect. The shift may be welcome or not – a colour that looks perfect in a sunny space might appear drab at night or if used in a room with no windows.

FLOOR TO CEILING
Colour can be used expressively to bounce light from one surface to another. In this kitchen, the golden hue of the floor is reflected onto the white walls and ceiling, changing the visual temperature of the room as a whole (above).

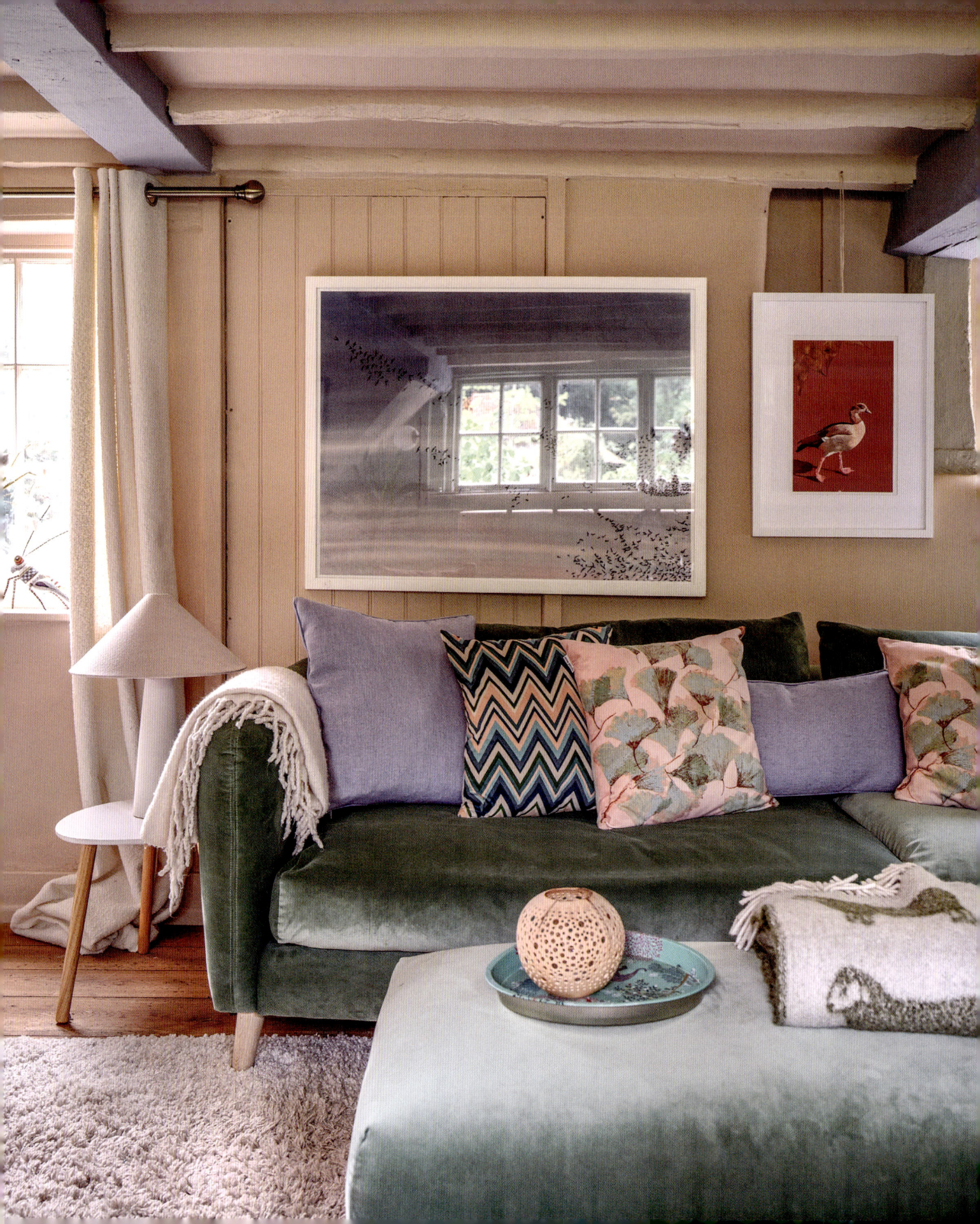

COLOUR & SUSTAINABILITY

Natural pigments have been used by humans for thousands of years and are still in use today. Choosing paints and dyes that are free from toxic chemicals and have a smaller environmental footprint is healthier for us and our surroundings, and delivers colour without compromise.

Many of the first found natural pigments seen in the earliest prehistoric cave paintings were taken from the earth. Our paleolithic ancestors used minerals such as ochre derived from clay, sand and mud. Alternative pigments were later found in flora and fauna, including plant-based dyes such as indigo and others derived from animals: cochineal from beetles and Tyrian purple from sea snails. Today, original artisanal techniques alongside modern-day processes have brought us paints and dyes with a pleasing finish that are kind to our planet.

Once the go-to for decorating nursery rooms, now non-toxic natural paint recipes are the preferred option for the entire home. Today's formulas have been created to deliver intense pigmentation and high performance. Containing lower levels of VOCs (volatile organic compounds), APEs (alkylphenol ethoxylates) and solvents, they provide breathable and cleaner air-borne credentials with the added benefit of no odours or fumes during application.

In most cases, pigments for interior decoration are mixed with a carrier, the most eco-friendly examples of which are water-based. Less resistant to moisture and wear and tear than their oil-based counterparts, these paints are most suitable for use in low-traffic and humidity-free spaces in the home.

AGEING GRACEFULLY
Another aspect of sustainable decorating is choosing old over new and learning to appreciate the way colours age over the years. Consider the timeworn beauty of vintage furniture or distressed paintwork. These rooms are decorated in soft greens and pinks, a timeless and well-loved combination that will only look better with age (opposite and right).

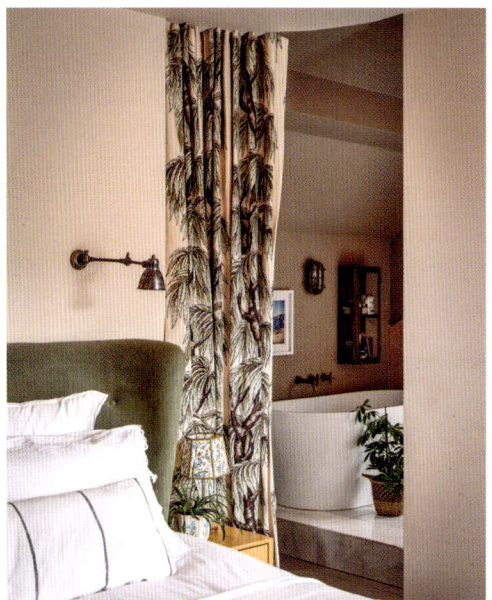

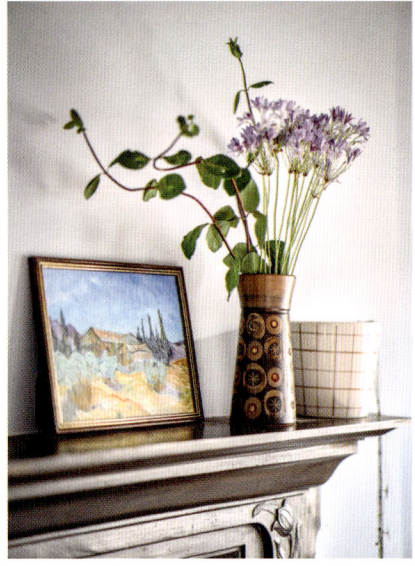

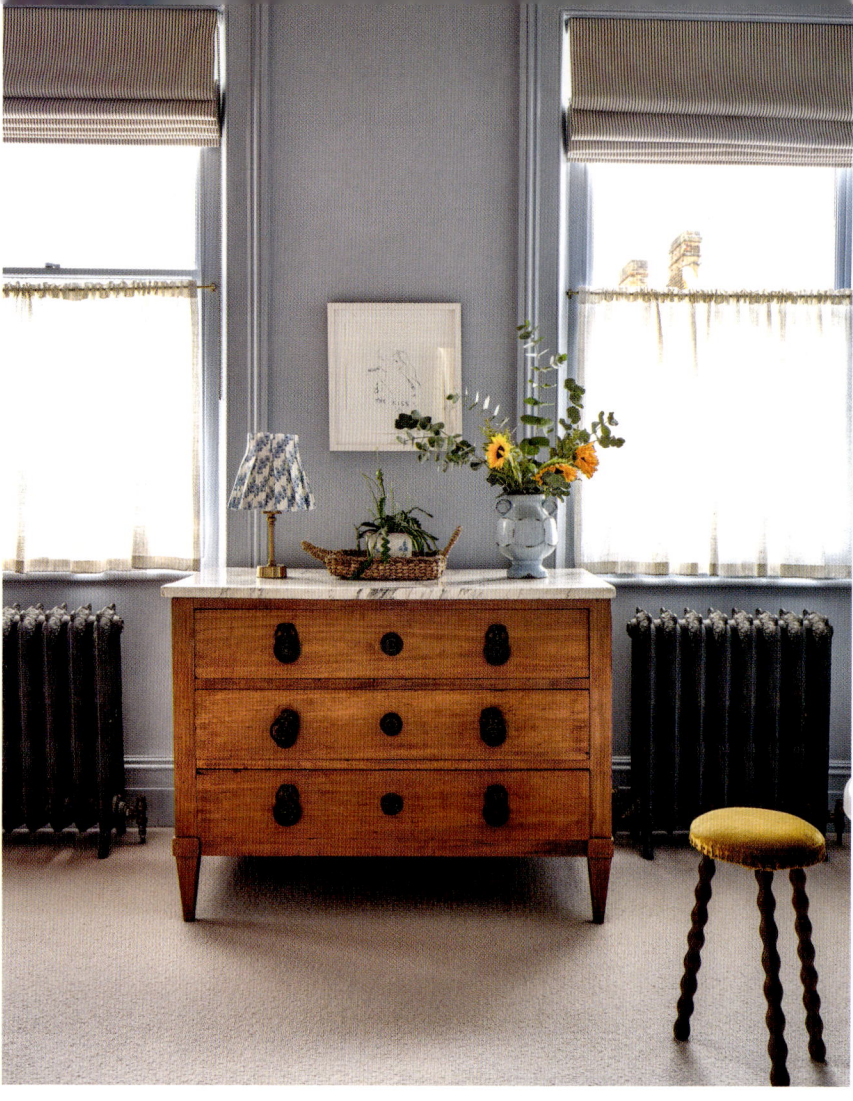

TIMELESS STYLE
Some shades never go out of fashion, like the blues in this bedroom (above and right). In general, colours with a hint of smokiness are more likely to stand the test of time, as their muted character is versatile and easy to live with.

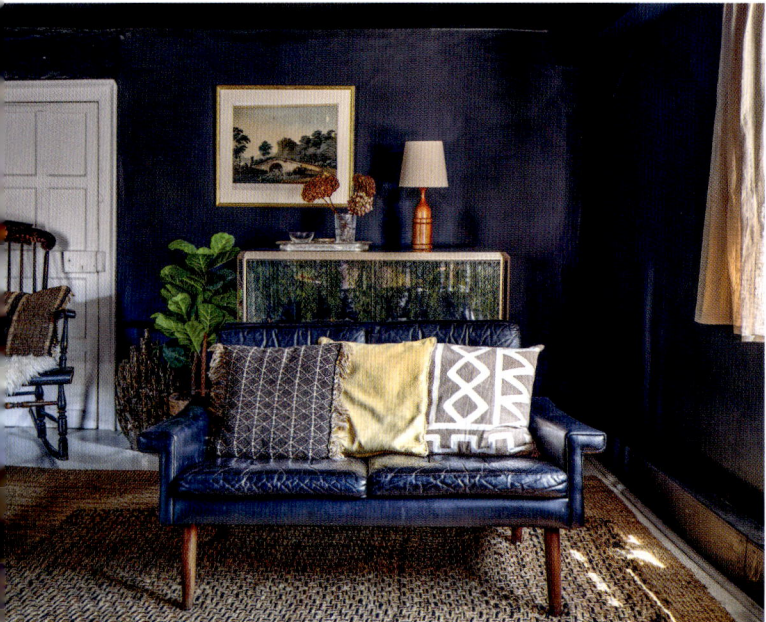

Some paints are made to be watered down to produce delicate washes. To use, gradually build up thin layers on surfaces to create textural and artistic finishes.

According to the Royal Society of Chemistry, approximately 50 million litres/13.2 million gallons of paint go to waste in the UK every year. In the US, the Environmental Protection Agency reports that the figure may be as high as 284 million litres/75 million gallons. To prevent this, some manufacturers have begun to offer reclaimed or remade paints that are better for the planet and for the pocket, too. Choose salvaged shades from a leftover scheme to make use of existing resources or buy reconditioned paint as a mindful choice.

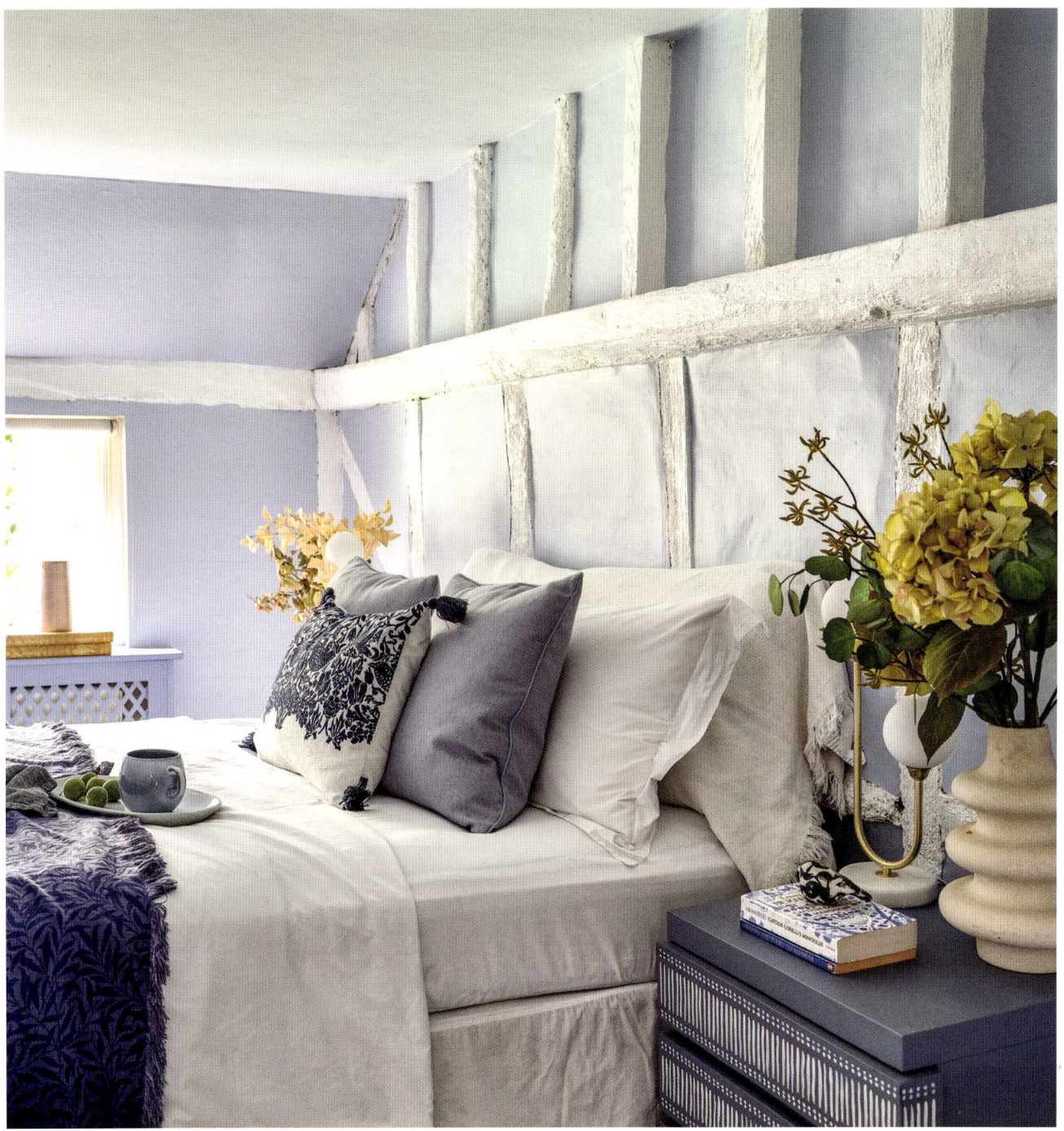

PERIOD DETAILS

Chalky tones tend to work better in historical homes. One reason for this is that they are the perfect choice to draw the eye to historic features. In this bedroom with its original wooden beams, the subtly greyed blue and white hues feel understated and timeworn (above).

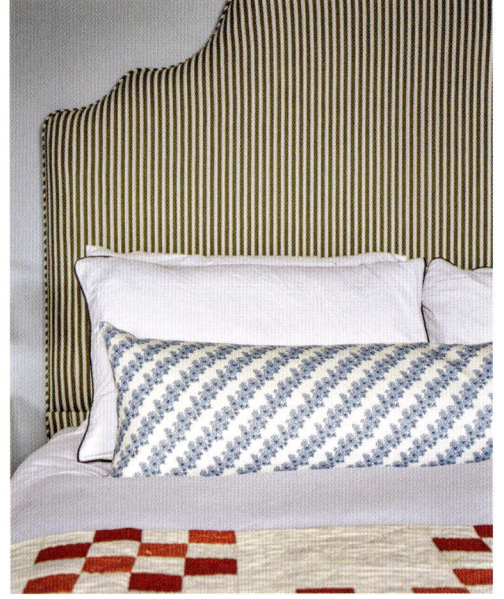
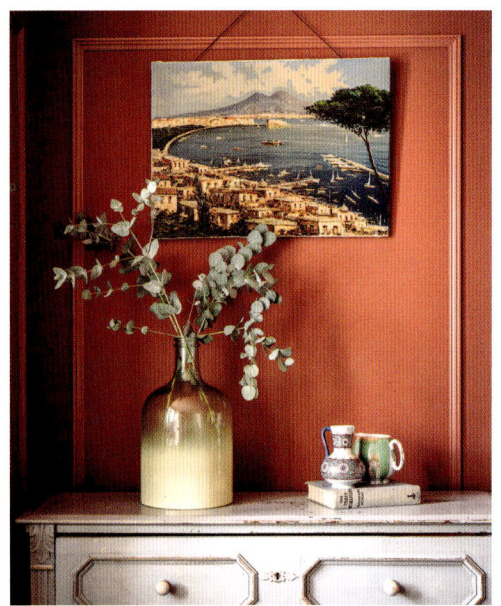

COLOUR & WELLBEING

Within and beyond their cultural and historical meanings, colours can have an amazing effect on our mental and physical wellbeing. This underlying psychology should be considered with care when choosing a palette for the home.

Colours enrich our world beyond our four walls and may have a variety of meanings and attributes depending on your cultural context. In Western societies, for example, white may be regarded as a spiritual and religious shade with associations of purity, while purple (once an expensive pigment used only by the elite) is a marker for luxury. Brands and official entities often make use of our reaction to particular hues to influence our decision making. Think of the globally recognized traffic-light colour trio of red, amber and green. Bright red or yellow signs signify danger, whereas a grounding shade of brown may be used to convey information.

But colours prompt a reaction from within us, too, switching on our internal awareness and emotions. Blues are often turned to for a calming scheme that promotes mindful clarity. Greens revitalize us and trigger our appetite. Oranges pep up and energize, while pinks nurture and nourish. Colour psychology can be harnessed in every room to create spaces in which to live and thrive.

Not just the shade, but the purity and saturation of a hue can be explored to devise the correct dose for our wellbeing. Surfaces can feature combined colours to make a room react with a positive outcome for the individual or collective needs of the household. Vibrant backdrops wake us up, for example, and softer shades encourage rest and relaxation.

Colour in our home also brings the opportunity to be sociable or solitary, loudly shout or quietly reveal our favourite objects and treasures. Surfaces and items can be arranged to pop out of the shadows or gently emerge from blended layers.

HAPPY COLOURS
Colour has the power to enliven our experience of being in a space and enhance or change the ambience of a setting. Although these schemes are very different from one another, they all tap into the remarkable psychology of how colour can stimulate the senses to improve our mood and even boost our productivity (left and opposite).

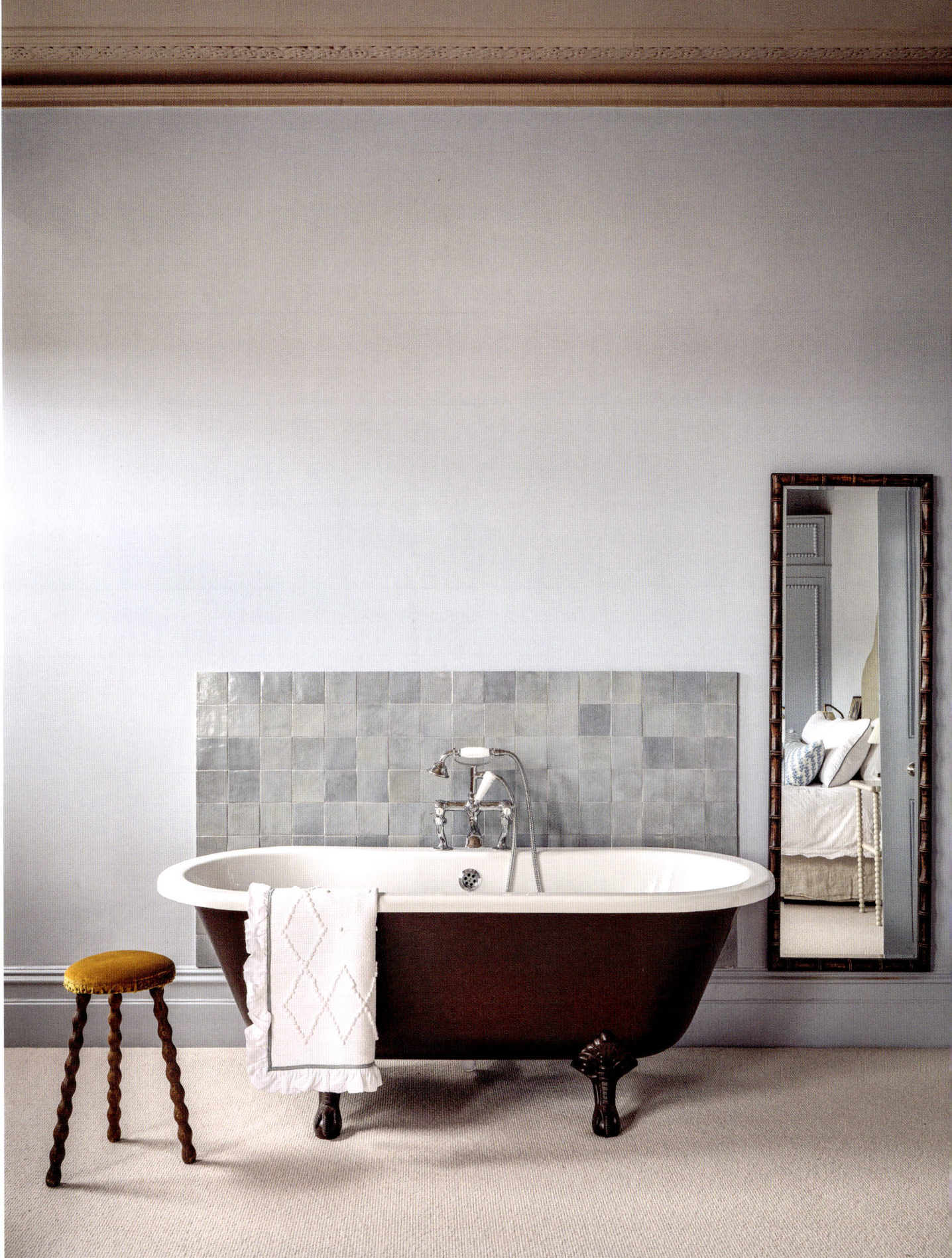

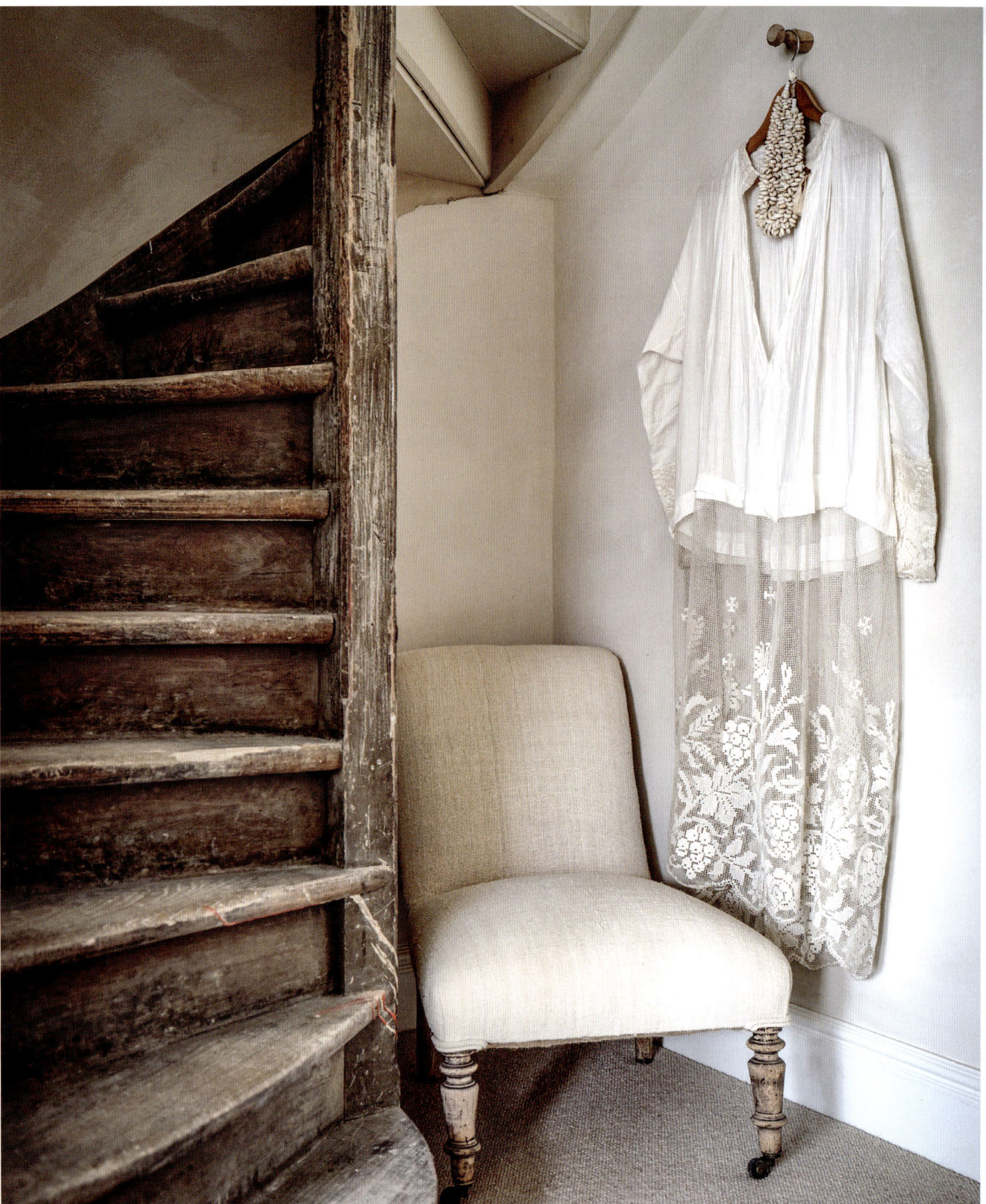

We may wish to engage with different palettes and pigments or feel spiritually enriched when drenched in deep tones.

As colours come and go, decorating trends can have an immediate effect on our mood and prompt us to refresh our surroundings. But in the long term it is far better to tap into your personal preferences to make a committed and meaningful colour collaboration between yourself and your home.

FAVOURITE SHADES

Surrounding ourselves with the colours we love has a powerful effect on the psyche. White and other pale neutrals are calm and soothing, especially when paired with textural accents (opposite and left). Blues and greens have biophilic qualities that make us feel grounded in the natural world (above).

COLOUR & WELLBEING

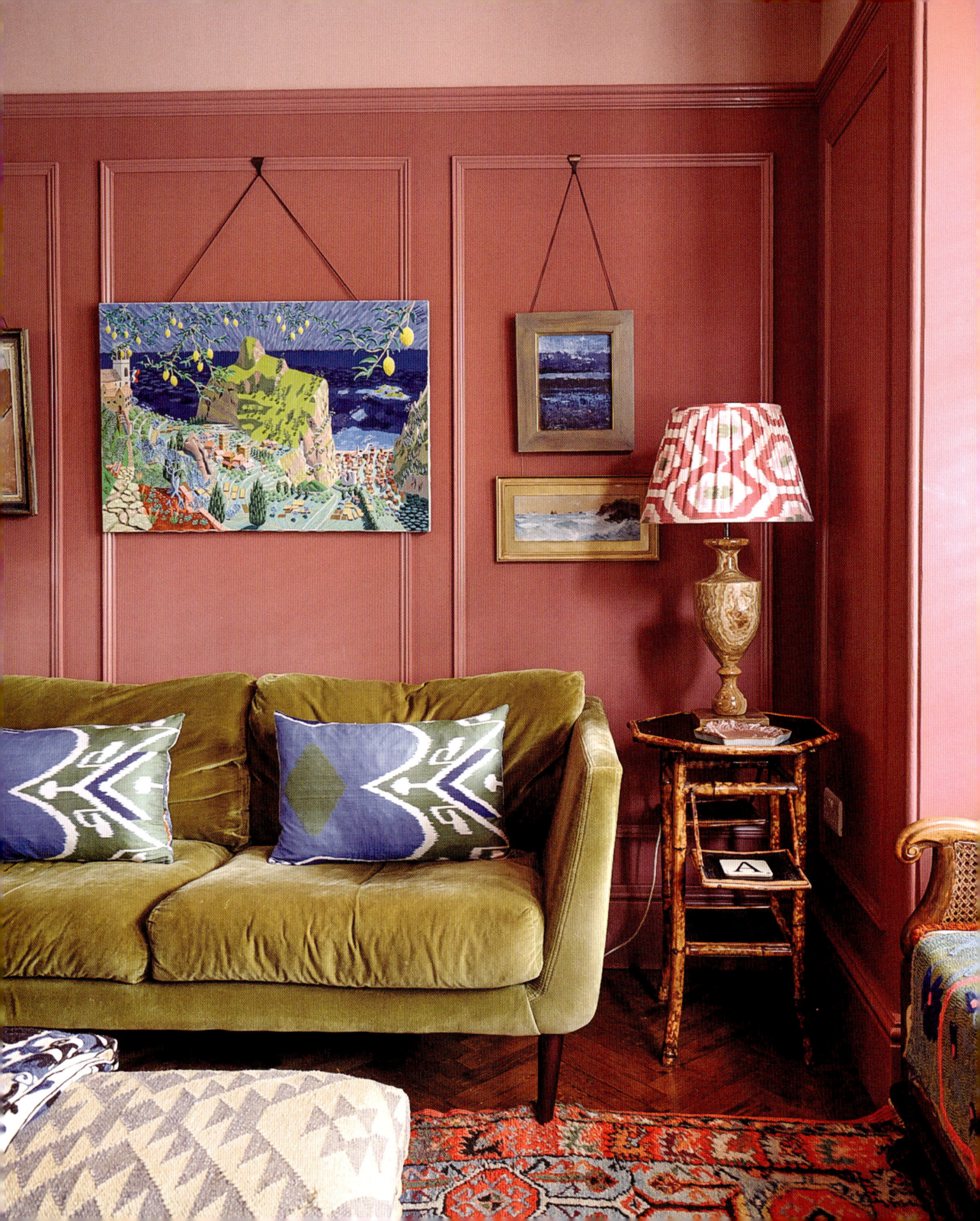

2
THE HOMES

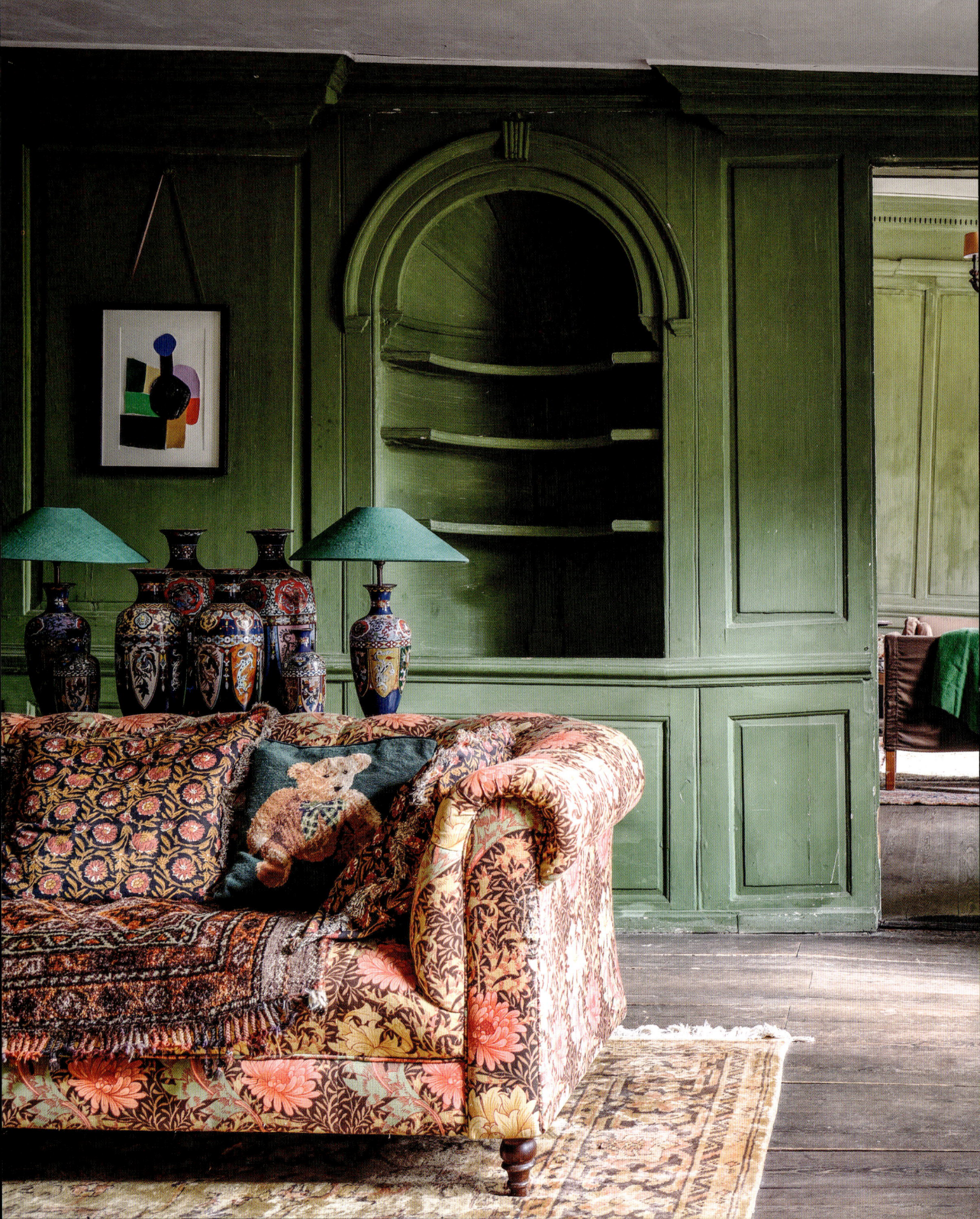

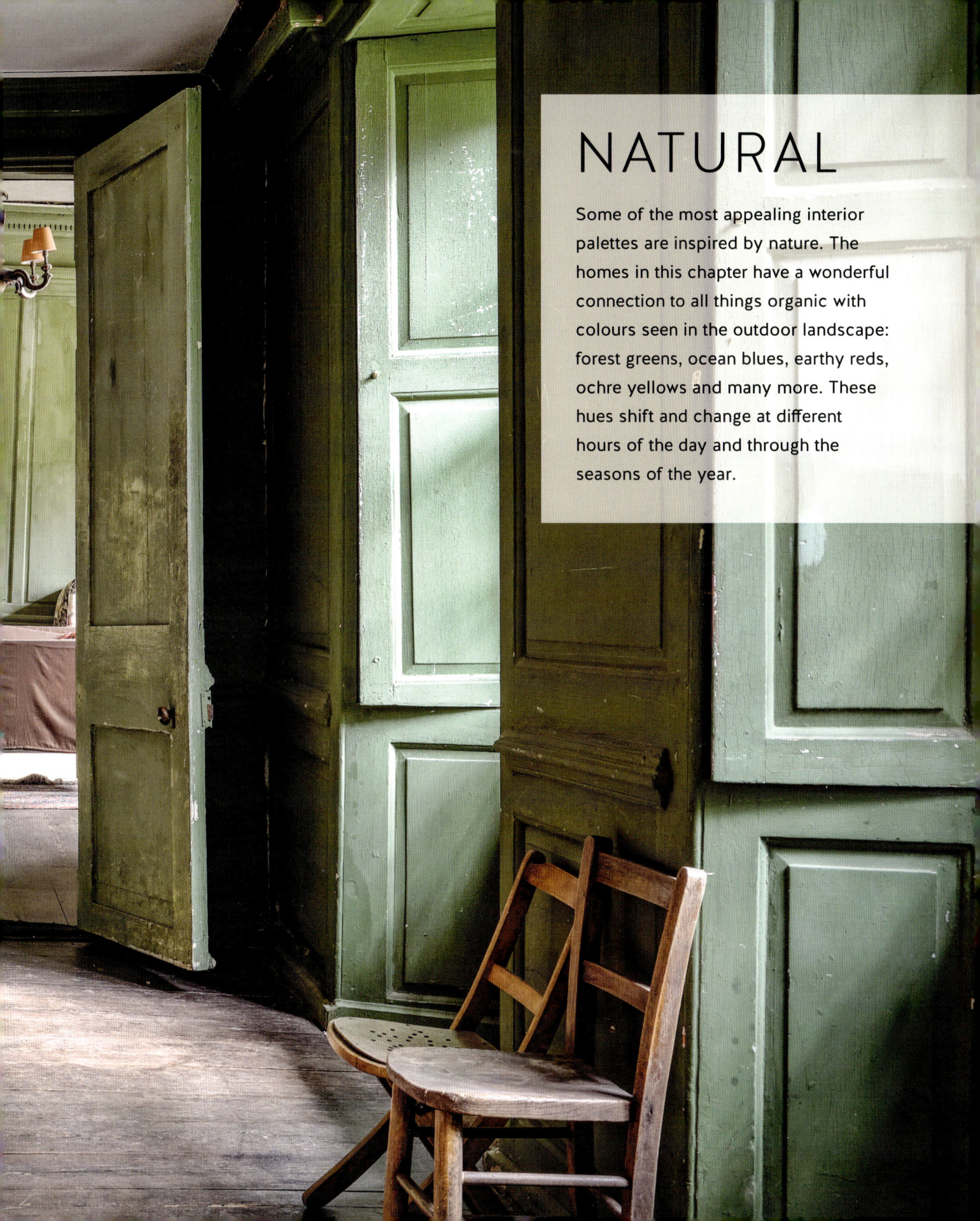

NATURAL

Some of the most appealing interior palettes are inspired by nature. The homes in this chapter have a wonderful connection to all things organic with colours seen in the outdoor landscape: forest greens, ocean blues, earthy reds, ochre yellows and many more. These hues shift and change at different hours of the day and through the seasons of the year.

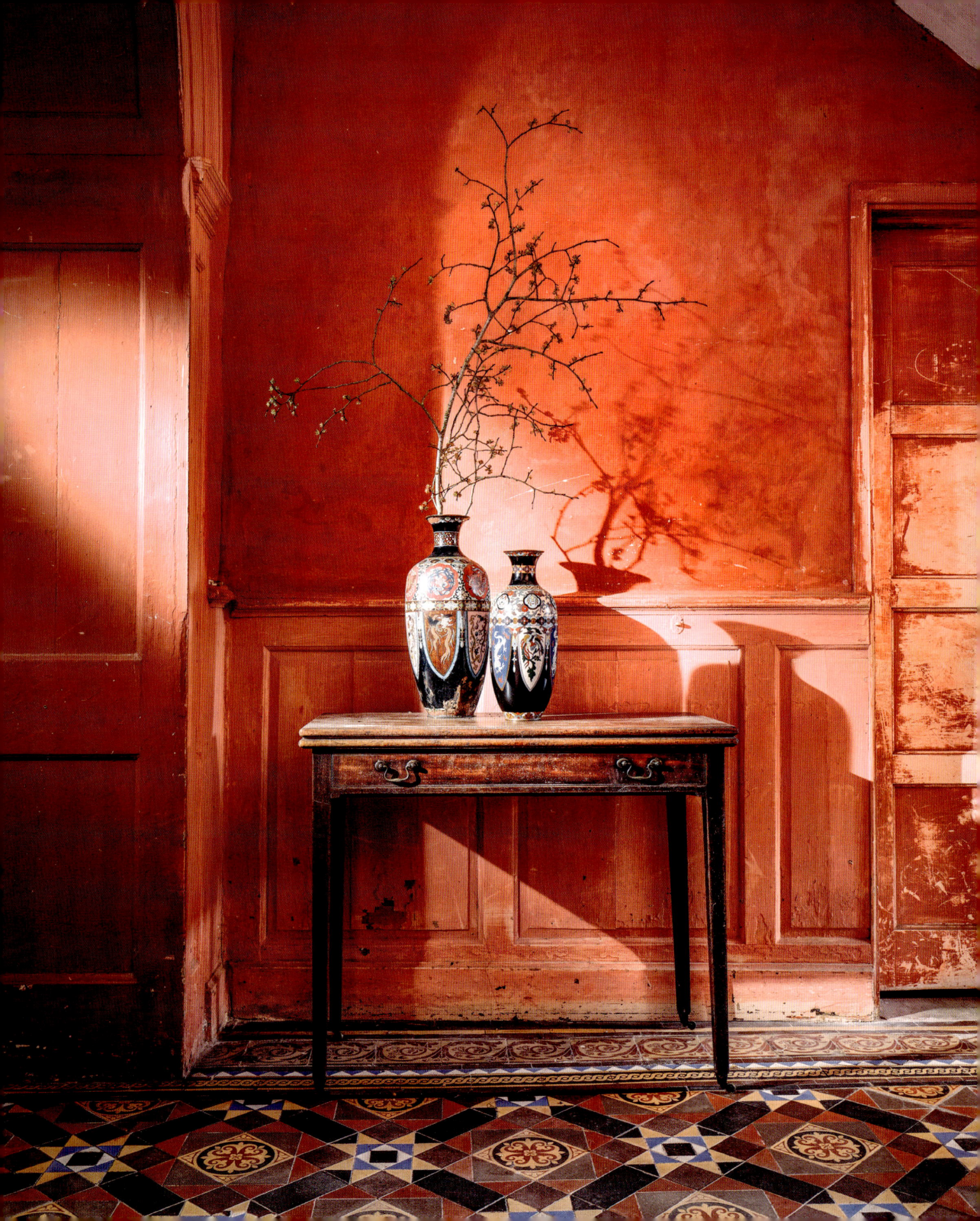

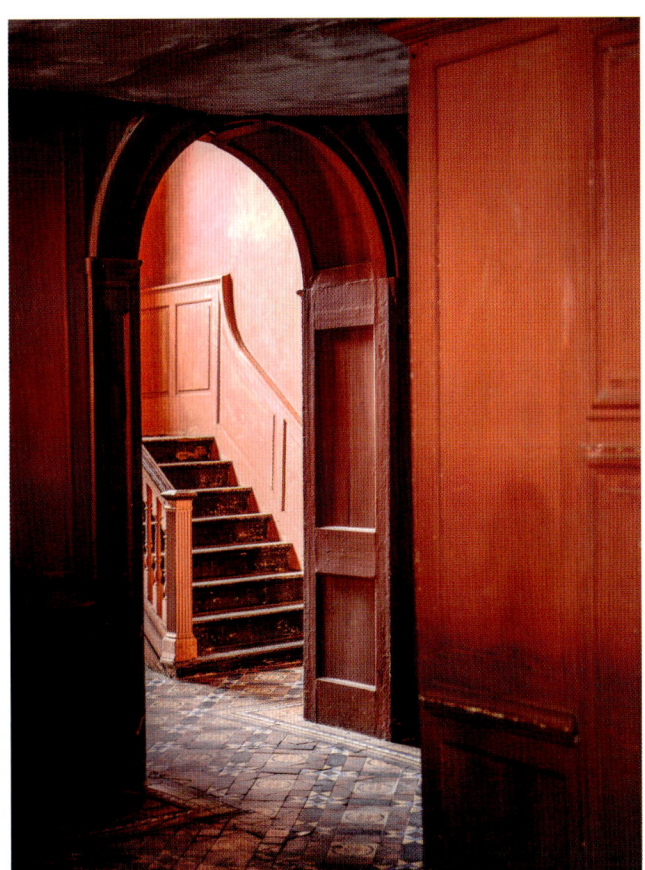
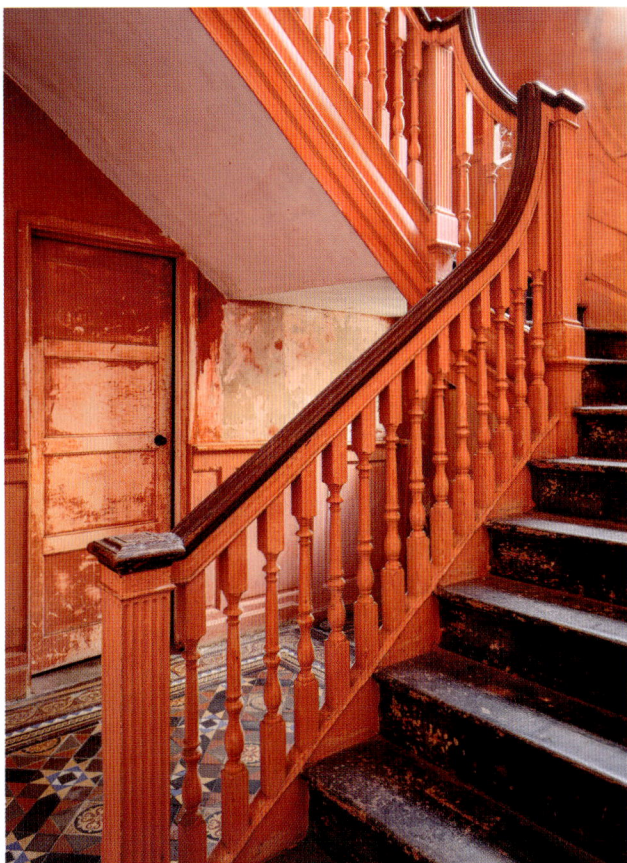

OPPOSITE & ABOVE

The magnificent staircase and hallway date back to 1730, when the house would have greeted guests in great splendour. Continuing this tradition, the area has since been drenched in a vivid red wash that picks up details in the Victorian floor tiles. Instead of using exactly the same colour on all surfaces, Sophie chose slightly different hues of aged and faded pigments that reflect their historical situation.

GRAND *romance*

It was destiny that brought ceramicist Sophie Wilson to this authentic and unmodernized manor house in the Lincolnshire fens. Looking back, she likens the discovery to finding 'the love of her life'. Over the years, she has continued the story room by room with an ensemble cast of finishes, furniture and finds.

Originally a humble 16th-century dwelling, by the Georgian era the manor had been expanded repeatedly until it was one of the most impressive properties for miles around. Sadly, when the region fell on hard times, the house was abandoned and left to wane. On moving in and making it her own, Sophie chose not to create a pastiche of what the house once was. Instead, she looked at the interior and listened to how it presented itself to her. Faithful to the building's origins, the current look blends the old vernacular with nods to Sophie's formative years of design discovery.

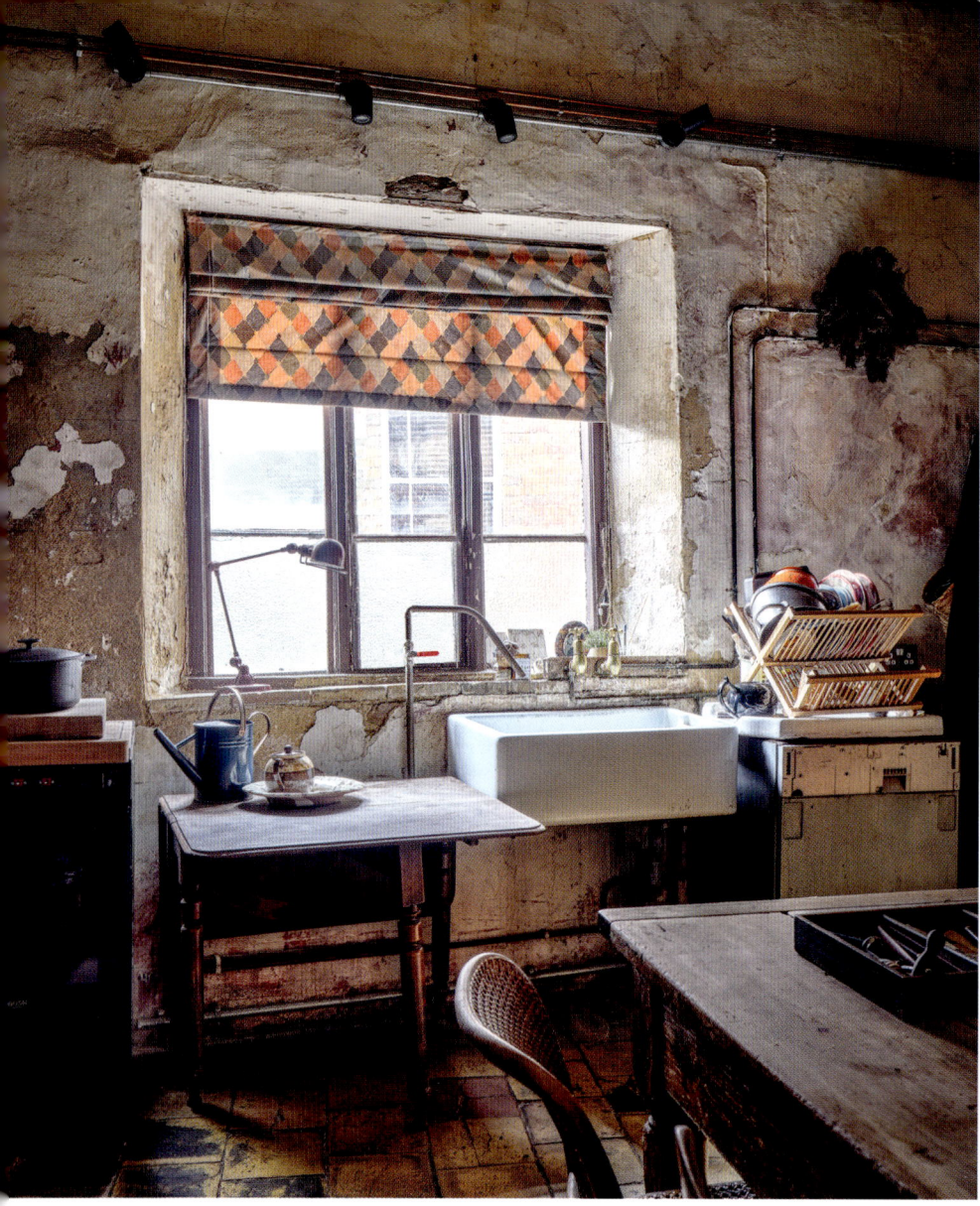

ABOVE
The room known as the middle kitchen has a very different feel to the rest of the house, with a simpler palette. A vintage Collier Campbell fabric has been made into a blind/shade for the window. Picking up on the colours of everyday household utensils, the bright and jolly repeat acts as a contrast to the aged and roughly plastered cream-coloured walls.

OPPOSITE
The mottled cream walls and high ceilings make the kitchen feel bright and spacious during the day. Low pendants overhead create a more intimate feel during the darker hours. No matter the time of day, the setting feels homely and homespun with its mismatched elements.

It is a pared-back but playful interior that pays homage to artistic moods and movements, as simple Georgian styling harmonizes with the streamlined silhouettes of late 20th-century fashion and furnishings.

The colour palette is immediately striking. Each of the splendid Georgian rooms had been splashed with rich and spirited shades by the creative former owners. There are many combinations of green and red, colours found frequently in nature and in traditional Yin and Yang partnerships.

These complementary shades work in unison to bring balance and offer a co-operative alliance of hot and cold. And while not necessarily a reflection of Sophie's own personal palette, the hues clearly came from the heart. Discovering all their many different personas and their influence on each other has been a revelation. A calming white-green or a quirky blue-red could change up the atmosphere of a room in an instant.

This new understanding of pigments, guided by her predecessors' tried-and-tested matchmaking, instilled a confidence in Sophie to experiment with colour choices in the house and then in her own work. The making up of the paint was bespoke to the house, with no official colour swatches. The hand-mixed renders were based on approximate recipes.

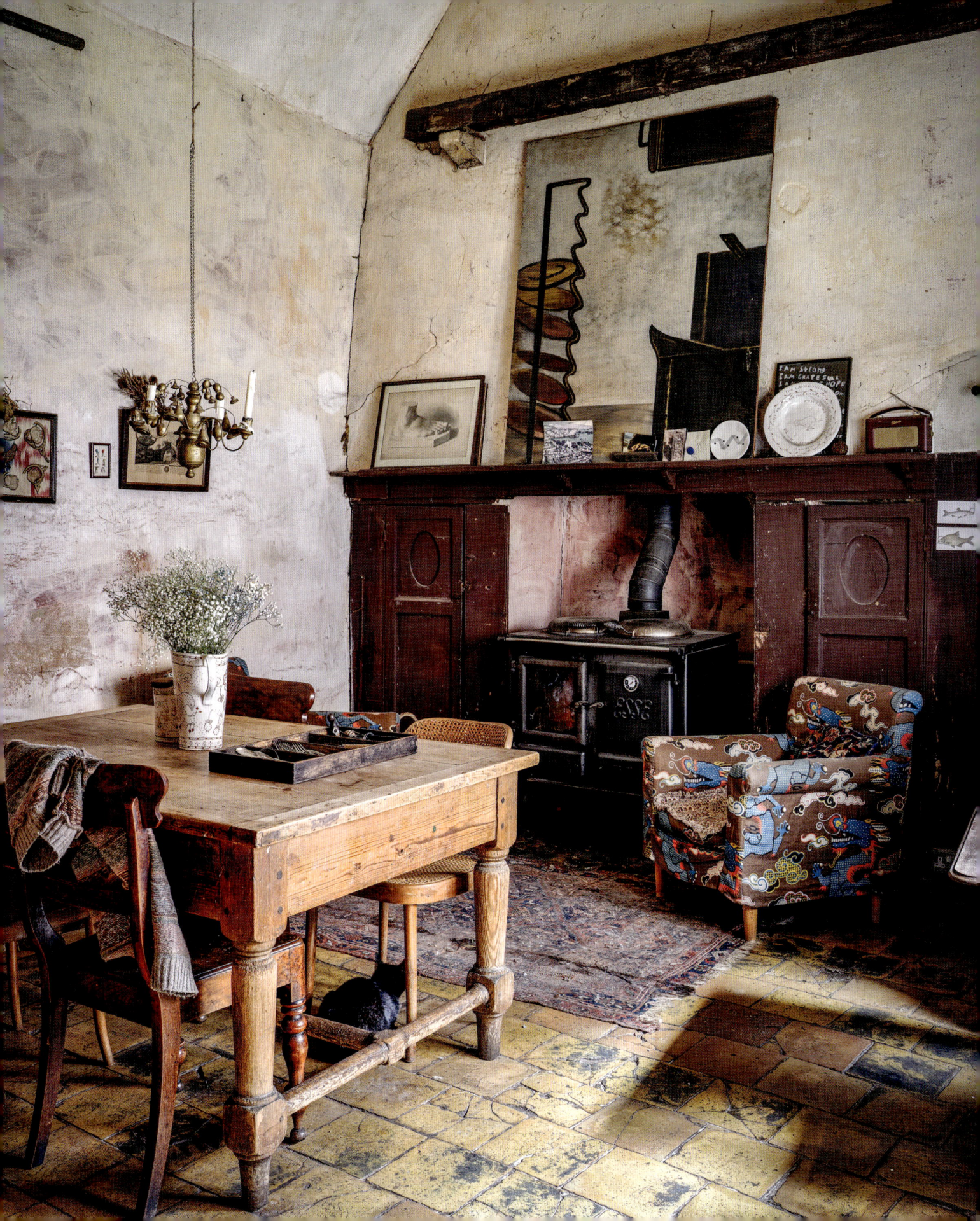

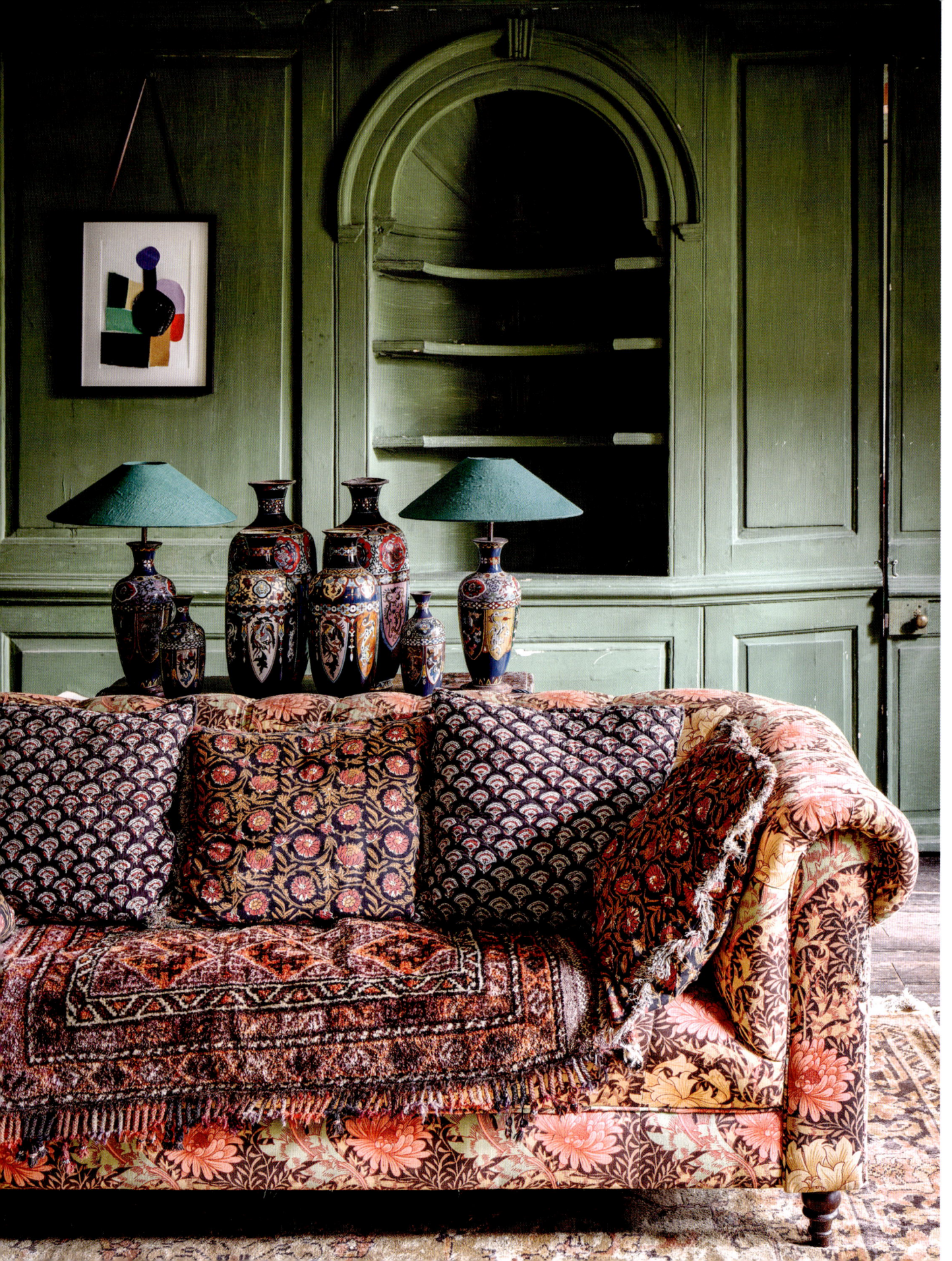

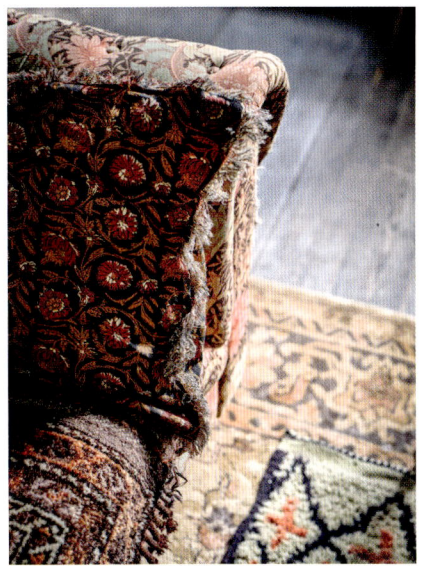

OPPOSITE & RIGHT
A crisp shade of green, inspired by foliage, brings vibrancy to the living room when matched with its colour-wheel opposites, red and russet. The luxurious sofa is covered with an archival William Morris fabric. It is a classic and timeless pairing and very at home in this historic property.

ABOVE
Earthy rust and terracotta hues combine in tapestry and carpet layers. Cosy and warming, they also bring a Moroccan flavour to the scheme.

Once the paint ran out, another batch had to be made and was delightfully never quite the same colour. Equally disparate is the depth of saturation of the paint: sometimes densely daubed on, elsewhere gauzy and gossamer. The original lime mortar, woodwork/trim and lath-and-plaster façade are beautifully imperfect and timeworn with scuffs and scratches inviting in a tangible quality. Every room sings with life, even when uninhabited.

The next phase of the project brought a chance to engage with colour quite differently. Sophie began to build up layers of decor from furniture to fittings, like an artist exploring different moods and periods while remaining true to her personal style. Preferring the weight and craftsmanship of older pieces, she purposely sourced vintage furniture from salerooms so that everything would settle naturally and at ease together. Streamlined Danish designs and smart vintage upholstery are positioned away from the walls and gather like gossips to encourage conversation. It's as though the rooms have become hosts to a party of pieces.

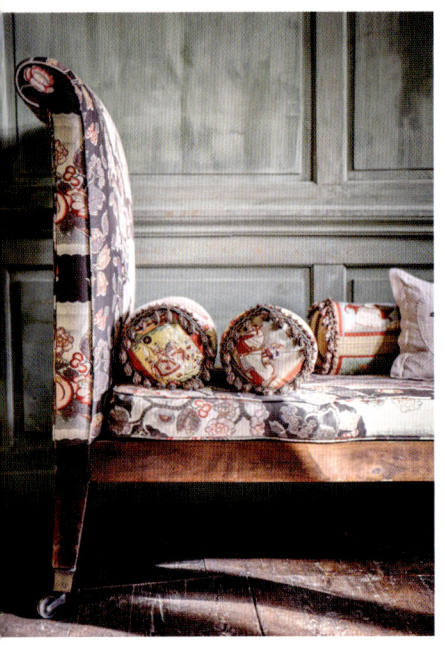

Textiles have been used to dress furniture and cloak or add comfort when seated. There is a definite link to the seasons, not least because the house is only partially heated – wherever possible, chills are lessened with soft furnishings. Practical rugs, rather than fitted carpets, camouflage uneven floors, while ubiquitous coverlets and throws are kept within easy reach. These textile layers, like the painted surfaces, offer enriching compositions of pattern on pattern.

However, Sophie wisely decided against maxing out on unnecessary furniture; the house benefits from some rooms being sparse.

ABOVE & OPPOSITE
In the drawing room, buff brown furniture, flooring and upholstery contrast with the washy green pigments on the walls. The two facing sofas are by the Danish Modern designer Børge Mogensen. Furniture of this era often took inspiration from the key principles of Georgian style such as weight, balance and composition.

LEFT
Scatter cushions/pillows and bolsters are an ideal vehicle to use textile remnants and add trimmings, buttoning, embroidery or extra stitching details.

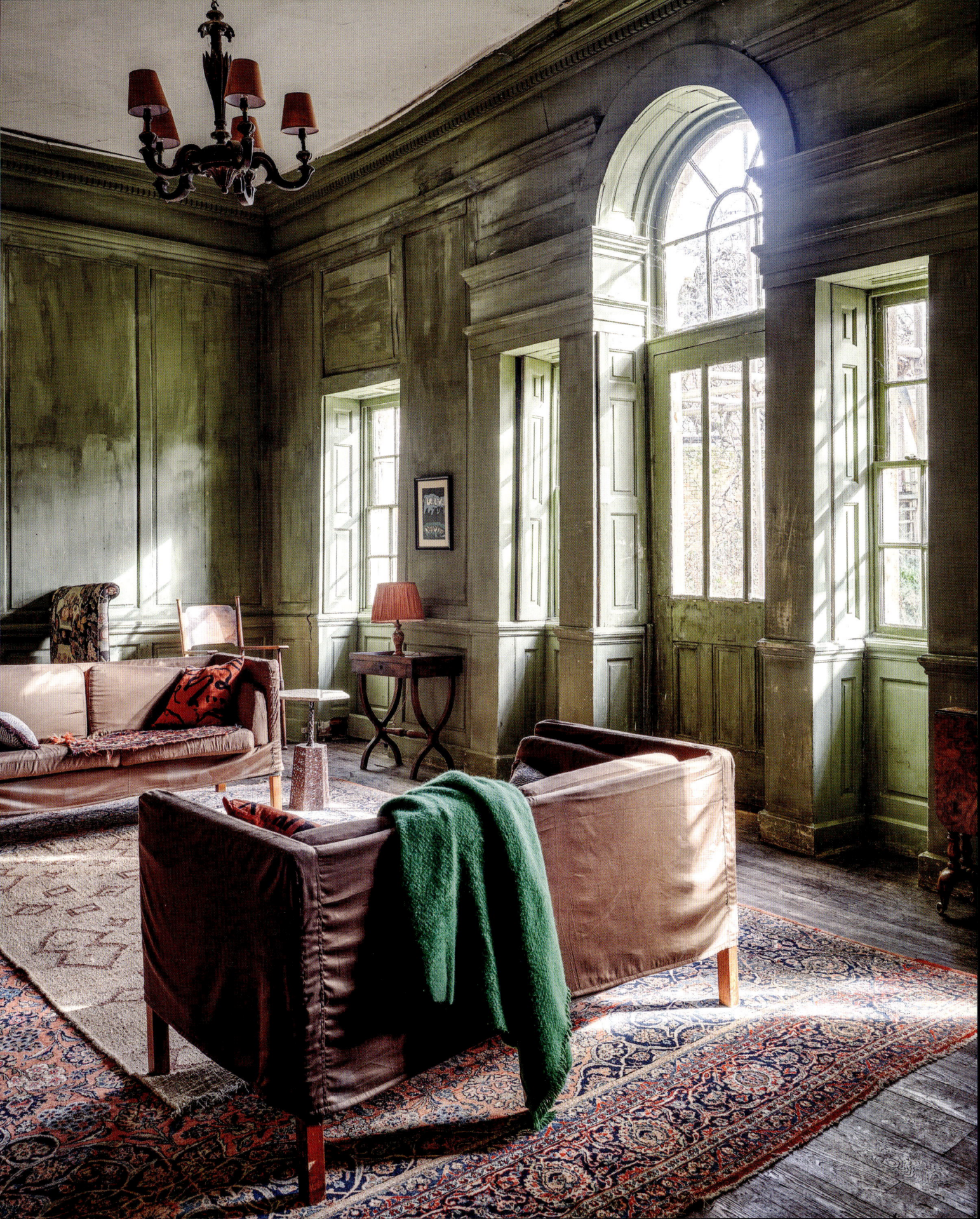

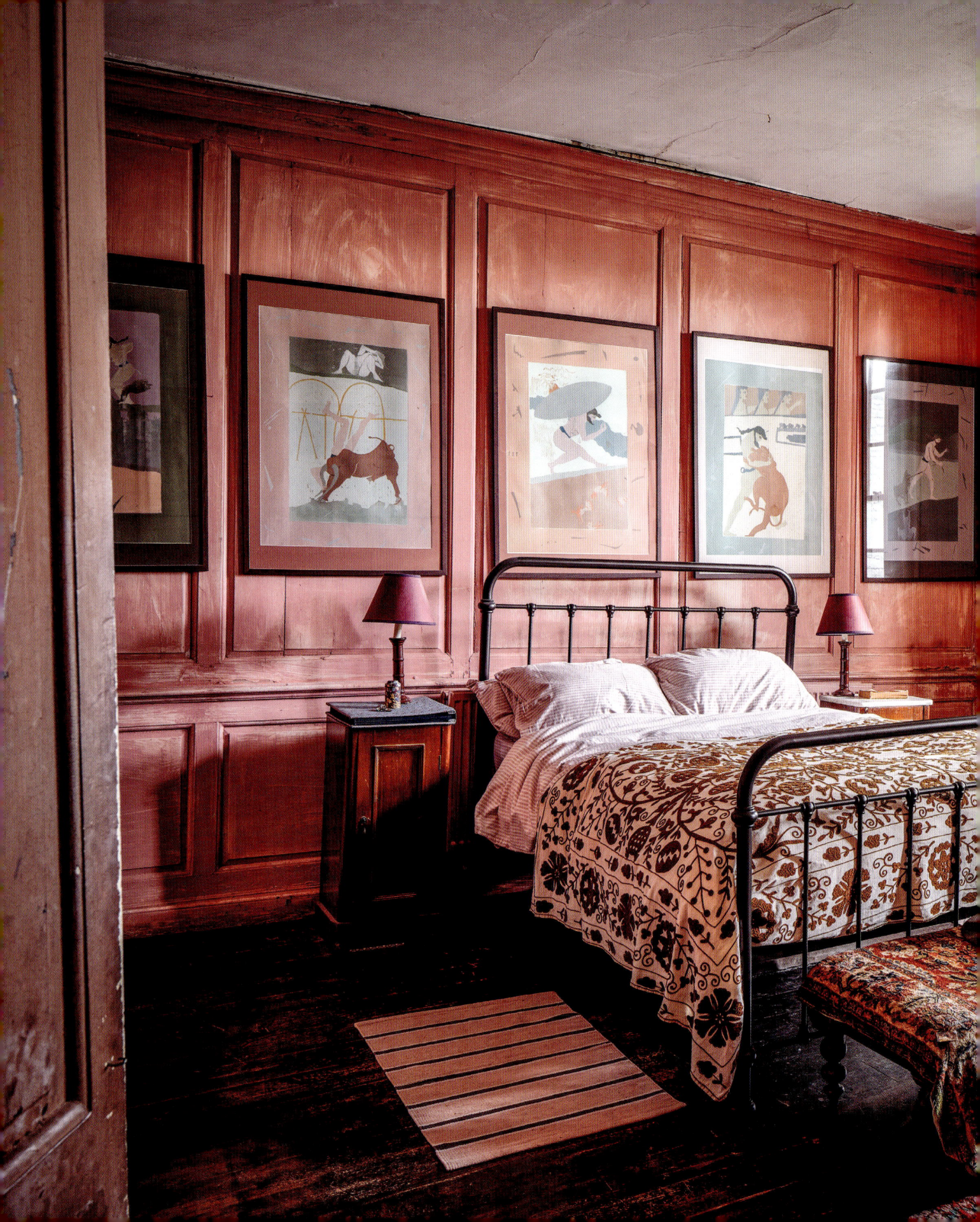

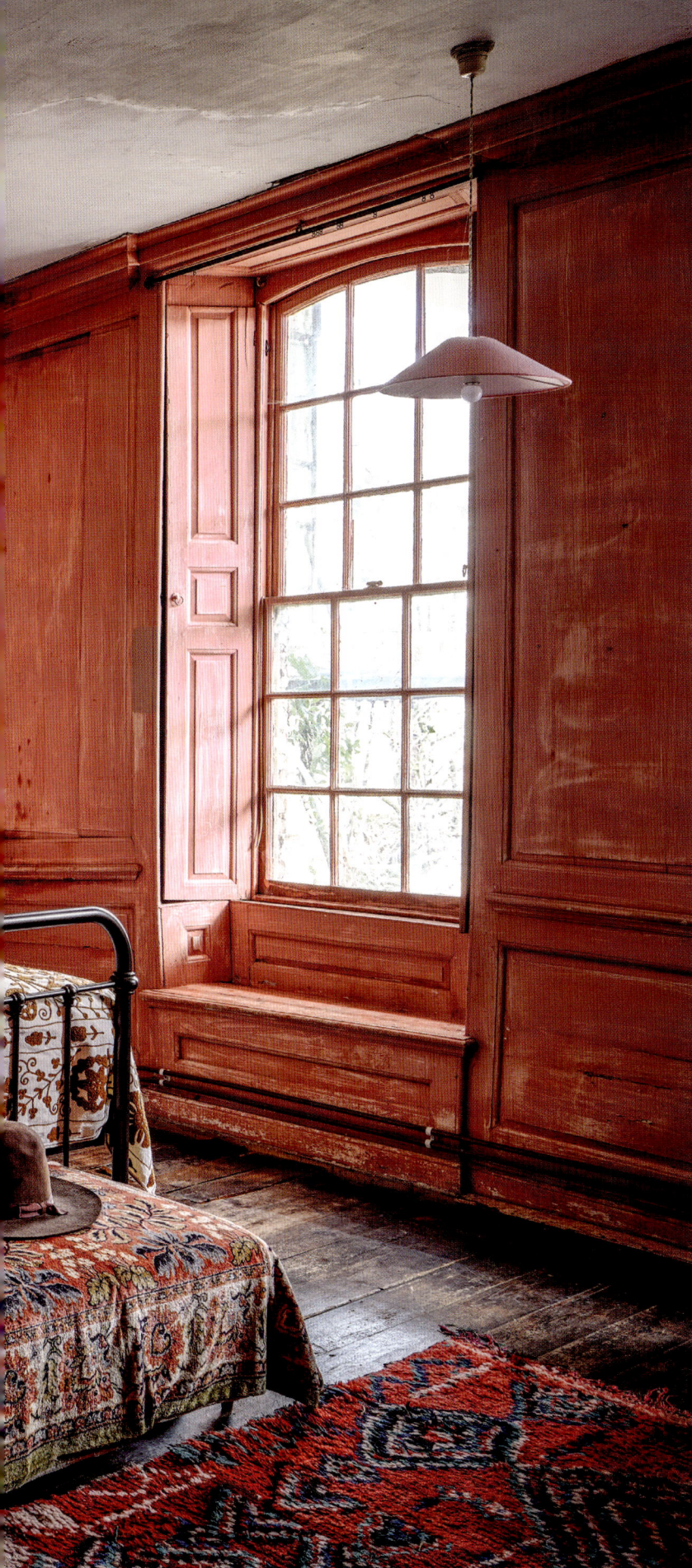

The light and shadows offer a stillness, enabling the colours to radiate and take on a new depth. One example is the hallway, which for a long time stood empty of furniture to highlight the beauty of the original Minton floor tiles in the low luminance from the two windows. Typically a hallway is a transient space, but here the setting created a desire to slow down and savour the experience of walking through.

Another space that offers a calm quietude is Sophie's favourite room, known as the middle kitchen. Established in the oldest part of the building, it is humbler in style than the later additions, but is well proportioned and rich in original materials. Sophie describes it as not just the hub of her home, but the fulcrum and operation centre. It is a joy to sit in this remarkable space, which must have played witness to so many exchanges, squabbles and reconciliations over the centuries.

With each room fragrant with layers of interior interest, the manor house presents an incredibly textured and theatrical setting, whether front of house or behind the scenes. For Sophie, treading across all boards of the house, it has been an opportunity for her and her family to experience life-enriching moments whilst playing a truly privileged part in the role of custodians to this colourful property.

LEFT
The bedroom has a colour-drenched scheme with cranberry and raspberry shades that are picked up in rugs, tapestries, pictures and lighting. The warm-hued mahogany bedside cabinets/nightstands and dark wooden floor ground the space and introduce a note of richness and luxury.

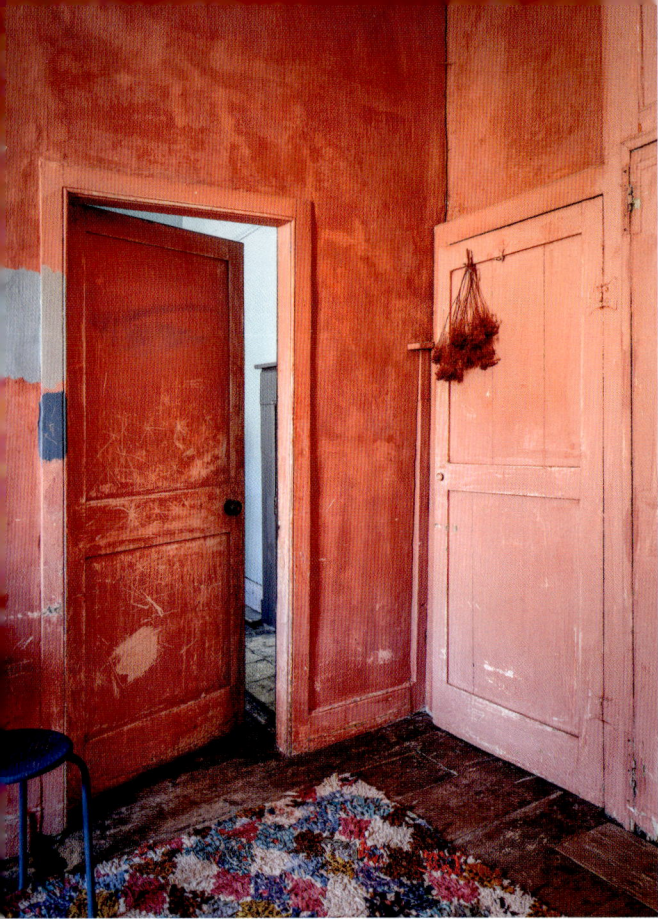

LEFT
The imposing red hallway becomes more playful upstairs. Decorating rules are broken and marks and daubs, whether accidental or purposeful, show up on surfaces. The same colours were used in the bedroom beyond, seen on page 50.

BELOW LEFT
Thanks to the opposing windows that puncture the walls, dappling sunlight seeps into the cavernous hallway and traces up and around the staircase as the light changes throughout the day.

BELOW & OPPOSITE
Sophie redecorated the upstairs bathroom to bring a sense of balance while preserving its history. Fallen Plum by Atelier Ellis on the walls and dark mahogany woodwork now share the space with painterly pinks and a limewash white. She retained the original clawfoot bathtub and added two new basins. An abundance of foliage ties into the natural palette used in the rest of the home. Other luxurious touches include a working fireplace fitted with a cast-iron stove.

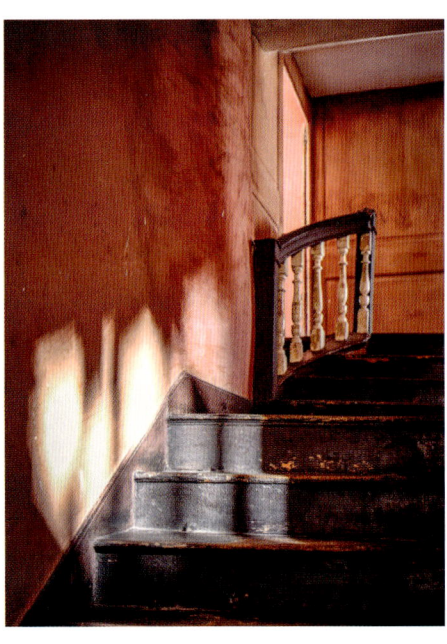

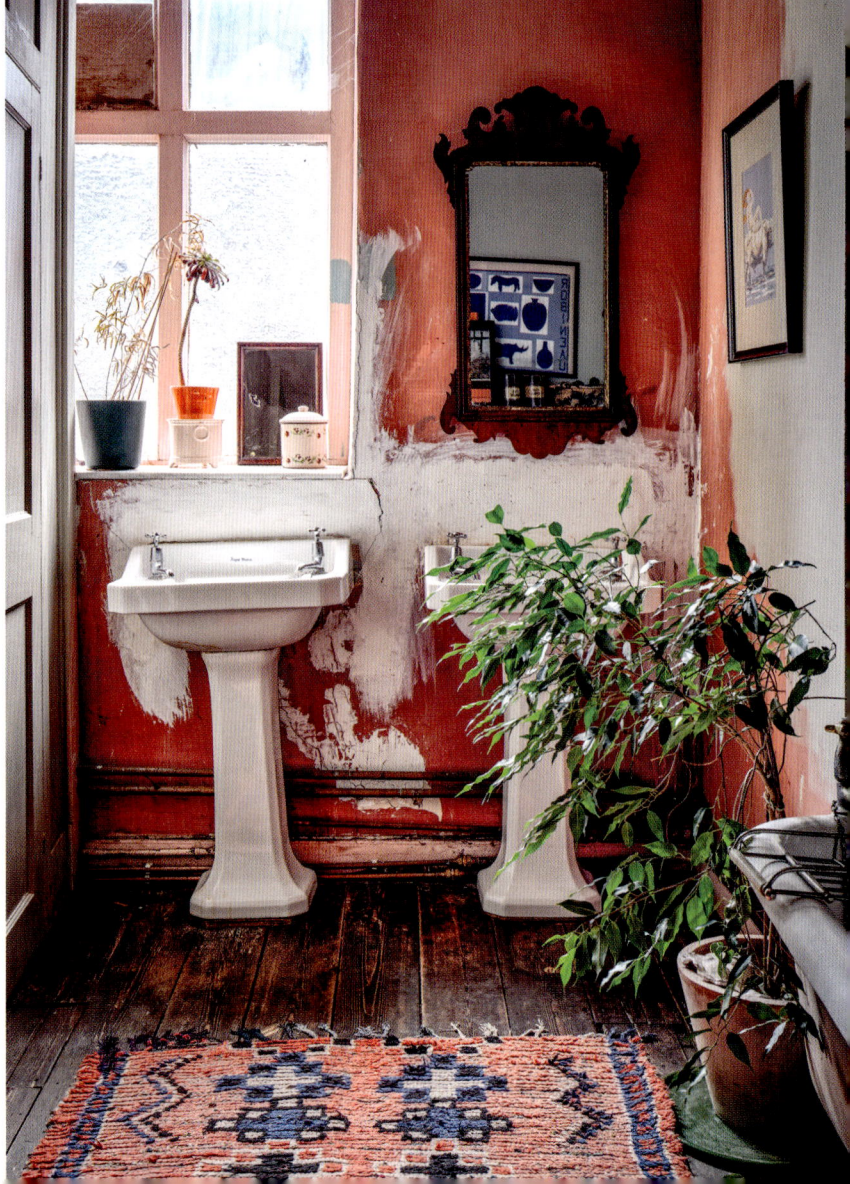

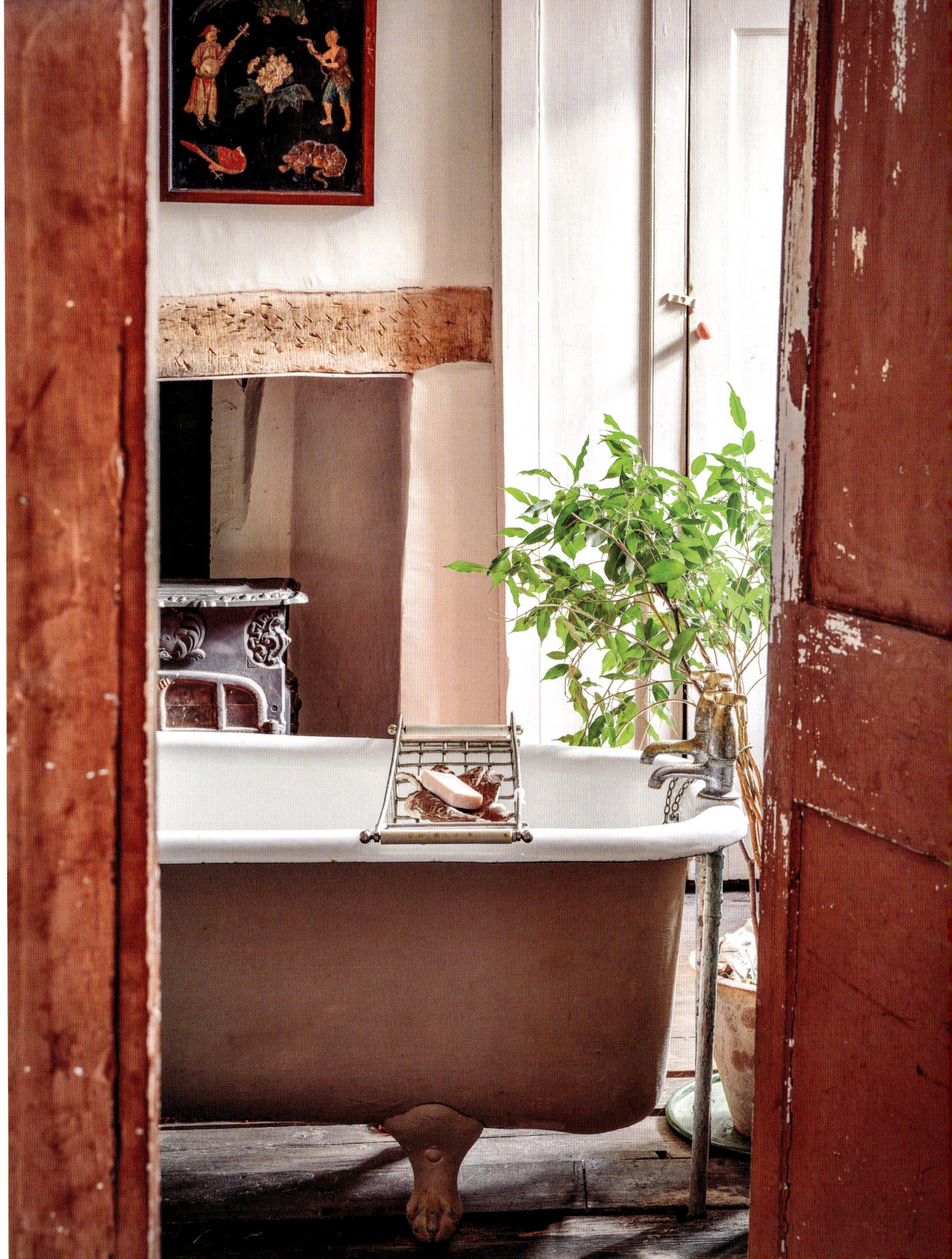

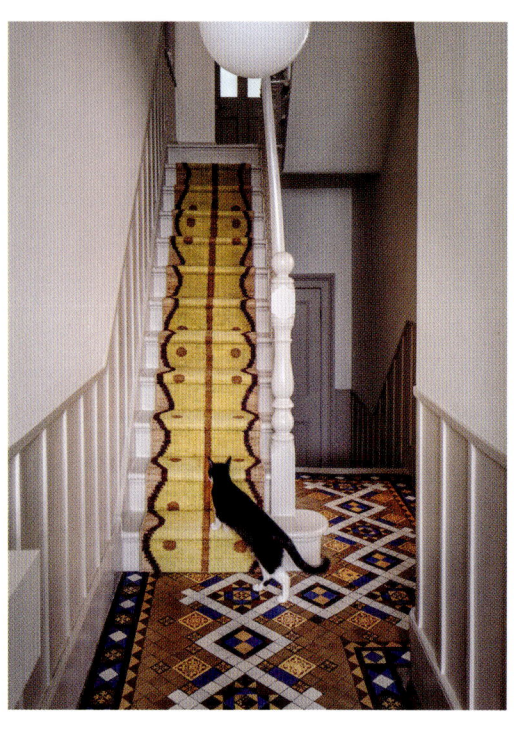

LEFT & BELOW
Blending original features with new paintwork, Lisa worked with interior designer Laura Stephens to create a new scheme for the hallway. Colours were taken from the original tiled floor for a harmonious look. The staircase has a cheerful yellow bespoke runner by Bombay Sprout. The glazed doors to the downstairs rooms have been highlighted in Lulworth Blue, a gentle shade by Farrow & Ball.

COME
together

Thanks to her eye for creating inviting spaces, Lisa Tudor-Jones's London home perfectly combines uplifting and cosy elements for her growing family to enjoy. The house has plenty of character and its playful colour palette has a defining role within the open floor plan.

A family home should be practical yet nurturing – somewhere that allows its occupants to take a breather from busy day-to-day life. Lisa's is a particularly stylish example, peppered with pleasing details. It also provides a strong and cohesive layout for everyone to engage with throughout the day.

This was not always the case, however. When Lisa, her husband and children first moved in, the house was sadly lacking in flow and the decor needed a rethink. After the family had lived here for a couple of years, the time came for Lisa to make her mark on the setting. It was the perfect moment to seek some professional direction and creative vision. Enter interior designer Laura Stephens, who gave Lisa confidence and inspired her to explore, be brave and look for inspiration beyond her own four walls.

OPPOSITE
Colours from nature are a favourite in Lisa's home. Earthy plaster hues were used as a textural backdrop in the kitchen, including Mink by Paint & Paper Library on the ceiling and its original cornicing. Using this warm pink overhead has made the large and lofty room feel atmospheric and intimate.

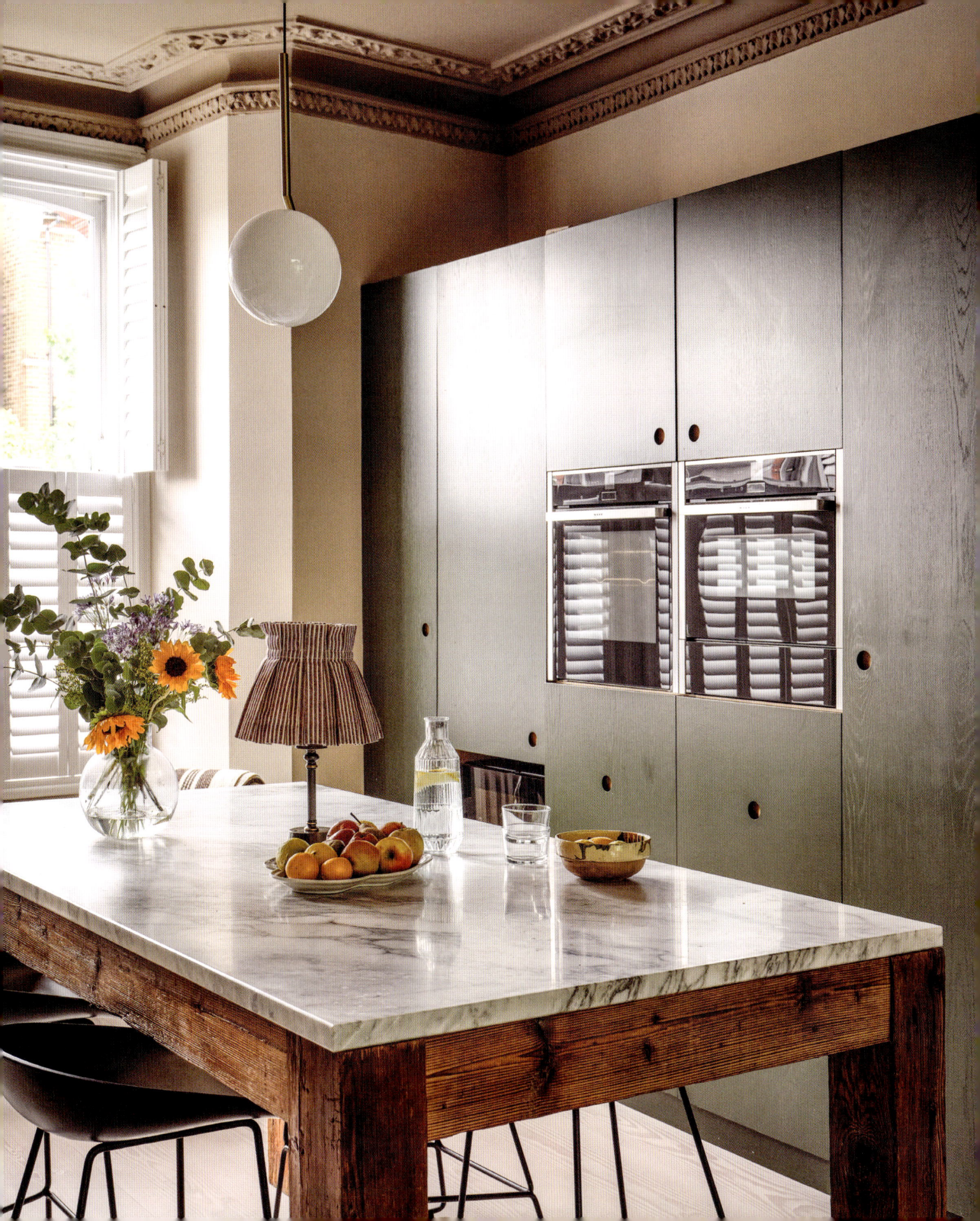

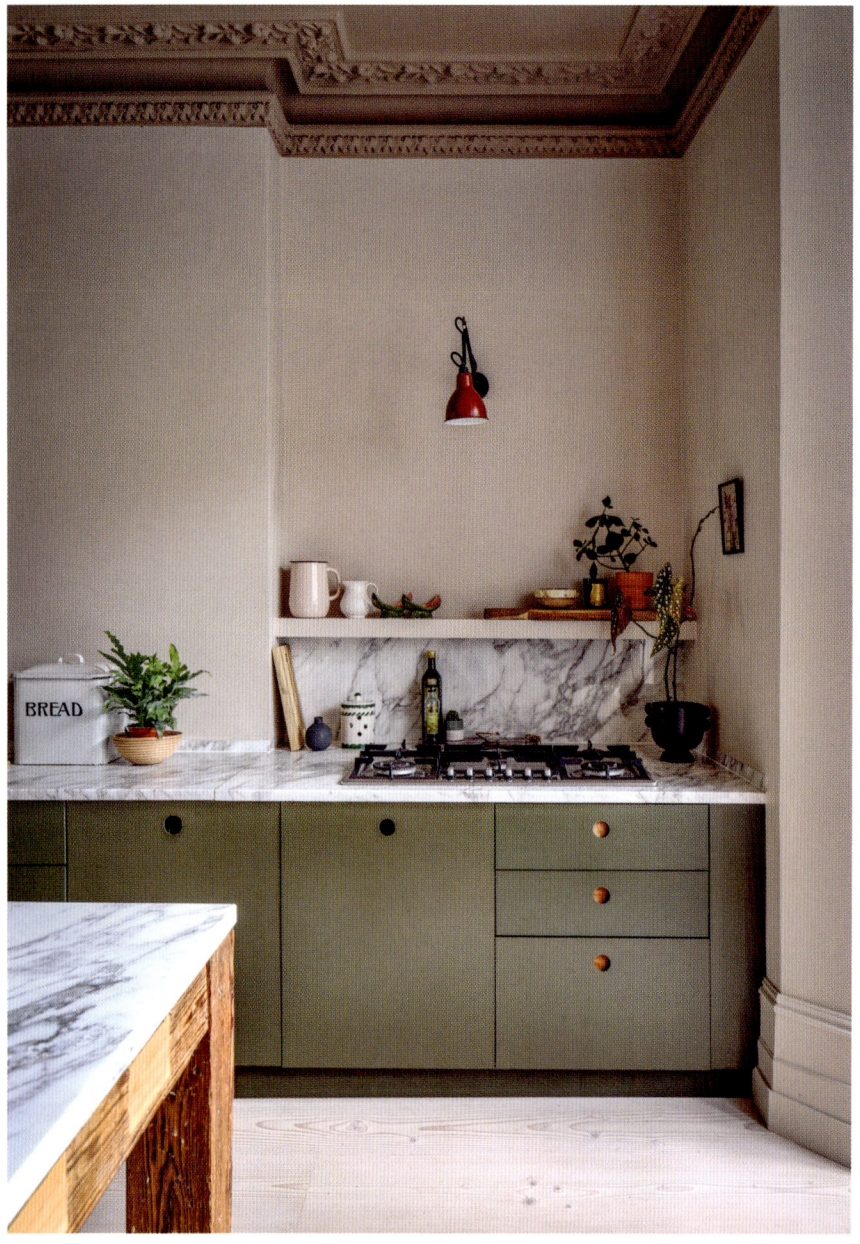

ABOVE
Under Laura's guidance, Lisa embraced strong colours on all the surfaces in order to sculpt the room seamlessly. Cabinetry by Naked Kitchens has been painted in a mossy woodland green, which grounds the scheme in a balanced partnership with the plaster pinks. The combination is well balanced and geared to a grown-up feel. Marble work surfaces and polished metal hardware bring a touch of elegance.

OPPOSITE
Originally an unused walk-through space, the new parlour is positioned between the bustling kitchen and relaxed rear living quarters. It lends itself to conversation and quiet time. The walls are painted in Powder V by Paint & Paper Library. The chair is from The Socialite Family with striped upholstery by Robert Kime. A neutral-toned rug from Nordic Knots adds a more subtle geometric pattern.

The house now works successfully as a whole and sings with personality, much of it achieved by developing a carefully curated palette inspired by the warmer months of the year. Just like a favourite fragrance, base notes of Lisa's much-loved shades feature throughout alongside Laura's suggested top notes. Spring and summer colours such as earthy putty, grounding terracotta, sky blues and forest greens now sit with deeper, harmonious and atmospheric hues.

Colours have been used to ingeniously carve up the downstairs floor into three zones: a lively kitchen space at the front, a sociable seating area in the middle and a family and dining room at the back. The original layout was unfocused; the front and rear extensions were where the family gravitated most of the time, leaving an expansive middle section largely unused. Now, the three areas are distinctly defined and each one has an individual mood, but they also remain connected via the colour palette for a cohesive sense of flow.

The use of colour extends to the ceilings, cornicing and woodwork/trim, which have their own roles to play in the scheme. They draw the eye, frame each zone and provide a high-end finish. The cooler shades recede and create a visually enhanced space, while earthy tones draw near and bring a cosy, cocooning feel.

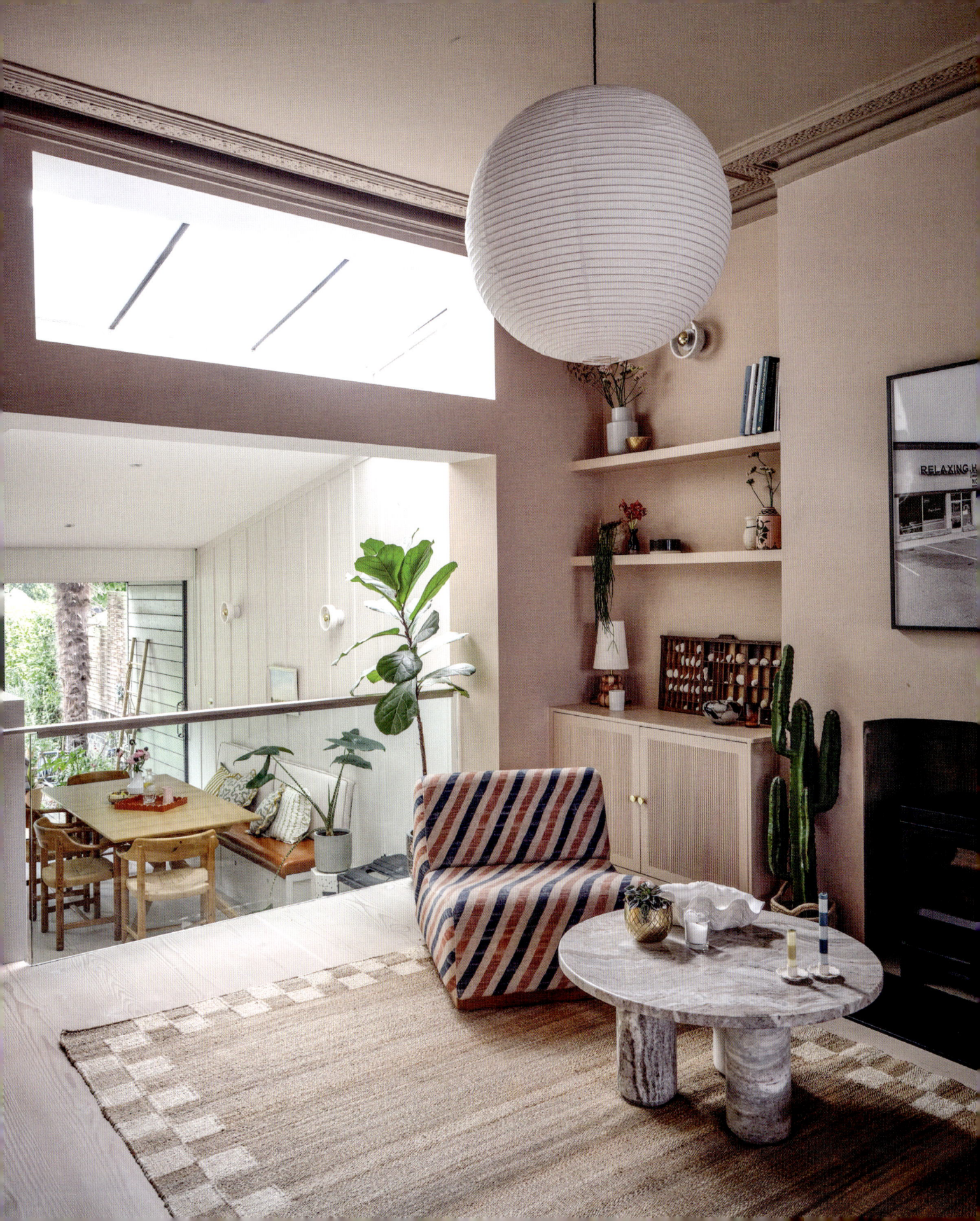

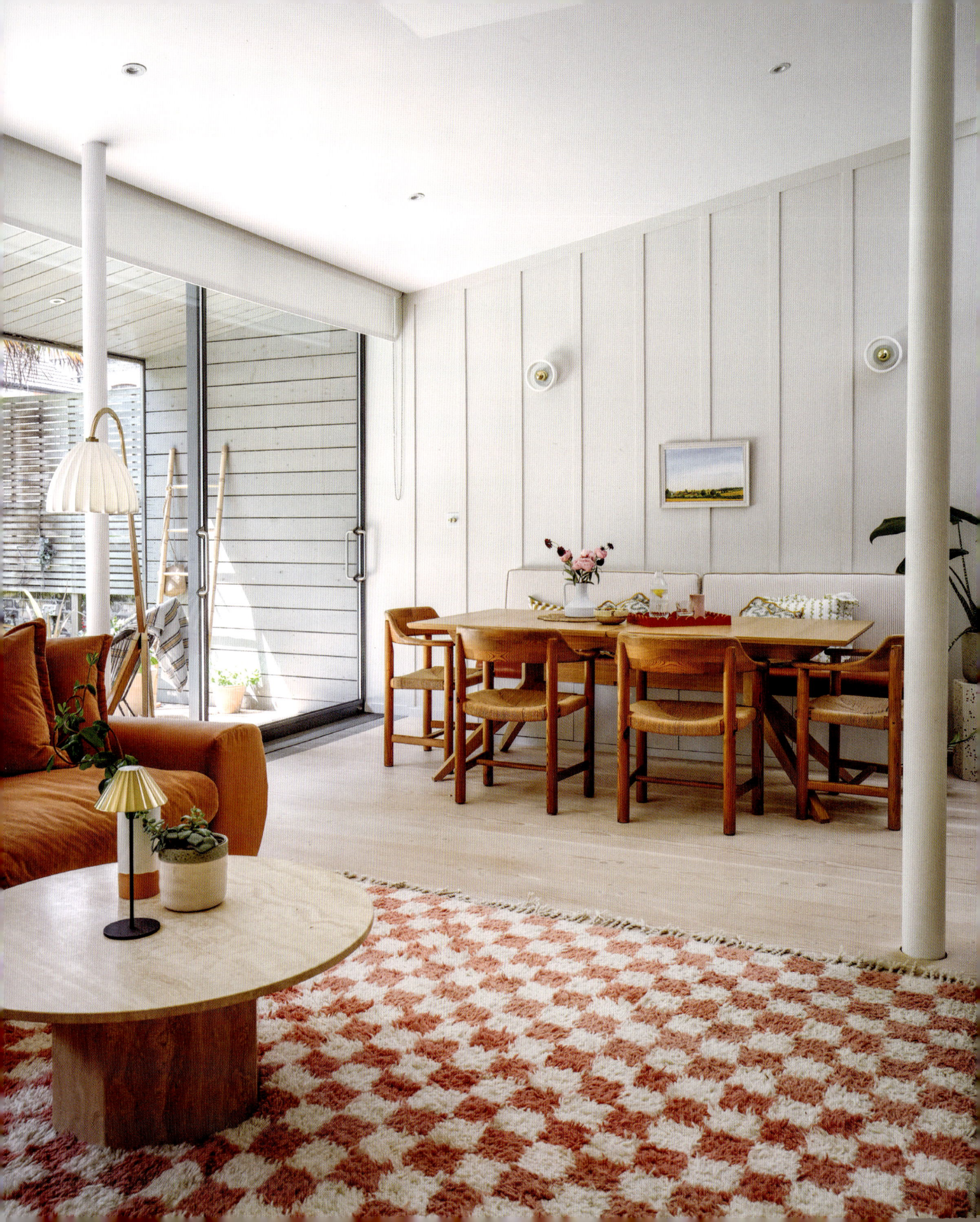

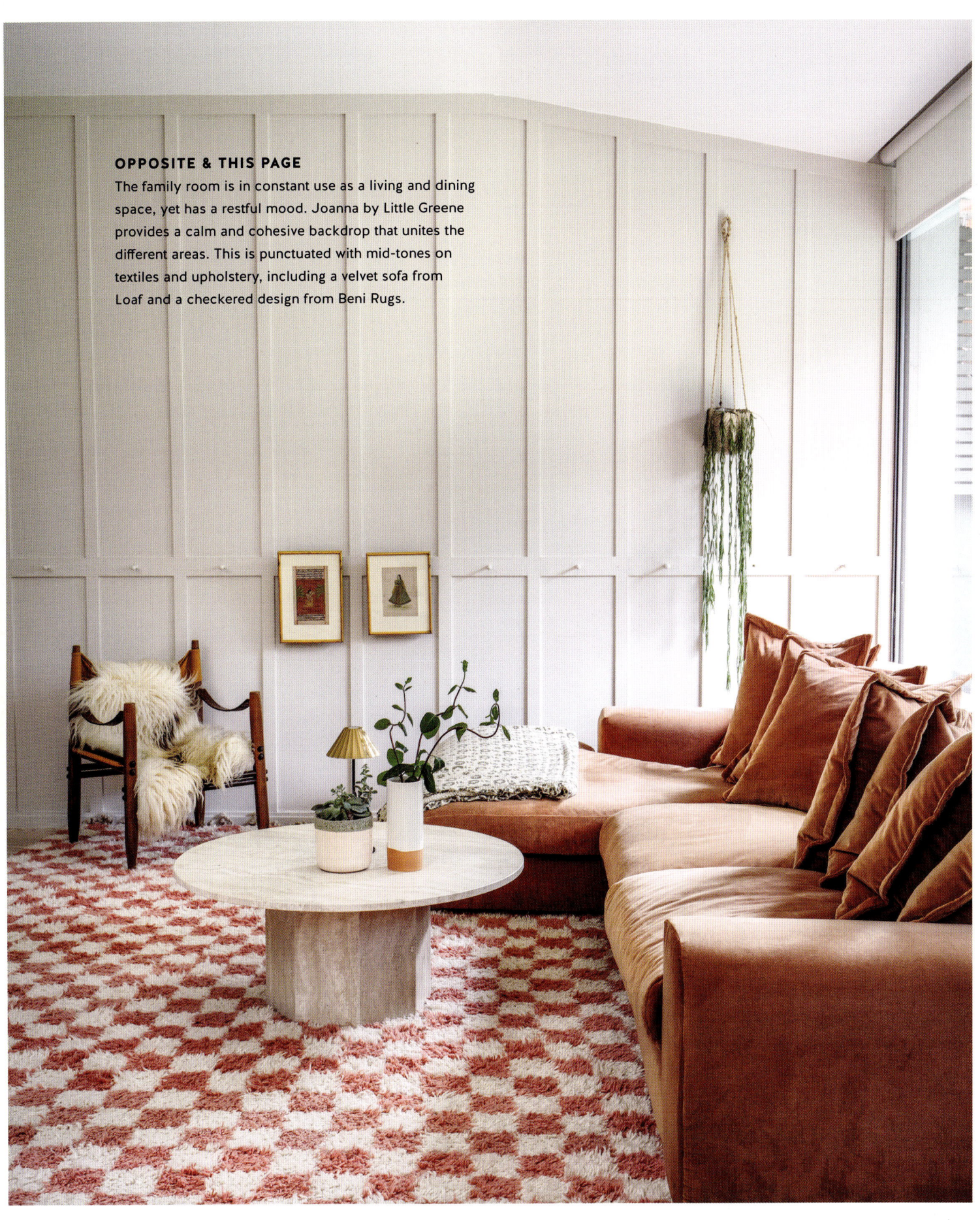

OPPOSITE & THIS PAGE
The family room is in constant use as a living and dining space, yet has a restful mood. Joanna by Little Greene provides a calm and cohesive backdrop that unites the different areas. This is punctuated with mid-tones on textiles and upholstery, including a velvet sofa from Loaf and a checkered design from Beni Rugs.

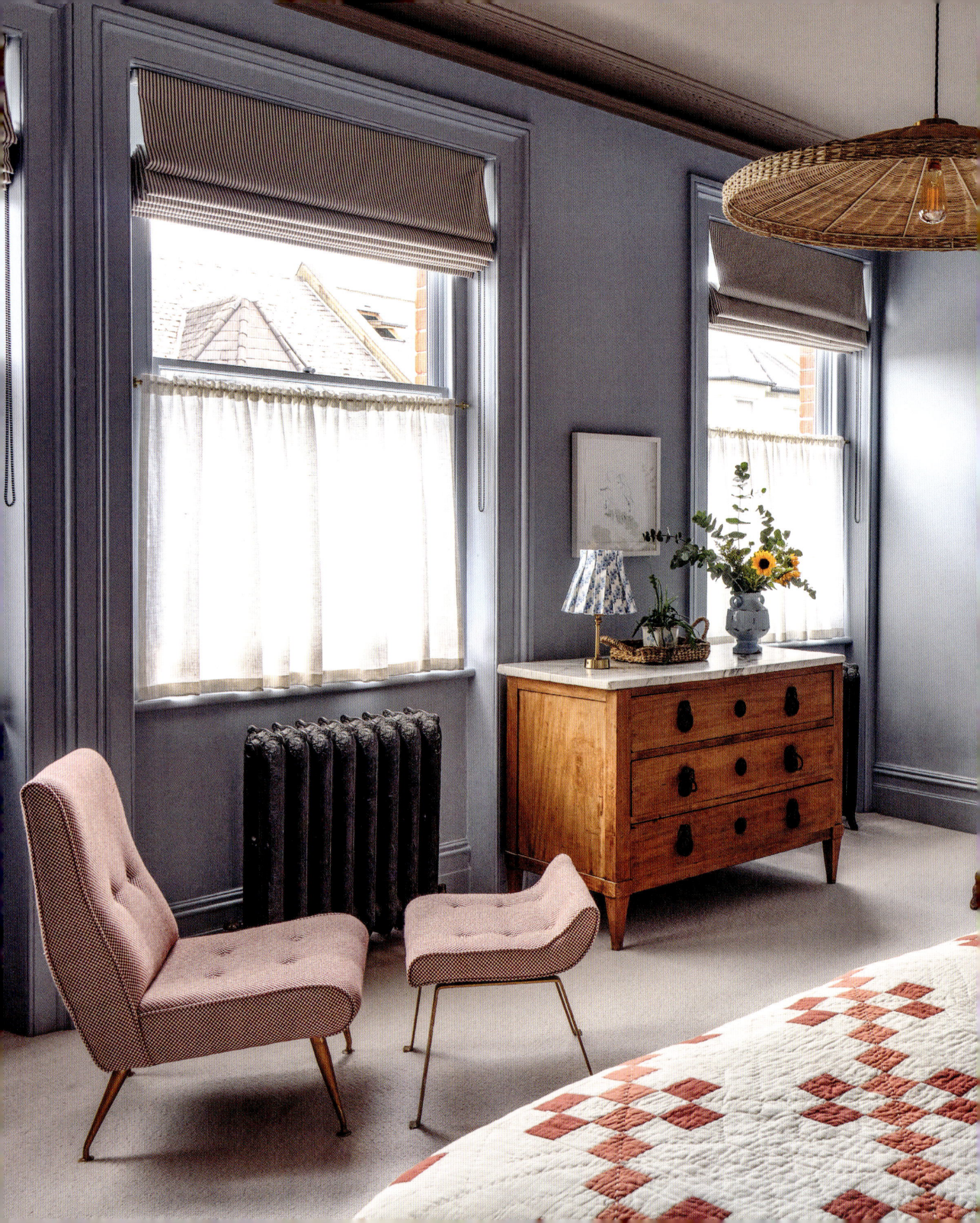

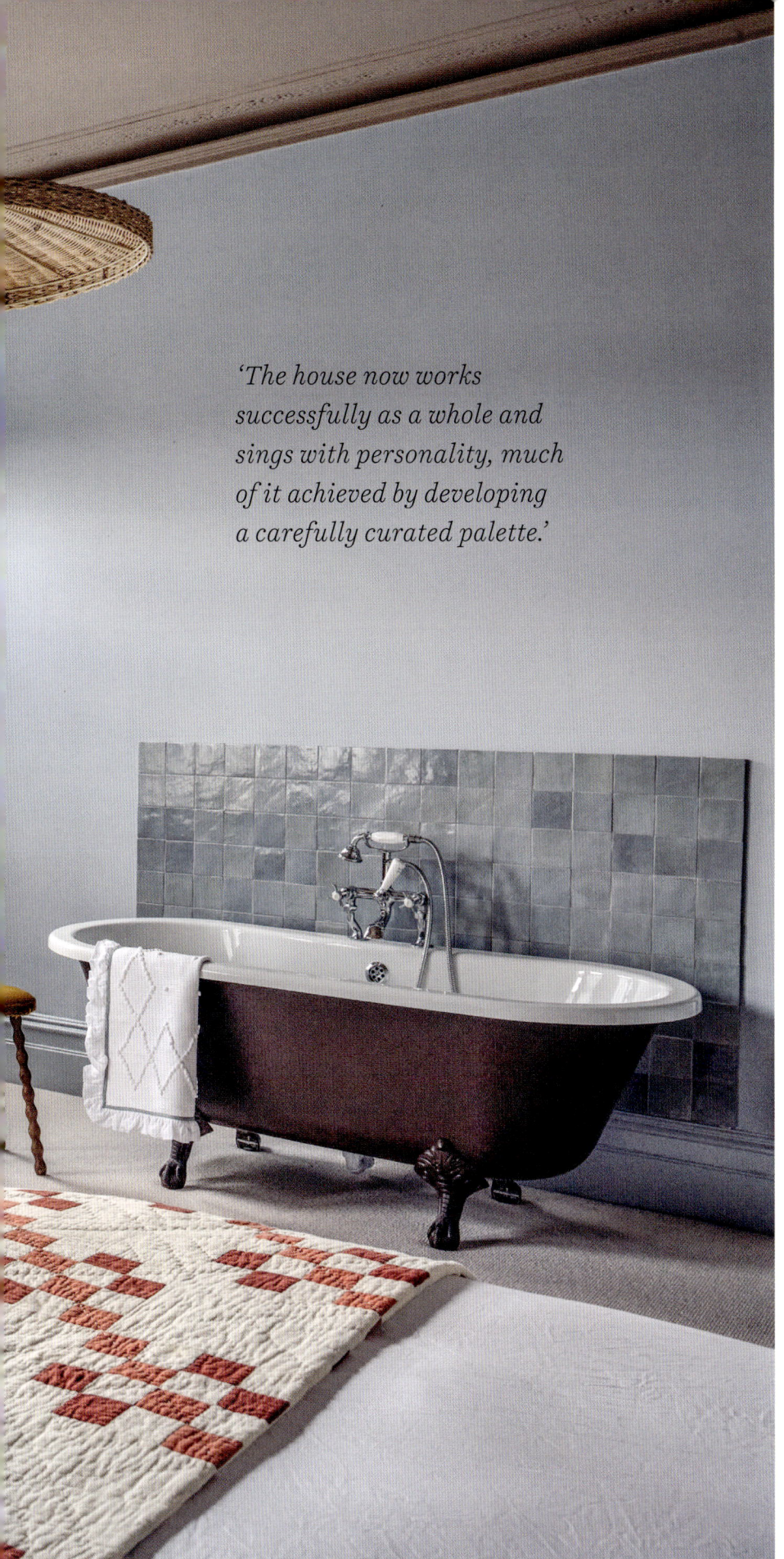

'The house now works successfully as a whole and sings with personality, much of it achieved by developing a carefully curated palette.'

Upstairs, the palette is explored to suggest different moods and carve out nooks and nesting places. One bedroom is decorated primarily in restful tones of blue, yet the other shades are still evident in highlights and details on homewares and furnishings. In the attic bedroom, which has its own terrace and ensuite, a nurturing putty shade and soothing green enhance the escapist feel where Lisa can wind down and feel the biophilic benefits of engaging with the sky and trees outside.

Colourful patterns feature in bold blocks without overlapping – a way to introduce eye-catching prints in a contained manner. Lisa's love of stripes is evident and this classic motif features on a variety of surfaces. Even the wall panelling has a vertical relief presenting a textural stripe design. The floral curtain in Lisa's bedroom picks up a linear foliage repeat and another bedroom has a ticking headboard. Scrolling runners lead up the stairs and zigzag tiling traces across the bathroom floor.

LEFT
Watery blues have been used in a soothing bedroom scheme that includes a freestanding clawfoot bathtub. Textured wall tiles help to define this spa area as a room within a room. Their hue is similar to the surrounding paintwork, but they bring a subtle variation in texture – a creative form of colour drenching.

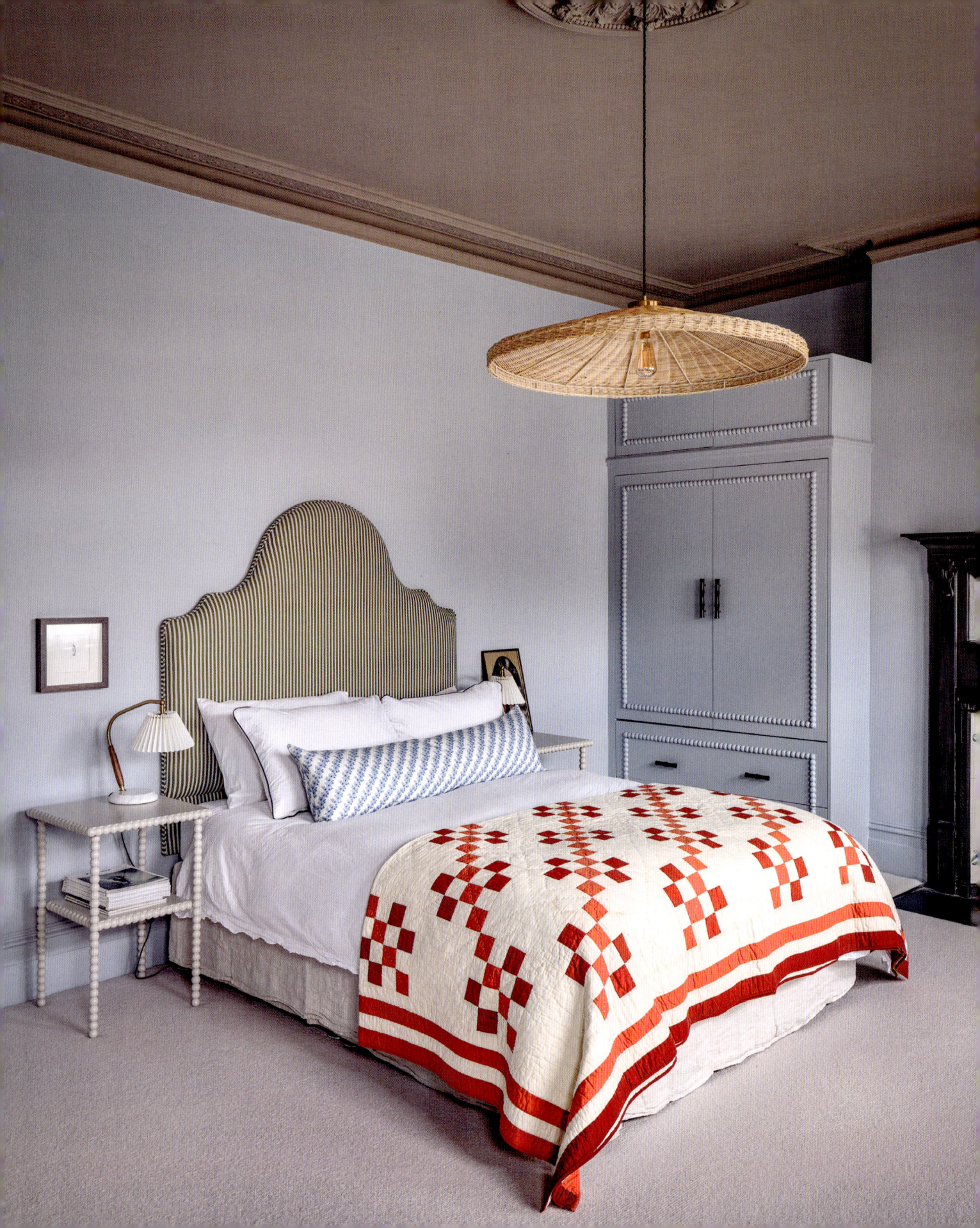

Furniture choices come from second-hand marketplaces and old and new sit comfortably side by side. These reupholstered furniture finds have been incorporated seamlessly into the interior scheme, with fabric remnants sustainably repurposed to make smaller accessories such as cushions/pillows and lampshades.

It's clear that the house is continuing to evolve as the family grows with the potential for further updates in keeping with the colour palette over time. With Laura's help, Lisa has successfully created a cosy, comfortable and happy environment for their family dynamic with this in mind. Designed to be enjoyed from day to day, the use of a cohesive colour palette brings the bustling household together to connect as a family and dwell with a prevailing sense of ease.

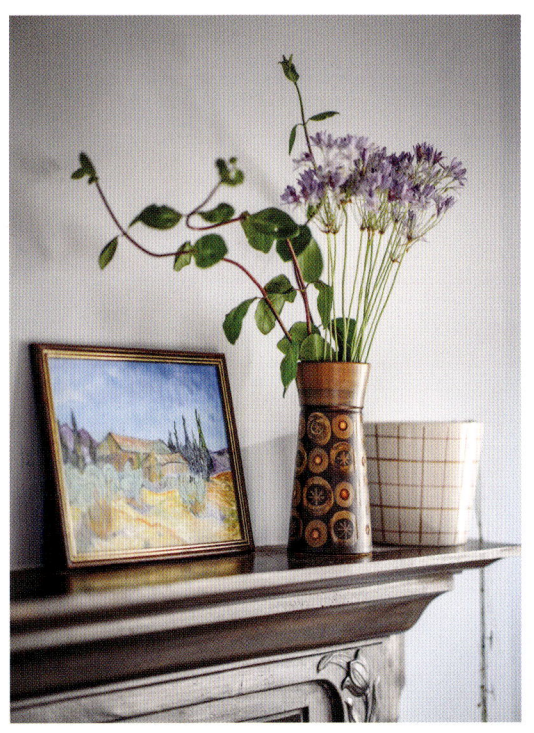

OPPOSITE
The whole bedroom is painted in Farrow & Ball's Parma Gray, which is really a beautiful grey-blue. It appears to recede from the eye, meaning that the bedroom can host many different areas without feeling overcrowded. The ceiling colour is Dead Salmon from the same brand.

ABOVE
This corner of the bedroom next to the fireplace is used as a home office. Warm and cool colours have been perfectly paired to create a sophisticated scheme that encourages creativity, with a bold contrast between the blue walls and the rich wood tones of the desk.

LEFT
There are many ways to bring nature into your home. Here, pretty fresh flowers and a colourful landscape artwork on the mantel complement the Parma Gray paintwork as it subtly shifts throughout the day.

COME TOGETHER 63

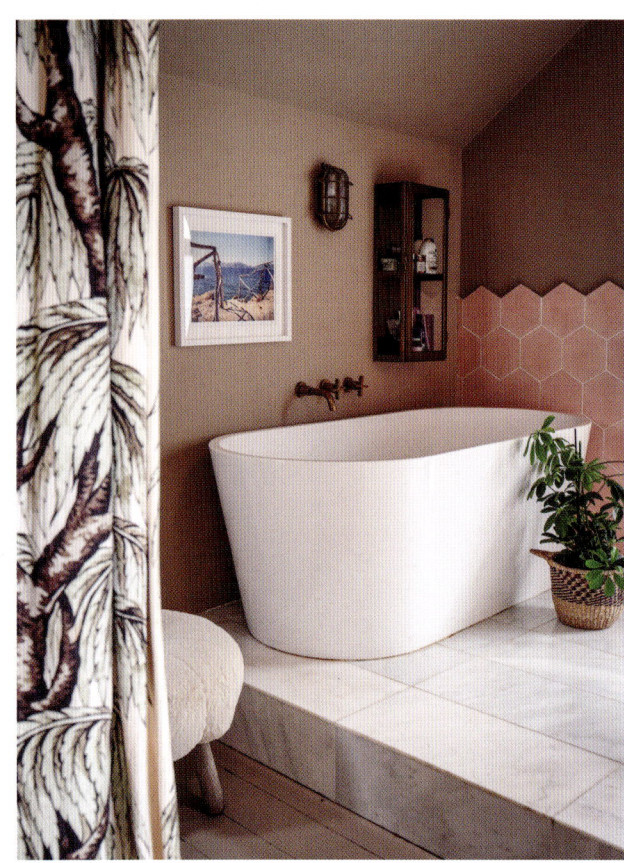

LEFT
Lisa has given a soft enclosure to her ensuite with a beautiful curtain. A rare treat in such a room, the fabric features a splendid palm pattern that introduces an energizing oasis feel. The fabric also tempers the hard lines of the porcelain bathtub and floor tiles.

OPPOSITE
A haven at the top of the stairs, attic rooms like this one are often given to children to explore and enjoy. However, they are just as inviting for grown-ups as a place to appreciate quality time tucked away together. Lisa's spacious attic has a dressing room, bathroom, bedroom and balcony space. Here she's turned to favourite nature-inspired fabrics, colour and textures to make it her own.

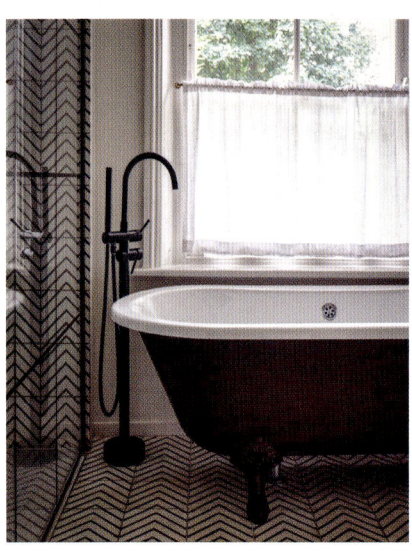

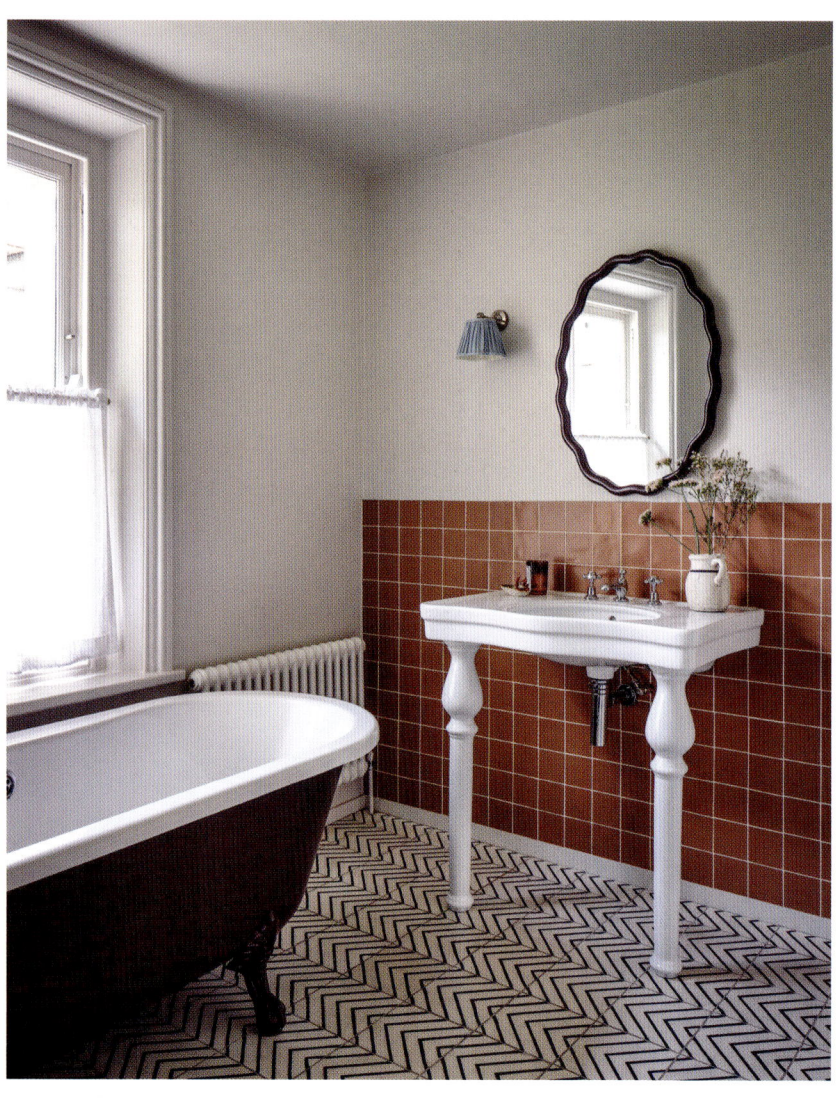

ABOVE & RIGHT
It's always good to have a bit of fun with unexpected elements in one room. In this bathroom, Lisa has been able to play with interesting juxtapositions of pattern and colour. Plain rust-hued tiles around the basin present a contrast to the playful zigzags seen underfoot and on the opposite wall.

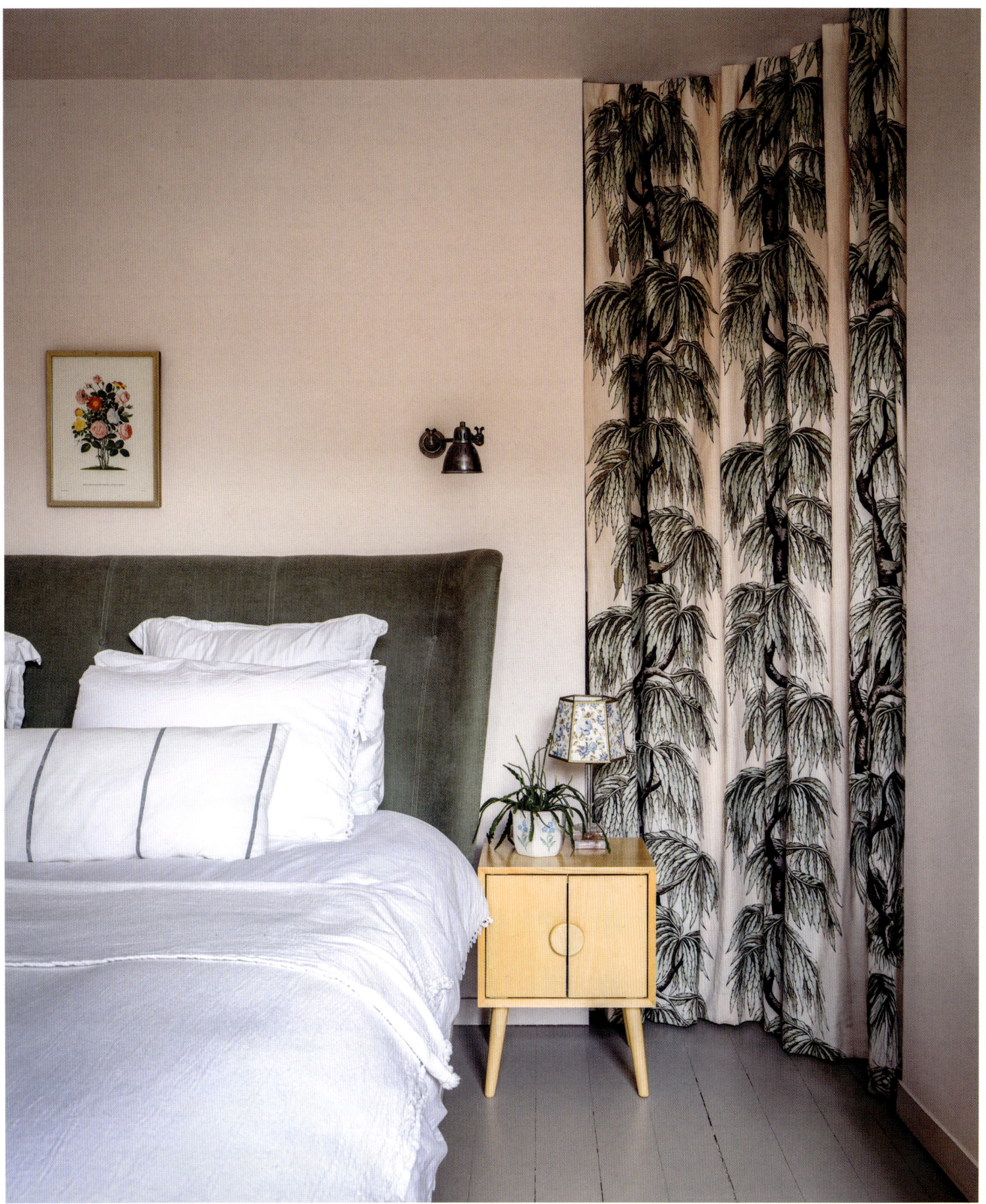

OPEN *house*

The doors are always open and a generous welcome to be discovered in the handsome and historic Sussex home of Amber and Jonathan Baker. Embracing its popular location position, the flow of many visiting loved ones has helped shape and colour the house with an at-ease atmosphere.

A chance night out with friends inspired Amber and Jonathan to find themselves a bolthole in the enchanting citadel of Rye, East Sussex. The 700-year-old building they call home has always played a part in the community and one corner still houses a pub at street level. The living space had been somewhat neglected and the decor was dingy and far from desirable, but the couple embraced the opportunity to take the rooms back to their bones.

BELOW LEFT
Dark and cavernous, the hallway entices visitors in with its beautiful black walls. To counter the gloom, a bright white floor offers a leading light and path into the house. It also reflects the natural light that pools in through the glazed front door onto the walls and ceiling.

RIGHT
A surprise ornamental seating area has been installed within this alcove in the hallway. The Amalfi Umore wallpaper from Graham & Brown features lemons, clementines and trailing summer blooms. Framed by an archway, it offers a vision of a moonlit orchard or an indoor pergola garden.

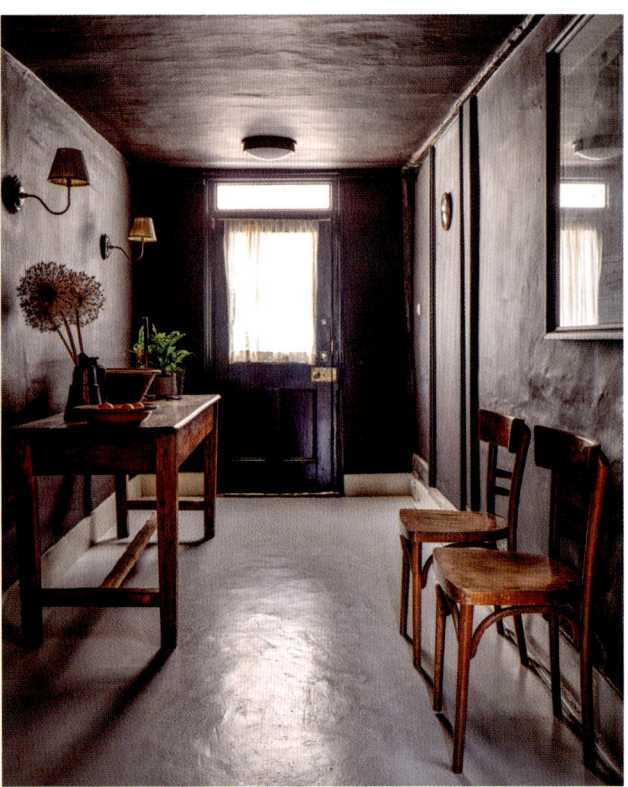

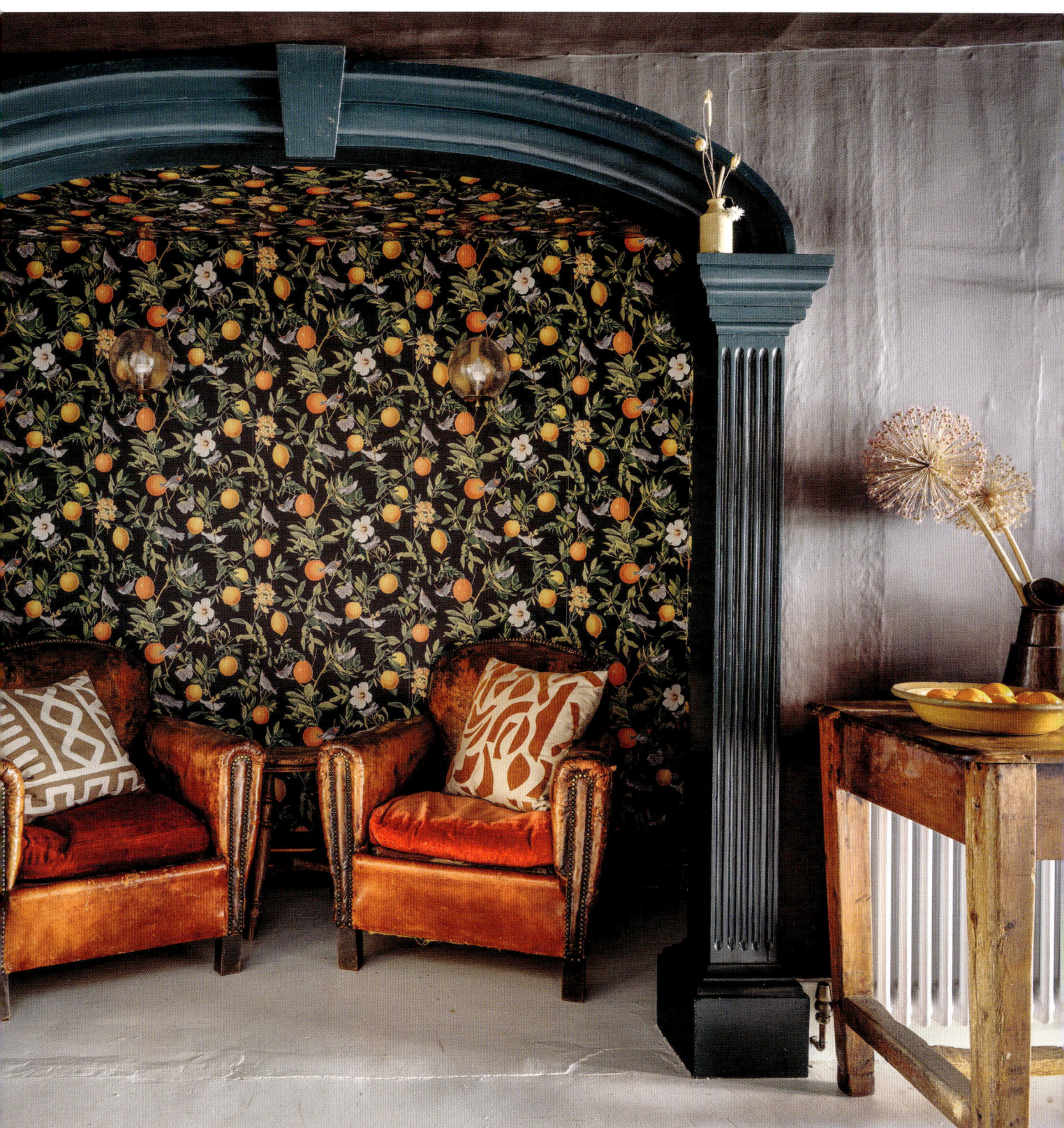

> '*Delightfully wearing with age, the softening of the floor pattern will mark the passage of time as the room is used and enjoyed.*'

LEFT
A wall dedicated to storage now divides the kitchen and dining space. This has been painted the same shade as the other walls so that it recedes into the background, with matching shelves that appear to hover over the surface.

BELOW
A floor is a clever way to bring in strong colour as a stylish focal point or interior interruption. In the dining room, the bold harlequin pattern in red and black creates the illusion of a broader space.

OPPOSITE
This room only found its purpose after an impromptu dinner-party table staging proved to be a hit with guests and became a permanent arrangement. The kitchen, which had been upstairs, was brought back to its original position.

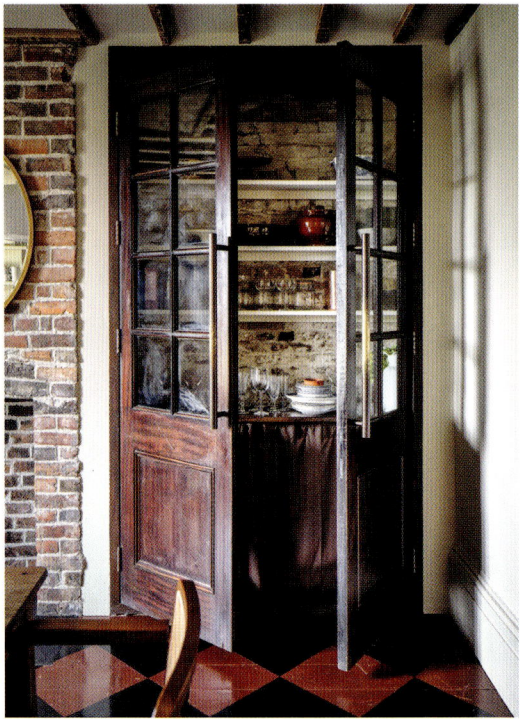

Located on a busy and bustling high street, the property is never far from the riot and colour of outside activity, and yet Amber and Jonathan have succeeded in creating a warm and inviting haven of a home. The layout is practical for modern life yet sensitive to the period architecture, balancing sociable open spaces with nurturing hideaway nooks.

Colour is an intrinsic part of the interior decoration: not just the palette used, but how it responds to the changing light at different times of the day. Time was well spent deciding and agreeing on an appropriate palette at the start of the project. Sometimes a house will favour a particular season, which provides ample inspiration.

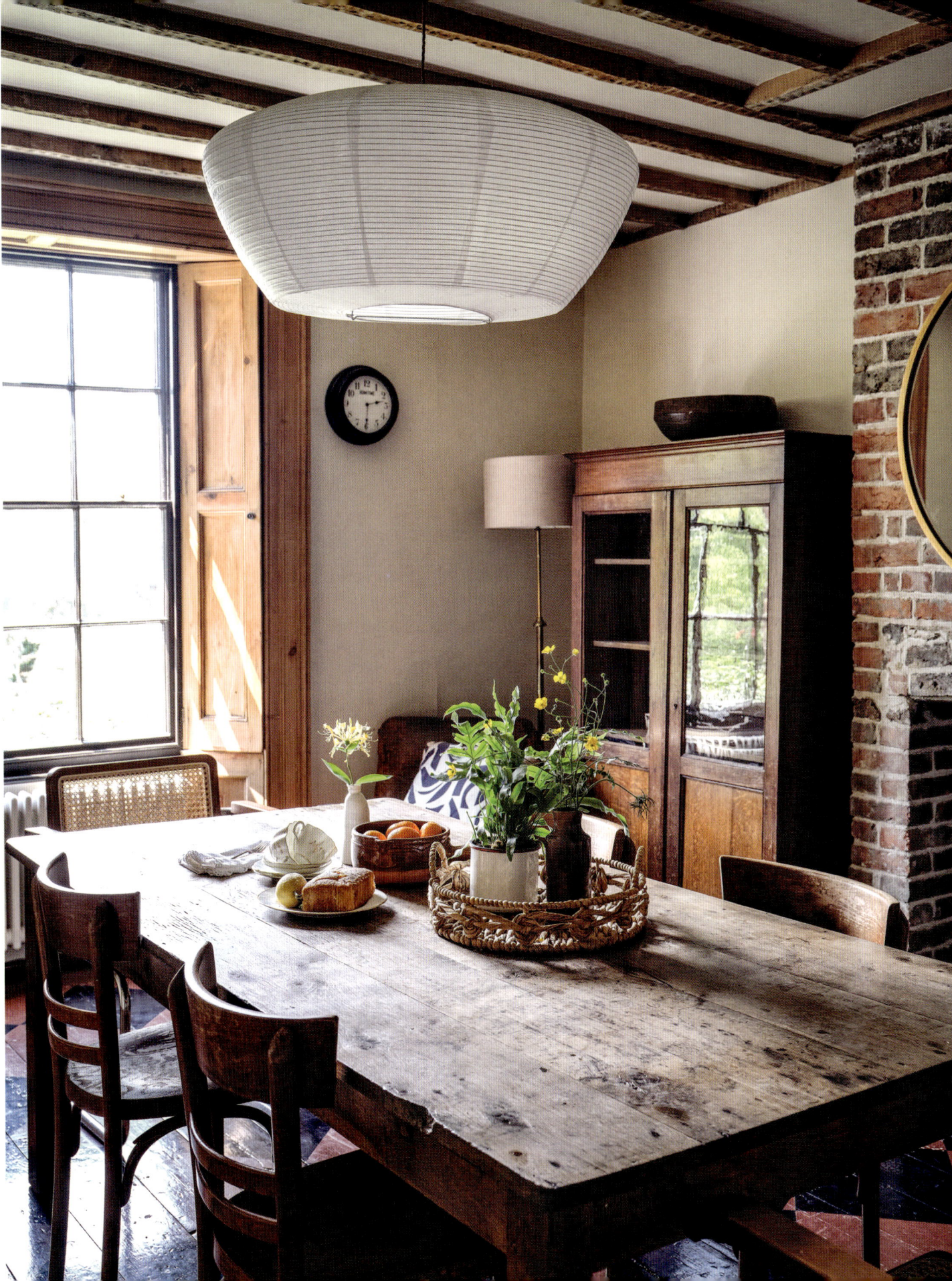

For Amber and Jonathan, it was clear that their home would suit the mellow and atmospheric mood of autumn. This is expressed throughout in turning-leaf and orchard-ripe shades.

The location and orientation of each room further influenced the choice of hues so as to inspire the right mood as you move through the interior. The dynamic open layout at the front is more darkly dressed, whereas the quieter and more private spaces at the rear feature warm and nurturing shades that enhance the effect of sunlight spilling into the rooms.

As a transitional space, the hallway is more than just a place to take off outdoor clothing. It also has emotional resonance as somewhere to leave the public world behind. By choosing a dark shade for the walls, you can create a mindful moment whenever you step inside the front door and feel the sense of being at home.

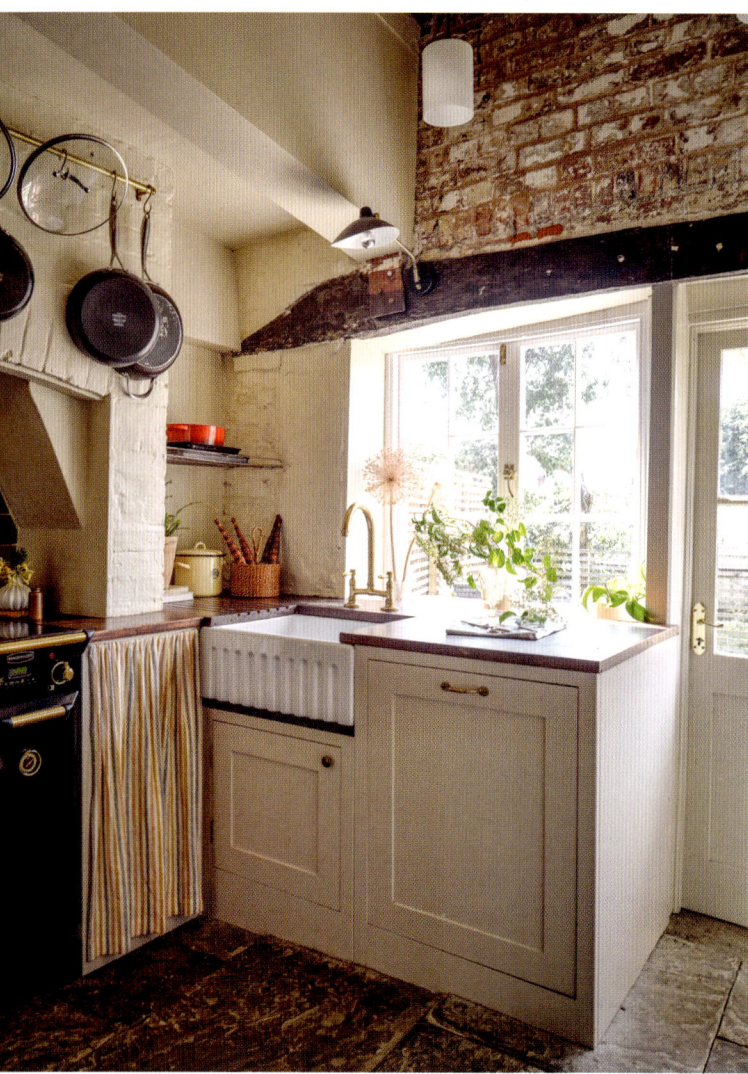

LEFT
The kitchen gets plenty of wear and tear, as the house is available to rent, so Amber and Jonathan favoured practical choices that would allow them to maintain its good looks. There is a variety of cabinet fronts, including Shaker-style doors and fabric curtains. All can be easily updated with a fresh coat of paint or a change of fabric.

RIGHT
Local craftsmen created this ample storage unit, which combines open and closed storage. Ceramics and glassware are displayed on the work surface or stacked on ledges underneath. Meanwhile, other items are hidden away in the drawers to keep clutter to a minimum. Decorative details and foraged finds are arranged on the wall shelves above.

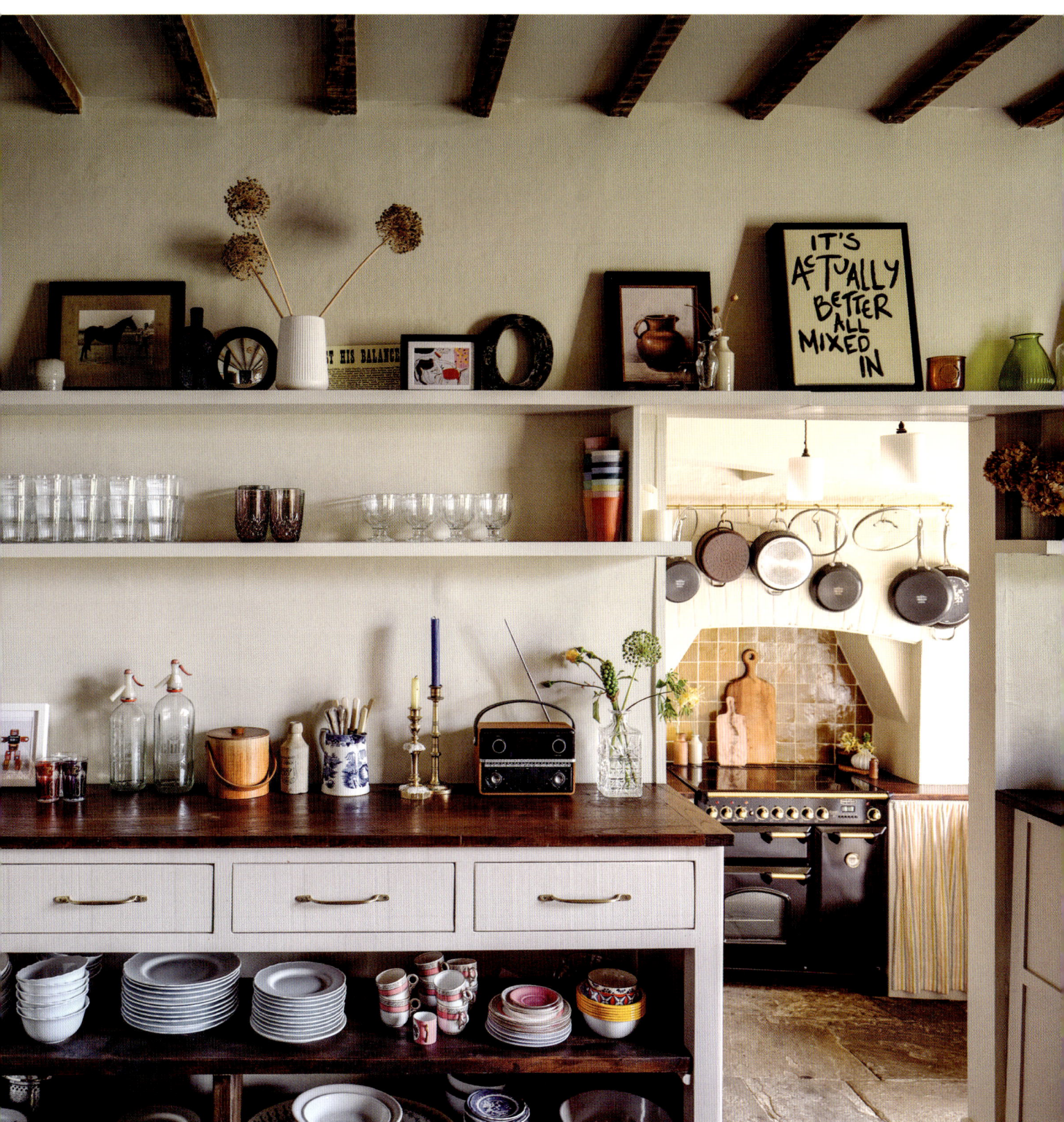

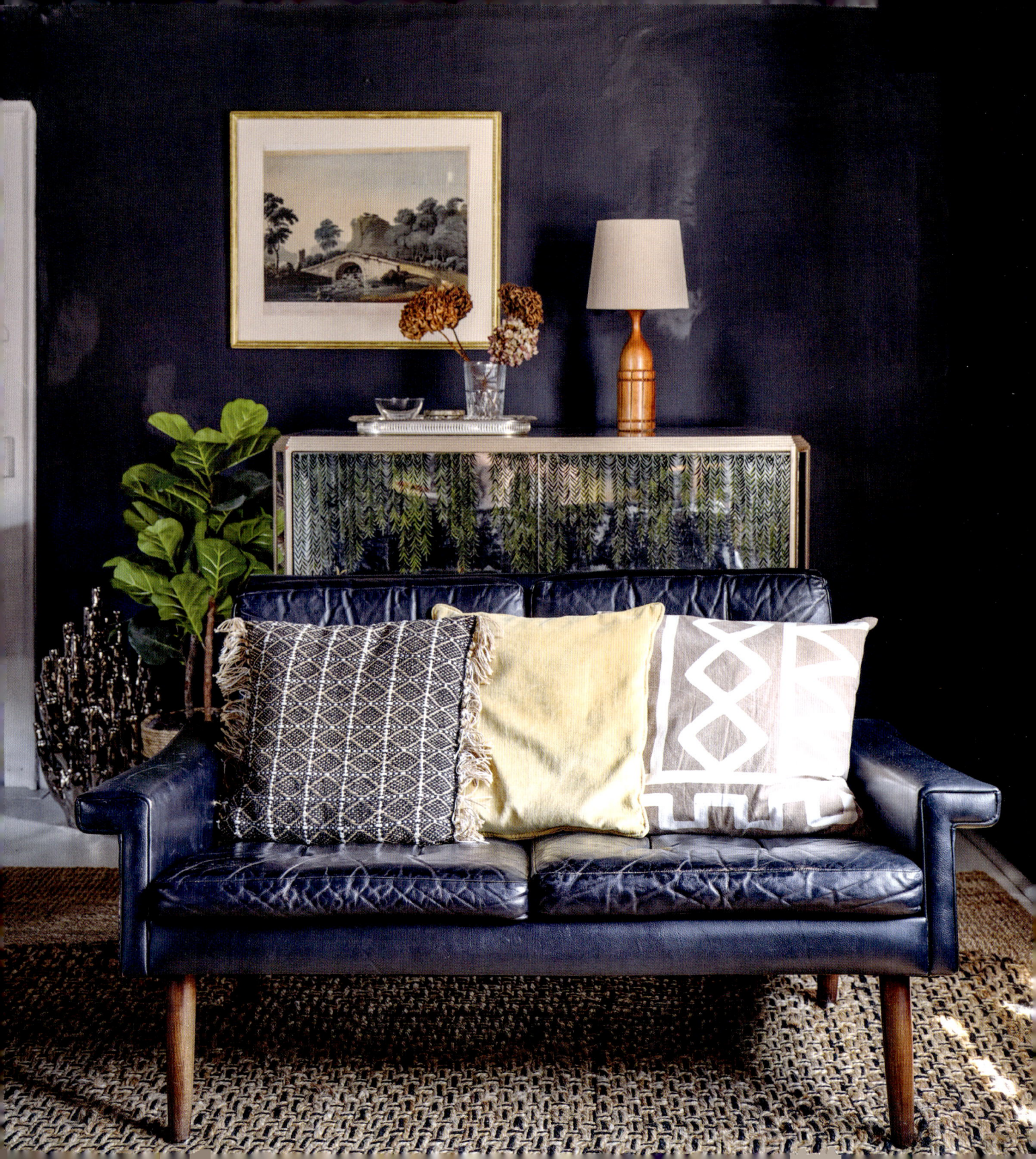

Here, paint has been applied cleverly to achieve a subtle complexity. Surfaces that look entirely black on first entering gradually change as the eyes adjust to reveal deep brown and green hues. A surprise pop of pattern in an alcove beckons you to sit and find a moment of seated stillness.

Pale walls and wood floors provide a subtle shift as you pass into the rear of the house. Featuring a creamy colour on walls and ceilings, with honey-coloured woodwork, this neutral canvas shifts with sun and shadows from early morning hours to the the end of the day.

OPPOSITE & RIGHT
Glossy materials including leather, glass, polished wood and metals reflect light onto the walls and ceiling of the living room, which were painted with Farrow & Ball's Railings in a satin finish. The small sofa by Danish designer Svend Skipper was sourced via eBay. Other online auction finds include the mirrored mini bar, which once belonged to The Dorchester hotel in London, and a large antique wooden chest.

ABOVE & ABOVE RIGHT
Homely details have been incorporated to bring character to the space and soften the bold colour choices. Wooden toys and dynamic patterned textiles add a playful vibe against the sombre shades, making this a room to be enjoyed.

RIGHT
The living room feels surprisingly light and spacious thanks to its large windows. A teal sofa from Soho Home brings in uplifting colour and soft texture, in contrast with the dark sheen of the other furniture.

BELOW
Against all odds, plants seem to thrive in the dark cavernous corners of this home, their foliage a wonderfully vibrant touch in the gloom. Amber and Jonathan chose mostly shade-tolerant varieties that grow in dense forests. Others, such as this fiddle-leaf fig, prefer bright indirect light.

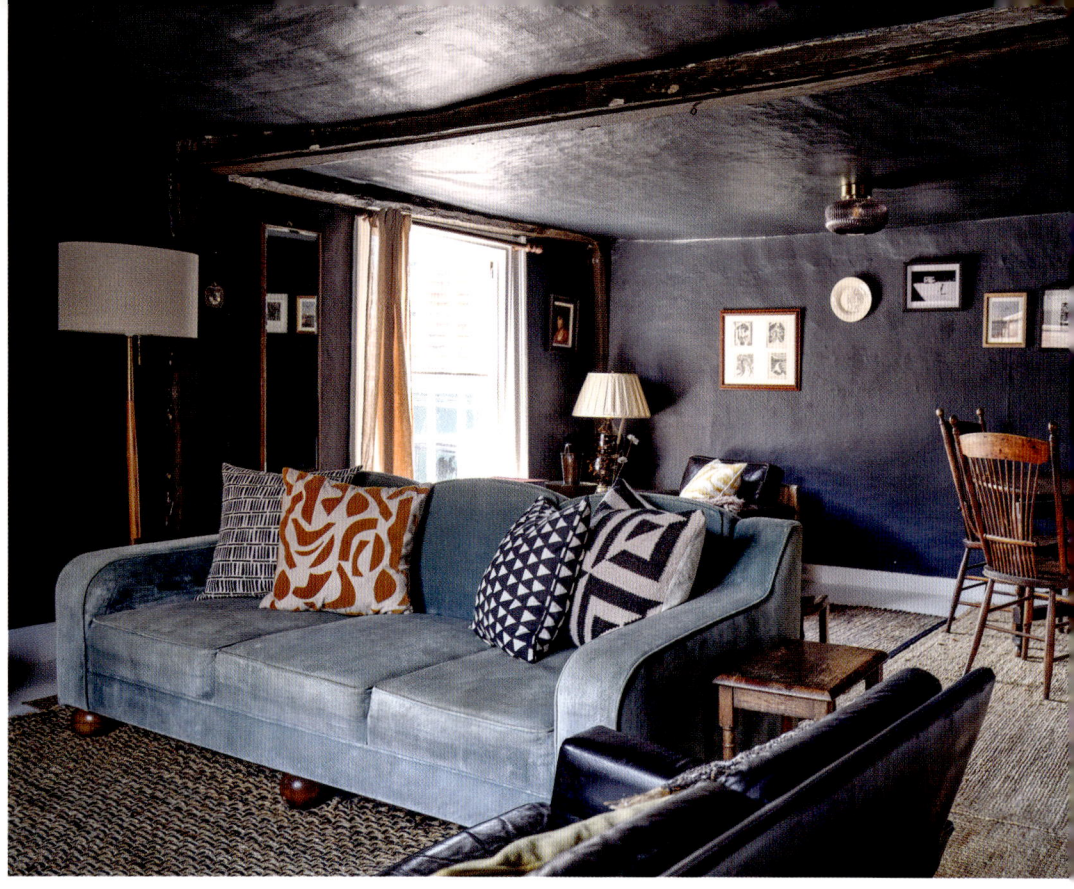

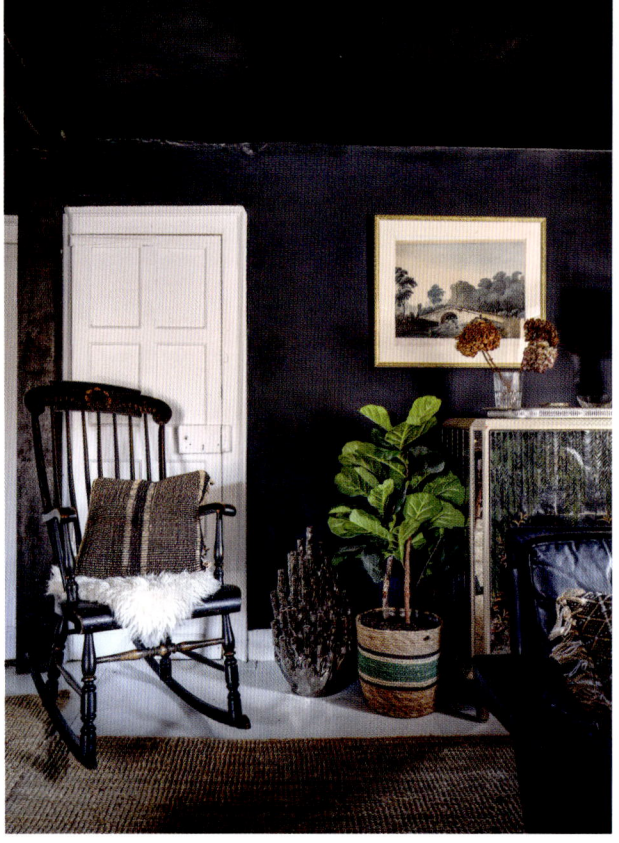

In the dining room, the floor is given star status with a chequerboard pattern in directional red and black gloss, which also picks up the shades found in the chimney-breast brickwork. Delightfully wearing with age, the softening of the floor pattern will mark the passage of time as the room is used and enjoyed.

The moody palette returns in the upstairs living room, in which the walls and ceiling have been colour drenched with an almost black shade. Bold and atmospheric, the deep hue is highly effective at softening the bright sunlight that streams into the room in the mornings. A slick splash of white on the floors and door creates a seemingly polaroid sensation. However, this stark monochromatic contrast has been softened with plenty of tactile furnishings in neutral tones.

OPPOSITE
A collection of paintings and prints punctuates the dark wall and makes a homely gallery installation in one corner. Warmth has been introduced to counter the cool black paint with cosy rush matting underfoot and vintage wooden furniture.

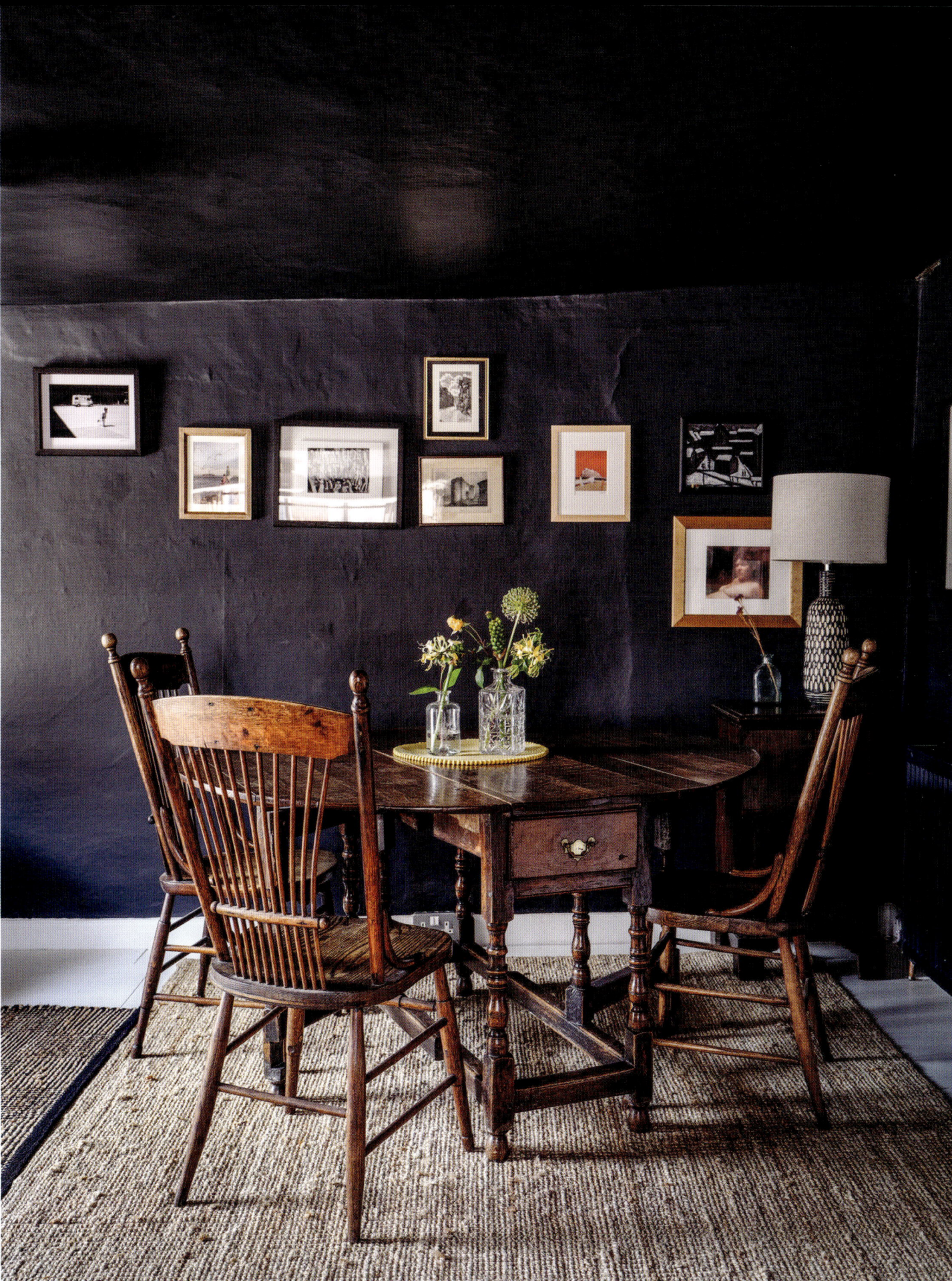

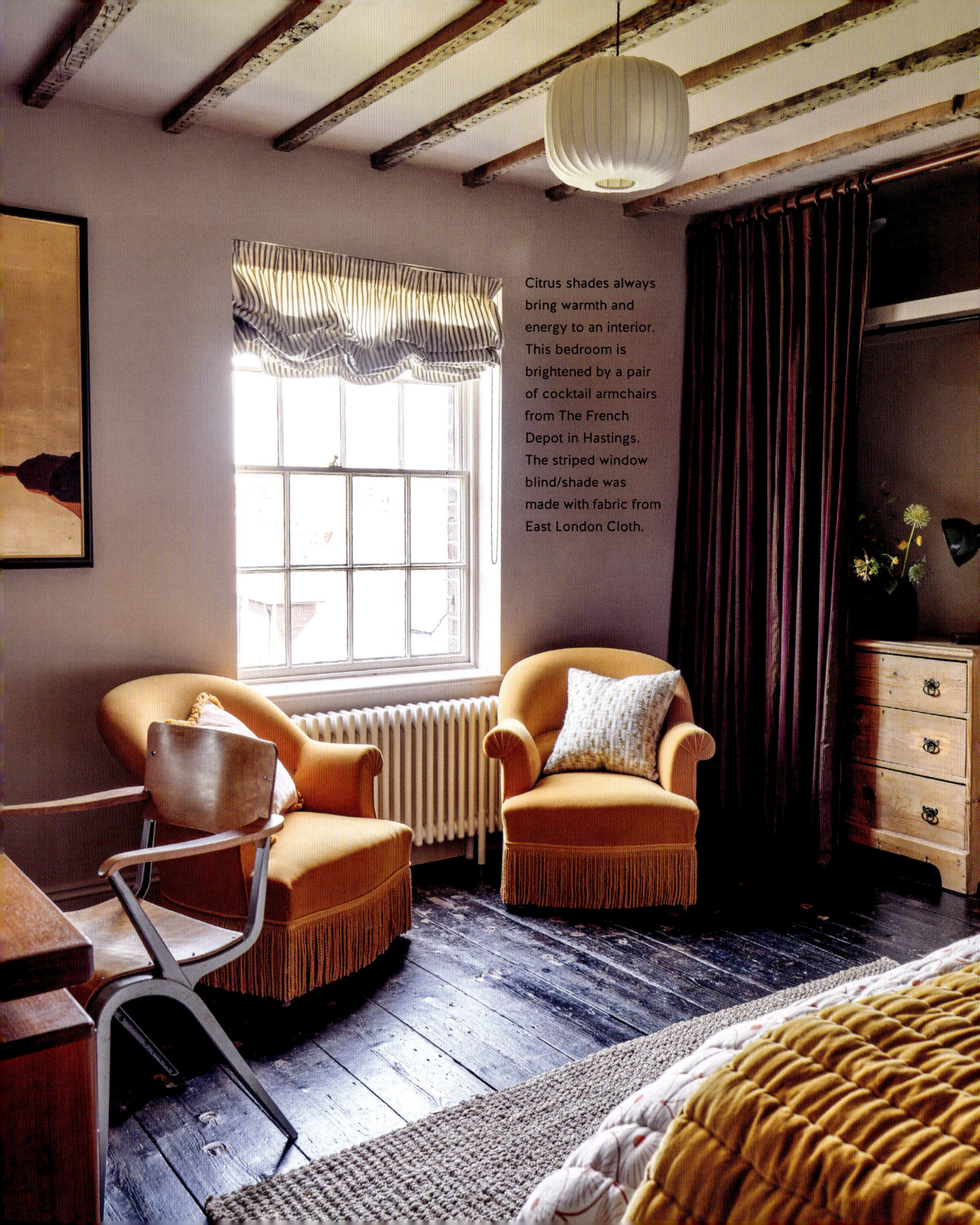

Citrus shades always bring warmth and energy to an interior. This bedroom is brightened by a pair of cocktail armchairs from The French Depot in Hastings. The striped window blind/shade was made with fabric from East London Cloth.

ABOVE
Clothing storage was quickly and conveniently fashioned in the bedroom by installing rails and drapes on either side of the chimney breast. Closed to conceal the space, the curtains then reveal their pattern. The purple fabric from Merchant & Mills is a complementary contrast to the yellow accents.

RIGHT
Shop your home for already owned books and bric-a-brac to add an unexpected hue.

There were many unexpected discoveries during the renovation, one of which was the original bead boarding in the bathroom. Adding additional and authentic textures and paintable surfaces, the boarding was also introduced into the main bedroom. It is in these rooms where the ripest and most fruitful shades of the autumn palette can be found, including wholesome and happy yellows and pinks. Rousing cheer and comfort, the colours sing in the sunshine when it reaches the back of the house.

But it's not just inside where colour feels present. From the rear of the house the windows reveal incredible pastoral views with immediate and profound effect. Despite the house's central location, the countryside and all its biophilic benefits feel incredibly close.

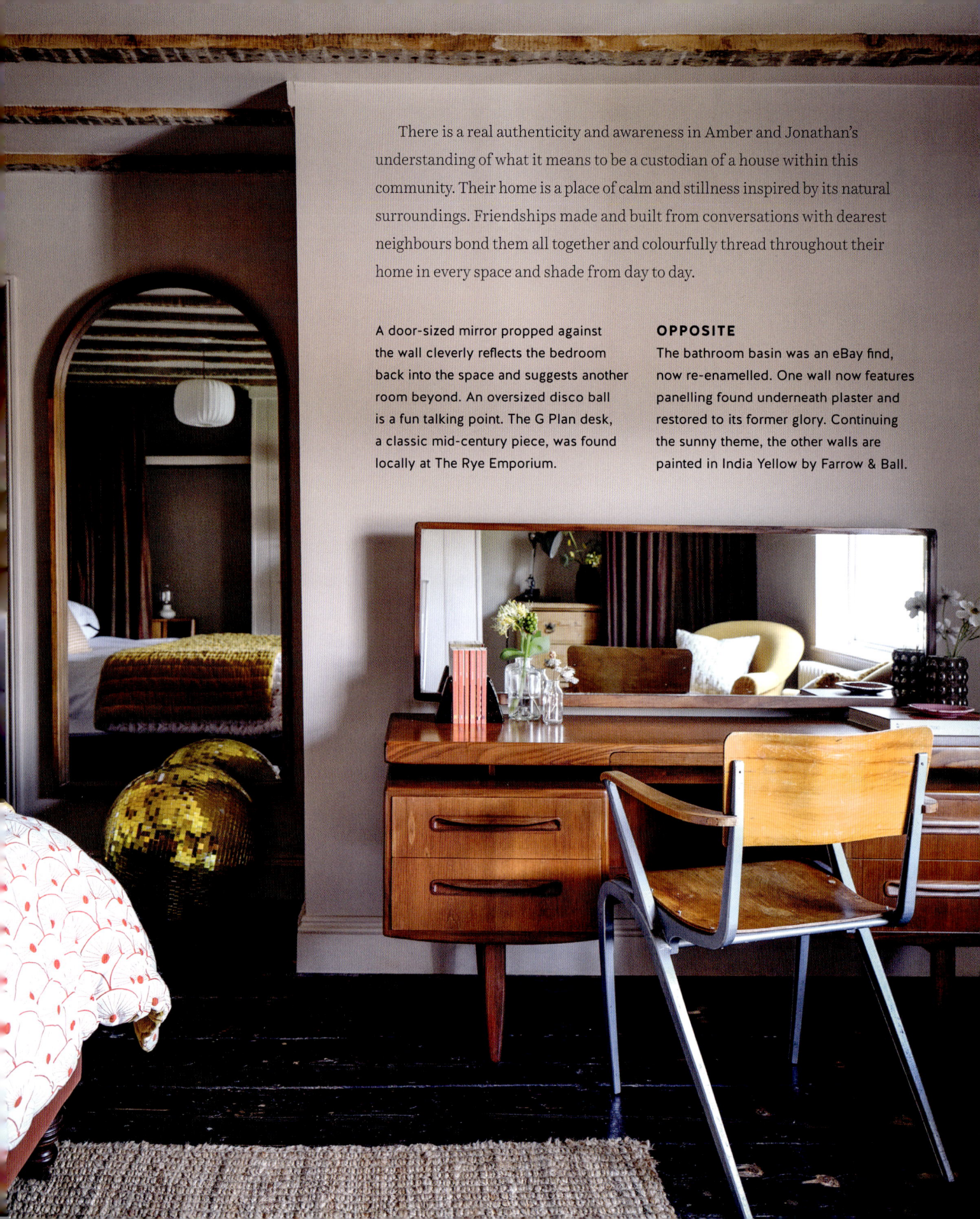

There is a real authenticity and awareness in Amber and Jonathan's understanding of what it means to be a custodian of a house within this community. Their home is a place of calm and stillness inspired by its natural surroundings. Friendships made and built from conversations with dearest neighbours bond them all together and colourfully thread throughout their home in every space and shade from day to day.

A door-sized mirror propped against the wall cleverly reflects the bedroom back into the space and suggests another room beyond. An oversized disco ball is a fun talking point. The G Plan desk, a classic mid-century piece, was found locally at The Rye Emporium.

OPPOSITE
The bathroom basin was an eBay find, now re-enamelled. One wall now features panelling found underneath plaster and restored to its former glory. Continuing the sunny theme, the other walls are painted in India Yellow by Farrow & Ball.

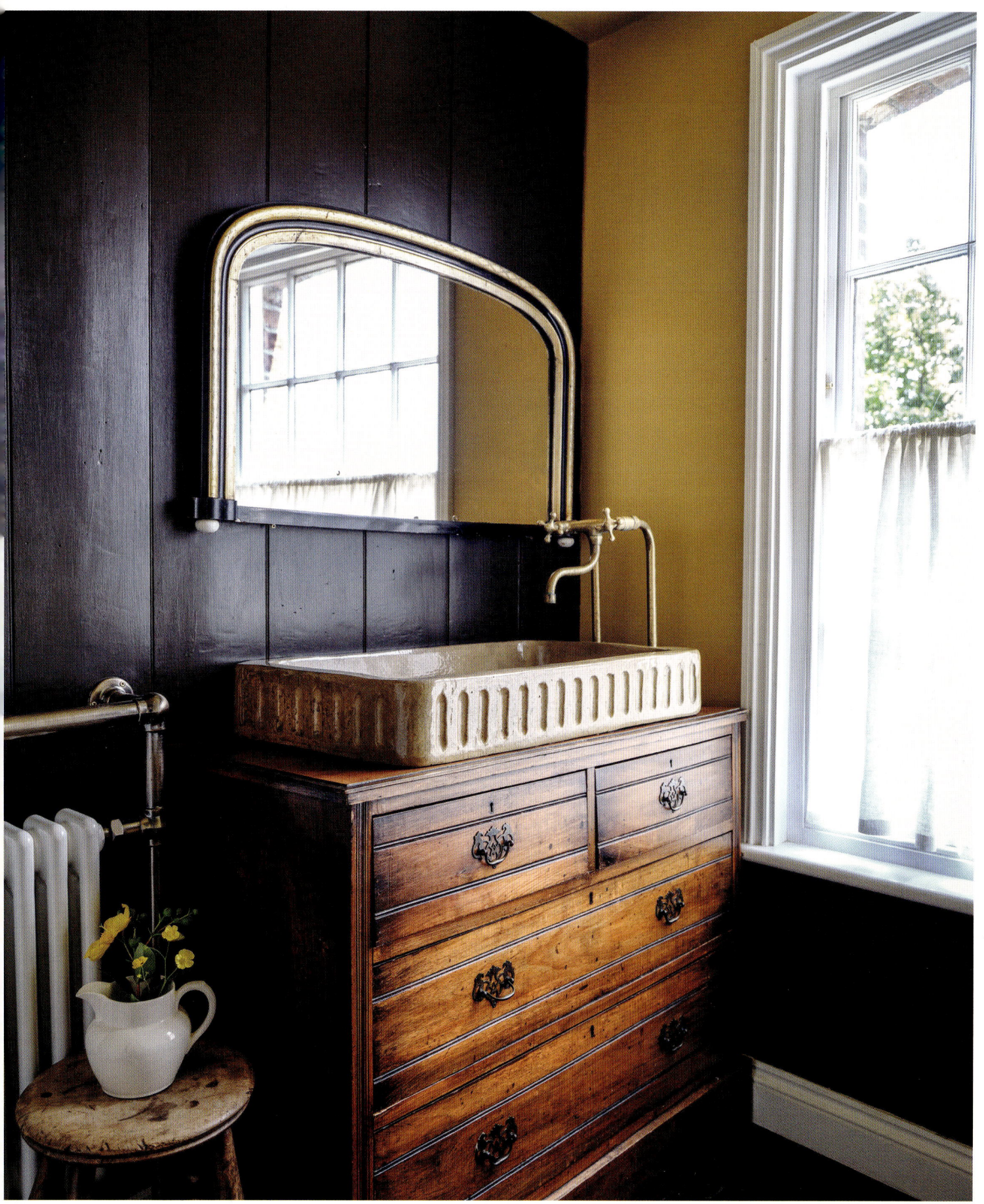

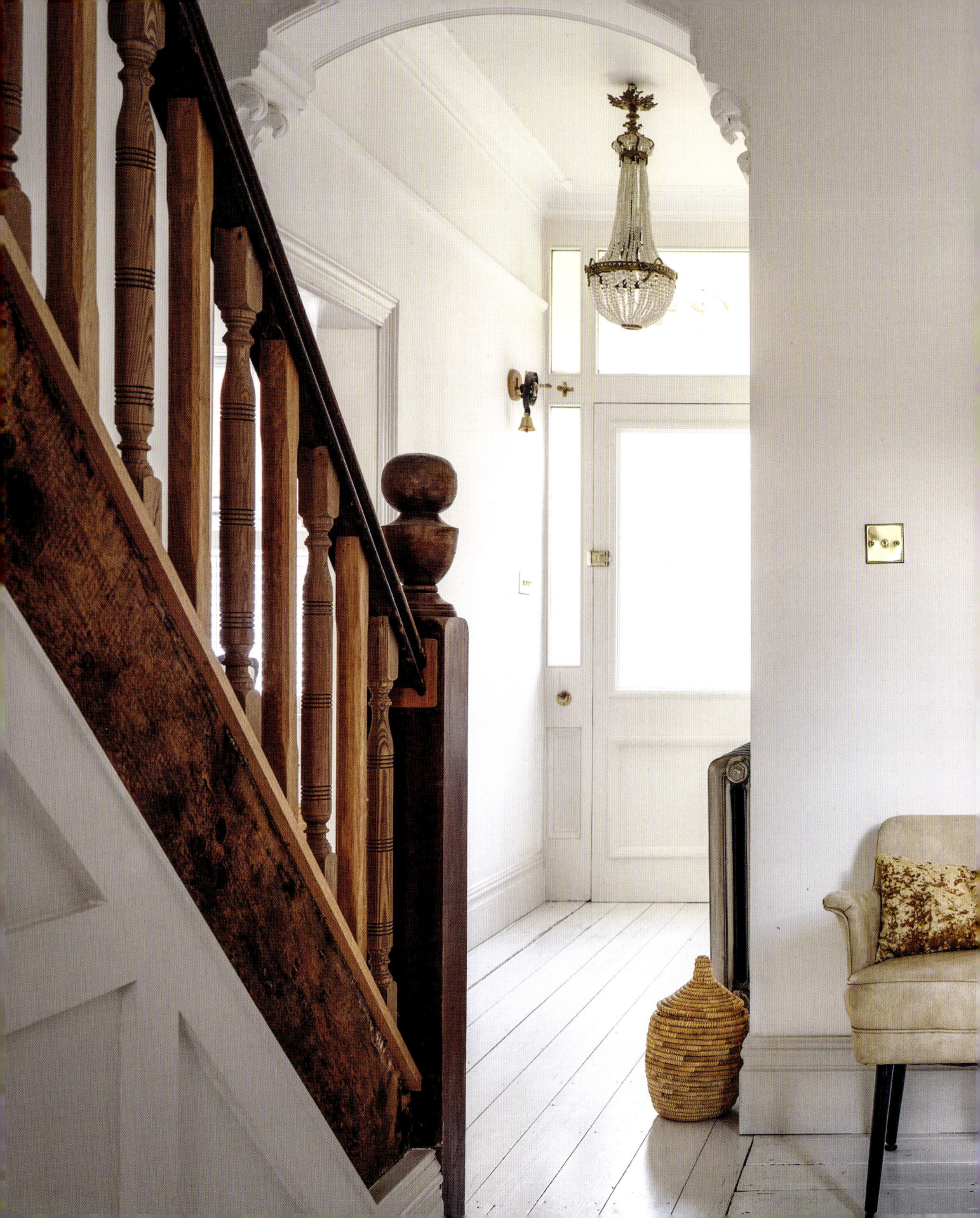

MINIMAL

Simple schemes with few shades are a go-to for low-key looks, especially if you prefer a calm environment. Relying on broad planes of colour and applied textural layers for interest, the homes in this chapter are understated in design but deliver impressive results, proving that sometimes less is more.

PEACEFUL
palette

Inspired by her desire to create a calming living environment and explore the benefits of mindful living, Hannah Beaumont-Laurencia's peaceful home near Manchester combines tranquil hues with soulful details to experience a better wellbeing within her surroundings.

RIGHT & BELOW
Found and inherited vintage pieces are mixed together to bring character to Hannah's calming home. Hand-me-downs from her grandmother, yard-sale sleuthing, high-street bargains and cherished memorabilia bring a gradually gathered feel and each tells a story. Umbrellas and carpet beaters are displayed as decorative objects in the hallway (right). The kitchen's retro barstools add an unexpected pop of colour.

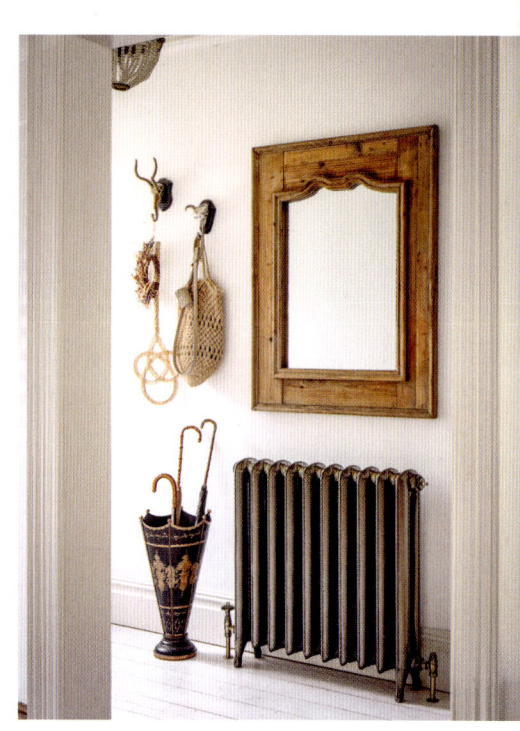

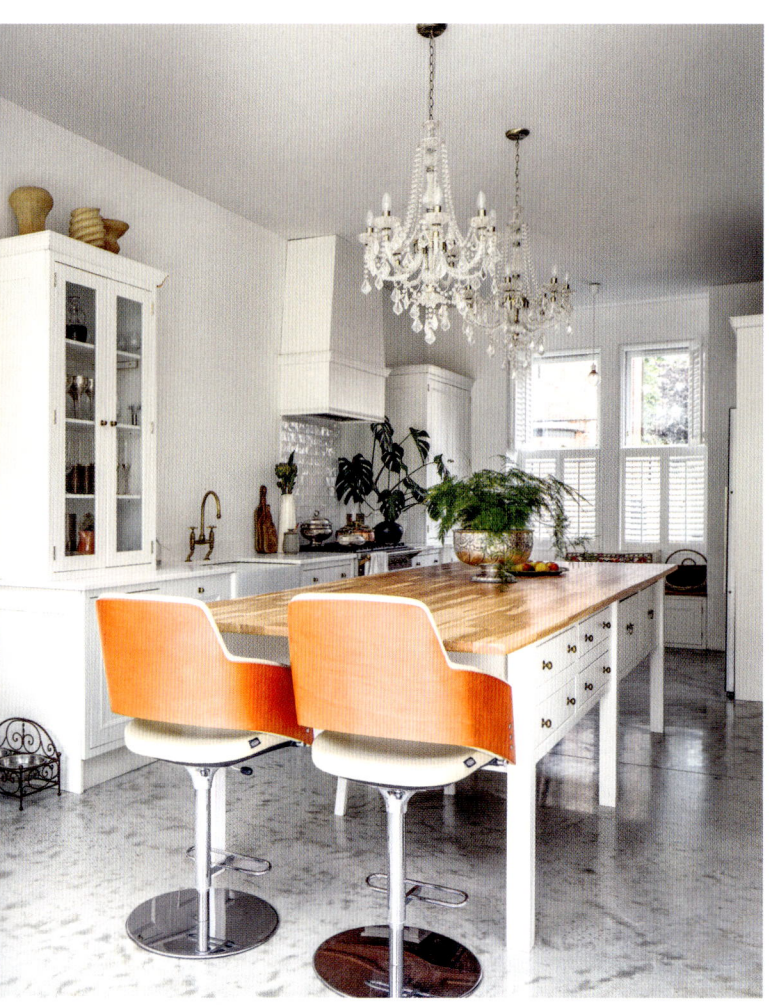

Creating a supportive sanctuary was at the heart of this renovation project. As the founder of her ethical and sustainable clothing and homeware brand Beaumont Organic, Hannah worked with her husband Nelson to create a home that reflects their passions and design a space sensitive to their own self-care and wellness.

Walking around the house is a cohesive and cathartic experience. There is a sense of focused clarity in the decor, which flows seamlessly through the space. The Victorian building had previously been divided into numerous flats, each carved up in turn into many tiny rooms. Hannah's concept for her home haven was to open it up, introduce subtle character and bring in the light. Choosing to use one white paint shade to drench throughout the home was central to this success, but it is the subtleties and considered attributes living alongside this shade which soften the starkness and cosy up the coldness.

Although many of the walls were removed, enough partitions, internal windows, returns and corners are left to create complexity. These layers shape and change how the daylight reacts with the white backdrop.

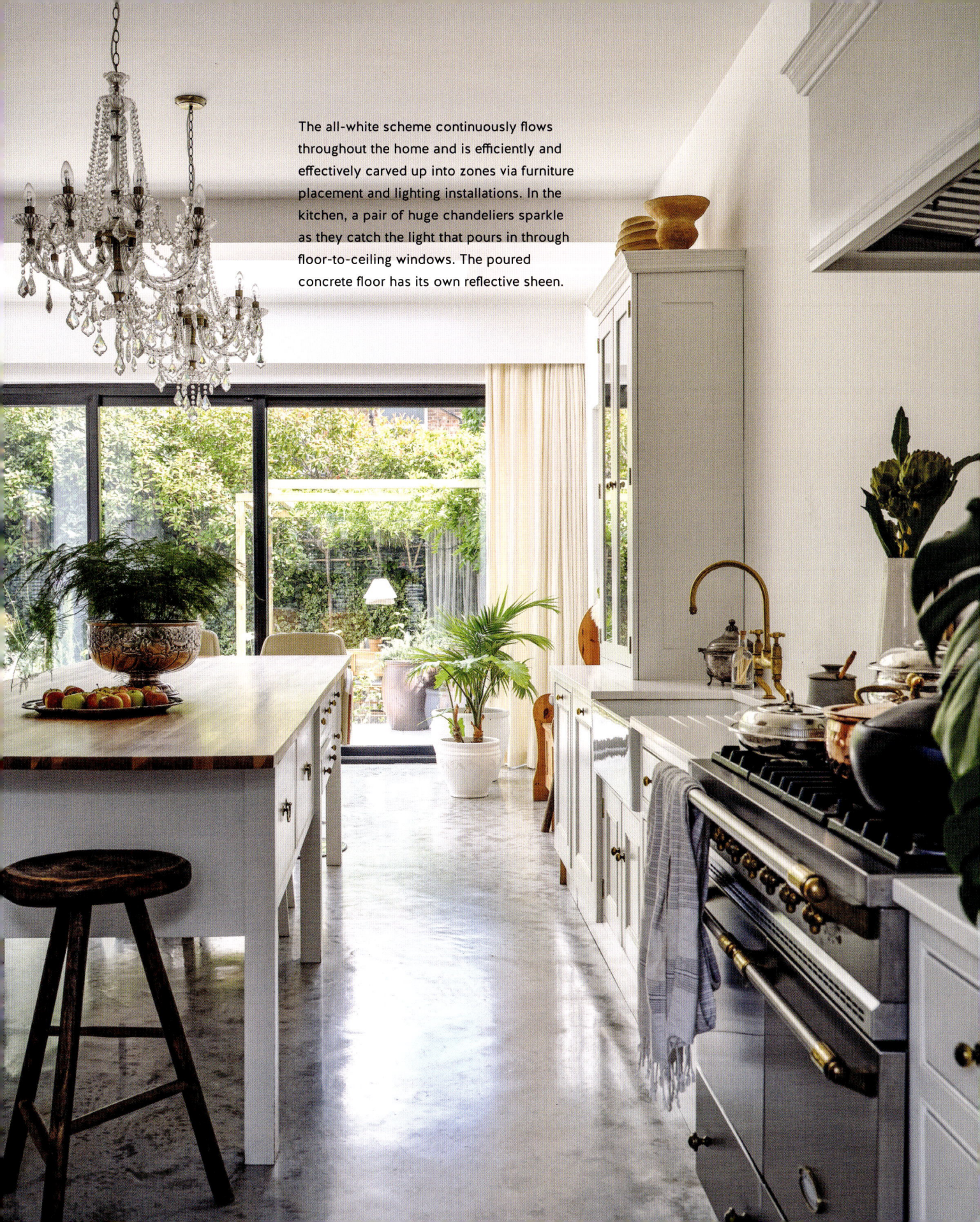

The all-white scheme continuously flows throughout the home and is efficiently and effectively carved up into zones via furniture placement and lighting installations. In the kitchen, a pair of huge chandeliers sparkle as they catch the light that pours in through floor-to-ceiling windows. The poured concrete floor has its own reflective sheen.

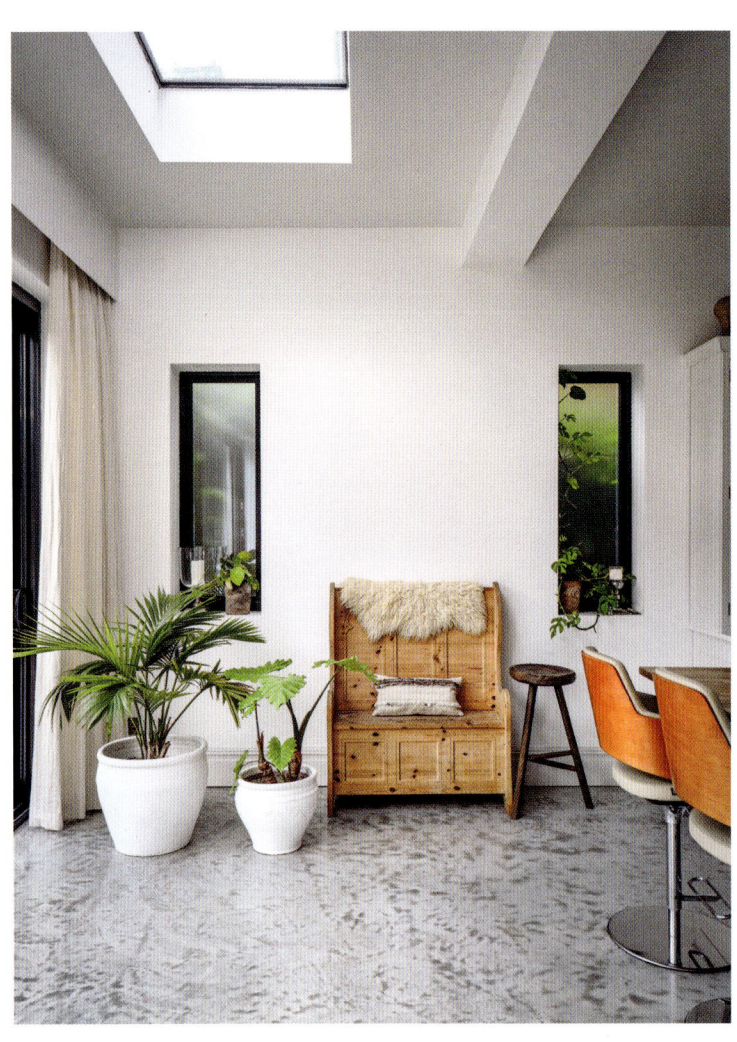
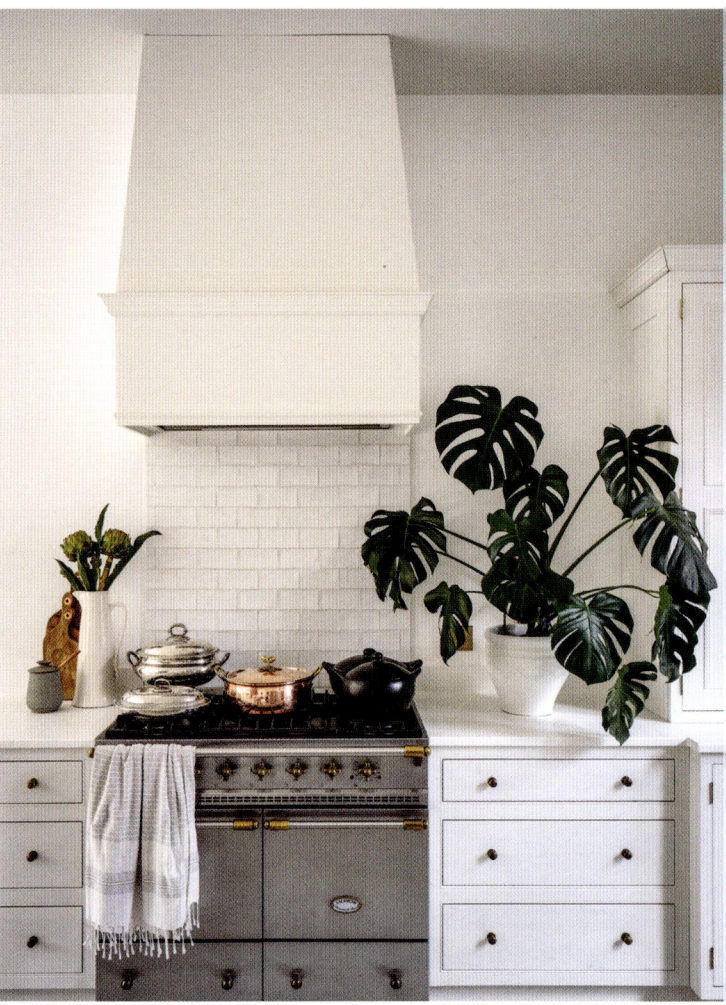

Shards of light flicker around the home, creating theatrical and atmospheric features that shift throughout the day. What is a very large space still feels intimate and the romance of exploration is tangible despite the open-plan layout.

A smattering of pared-back colour has been added, together with organic textures. The innate hues of natural materials, including leather, wood, marble and brick, lend warming tones that offer a welcome contrast with the chalky paint finish. The daylight flows over these tactile surfaces, highlighting their glossy sheens and rough-hewn finishes.

Light-coloured linens have been used to soften and filter the sun within the home. Layering white on white, they alter the brightness while shaping and containing the interior spaces. Drapes feature not just at windows, but also on furniture to cocoon and comfort while rugs bring softness underfoot. Luxurious upholstery sits easily alongside unseamed selvedged fabric throwovers.

The age of the house meant Hannah could engage with its history and embrace decor that would gradually distress and wear with time. White is not always precious and pristine – it is meant to be lived with and can look better when it has had some time to mature. Hannah has welcomed the developing patina of scuffs and scrapes on every surface as a feature. In a house where many of the original aspects had been removed by former owners, this shabby-chic approach brings a relaxed and lived-in feel and restores a sense of authenticity.

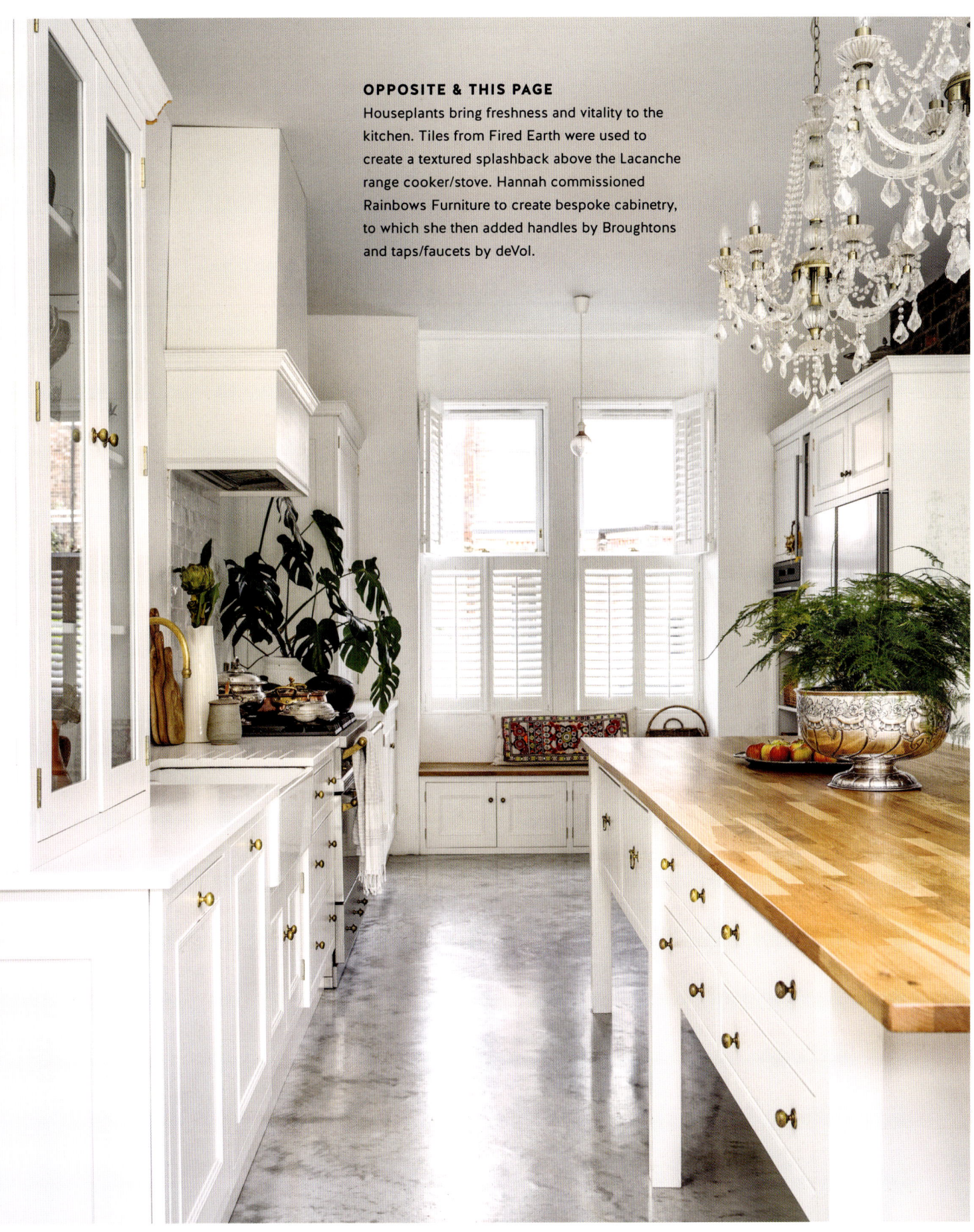

OPPOSITE & THIS PAGE
Houseplants bring freshness and vitality to the kitchen. Tiles from Fired Earth were used to create a textured splashback above the Lacanche range cooker/stove. Hannah commissioned Rainbows Furniture to create bespoke cabinetry, to which she then added handles by Broughtons and taps/faucets by deVol.

OPPOSITE & LEFT
Hannah has used texture in order to add interest and bring authenticity. In the rear living room, deep-pile carpets and faux furs soften hard surfaces and seating (opposite). Lighting installations become talking points with unexpected styling or forms that bring a sense of fun, such as this playful pendant. Building materials such as the brickwork of the fireplace are left exposed and celebrated for their humble appearance (left).

BELOW
Part of the living room is a tranquil sanctuary zone where Hannah can practise wellness rituals. Its design allows her to breathe and move freely while feeling the benefits of light and closeness to nature.

There is a readymade blank canvas as a backdrop when living in an all-white home which has the benefit of being easily able to link different styles, eras, colours and finishes. Hannah's travel-found treasures from Asia and Morocco sit easily with her inherited hand-me-downs, such as woven rugs and baskets alongside vintage silverware and pictures.

Proving pale shades work from season to season, Hannah's home is naturally light and cooling during the summer, with an abundance of energy and freshness. Come winter, the house is dressed for comfort with extra layers on the floors and windows. With inviting candles and a roaring fire, the home takes on a different tone as it glows with cosy and warming qualities.

Holistic wellness and opportunities for mindful moments were priorities for Hannah in the design. With this in mind, she has made contemplative spaces for candles and incense that glow and smoulder in the all-white setting.

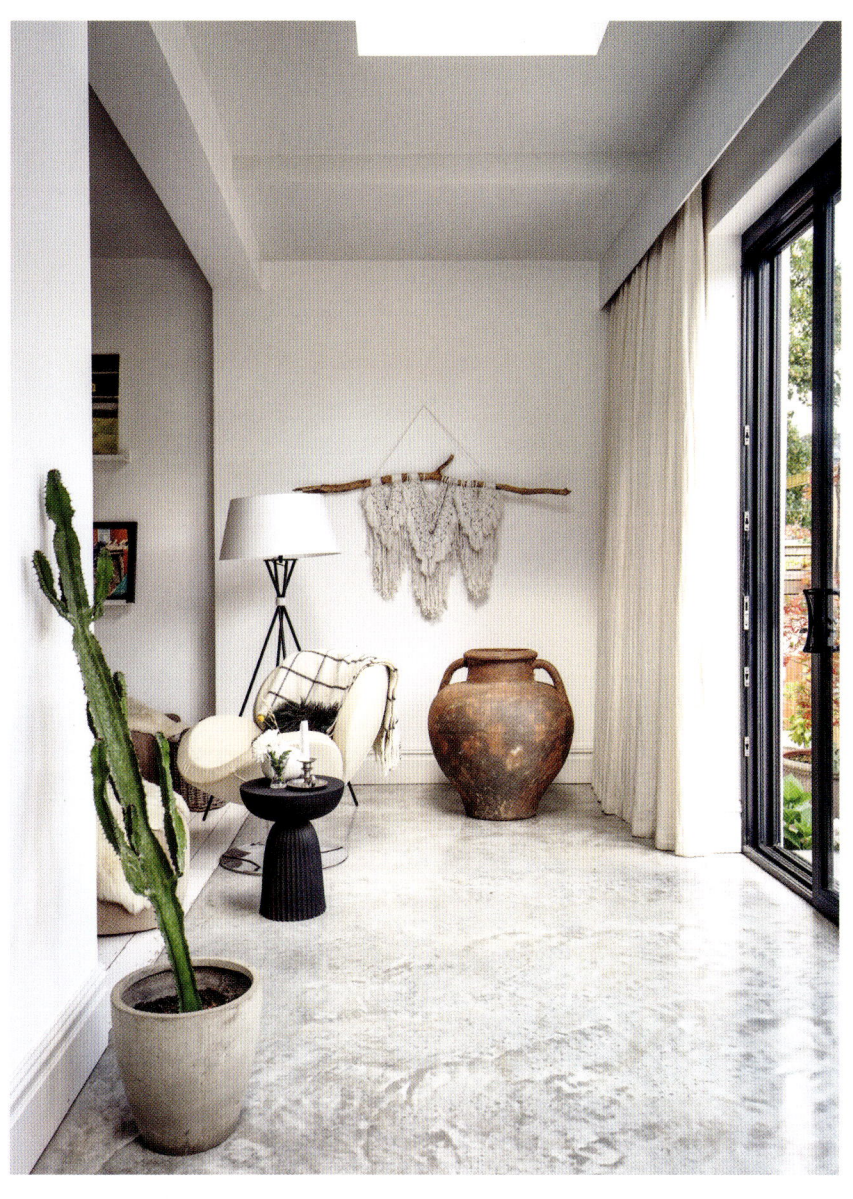

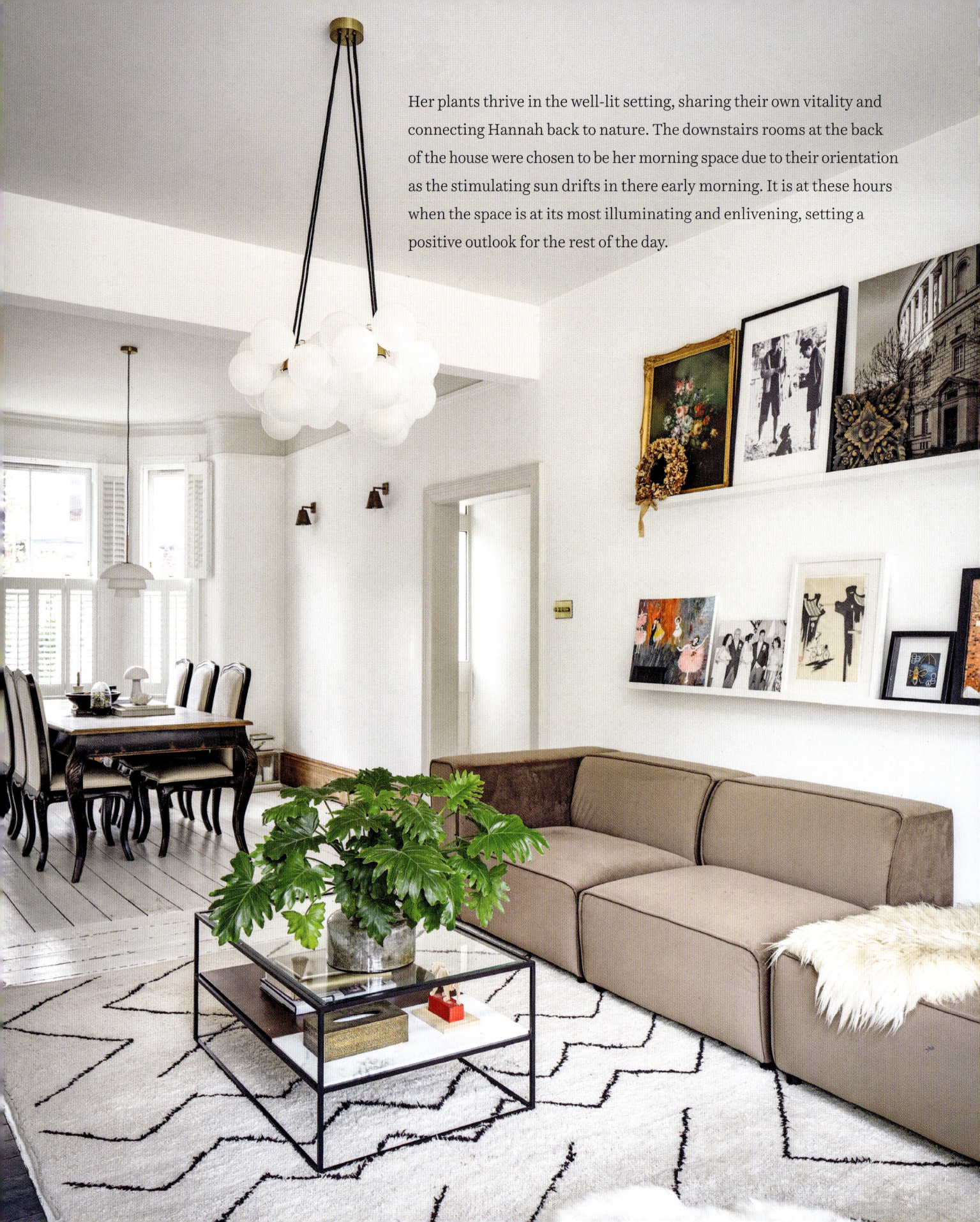

Her plants thrive in the well-lit setting, sharing their own vitality and connecting Hannah back to nature. The downstairs rooms at the back of the house were chosen to be her morning space due to their orientation as the stimulating sun drifts in there early morning. It is at these hours when the space is at its most illuminating and enlivening, setting a positive outlook for the rest of the day.

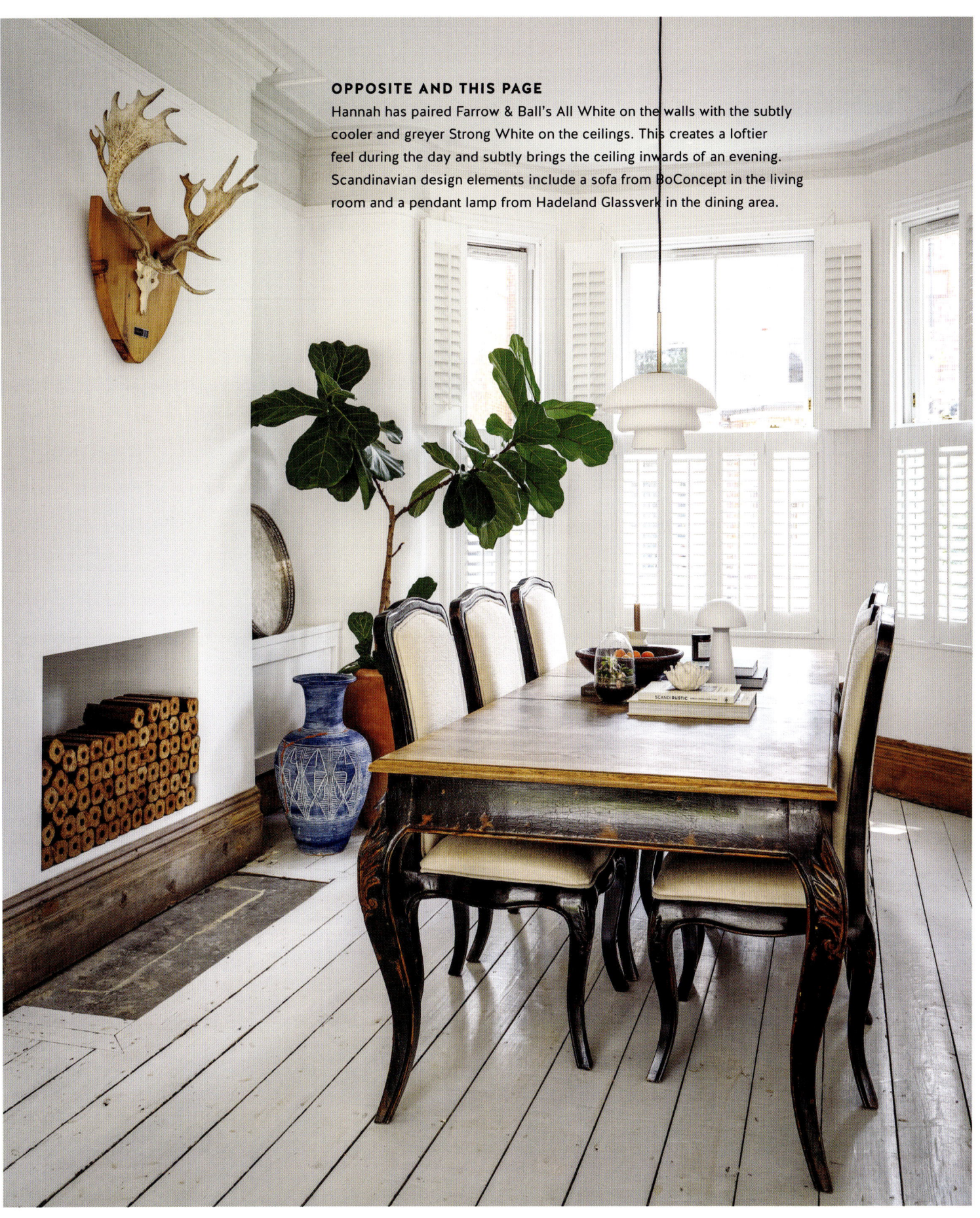

OPPOSITE AND THIS PAGE
Hannah has paired Farrow & Ball's All White on the walls with the subtly cooler and greyer Strong White on the ceilings. This creates a loftier feel during the day and subtly brings the ceiling inwards of an evening. Scandinavian design elements include a sofa from BoConcept in the living room and a pendant lamp from Hadeland Glassverk in the dining area.

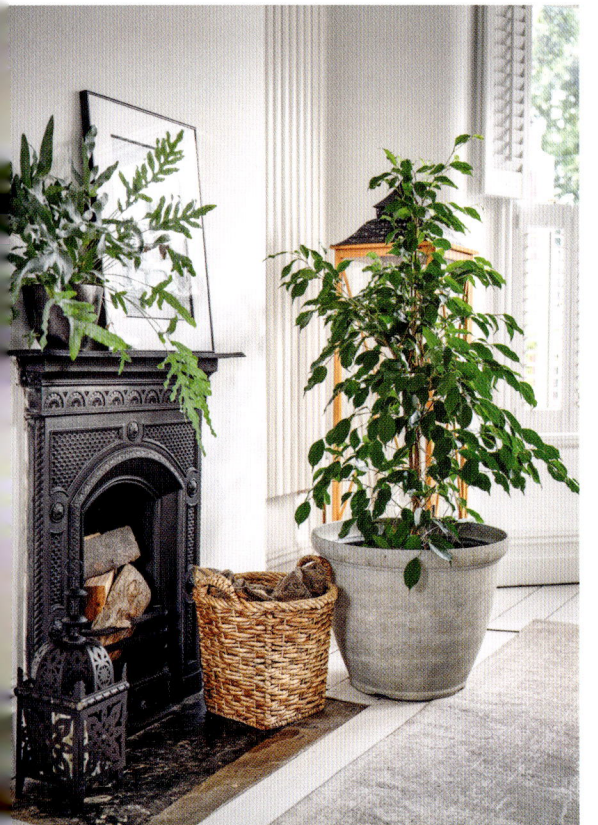

ABOVE
Inspired by the couple's travels abroad, the romantic voile drapes around the bed bring intimacy, privacy, shade and screening. They also soften the hard lines of the dark wood furniture and create a room within a room.

LEFT
The power of plants is captured throughout the home. Not only do they connect us to the outside world, they provide significant physical and mental health benefits.

OPPOSITE
Adjacent to the bedroom, Hannah has created an upstairs seating area with a pair of wingback armchairs. A restful place for morning or evening drinks, reading or simply a pause to transition to and from bed in the quieter hours. Textural finishes encourage a relaxed mood with velvet upholstery and a flatweave rug underfoot. The statement oversize mirror is from a selection at The Coach House.

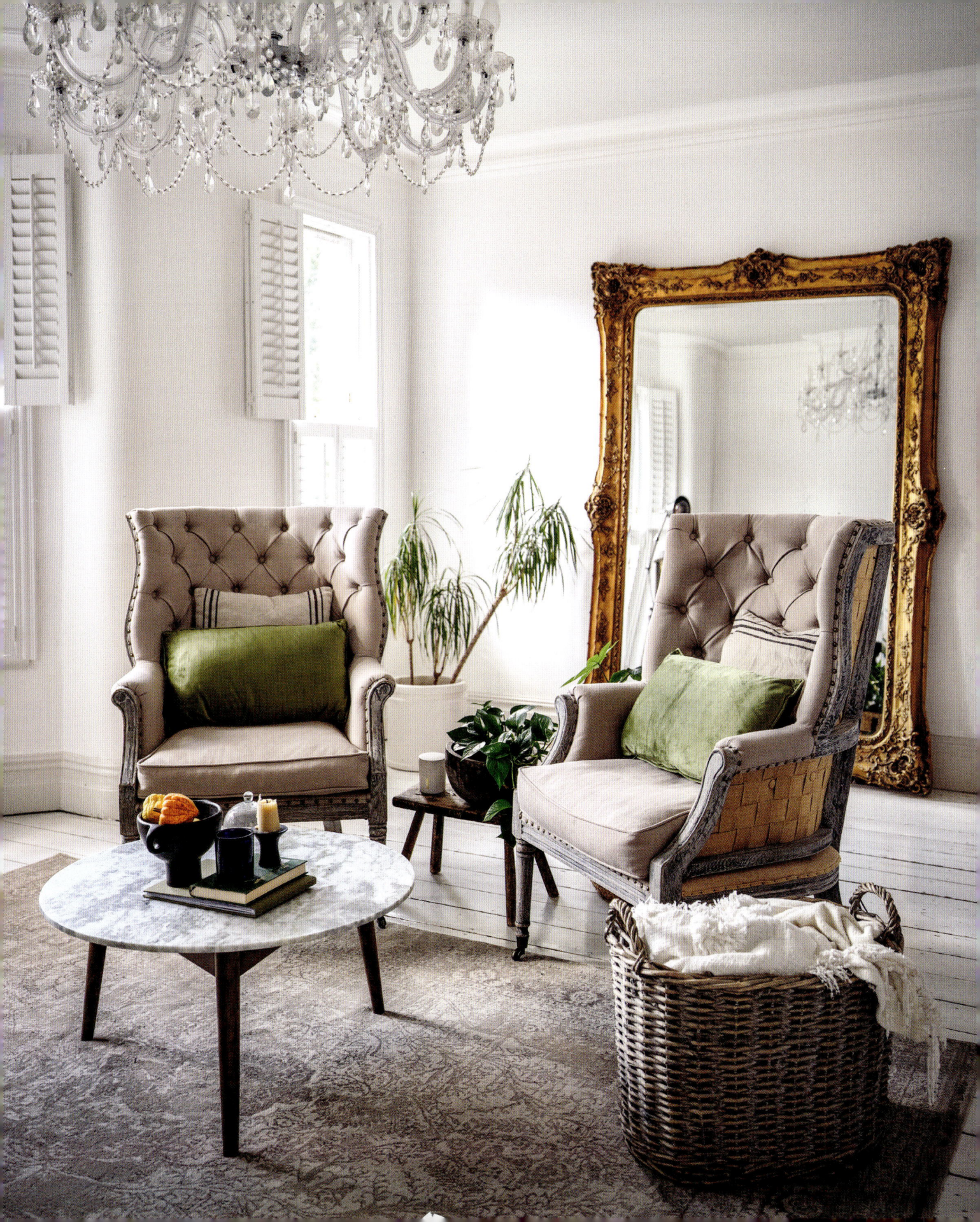

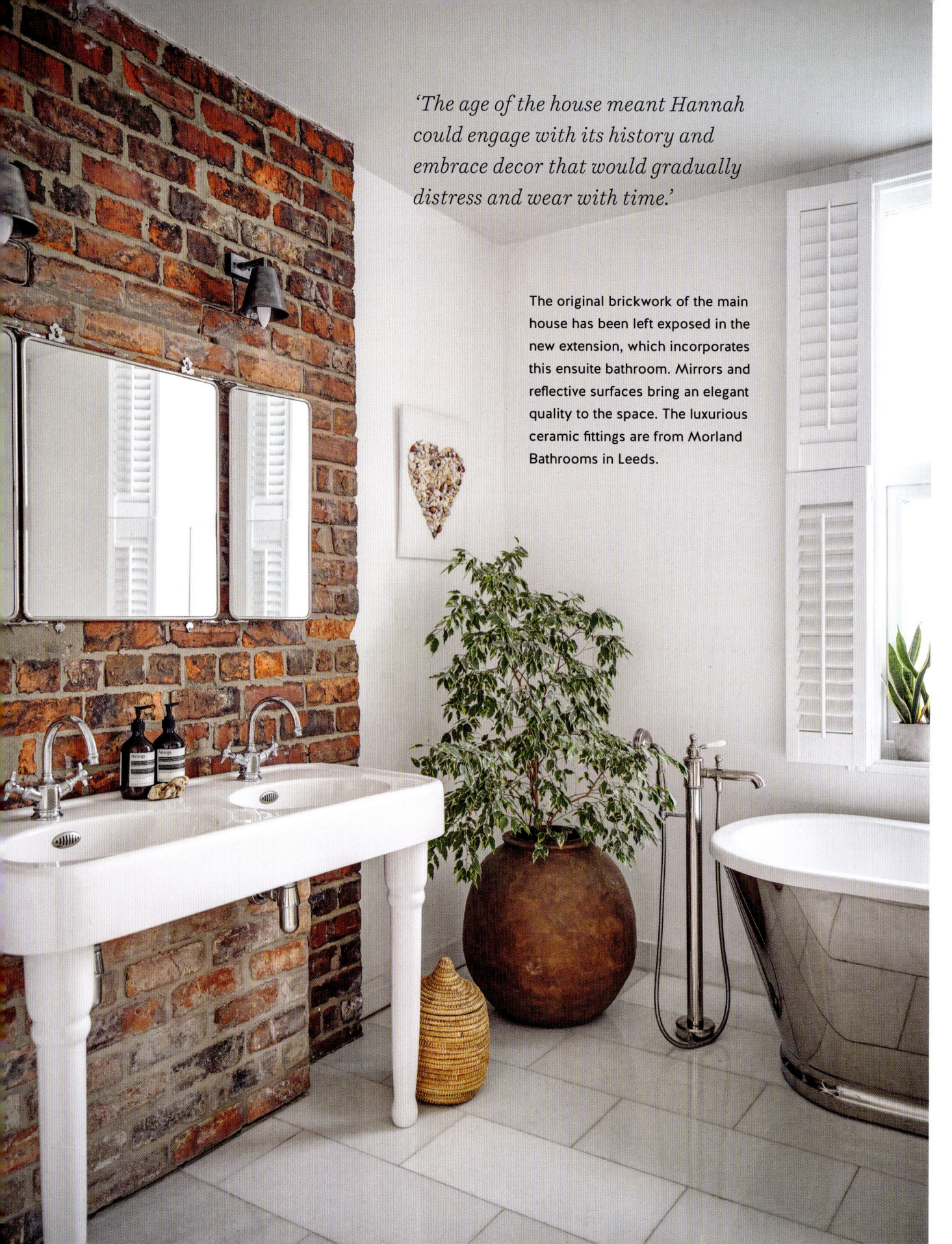

'The age of the house meant Hannah could engage with its history and embrace decor that would gradually distress and wear with time.'

The original brickwork of the main house has been left exposed in the new extension, which incorporates this ensuite bathroom. Mirrors and reflective surfaces bring an elegant quality to the space. The luxurious ceramic fittings are from Morland Bathrooms in Leeds.

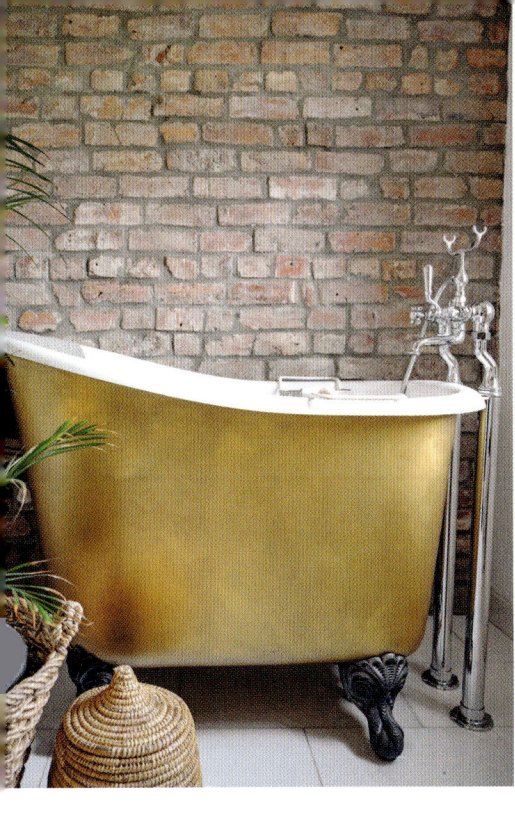

LEFT
A tiny gold Tubby bathtub from The Albion Bath Co is a show-stopping star in the guest bathroom. Ultra-deep despite its compact footprint, its shape allows for luxury bathing in a limited space. The metallic finish adds a touch of opulence in contrast with the rough brickwork.

Hannah's house is a very personal space, and she has honoured its history without creating a museum piece. Instead, it is a well-loved interior where the tactile patina of the past and present welcomes and engages with guests to make new memories in her home.

There is a flow within the interior via the simple palette alongside textural touch points and spiritual elements. In particular, Hannah's application of white has brought a calming focus. A physical, mindful and soulful exchange is naturally delivered by the decor, which can be explored to set her up for the day and provide a restful retreat when night falls.

The guest bedroom has been made inviting with a mix of hand-me-downs and heirlooms, vintage discoveries and gifts from friends and family. Visitors can feel at one with their hosts when welcomed with personal touches. The vintage bedstead came from Levenshulme Antiques Village.

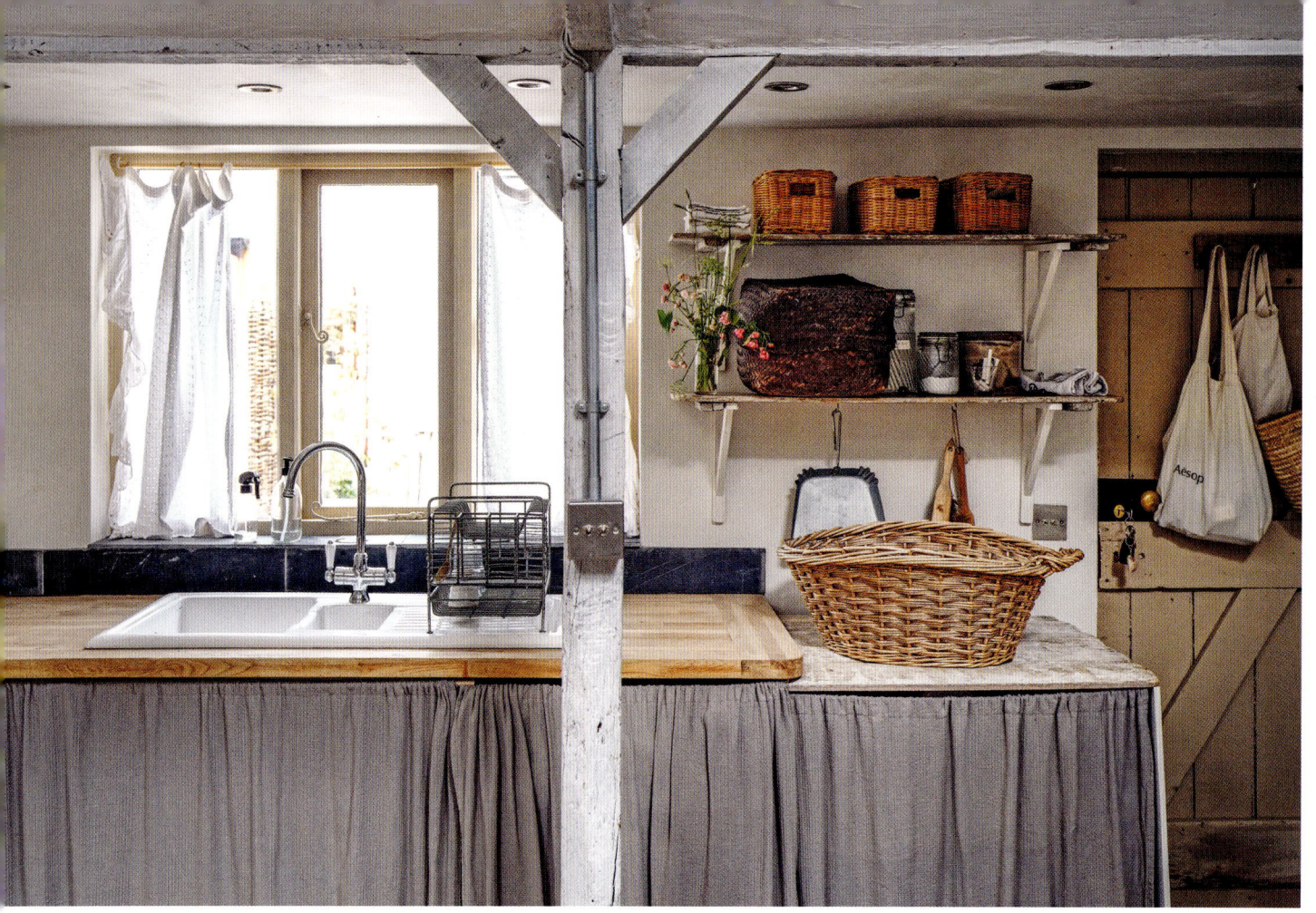

TONAL *touch*

Keen to create a restful refuge and put their own stamp on their delightful Welsh rental home, Amy Jones and Karl Bauer have expertly layered textures and finishes to craft an improvised and exquisite colour scheme.

The challenge of making a unique home from a simply furnished rental has been expertly met by brocante buyers Amy and Karl. Tapping into their love of vintage treasures, they have breathed new life into the space with a calming palette and rustic finds.

With much of their lives spent on the road, Amy and Karl were looking for a home that would make them feel grounded. Their love of period features meant they were destined for a historic property, and luckily they found a rental that worked for them.

ABOVE
The cottage is filled with repurposed materials, including reclaimed wooden cheese-drying boards used as shelving in the kitchen. These unfitted elements are perfect for rented spaces, as they can be easily packed up and moved on to the next place.

OPPOSITE
Under-counter curtains made from inexpensive salvaged linens are straightforward to install and easy to clean. They allowed Amy and Karl to create a new look without the cost of installing cabinet doors. The fabric can even be dyed to a new shade if they decide to refresh the colour palette.

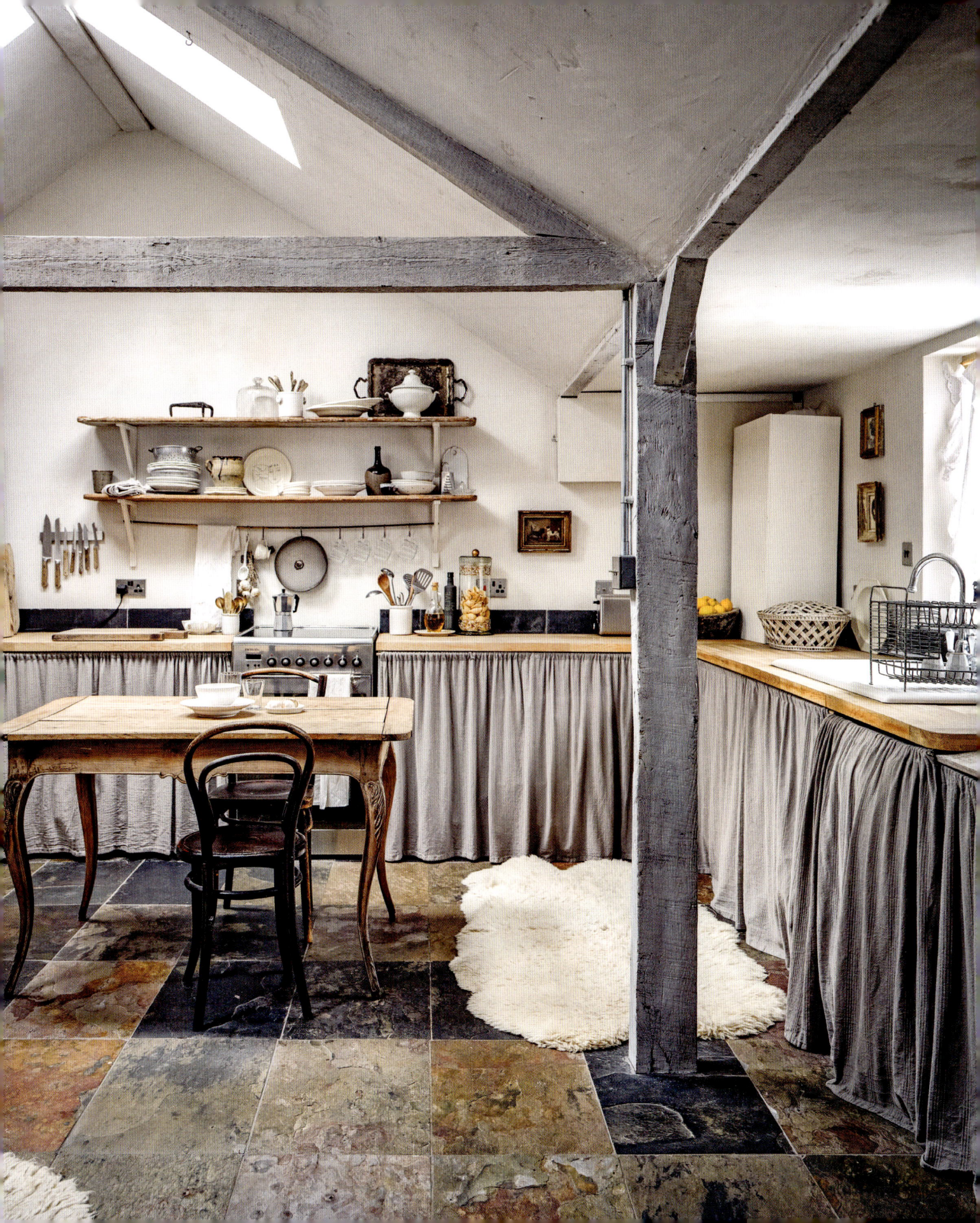

The building dates from the 19th century; like many from this period, its rooms have been gradually tacked on and patched together, resulting in somewhat disjointed decor. As tenants rather than owners, the couple were mindful of the need to adopt quick and temporary staging ideas to effectively make the house feel like their home.

To bridge the eras and link different parts of the house, Amy and Karl chose to use a limited colour palette. They were led by the existing hues of tawny quarry tiles, bare stone and aged timbers. Innately tied to the Welsh landscape, these vernacular materials exude a rich and warm natural tone. Fortunately, the owner had already applied a pale lime paint to the internal brickwork, a considered choice that gave the new occupants plenty of scope for the imagination.

The rustic backdrop lends a perfect patina to play with and deliver an evolving and inviting setting, so the couple didn't need to take on any major decorating. The quarry tile flooring has been buffed and burnished over time, imparting a slight sheen that reflects the light beautifully.

'The dramatic decor, the blend of hand-me-downs and witty details and the balance of light and shade make for a beautiful space that soothes.'

RIGHT
The open-plan layout of the cottage has been cleverly zoned into practical spaces, with beams and furniture providing natural divisions. A delicate voile drape between the kitchen and living room subtly screens the metal refrigerator from view.

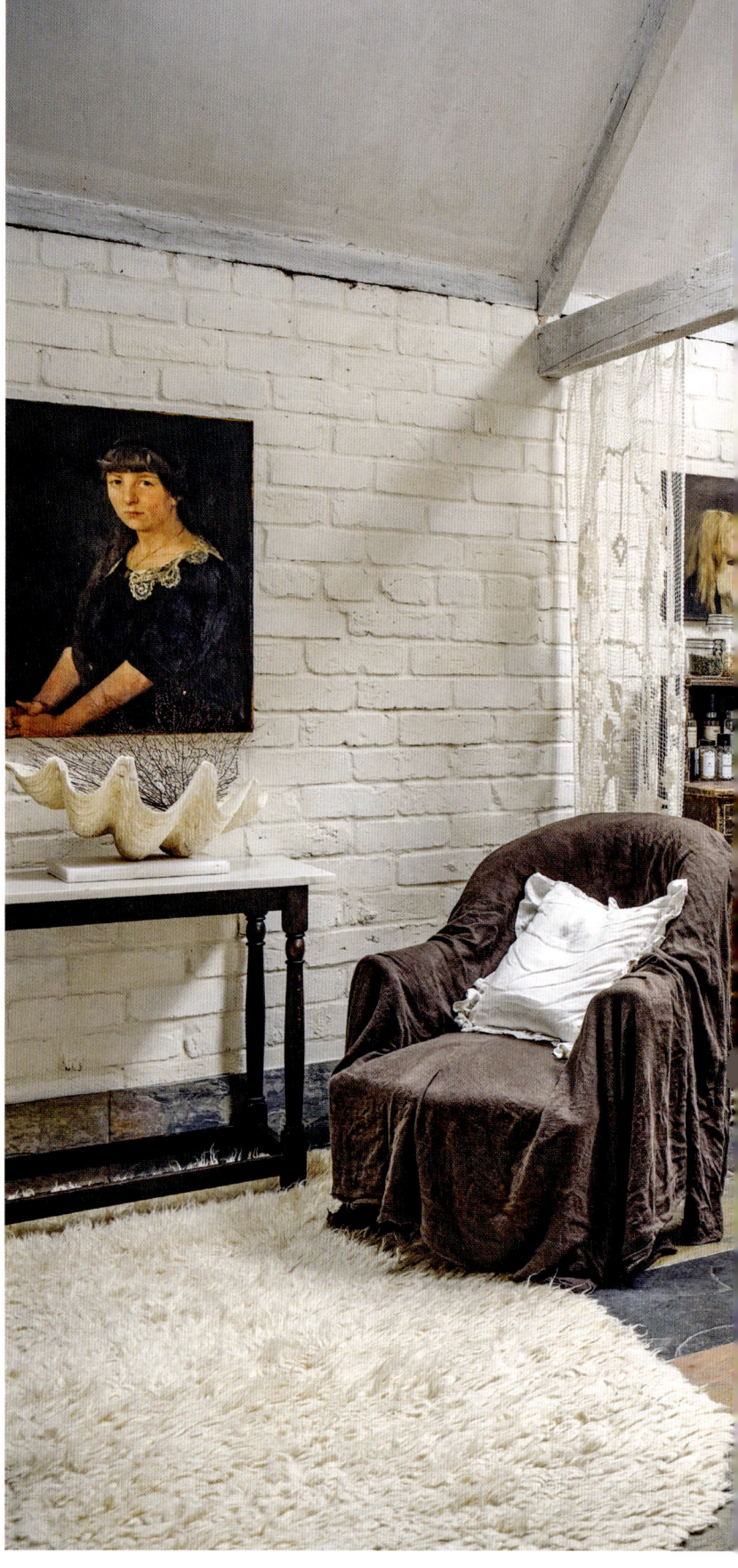

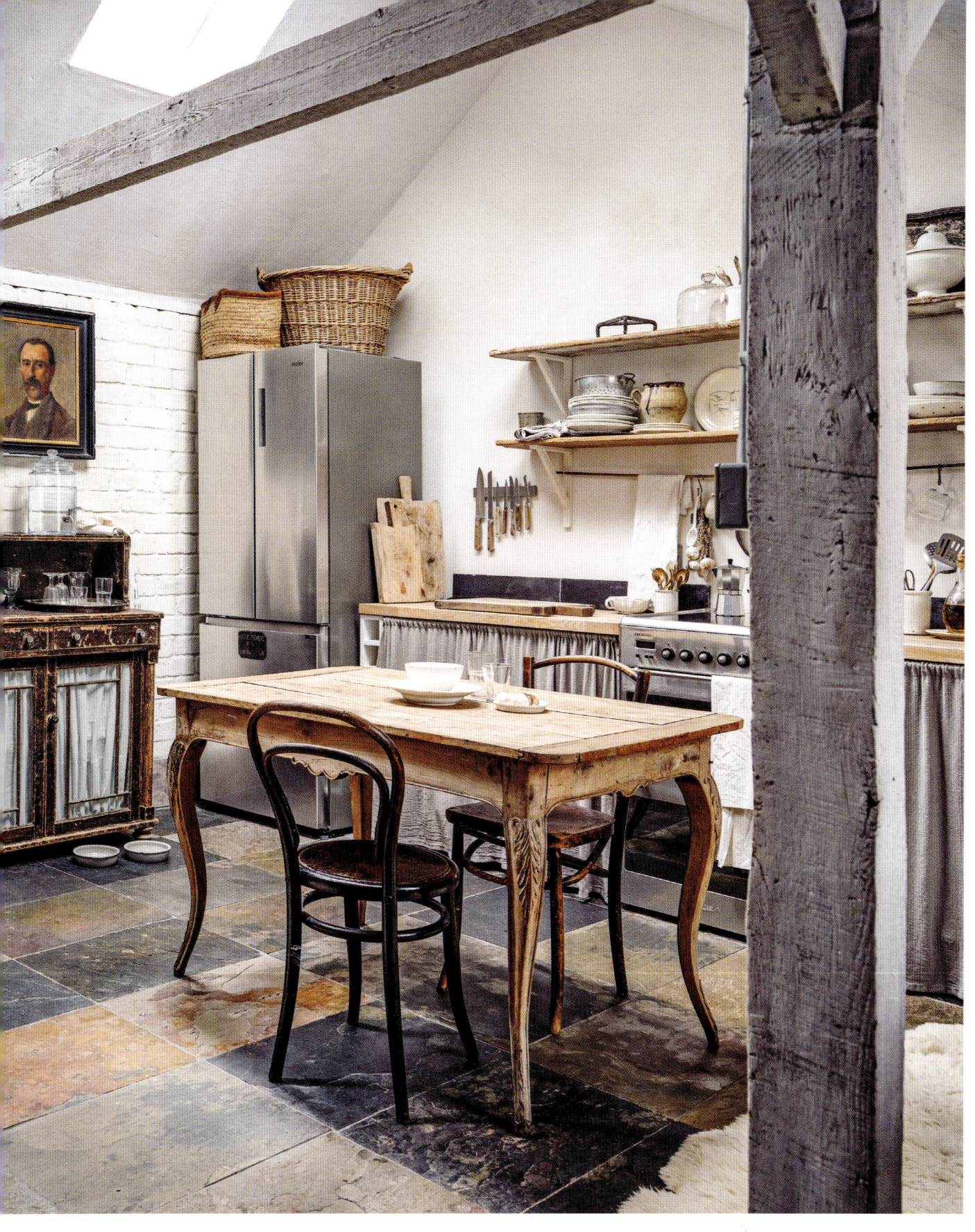

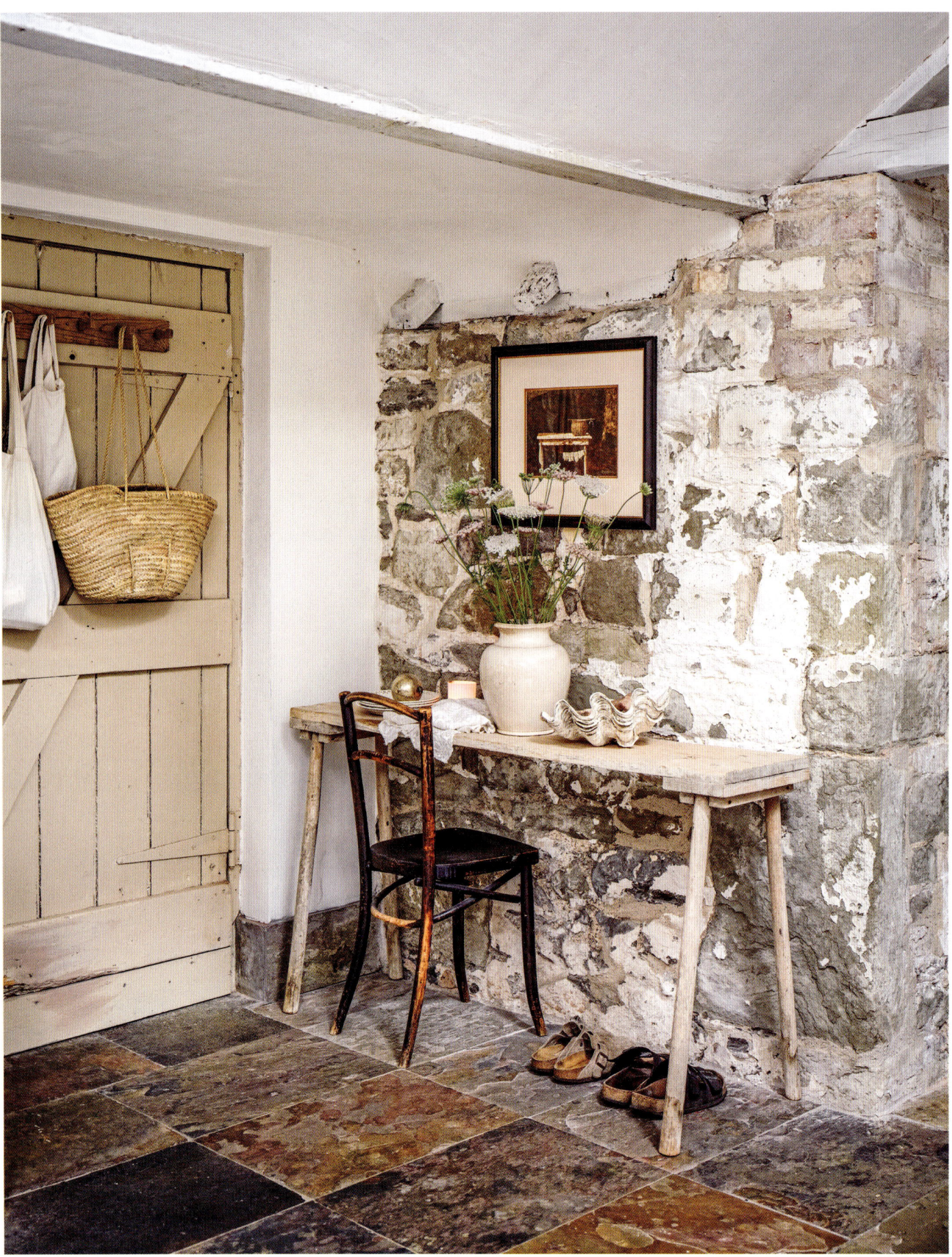

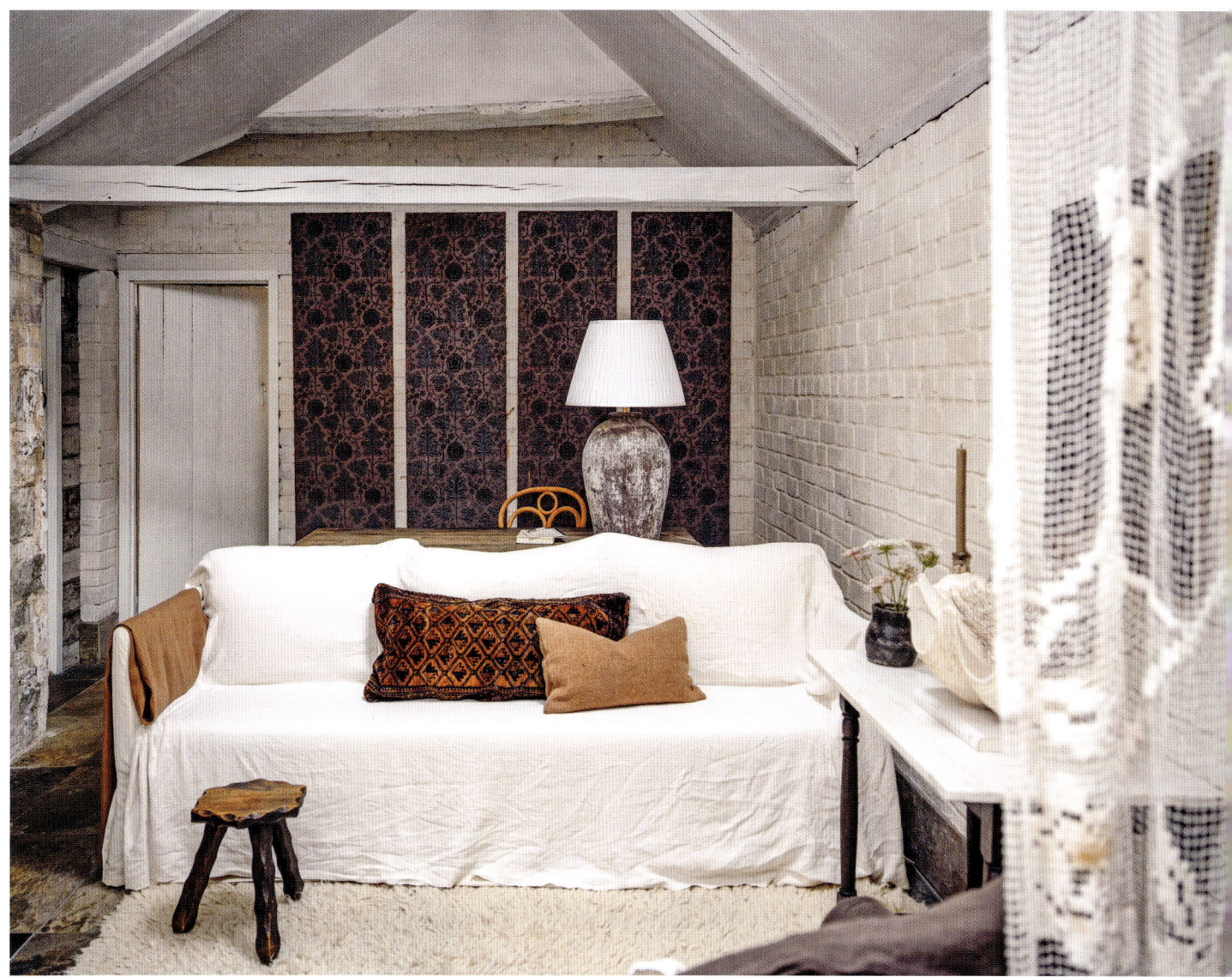

The pared-back brickwork reveals a subtle tessellated pattern with its shapely coursework. Undulating roughened stone contributes a matt and sturdy flatness, while the coarse wooden beams show an organic quality in their grooves and grain.

Amy and Karl have supplemented these found textures by using fabrics to soften the harder elements, making the rooms feel relaxing and welcoming. In the main living space, curtains and drapes have been deployed to create zones that can be screened off from one another. This is an inexpensive way to divide a space and add temporary colour.

By upcycling old fabrics, Amy and Karl have introduced time-worn shades from the naturally bleached and weathered fibres.

OPPOSITE
To allow the old building to breathe, lime paints have been sensitively used throughout. Their powdery finish complements the exposed stonework and locally sourced slate floor tiles. This area just off the living room houses a useful narrow desk.

ABOVE
A favourite shapely sofa has been dressed with antique linen sheeting so that it sits harmoniously within the muted decor. Old bedding often looks better as the fibres loosen and relax over time – it drapes, folds and gathers more gracefully with every wash and wear.

Textiles have been used to cover and blend, maintaining the couple's chosen colour palette used throughout the home.

Cabinetry and fittings have been selected to complement the tonal scheme. Reclaimed boards and ledges, many of rustic or industrial origin, have been placed and propped to create new surfaces or to cover and conceal. Most are temporary and can be moved around as needed. Their worn finishes introduce time-tumbled tones and understated detailing with their dents and dimples. There is a charm to these makeshift additions with their quirky planes and at-odds fixings. Simple making methods have been celebrated and there is a prevailing homeliness via the ethos of 'make do and mend'.

Keen to make a home where they would be able to consciously disengage from their busy lives, Amy and Karl have also used textured surfaces and vintage finds to add interest and change the pace with natural tones and patterns.

RIGHT
Amy has used white finishes to create a cohesive scheme in every room that is far from austere. Distressed vintage pieces sit effortlessly alongside freshly painted finds. Layers of gathered homewares add character with textiles on the floor and bed bringing comfort to the scheme.

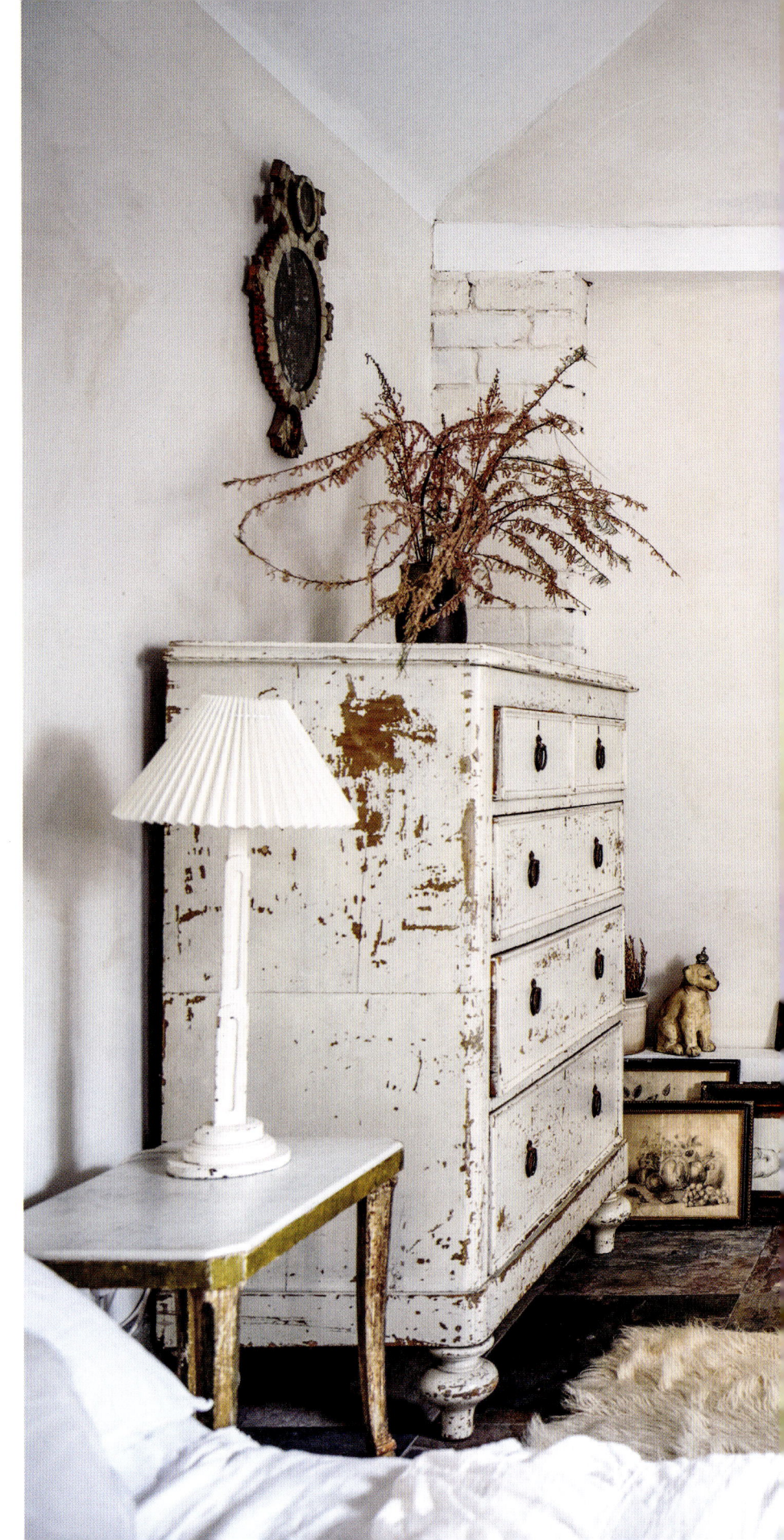

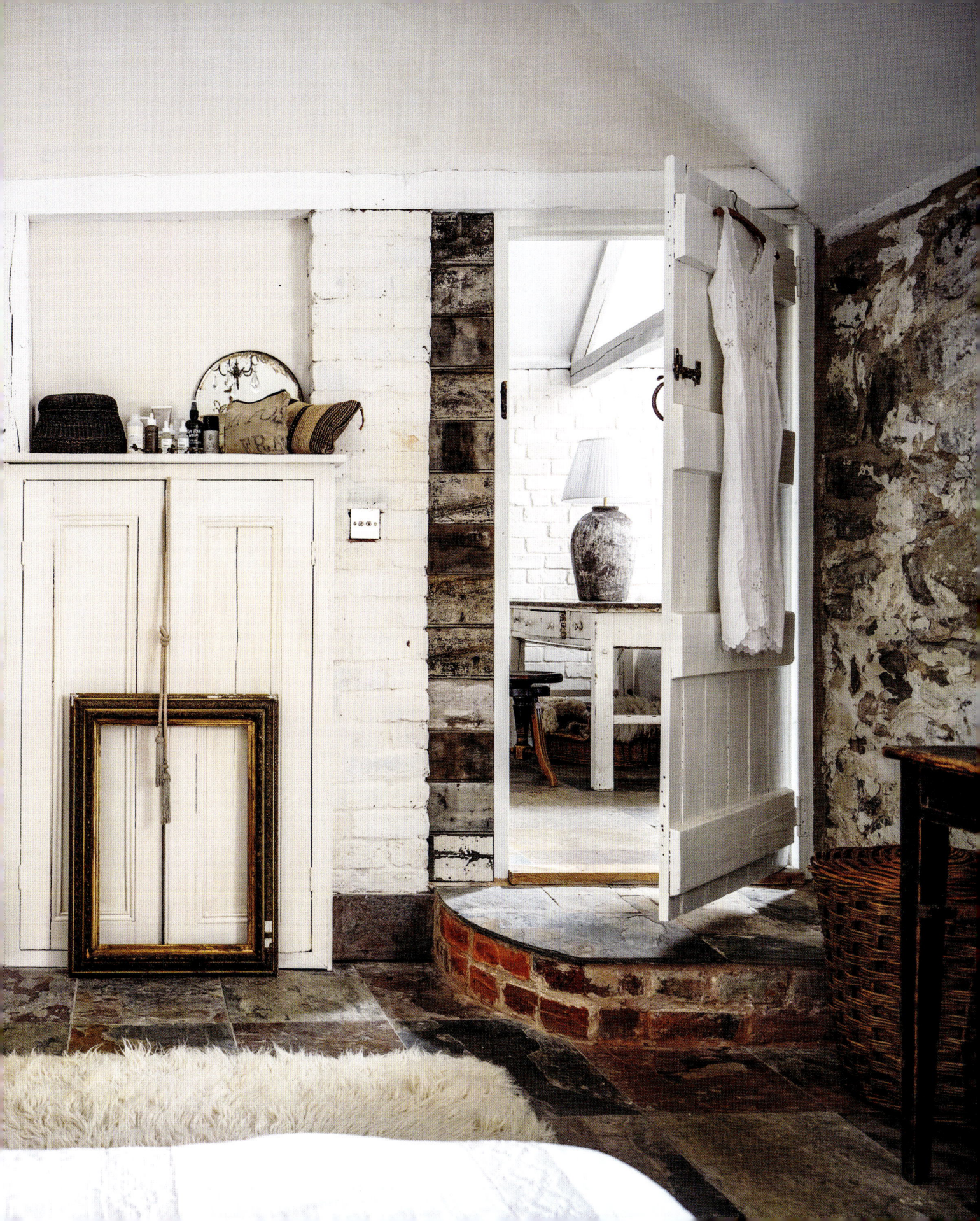

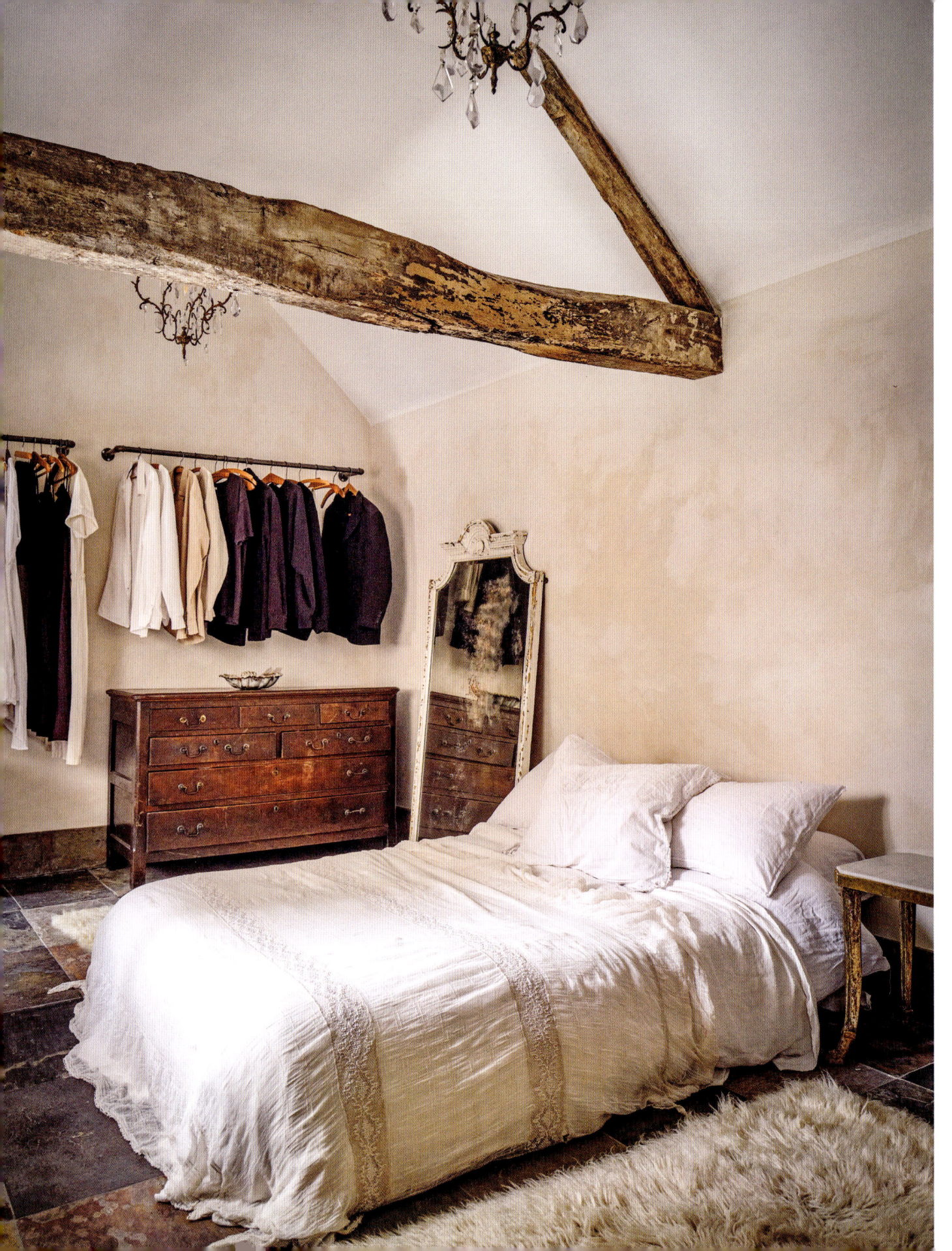

Flat chalky paints with mirrors and mercury glass, or polished slate next to fibrous timbers, offer a pleasing contrast that sets the scene for mindful contemplation. Authentic reclaimed and vintage items age beautifully and show the marks of how they were made or used, which delightfully engage and interest the eye.

Being of a busy mind with a life of little routine, home has always been a support for Amy and Karl. Naturally shifting with the seasons and adapting to meet the needs of the family, the calming palette is a continuous touchpoint for grounding and connection, aided by decor that has evolved without overthinking. By designing with modesty in mind, the couple have made a blank canvas for creativity and a peaceful place to come home to whenever they need to rest.

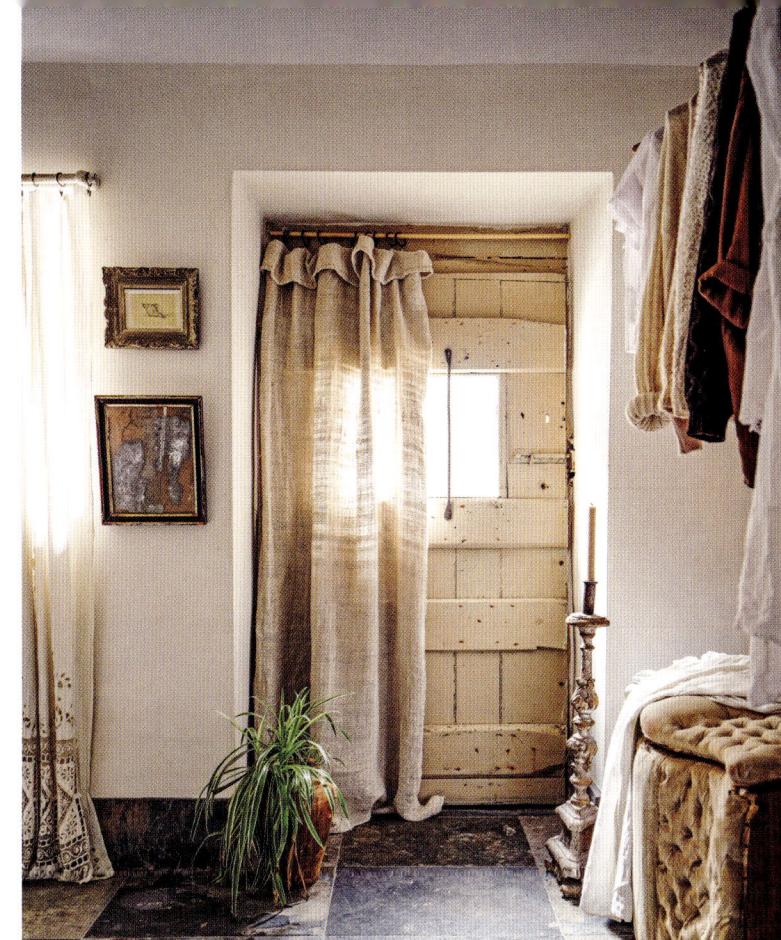

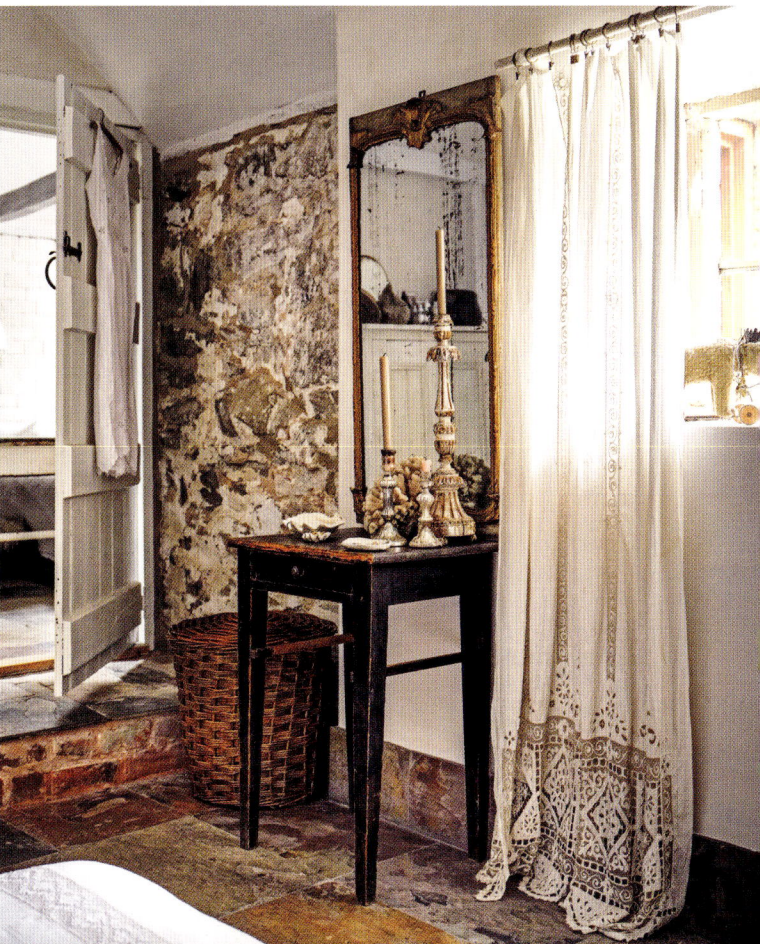

OPPOSITE
The bedroom is the oldest room in the house and dates from the 1800s, with the living areas being a later addition. To celebrate its age, Amy and Karl left the walls largely undisturbed. Rails offer hanging space without the need for solid cabinetry.

ABOVE RIGHT
An original door to the exterior courtyard is lined with a curtain for warmth. The wood weathers all the elements and moves over the year, so the lengthy drapes with extra folds and valances insulate the gaps in the ancient timber.

RIGHT
The calming bedroom is where Amy gathers some of her favourite pieces. Preloved items, some of which were found in Amy's teens, are highly prized and cherished alongside new finds that she sources from numerous trips to brocante fairs. The older items suit the rustic backdrop of her home and seamlessly establish themselves next to the bare stone, lime plaster and antique textiles.

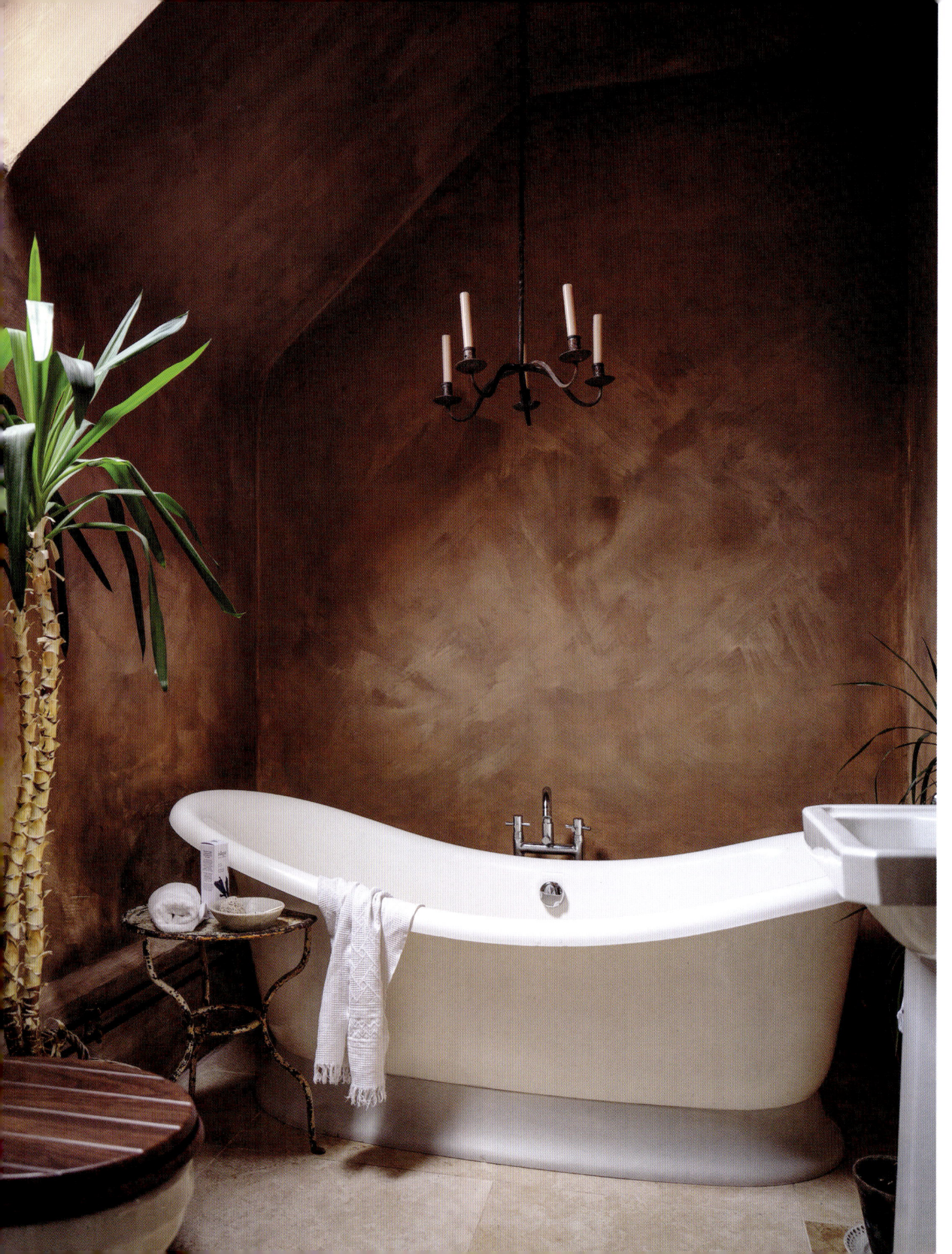

OPPOSITE
Lime paint from Bauwerk Colour has been applied to the bathroom walls. The mud plaster shade was chosen to warm up the space. Natural light and candles illuminate the room in dapples and drifts for an atmospheric mood, while the plants make it feel like an interior oasis.

ABOVE LEFT TO RIGHT
Bathing collections in the form of vintage toiletries and dressing-room details provide a decorative touch and bringa personal element to the bathroom. Blending home comforts with boutique luxury, it feels like a special place to linger rather than being solely functional.

RIGHT
The existing shower received a quick and easy makeover with a loosely hung curtain. The linen fabric lends a softer shape and drape than a typical plastic version. A temporary disguise for the plastic and steel, it is also machine washable and easy to re-hang.

LIGHT & *shade*

Restoration and interior curator and designer Alex Legendre has a flair for sophisticated decorating, which she brought to the renovation of this 19th-century home on the coast of East Sussex. Using a textural palette of natural materials in finely balanced hues, she has created intricate, intimate and soulful spaces filled with curated antique finds and rustic relics.

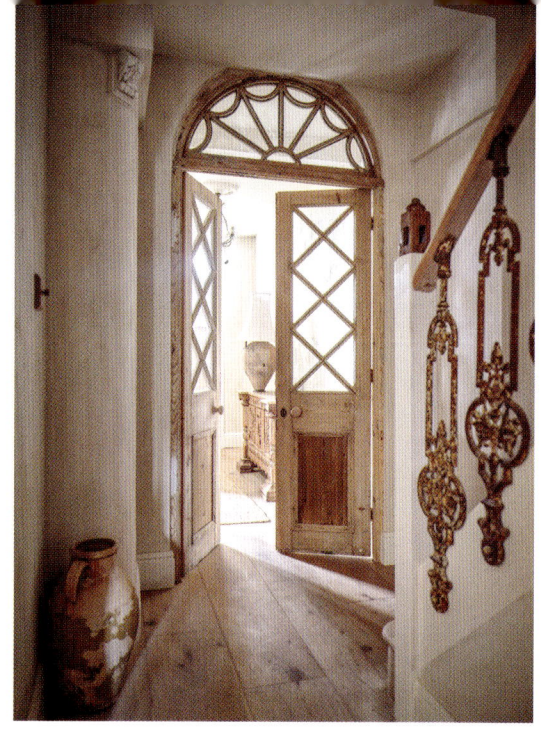

ABOVE
The property, built in the late 1800s, was previously part of a bank. Alex has retained many of the original features and sourced reclaimed pieces for added authenticity. Stripped back to bare wood or metal, they blend seamlessly together.

LEFT & OPPOSITE
A large farmhouse-style dining table sits in between the kitchen and living space. It has a variety of uses, whether at mealtimes or as a place for work. The simple design can be left exposed or dressed to suit the occasion in formal linen layers.

The interiors of Alex's home in Shoreham-by-Sea have an air of elegant concord, thanks to her skilfully crafted application of seemingly monochromatic neutrals. Upon closer inspection, it becomes apparent that she has cleverly combined many muted shades from room to room. This subtly varying palette forms the base for layers of texture and ornament.

With a love of natural materials, Alex has managed to convey hints of colour from wood, clay, stone, woven grasses and pleated paper.

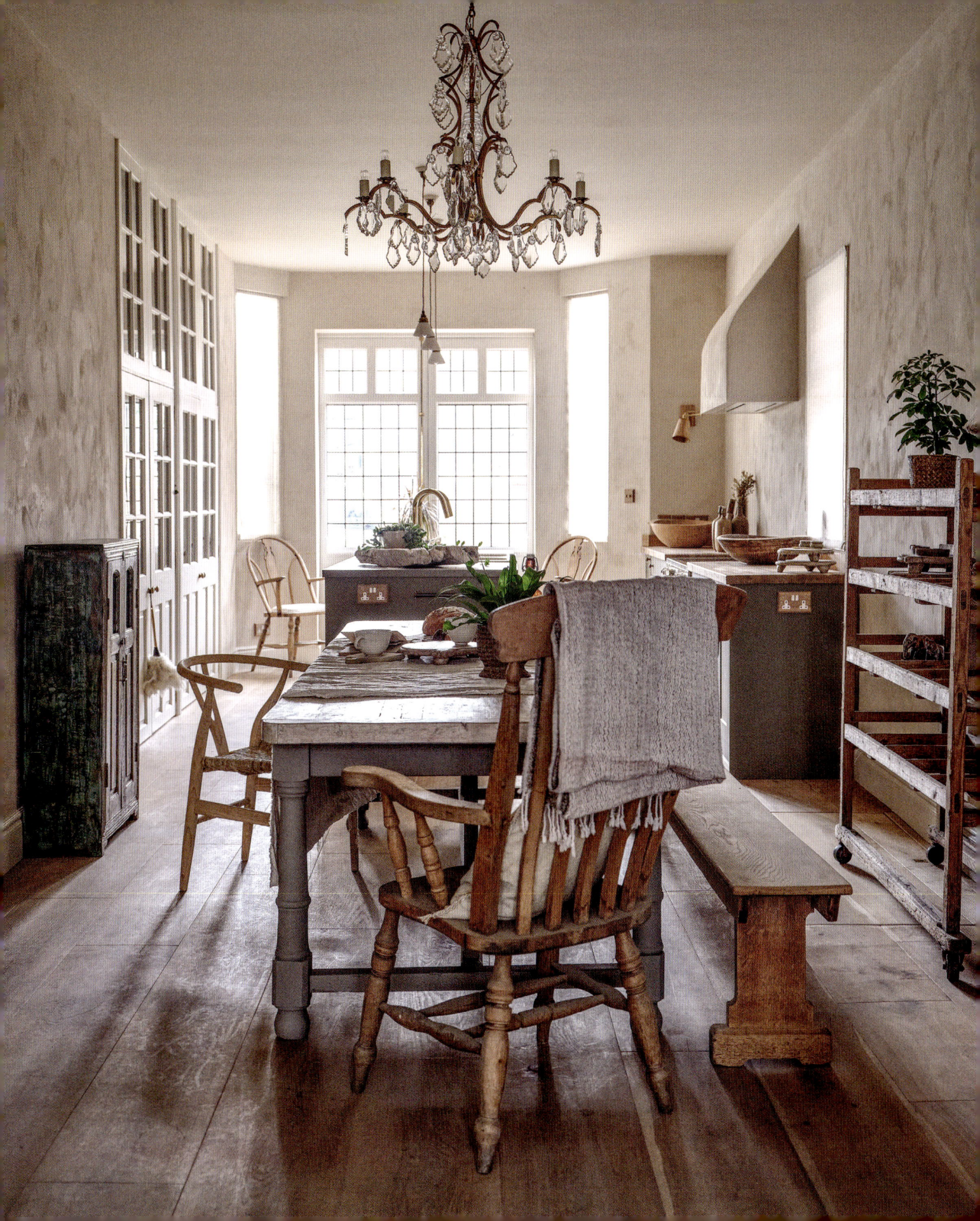

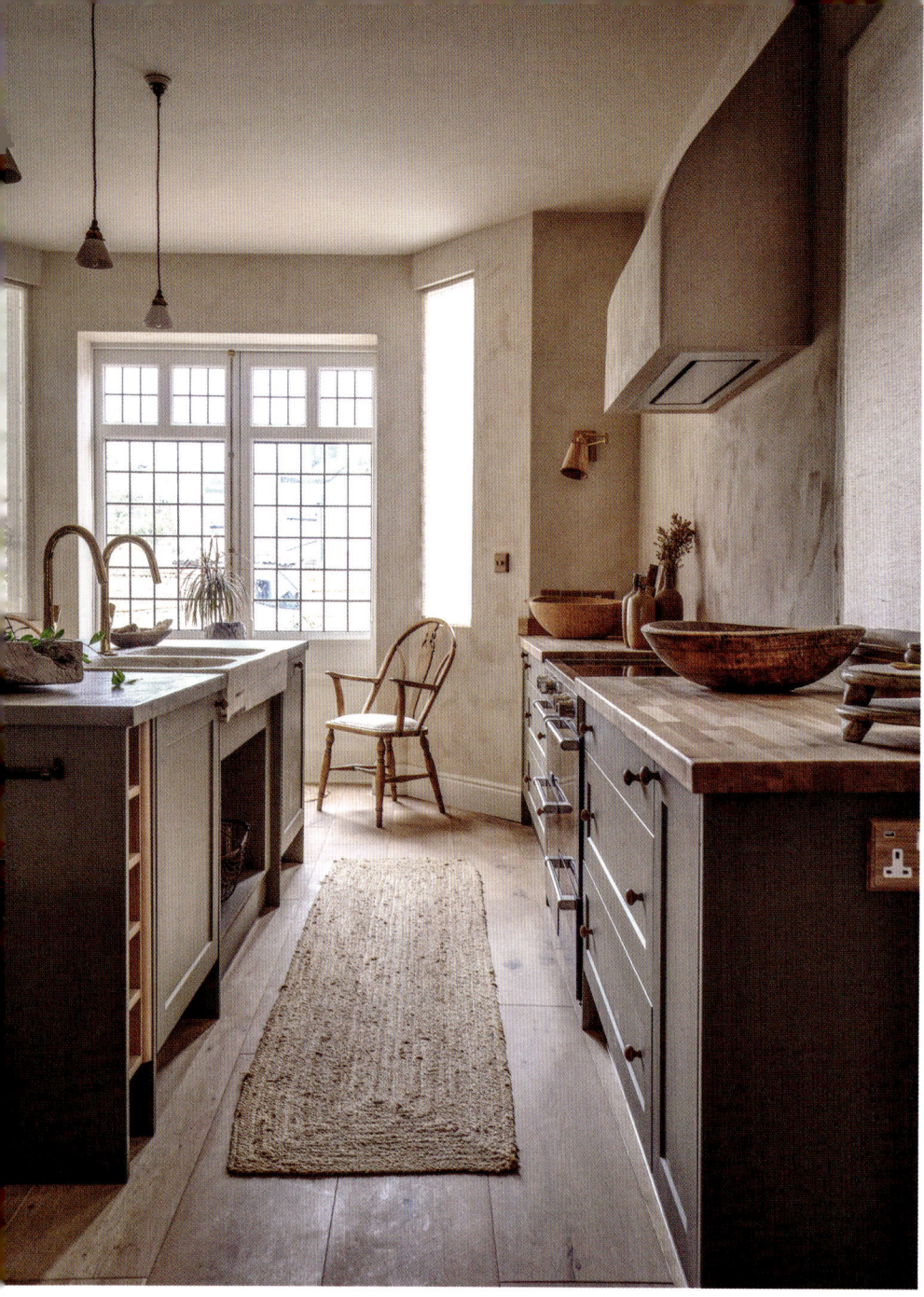

Organic variations in pigment tell the story of how these materials came into being. The grain of timber reflects the environment in which it was formed, and the same is true of strata or veining in rock and the sun bleaching of grass and other fibres when they were threshed and dried. These shades are unique and intrinsic to the character of each material and they bring their natural beauty to Alex's interior schemes.

A powdery matt finish prevails on surfaces as the main backdrop for Alex's belongings. Lending a cosy, textural touch, the uneven muted materials are warm and tactile, inviting moments of physical connection and bringing a tender quality to the room. As a foil to this, there are considered elements of shine and polished patina in the form of antiqued brushed and polished brass hardware. Like treasured trinkets, these burnished surfaces offer a soft and metallic glimmer and glow as they catch the light.

Alex has tapped into colour changes to enhance the flow of the home. Beyond the practical considerations of layout, she has used her palette to heighten the experience of moving from one room to the next. There is a romantic journey that unfolds through gradually revealed views and thresholds, crafted with a keen awareness of light and shade.

ABOVE
A galley kitchen and central island make the best use of the narrow room and maximize storage space. Hard surfaces are softened with textural plasterwork and rustic runners. The trio of pendants over the island is from Pooky with shades from Lighting By Stacie.

OPPOSITE BELOW
A kitchen corner is a backdrop to a collection of wooden finds and fittings. Bare timber features on kitchenalia such as chopping/cutting boards and a large bowl. Alex even sourced a wooden wall light to belong to the group. The warmth of the material sits well with the bare plaster walls and stoneware bottles.

 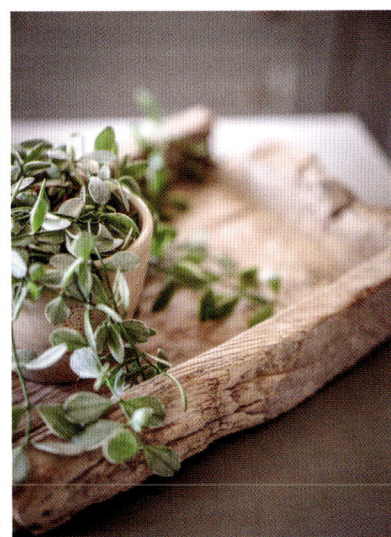 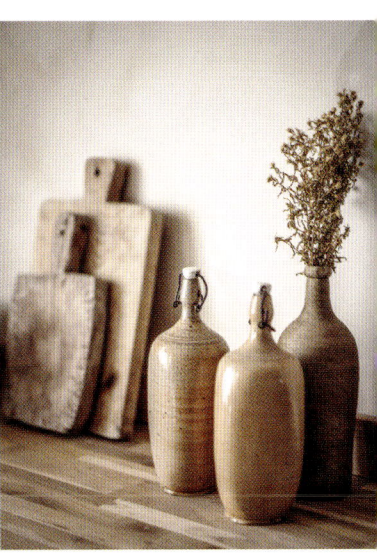

ABOVE LEFT TO RIGHT
Browsing boot fairs/yard sales, markets and retail stores at home and abroad, Alex has gathered homewares from familiar and far-flung corners of the world. Celebrating different cultures, crafts and textures, these items unite form and function. A particular find is the artisan-style brass tap/faucet from high-street store Wren Kitchens, which gives the impression of designer detailing when paired with a vintage marble sink.

'Lending a cosy, textural touch, the uneven muted materials are warm and tactile, inviting moments of physical connection.'

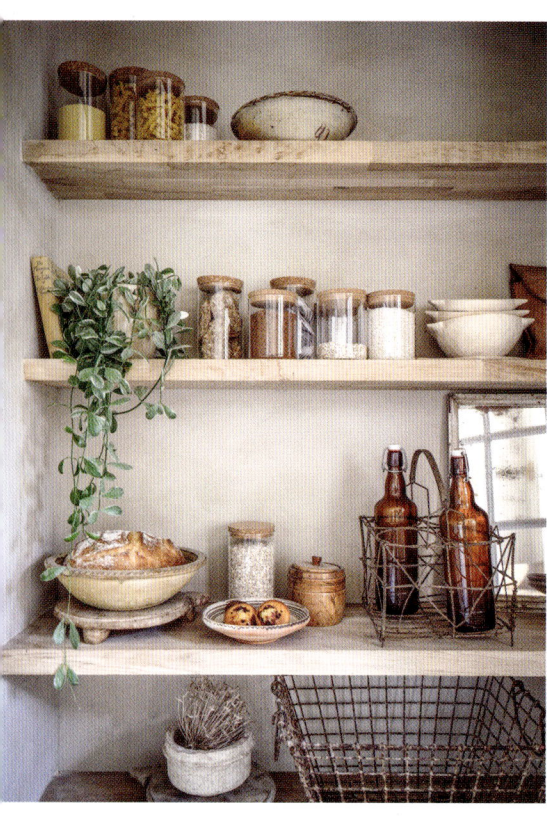

LEFT
Alex has installed a larder cupboard with raw plank shelving behind a run of glazed doors. Dry ingredients have been decanted into glass jars with wooden lids, which integrate sublimely with vintage bottles and crates.

BELOW LEFT
A side window is given privacy and screening with a subtle stretched voile. Neatly trimmed to fit the frame, it softens daylight and obscures the views indoors and out.

BELOW
The reclaimed columns in this open archway bring an architectural aspect and an element of surprise. They divide the room and mark the passage between two spaces. Alex added an urn of oversized seedheads to mix up the decor.

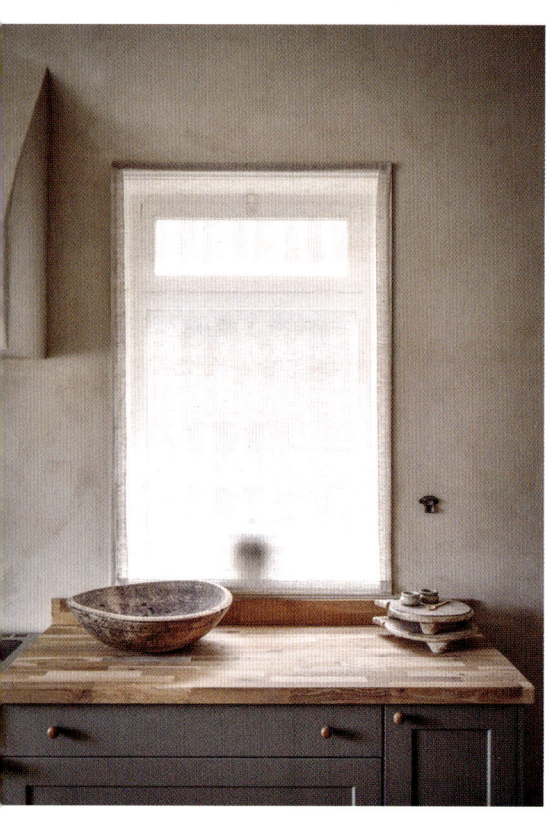

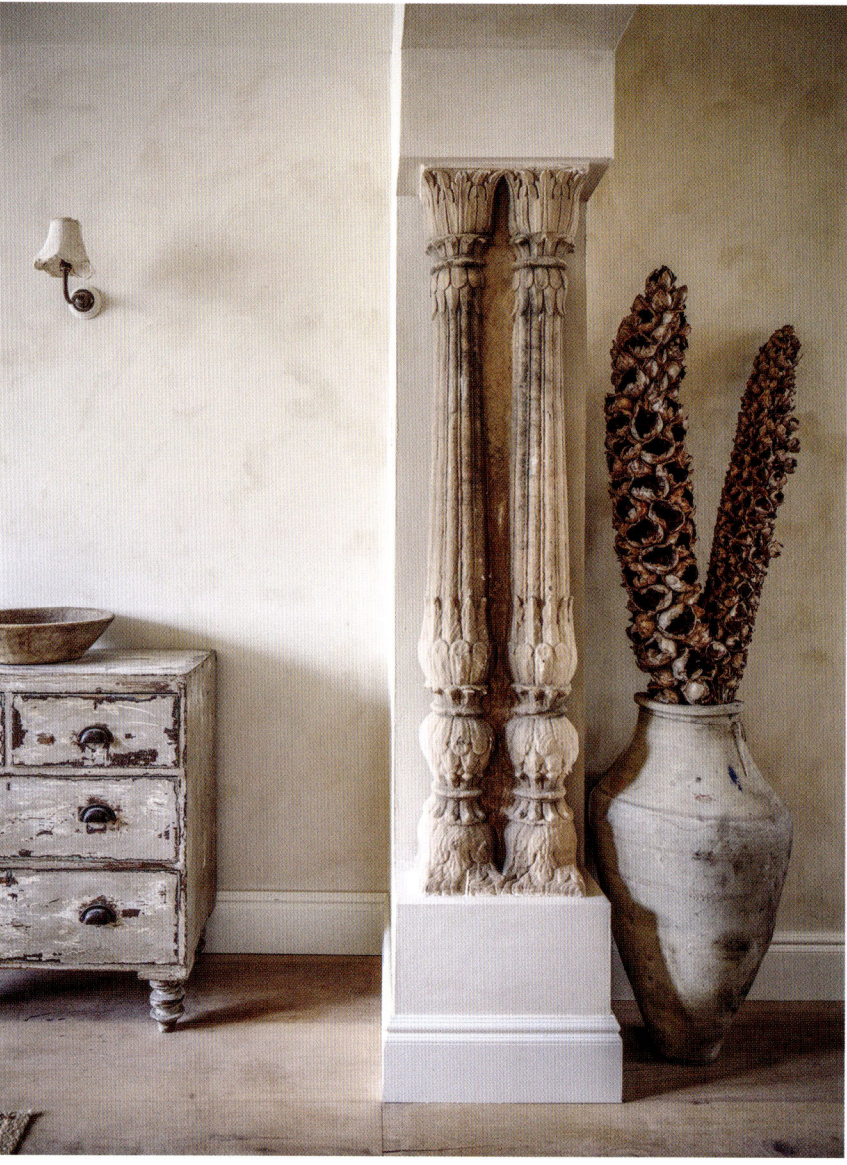

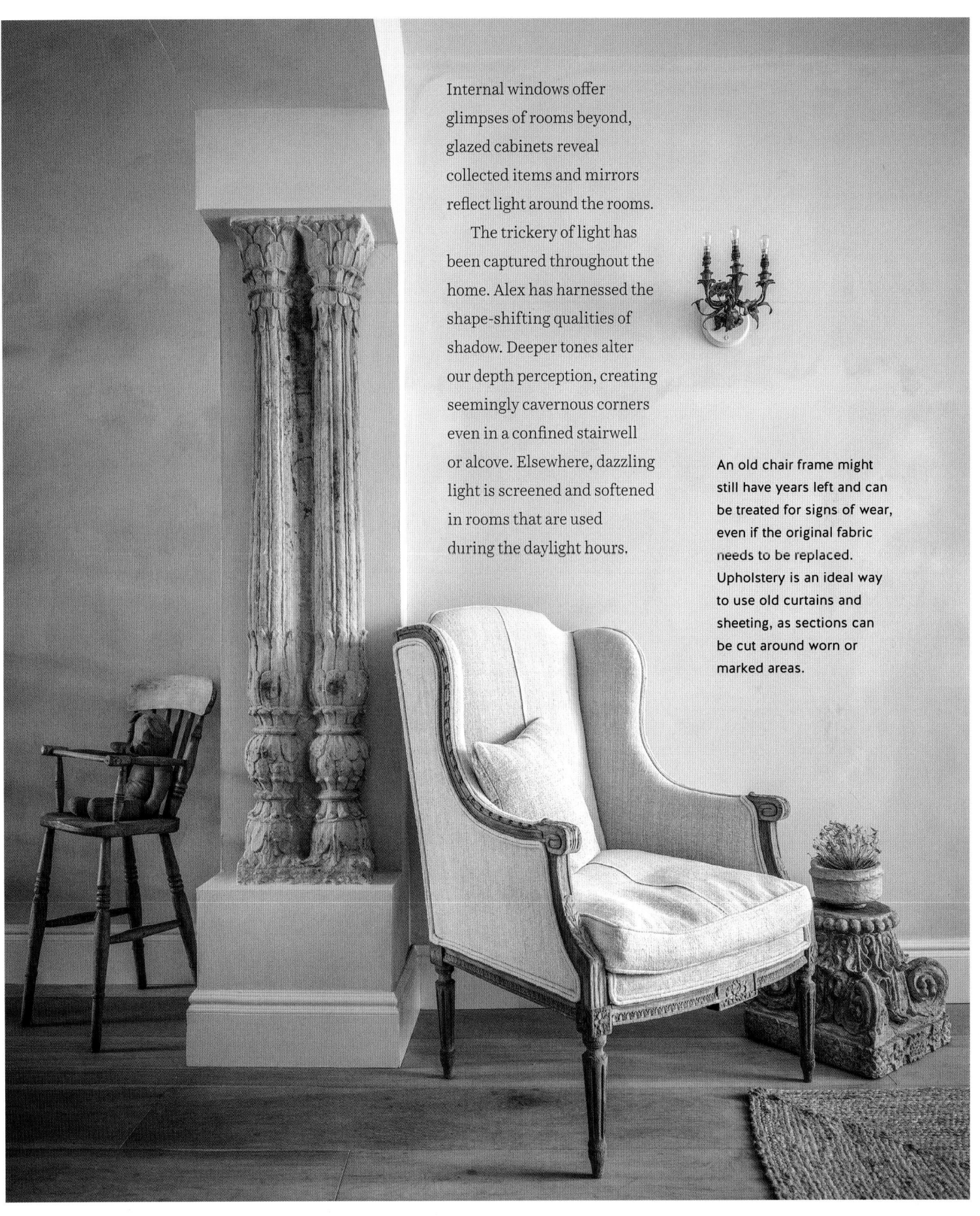

Internal windows offer glimpses of rooms beyond, glazed cabinets reveal collected items and mirrors reflect light around the rooms.

The trickery of light has been captured throughout the home. Alex has harnessed the shape-shifting qualities of shadow. Deeper tones alter our depth perception, creating seemingly cavernous corners even in a confined stairwell or alcove. Elsewhere, dazzling light is screened and softened in rooms that are used during the daylight hours.

An old chair frame might still have years left and can be treated for signs of wear, even if the original fabric needs to be replaced. Upholstery is an ideal way to use old curtains and sheeting, as sections can be cut around worn or marked areas.

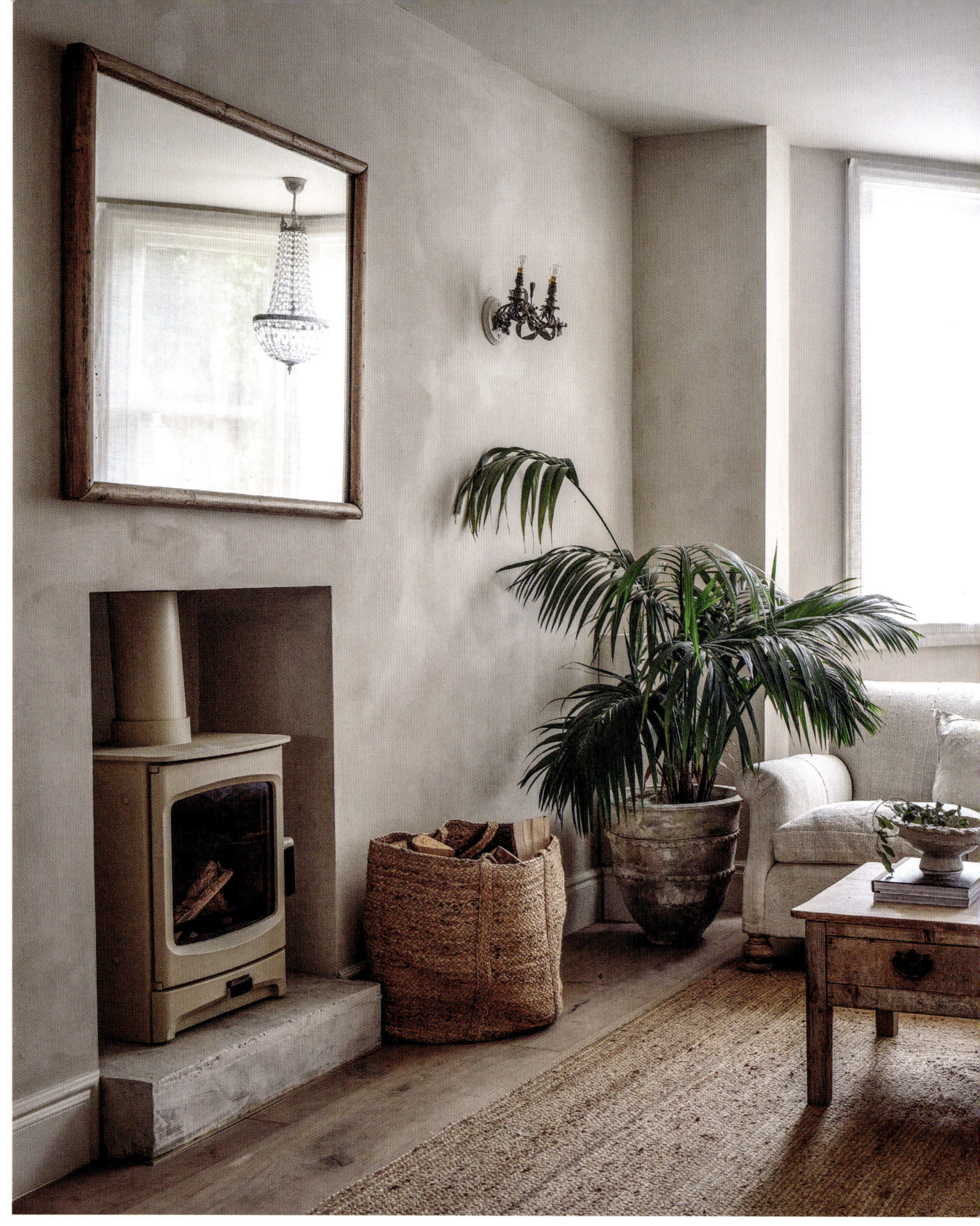

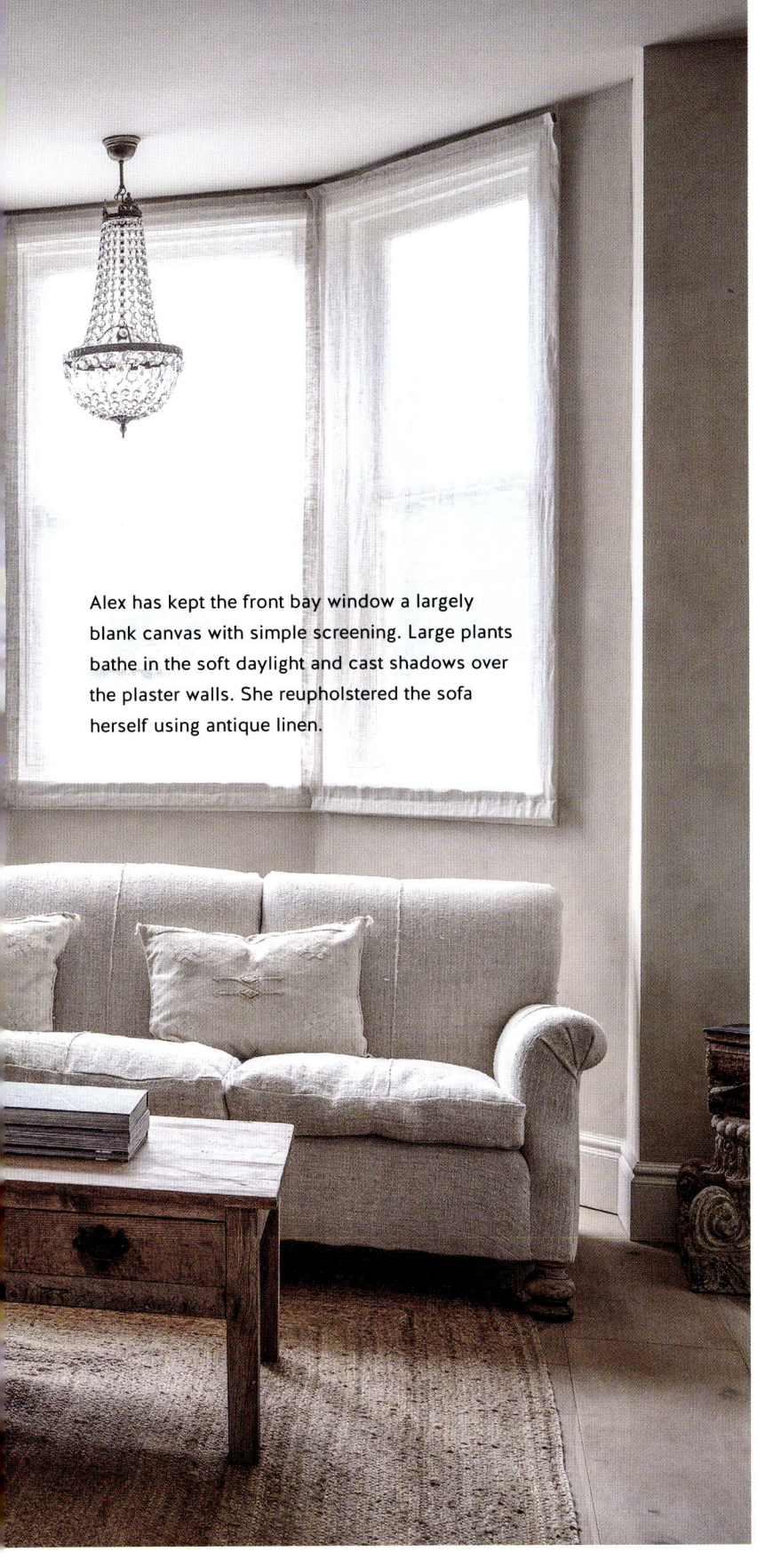

Alex has kept the front bay window a largely blank canvas with simple screening. Large plants bathe in the soft daylight and cast shadows over the plaster walls. She reupholstered the sofa herself using antique linen.

The sun shifts along the skyline as the seasons change, dipping low in winter and offering high contrast in the summer months. The natural light traces across the walls and surfaces, highlighting uneven plaster, hewn woodwork and rumpled textiles.

The first to admit that she is a hoarder of homewares, Alex has a long-time commitment to sustainable styling with reclaimed materials and one-of-a-kind antiques. Reusing and repurposing existing items is an uplifting experience, with joy to be found in the discovery of new-to-her buys and the occasional bric-a-brac given to her for free. She buys what she loves and keeps pieces in mind for future projects, with the result that all kinds of curiosities from different cultures and historical eras frequently find their way into her schemes.

Alex has been resourceful and mindful of her environmental footprint when sourcing pieces for her home. In particular, she is always looking out for well-crafted pieces that have seen many years of daily use. Their maker's markings, patinas and variations in colour are valued just as much as their shapely forms. Surfaces are chiselled and notched, scored and sculpted, often with kiln-fired finishes, pigment washes or oiled and waxed details. Transformed by the passage of time and continuing to evolve for as long as it is handled and cherished, each of these pieces comes with its own history of use and reuse.

Taking her time to form a scheme for each room, Alex set about curating a collection of interior ingredients, always keeping her preferred palette in mind. These elements were accumulated gradually, with newly acquired objects integrated seamlessly into the mix.

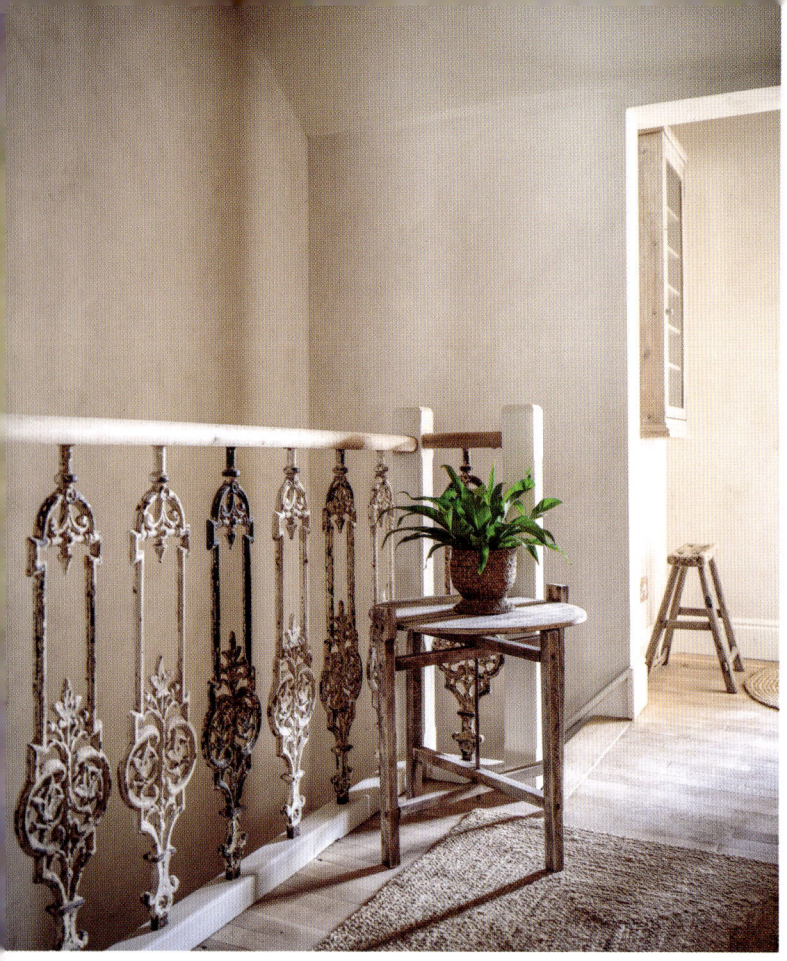
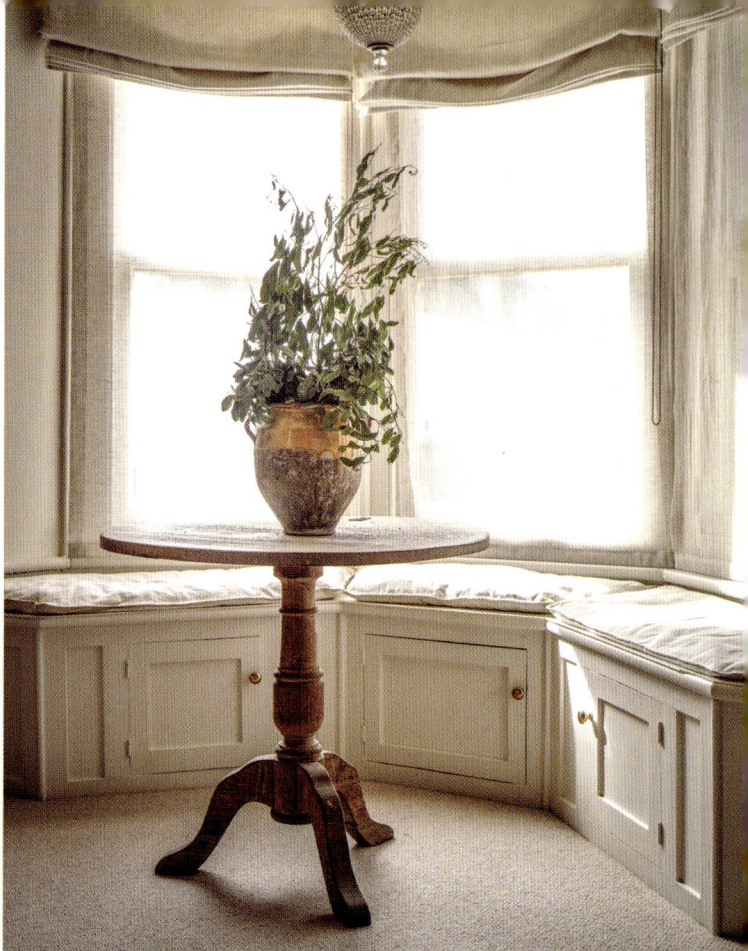
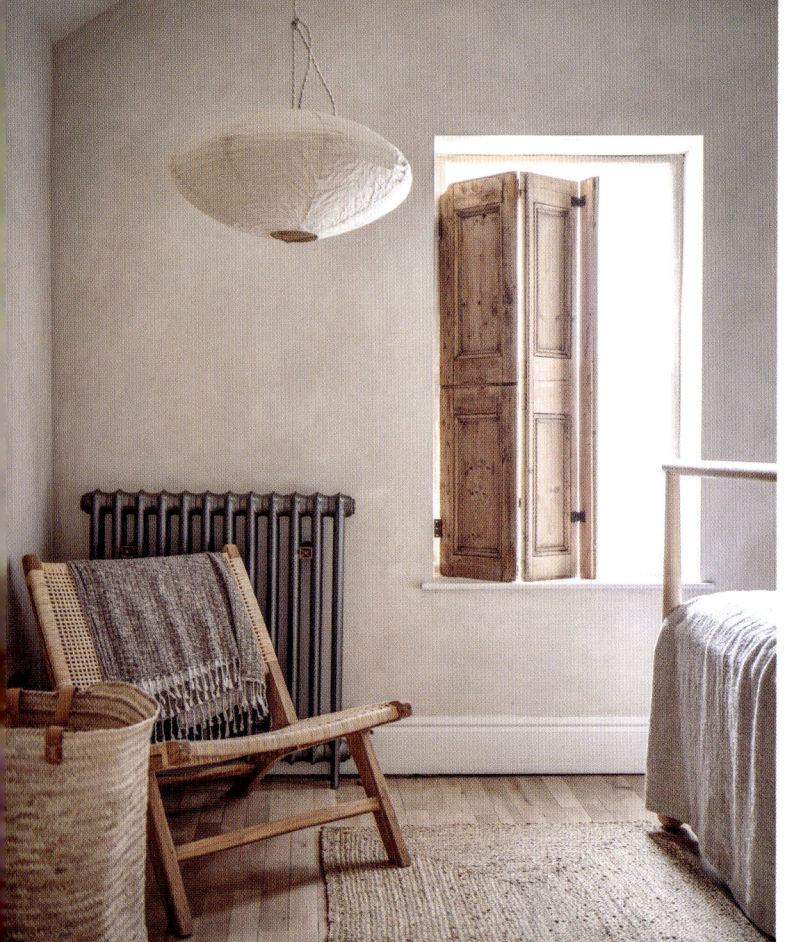

ABOVE LEFT
Upstairs, daylight filters through these elegant filigree spindles on the landing to reach the rooms at ground level. It picks up the gentle peach plaster tones as it trails and adds a change to the repeating shades.

LEFT
Natural tones feature in the materials and fittings of this bedroom. Rattan, wood and paper sit effortlessly sit against walls painted with limewash from Bauwerk Colour. The reclaimed shutter makes a humble appearance.

ABOVE
The softly draped roman blinds/shades in the bedroom were made by Julie Adams Curtains. They are heavier than the voiles used downstairs, for more effective screening of the light. The pedestal table is one of Alex's favourite items brought from her previous home, and the round shape sits perfectly in the bay window.

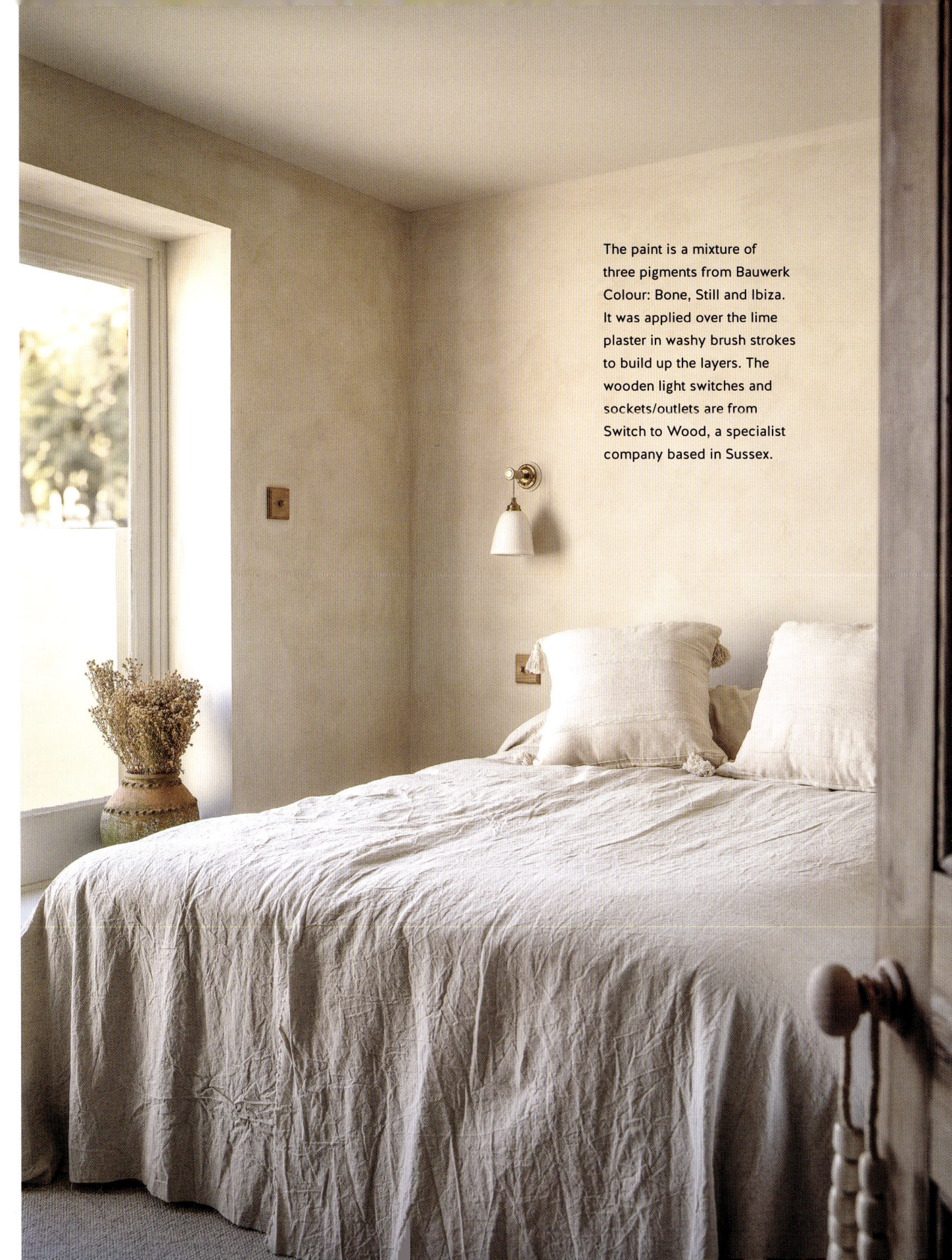

The paint is a mixture of three pigments from Bauwerk Colour: Bone, Still and Ibiza. It was applied over the lime plaster in washy brush strokes to build up the layers. The wooden light switches and sockets/outlets are from Switch to Wood, a specialist company based in Sussex.

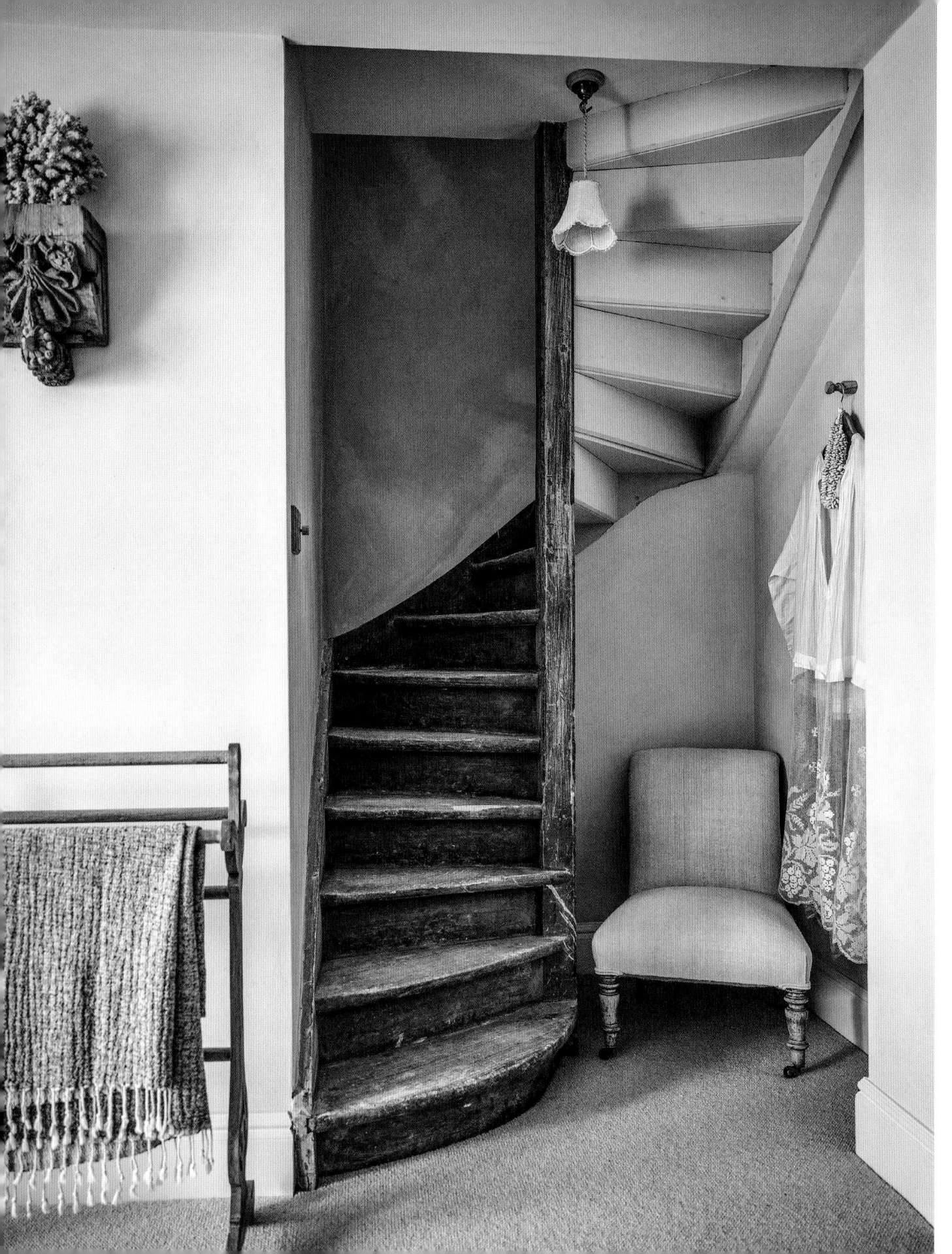

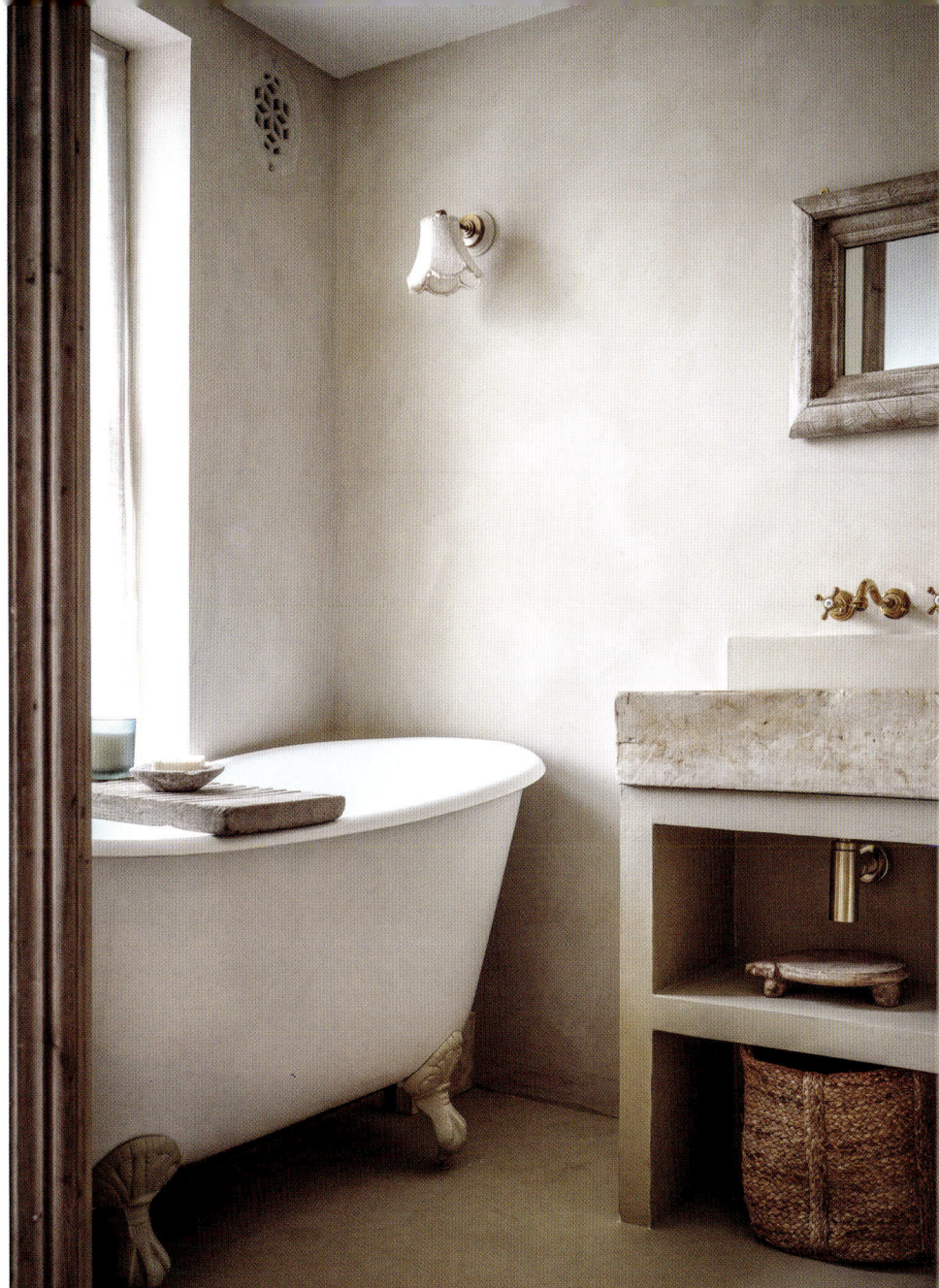

OPPOSITE
Alex has a collection of fixtures from architectural reclamation yards waiting for the right place to be used. One example is this staircase from French Loft Antiques in Arundel, which is beautifully shaped with period proportions. It has finally found its new home leading upwards from the bedroom to a newly carved-out loft space.

LEFT
A small ultra-deep bathtub was sourced to fit along a narrow wall under the window with a wall light overhead. It is perfectly placed to watch the world go by during bath time.

Vernacular materials and market novelties alike have all found a place here. Old furniture has been reupholstered, linens stockpiled and assorted earthenware platters and bowls artfully arranged in stacks. Dry goods in the kitchen and soaps and salts in the bathroom are kept in glass vessels that reveal their innate colours and textures.

Foraged finds from nature are treasured just as much as artisan-made objects. Stones and pebbles are used alongside flowers and foliage, the latter arranged and seen in various life stages, from living plants to dried seedheads and preserved petals. The original vibrant shades gradually fade depending on their age and their position in the sunlight. Alex has sensitively used these found objects to express her unique sense of style in perfect harmony with her go-to hues. Above all, her home reflects her lifelong commitment to preserve the palette of the past.

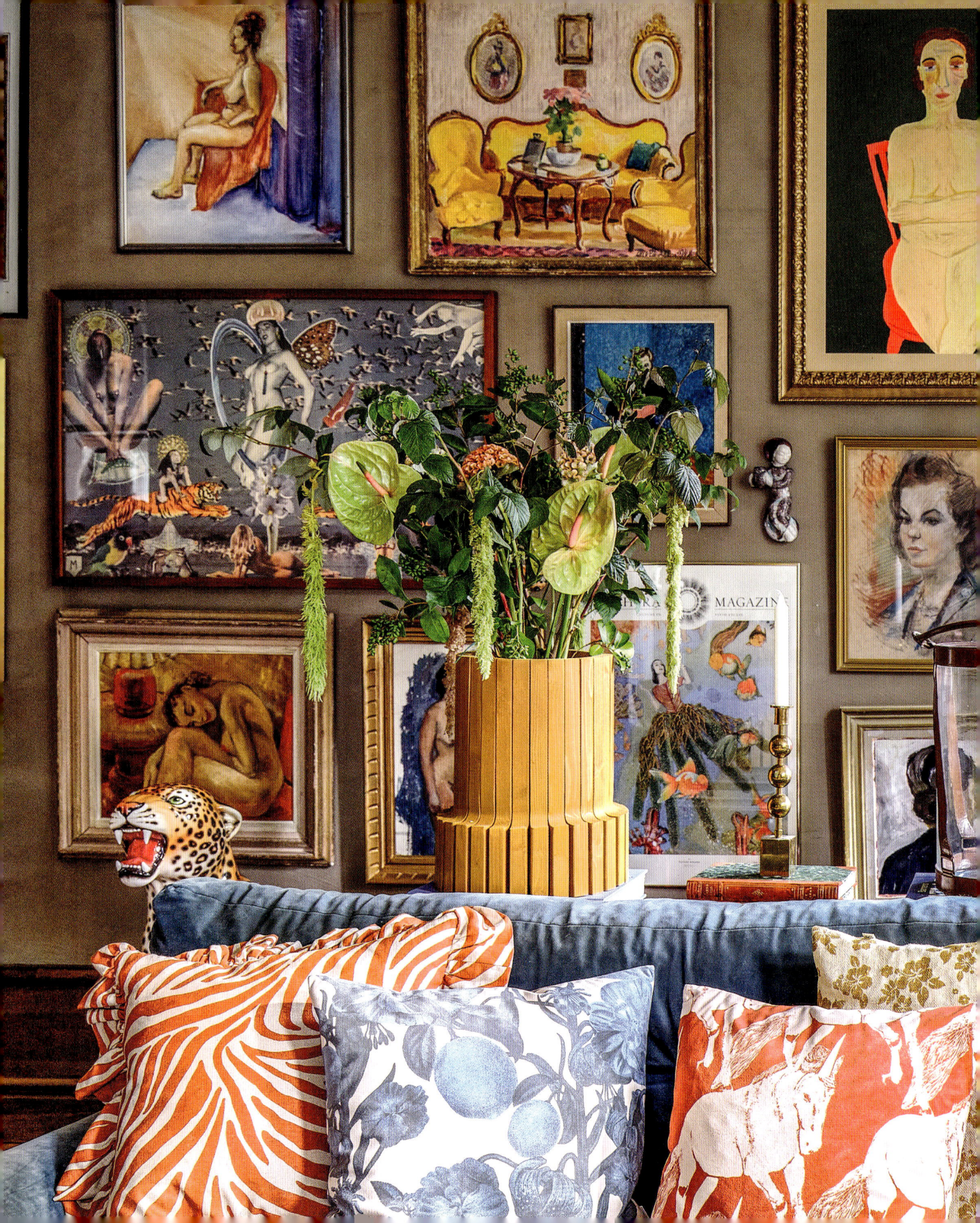

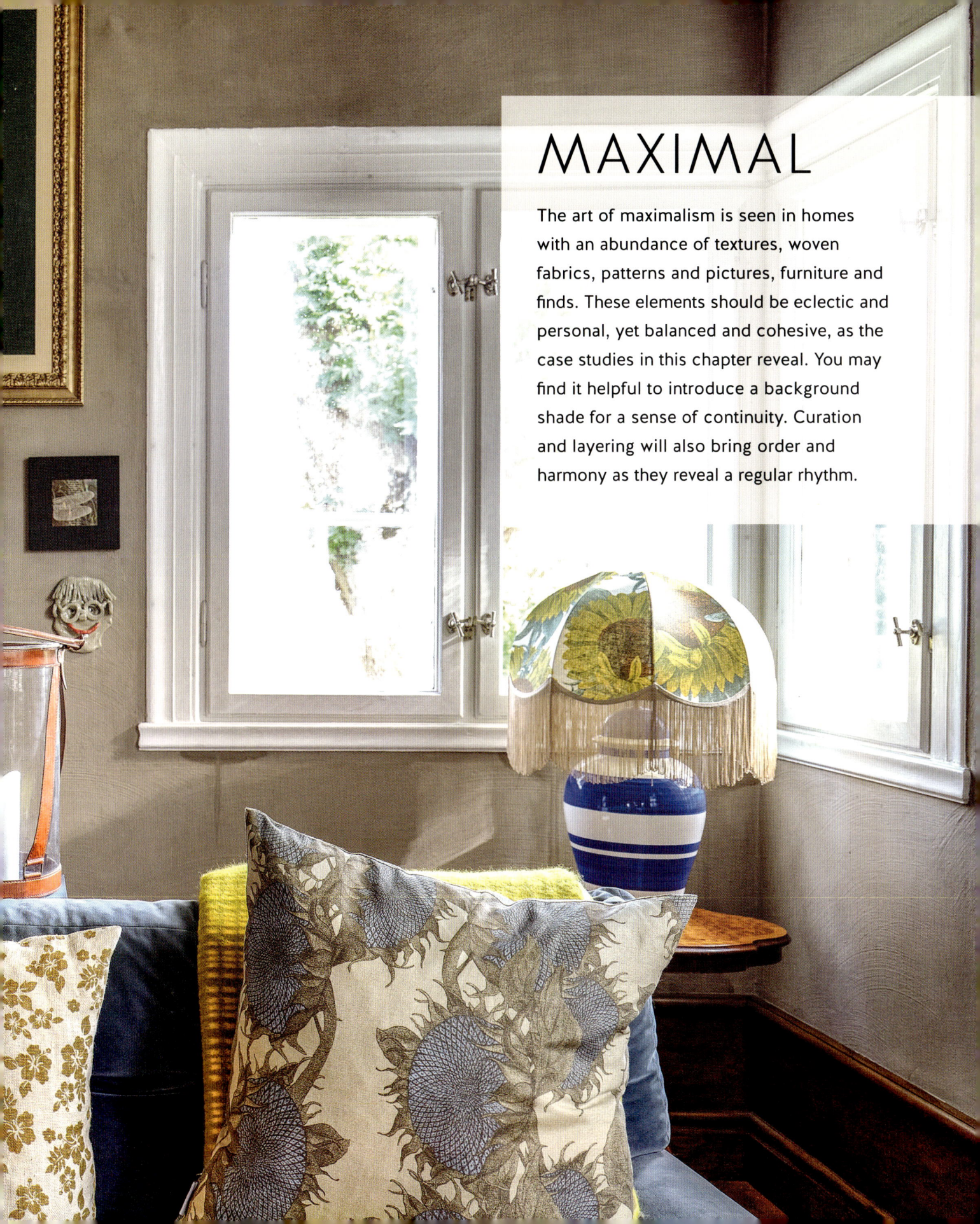

MAXIMAL

The art of maximalism is seen in homes with an abundance of textures, woven fabrics, patterns and pictures, furniture and finds. These elements should be eclectic and personal, yet balanced and cohesive, as the case studies in this chapter reveal. You may find it helpful to introduce a background shade for a sense of continuity. Curation and layering will also bring order and harmony as they reveal a regular rhythm.

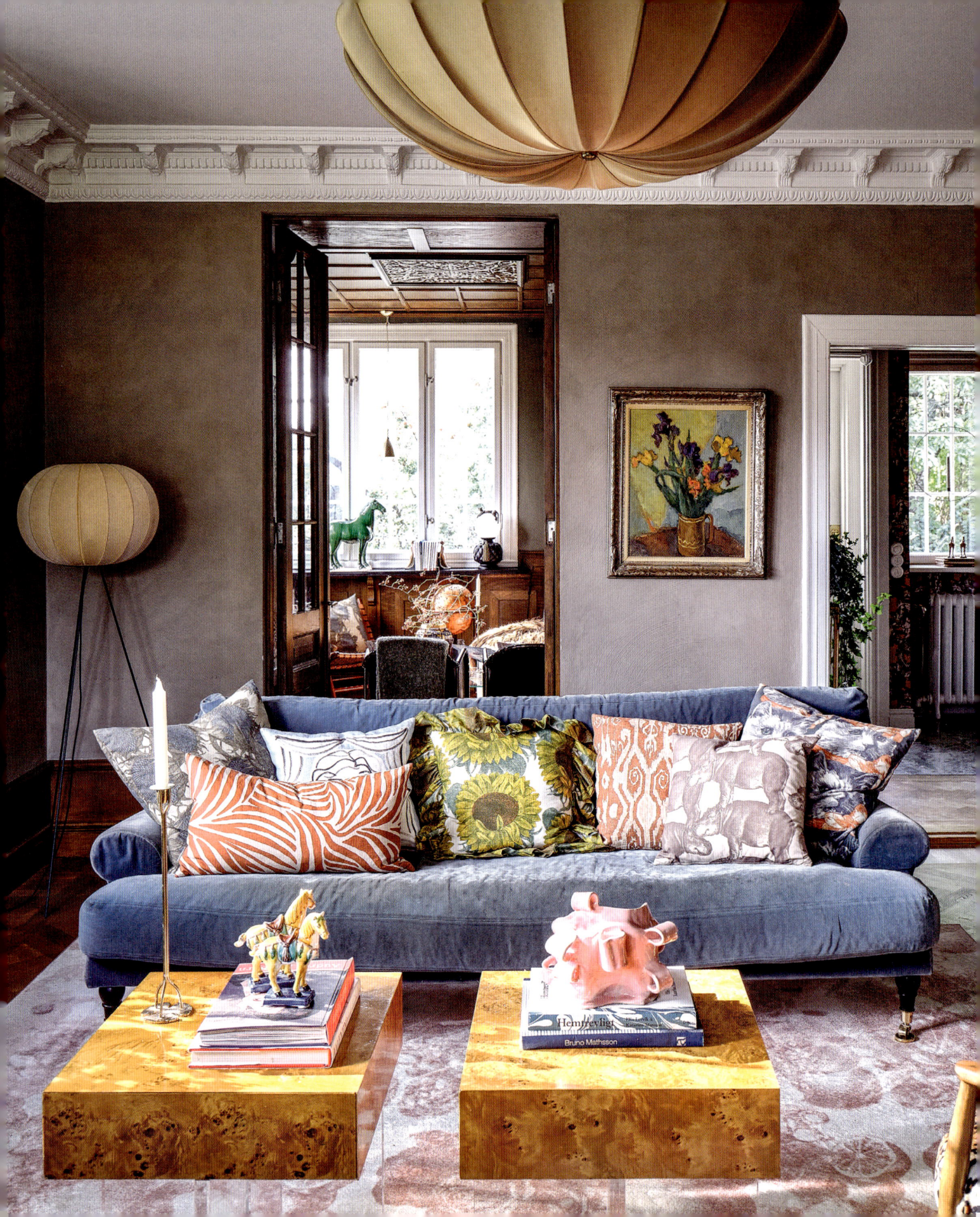

LIFE IN *colour*

With a head and heart firmly led by colour, Swedish designer Lisa Bengtsson has created a joyful home in Stockholm. Alive with multiple layers of shades adorning every surface, it is an expressive and inspiring sanctuary where Lisa and her family feel a sense of belonging.

OPPOSITE & BELOW
Loading pattern on pattern, the living room is a lively setting with printed textiles, a woven rug and painterly artworks. Burlwood tables from Jonathan Adler appear to float on acrylic legs. The Melimeli sofa has many cushions from Studio Lisa Bengtsson, including the Zoe, Hippo, Firenze, Vera and Sunday designs.

RIGHT
Lisa used her Sir Grace wallpaper in this small adjoining room. The bold and busy pattern features mustard and mulberry hues in a pattern of prancing horses.

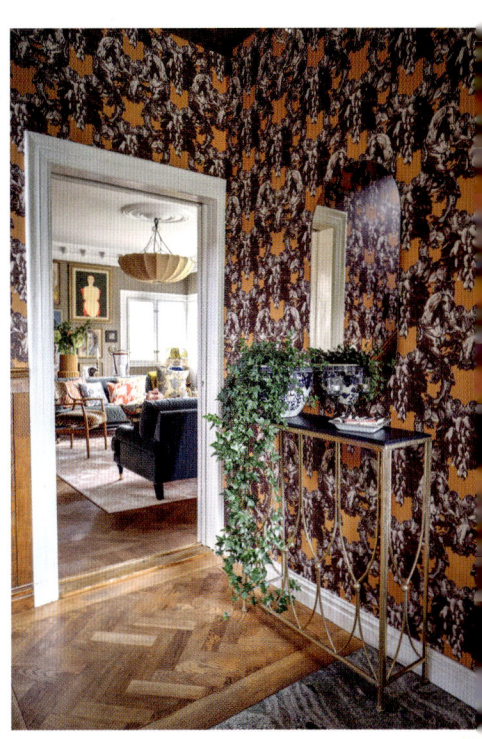

Originally trained as a graphic designer, Lisa has since turned her talents to homewares, textiles and wallpapers. Her homes over the years have always been colourful affairs, but it was buying a larger property that gave her a chance to envisage the potential of a bigger canvas for her creativity. Built in 1910, this historical home combines beautiful proportions, original features and generous light from many handsome windows, enabling her to play with colour on every contour.

Lisa has used a range of hues from floor to ceiling to make her home inviting for guests and loved ones alike, dipping into her artist's palette to find unexpected combinations. Each area has been built up with daubs and brushstrokes, like an Impressionist or Pointillist painting. This tailor-made use of colour has allowed her to find the perfect balance of daring and delicate hues around her home. Large expanses of colour on walls and furniture are tempered by carefully chosen textiles, pictures, plants and collected objects.

Having a house filled with every colour has not only freed Lisa from being tied to a specific palette, it has enabled her to introduce a diverse range of patterns; the only rule here is that there are no rules. Playful flora and fauna motifs have been layered on textiles and wallpaper, while personal collections add to the feeling of childlike wonder. The patterns reveal the family's adventurous character – their travels to different continents, interest in animals and particular love of Italy. The bold palette throughout their home recalls happy memories and encourages bravery and self-expression.

ABOVE LEFT TO RIGHT
Lisa has spent a long time accruing a collection of quirky oddments and objets. These colourful curiosities bring a hint of the unexpected and are sure to start a conversation. They are easy to move from room to room, so Lisa is able to shop from her home when she wants to make a change. Her collections are designed to clash and not match, allowing her to experiment with new combinations when restyling her home.

OPPOSITE
Antique and original features in the living room scheme include this inlaid display cabinet and traditional Swedish tiled stove. Sculptural and beautifully decorated, fireplaces in this style are a trademark of period homes here and would have been regarded as a marker of social status in the era when this house was constructed.

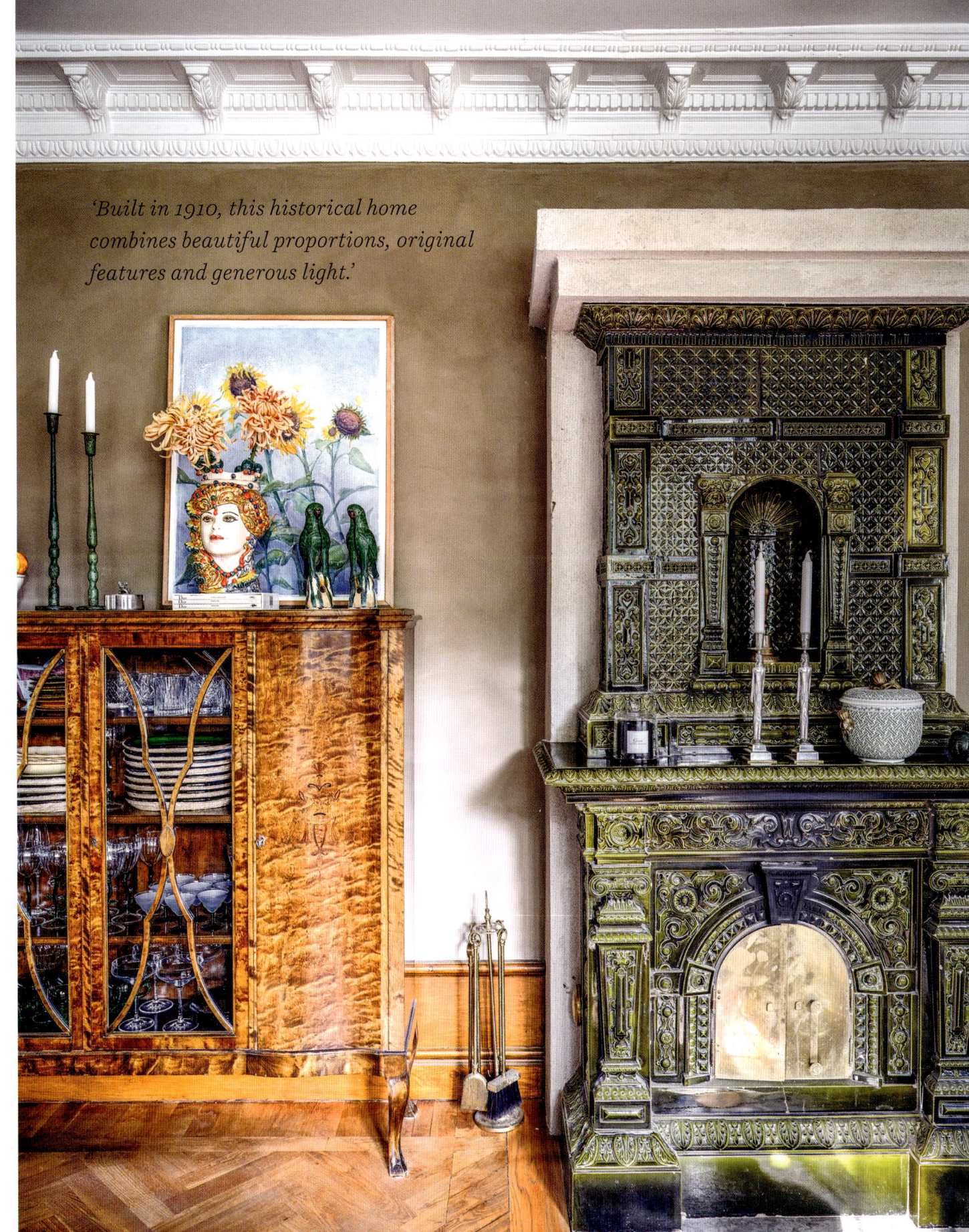

'Built in 1910, this historical home combines beautiful proportions, original features and generous light.'

RIGHT & BELOW

This intimate room at the front of the house is known as the library and is a favourite place for the family to gather. The walls are like a gallery with many paintings and pictures (right). Shelving has been built on one wall to frame the entrance to the living room with an archway of books (below).

BELOW RIGHT & OPPOSITE

Another doorway from the living room opens into the dining space (below right). This room features various takes on striped patterns, from a classic linear design on Lisa's Stripe Forward wallpaper to her Zoe tiger print on the tablecloth (opposite). The unusual glass pendant is from the Swedish lighting brand By Rydéns.

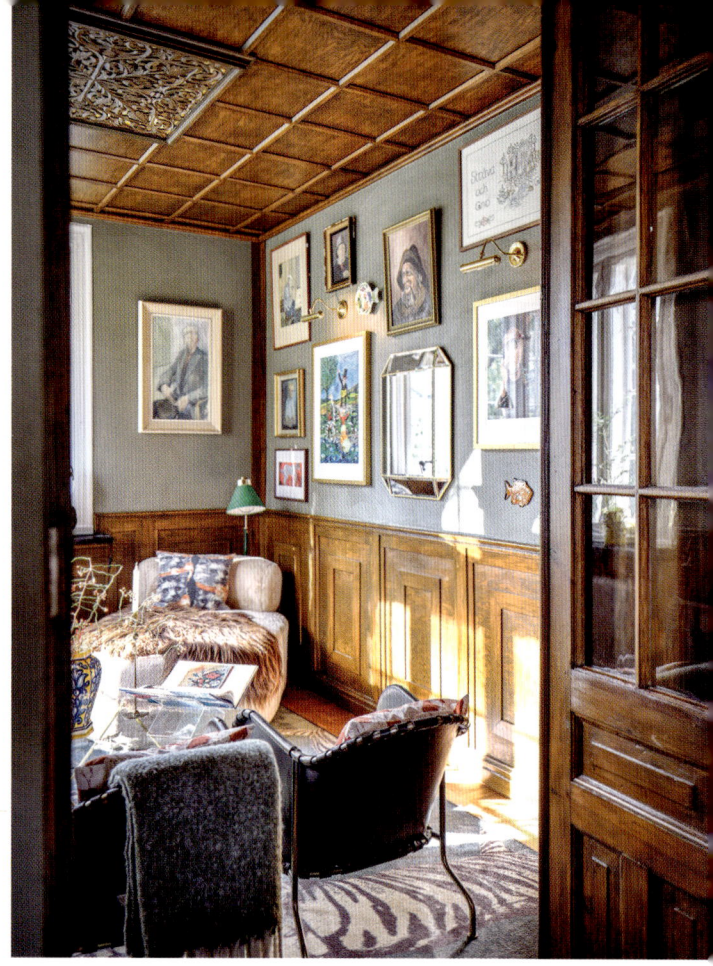

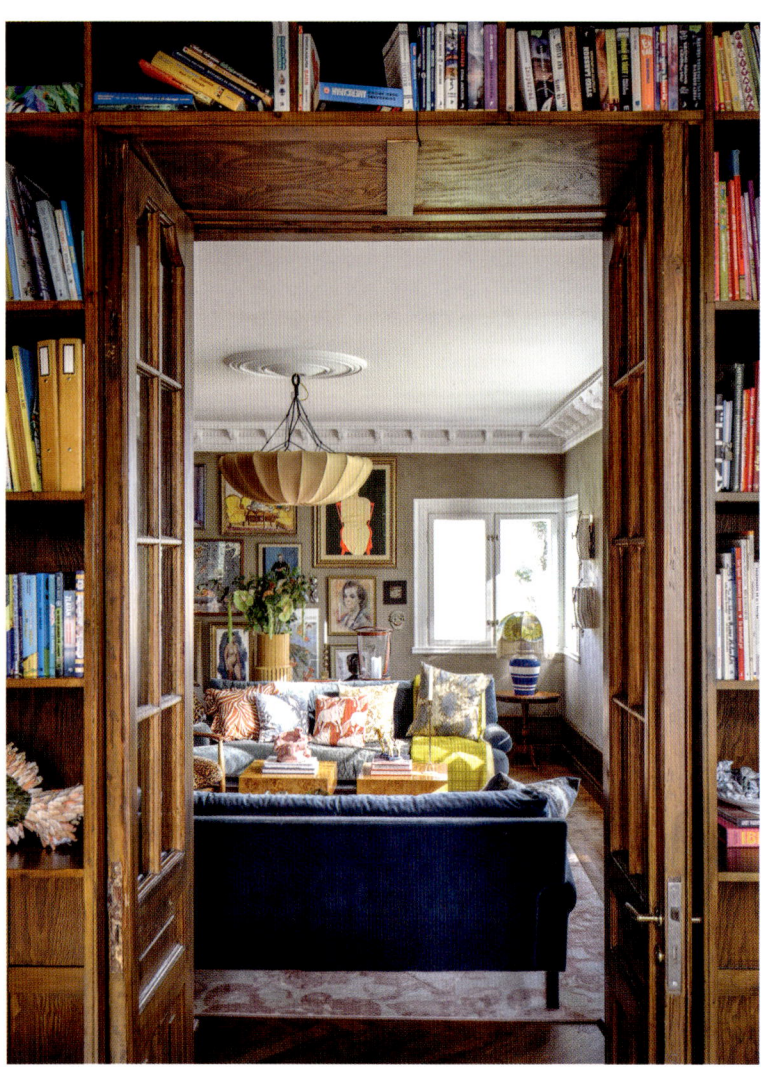

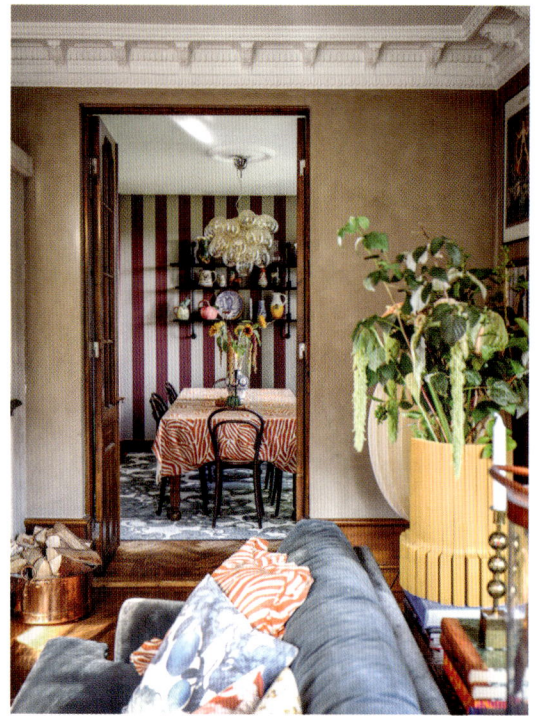

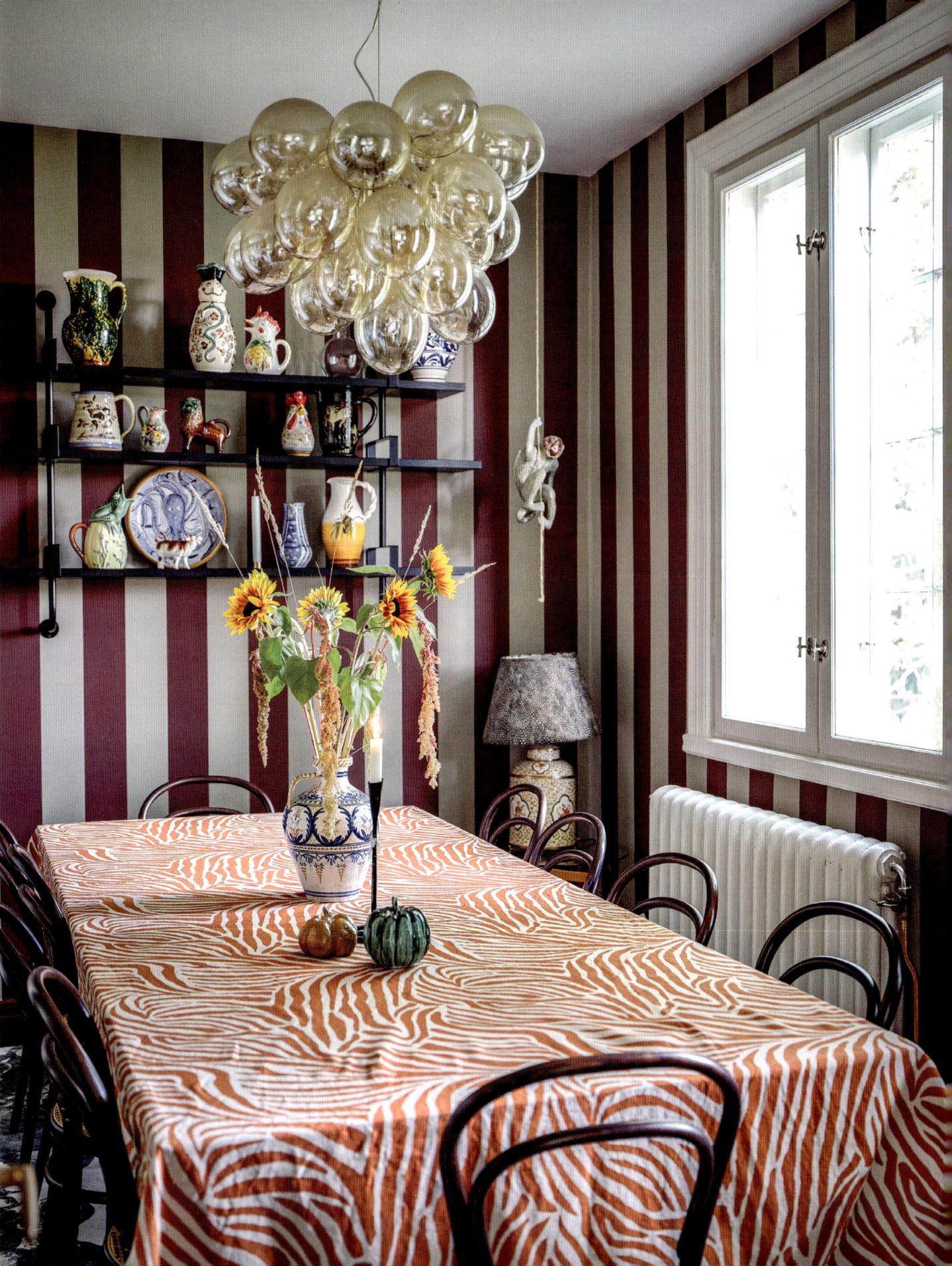

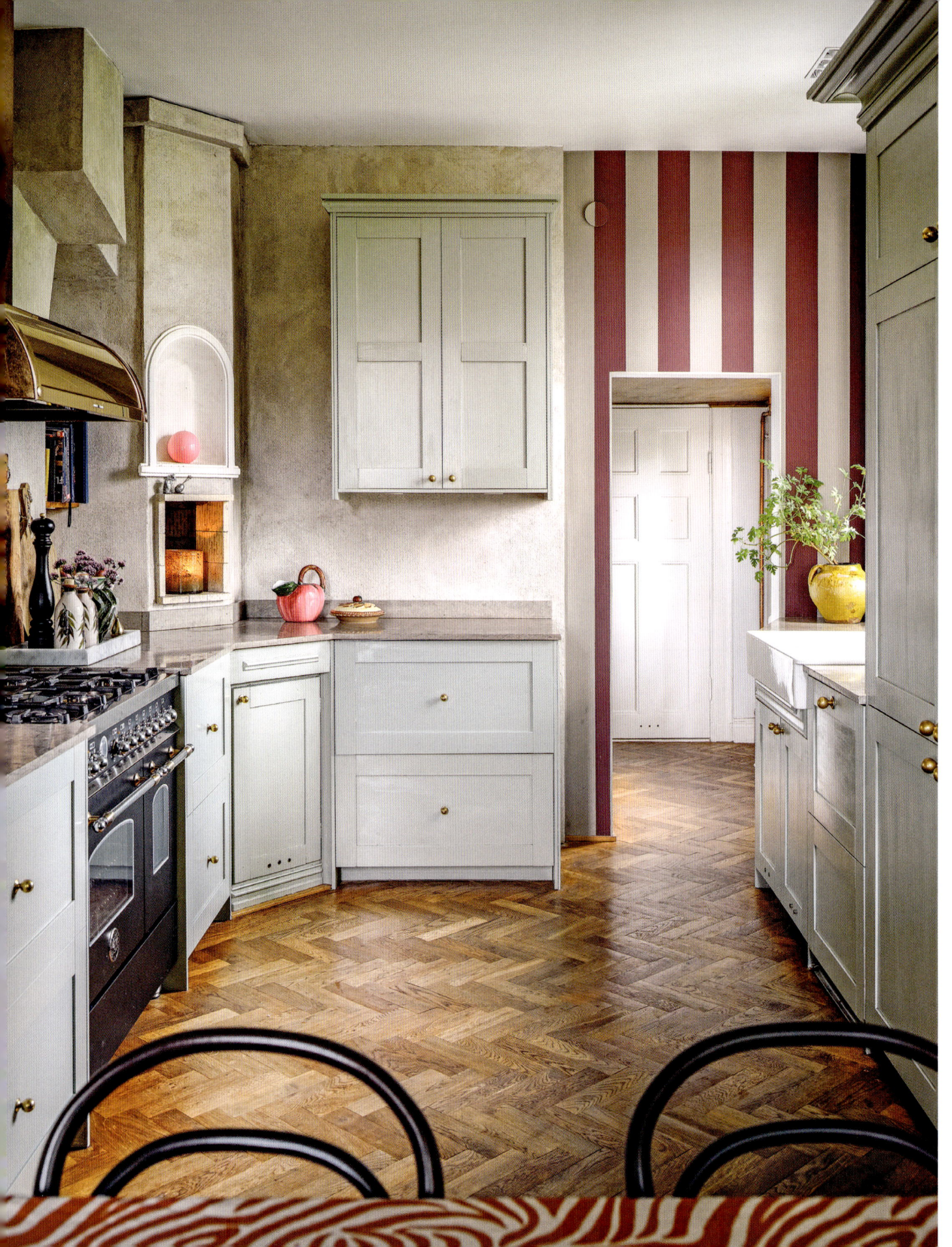

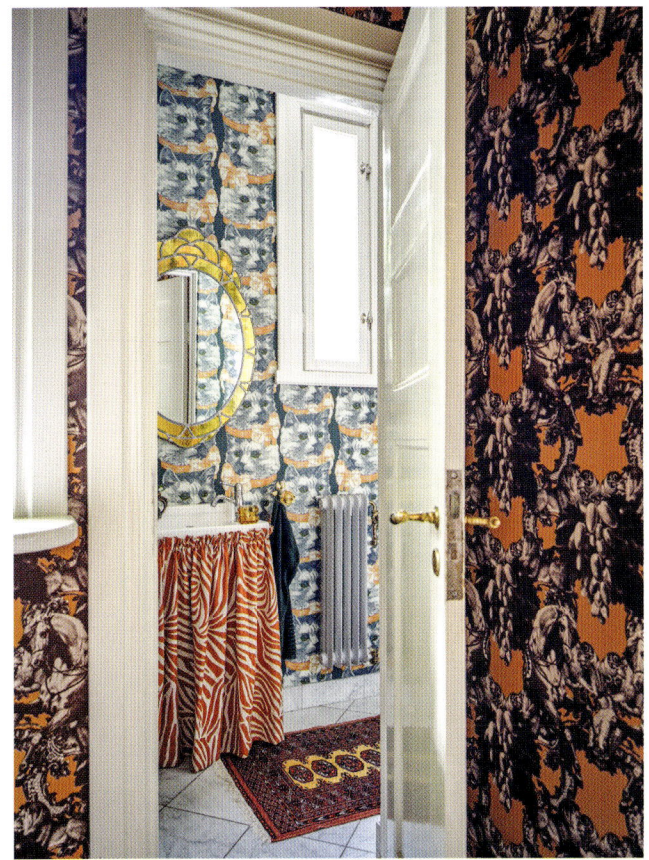 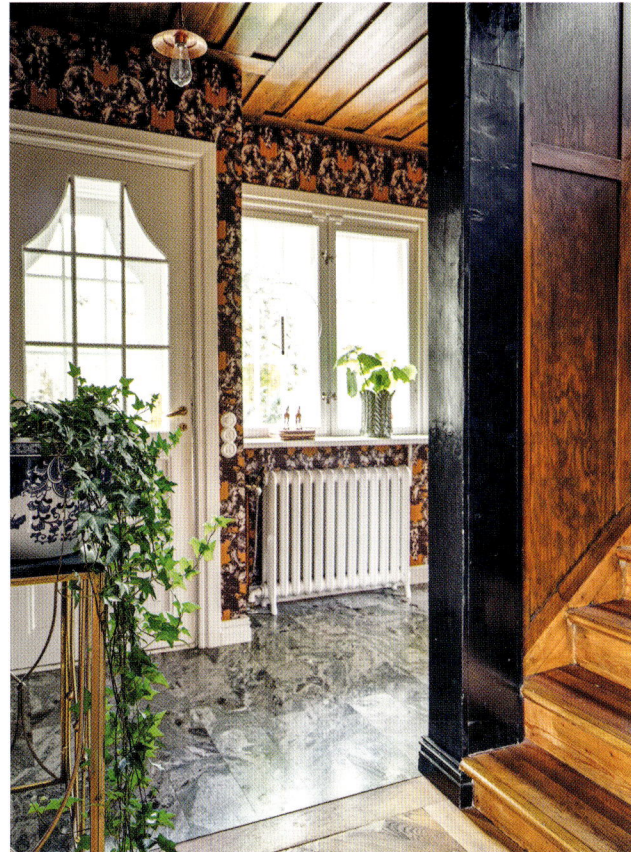

In many of the rooms, Lisa's initial plans for the decoration fell easily into place. However, it was always her intention for these schemes to be augmented and cultivated over time with the addition of further soft furnishings, pictures and ornaments. With this in mind, storage and display are built in so that artworks and objects can be added, moved and replaced with ease. A wall of female portraits faces out in the living area, ceramics and glassware on open shelving bring their shapes and colours to the dining room and well-loved books line the panelled walls of the library. These evolving vignettes create their own conversations and identity.

Just as colours are blended across the home to make a welcoming environment, textures play a part in bringing comfort and variety to the scheme. Lisa has brought together velvet, linen, wool, ceramic and wood in order to experience the full spectrum of shiny, matt, luxe and rough finishes. Tactile contrasts invite her visitors to explore and engage with the decor using all their senses.

OPPOSITE
The dining room is open to the kitchen, beyond which an anteroom repeats the former's striped wallpaper to link the spaces together. Plaster walls offer a hint of warmth in contrast to the cool tones of the painted cabinetry.

ABOVE LEFT
The smallest room is one of the most animated with colour and prints. Lisa brought together her Crazy Cat Lady wallpaper and Zoe fabric for a masterclass in combining blue, orange and berry tones.

ABOVE
Sir Grace wallpaper appears again to greet guests in the hallway. It is one of Lisa's most opulent designs and serves as a delightful way to set the scene and introduce the character of her home.

RIGHT
The majestic wallpaper from the downstairs hallway continues upstairs. More animal magic awaits at the top of the stairs with a fun leopard rug.

BELOW
A bespoke bedroom has been created for Lisa's daughter with Betty Pretty mural wallpaper in her favourite pink and plum tonal flowers. The Lou Lou pendant light is another of Lisa's designs.

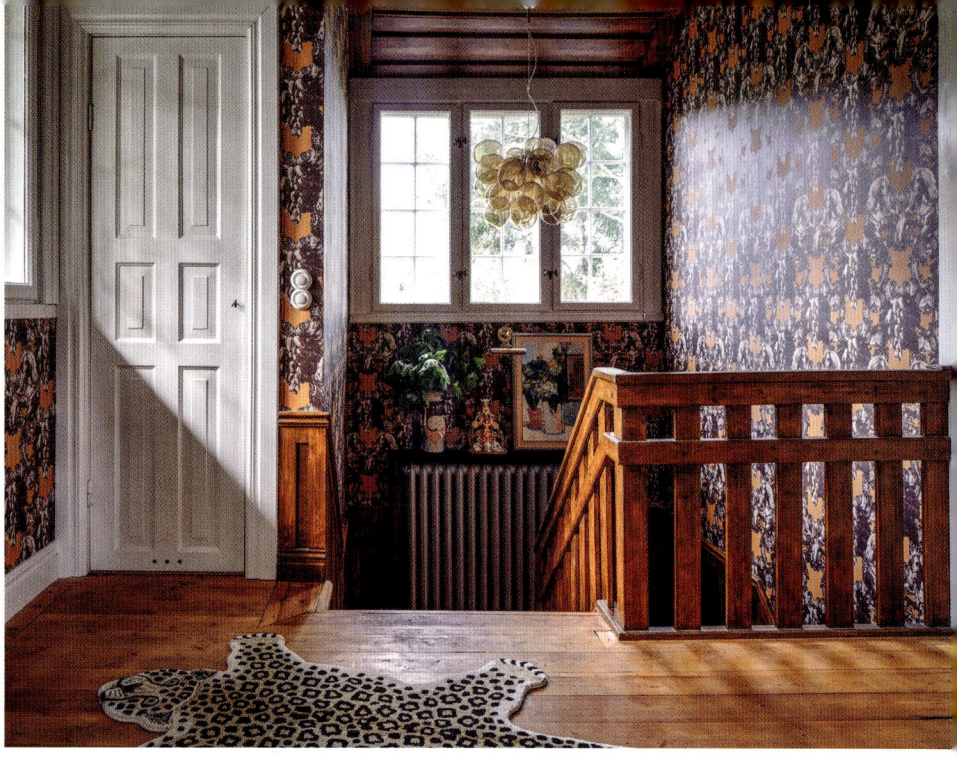

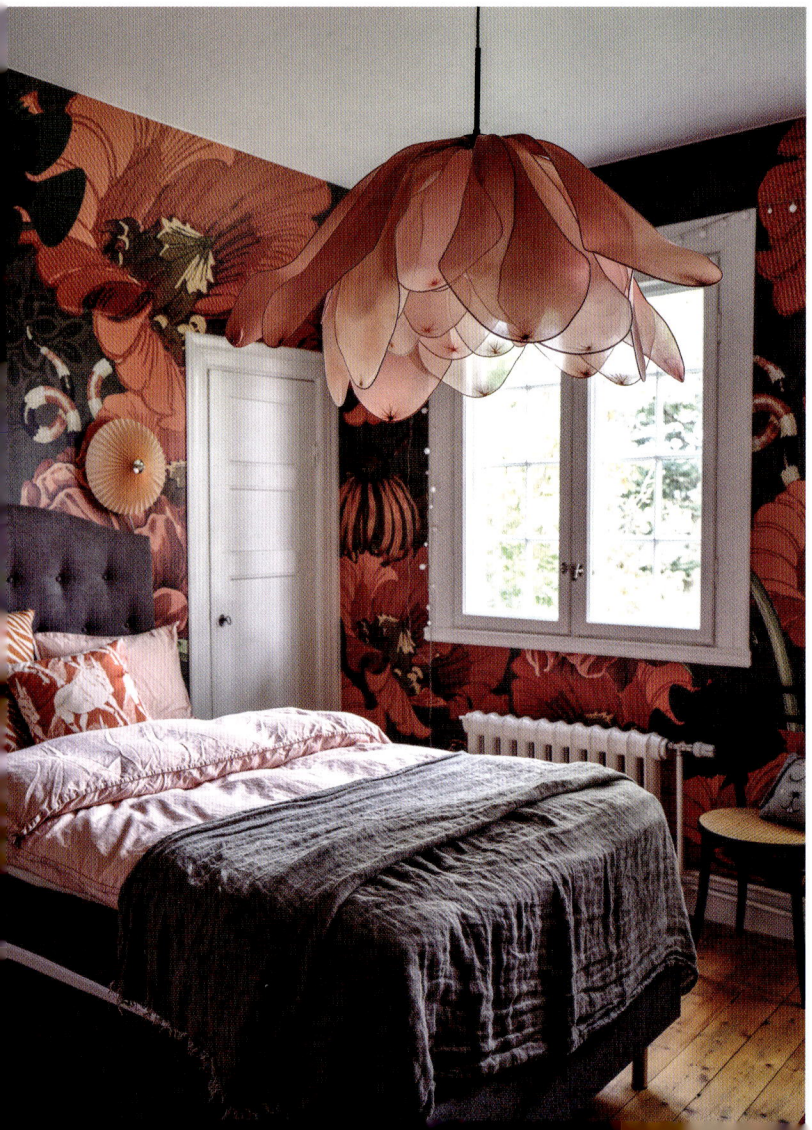

Understanding how colours interact with the seasons, Lisa has used her palette to pep up and energize her home. Living in a country that lacks a significant amount of natural daylight for many months at a time, she has tapped into the naturally occurring hues of the outdoor environment to bring warmth and boost the spirits during the low-lit winter months. In the depths of winter, when all is white and there is nothing growing outside, her home is filled with summery and revitalizing shades to counter the bleak and barren landscape. The nurturing hues in her home transport her to a season that makes her happy.

As colour helps with the flow from one room to the next, favourite rooms offer a change of pace and palette at different times of the day and year.

OPPOSITE
Lisa's son's bedroom in the attic features a wild and wavy wallpaper called Snake Peek, which creeps up the walls and onto the sloped ceiling for a cosy, enveloping feel.

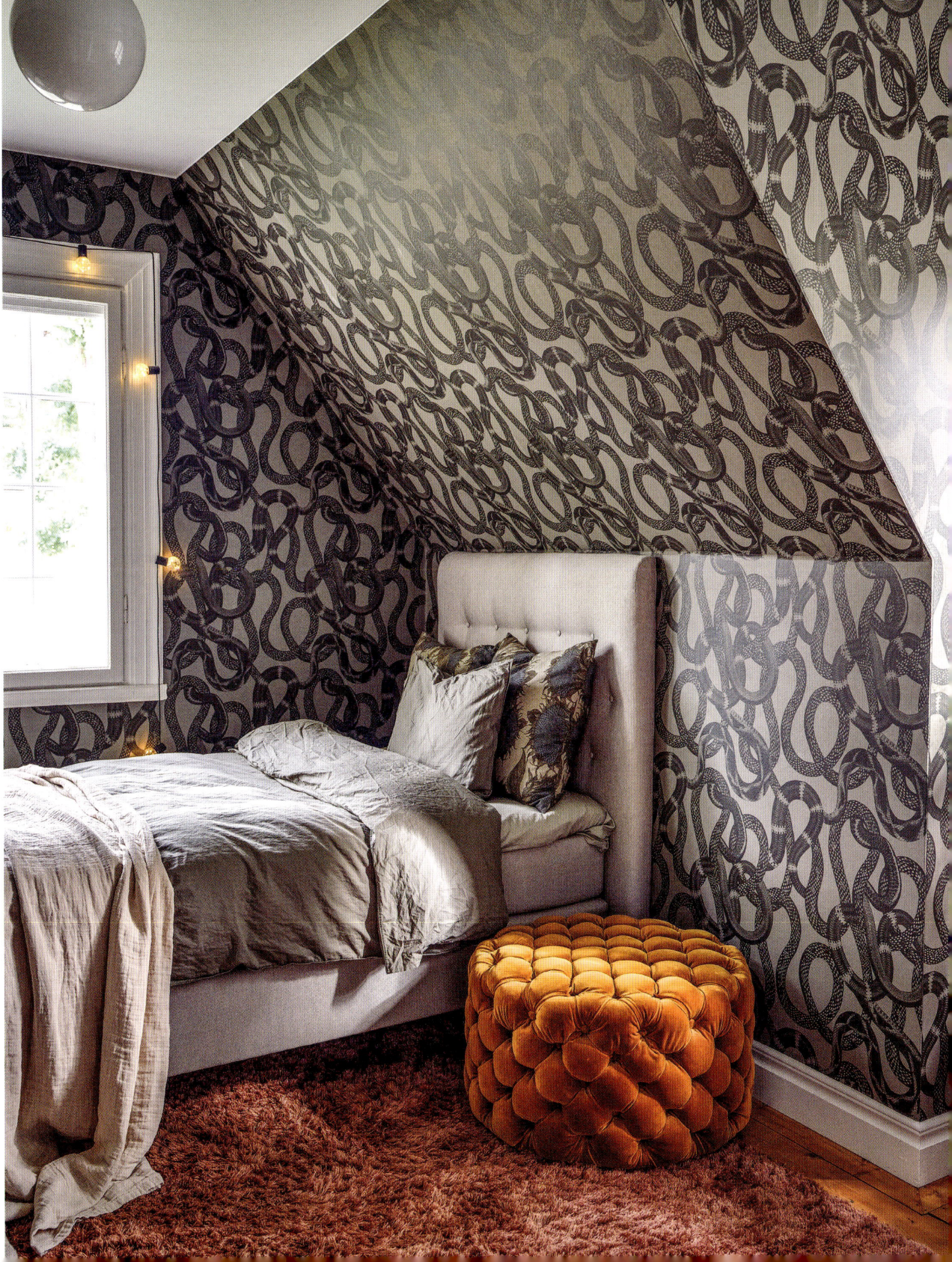

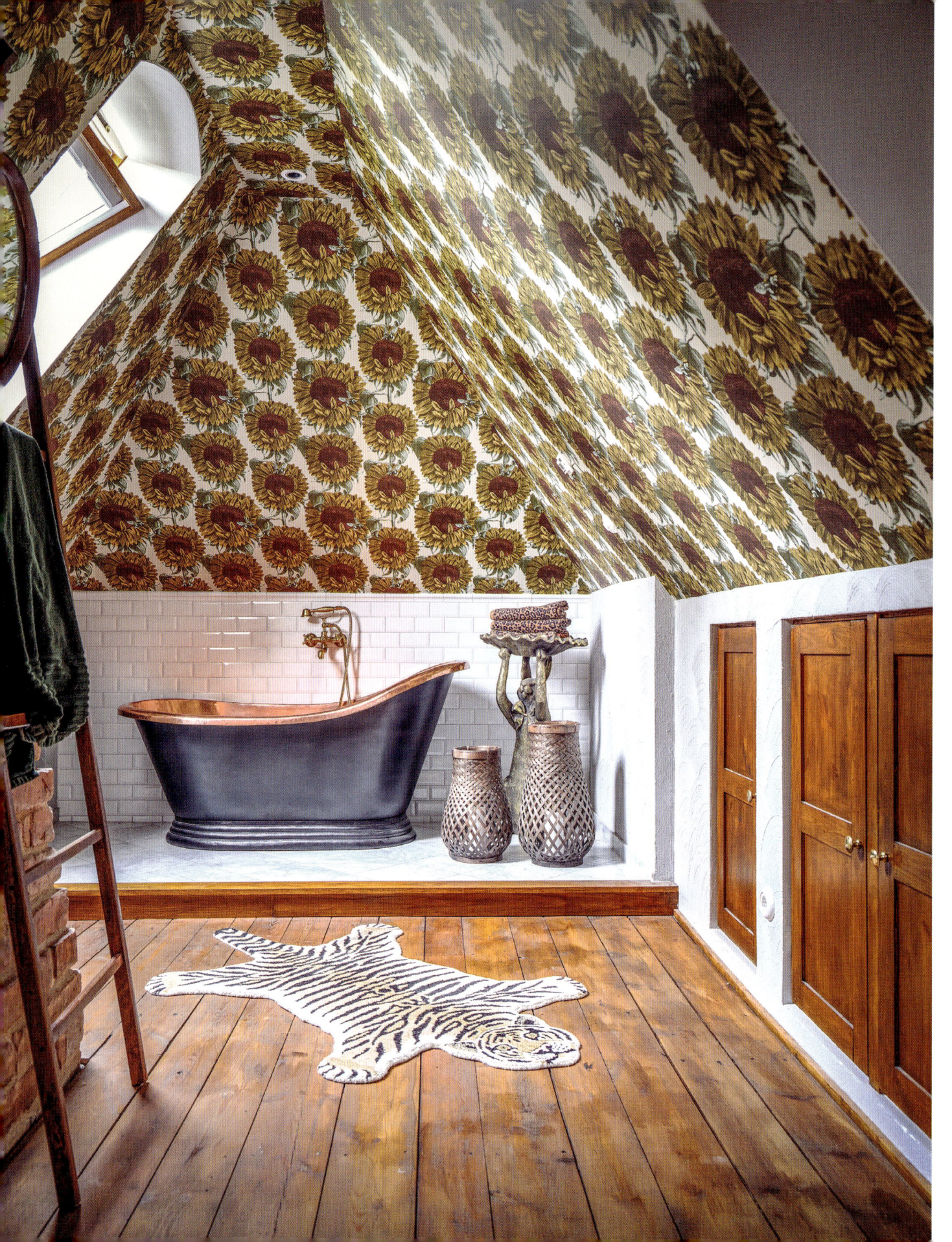

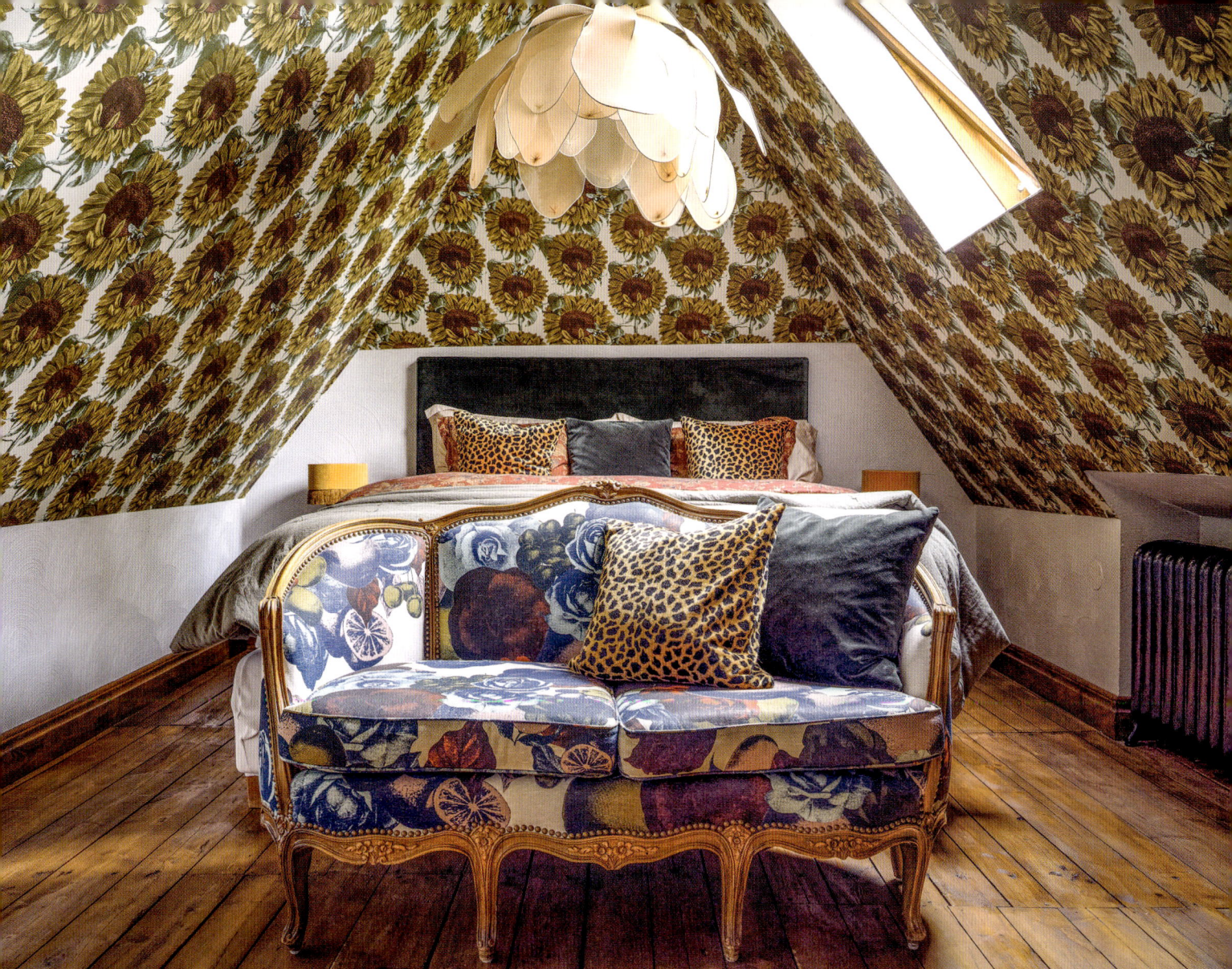

OPPOSITE
The attic also houses Lisa's bedroom with its full-sized freestanding bathtub. Warm bronze and copper tones prevail against the crisp white metro tiles that define the bathing area.

Clever greens and blues light up the larger spaces of the kitchen and living room in the summery months, while dense brown and burgundy hues create a cosy atmosphere in the study and attic bedroom.

Lisa's home brims with gorgeous moments of creative originality in its abundant application of colour and pattern. Oozing confidence and character, it provides year-round appeal for its inhabitants and visionary inspiration as a hosting haven for family and friends to enjoy.

ABOVE
The bedroom itself is a luxurious suite with cavernous credentials. Lisa's own Sunday wallpaper provides a heady wildflower feel across the walls and ceiling with a statement pendant light elevating the heights. The sofa at the foot of the bed is upholstered in Lisa's Boudoir fabric with its sumptuous pattern of fruit and flowers.

LIFE IN COLOUR 131

PLAYFUL *paintbox*

A life-long love of colour and a lot of experimenting with paint led Emma Morley and Simon Goff to create a vibrant vision for their London home.

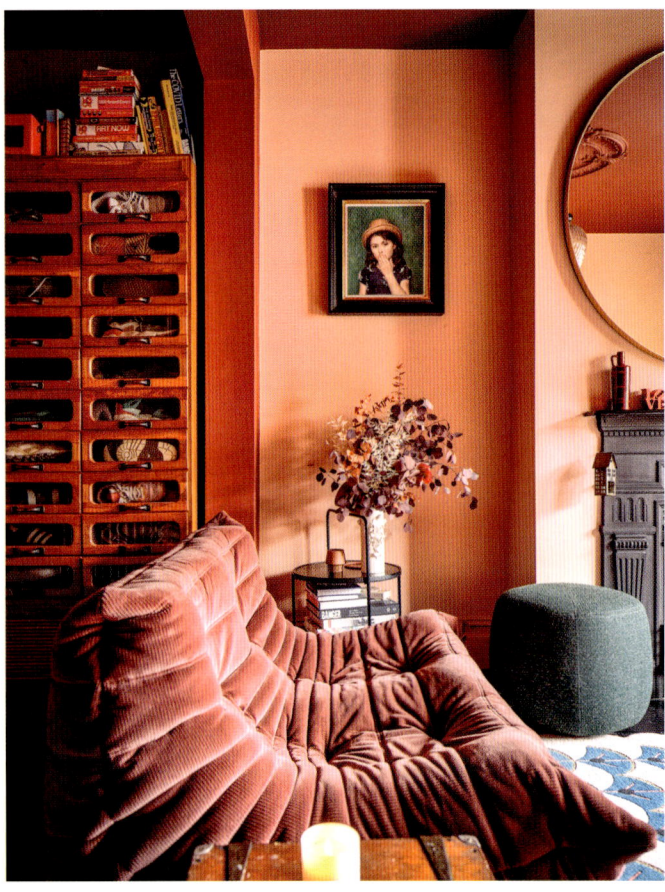

ABOVE
The living room offers an enveloping sensory experience via colour. Emma and Simon chose a harmonious blend of shades, from deep Arabian Red by Craig & Rose on the ceiling to uplifting Tropicalia by Valspar on the walls. The Togo sofa is a classic 1970s design by Michel Ducaroy for Ligne Roset.

RIGHT
As if to mirror the wall and ceiling hues, a shapely sofa from Soho Home is upholstered in a likeminded rust-toned velvet. Its curved shape has a cocooning effect and brings luxury to lounging. The Floor Story rug (one of several throughout the home) adds a complementary contrast.

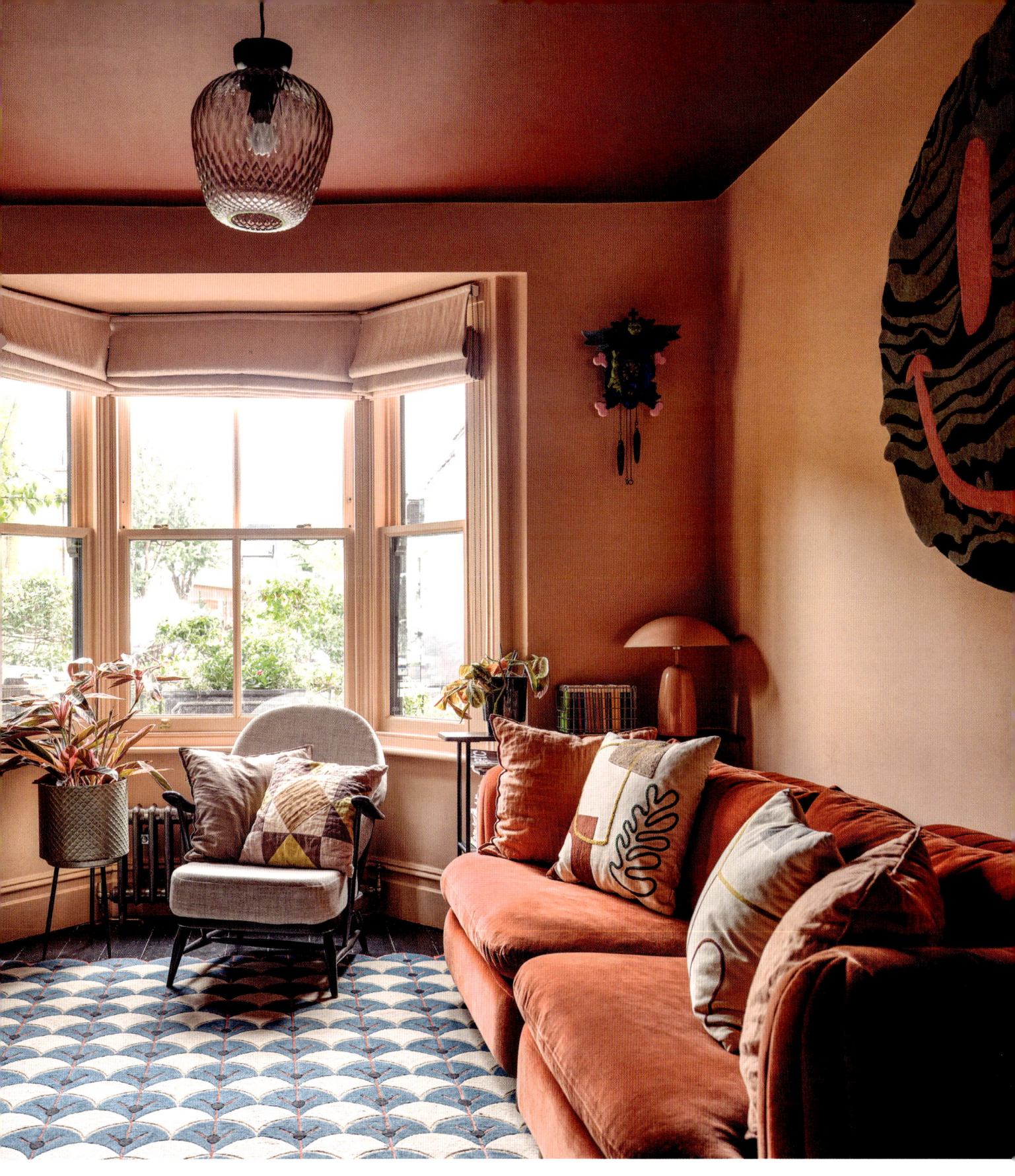

PLAYFUL PAINTBOX 133

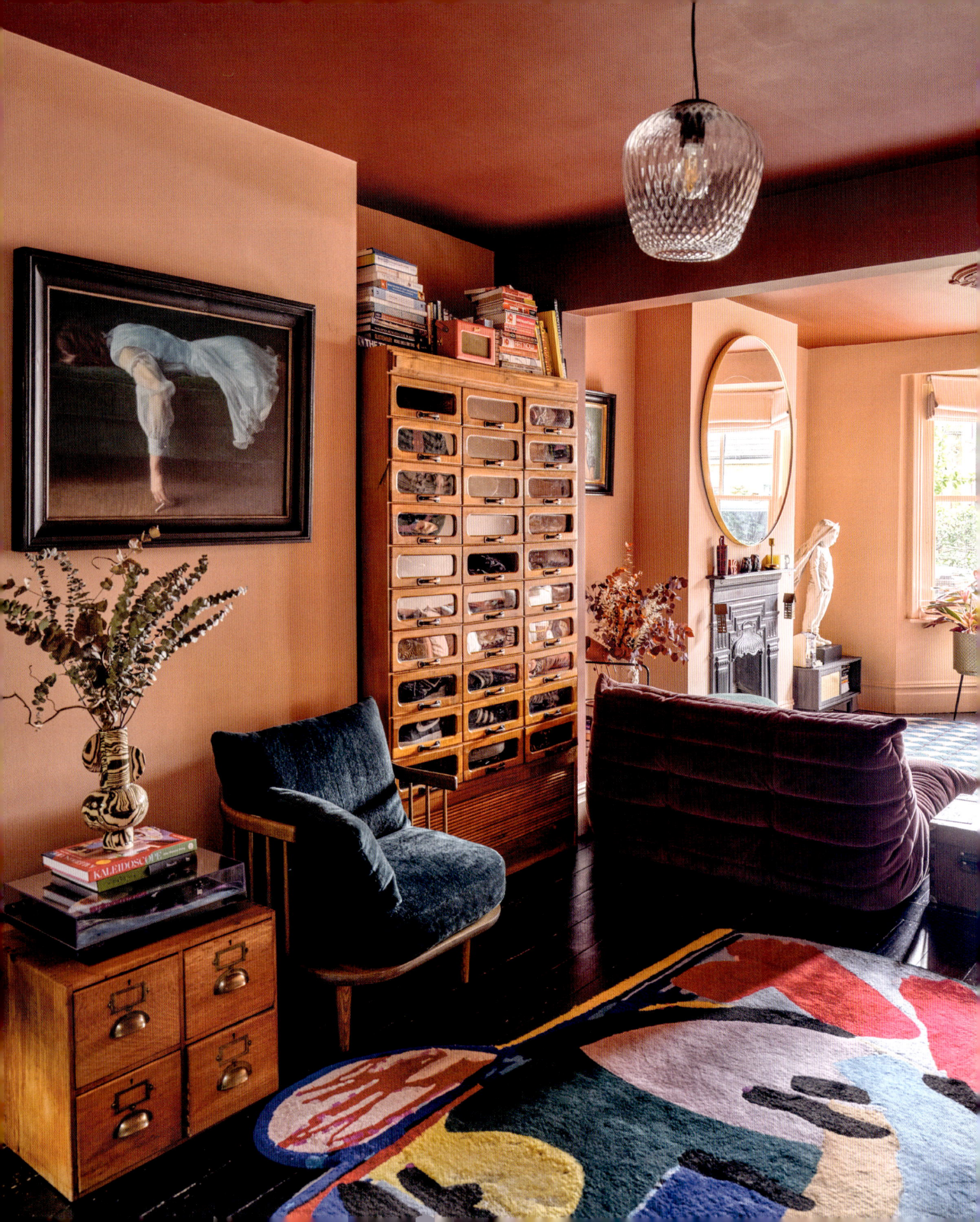

FAR LEFT & LEFT
Attention to detail creates captivating corners in the home. A beautiful scaled rug has an unexpected red edge (far left) and different paint colours meet at right angles (left). Easily missed on the first glance, these clever touches reveal themselves over time.

BELOW
The floor has taken on a major role in this home with rugs providing pattern, colour and texture. They also tell a story and add warmth and humour. Each one is like an artful installation and together they serve as a grounded gallery that leads from room to room.

Emma and Simon's home was always destined to be colour confident. Both with a background in design, the couple have created an imaginative setting defined by a personal palette. The house had recently been extended, so the main objective was to design unique spaces for the family to enjoy throughout the new layout. Today there is a sense of flow from room to room, with a series of inspiring backdrops each created with a different mood in mind.

The decor cleverly dips its paintbrush into variations of only three shades: yellow, green and pink. Going on a tour of the property, one can see how the colours interact with one another. There is a clear partnership between the communal spaces downstairs, which together provide a much-needed buffer from Emma and Simon's busy day-to-day lives.

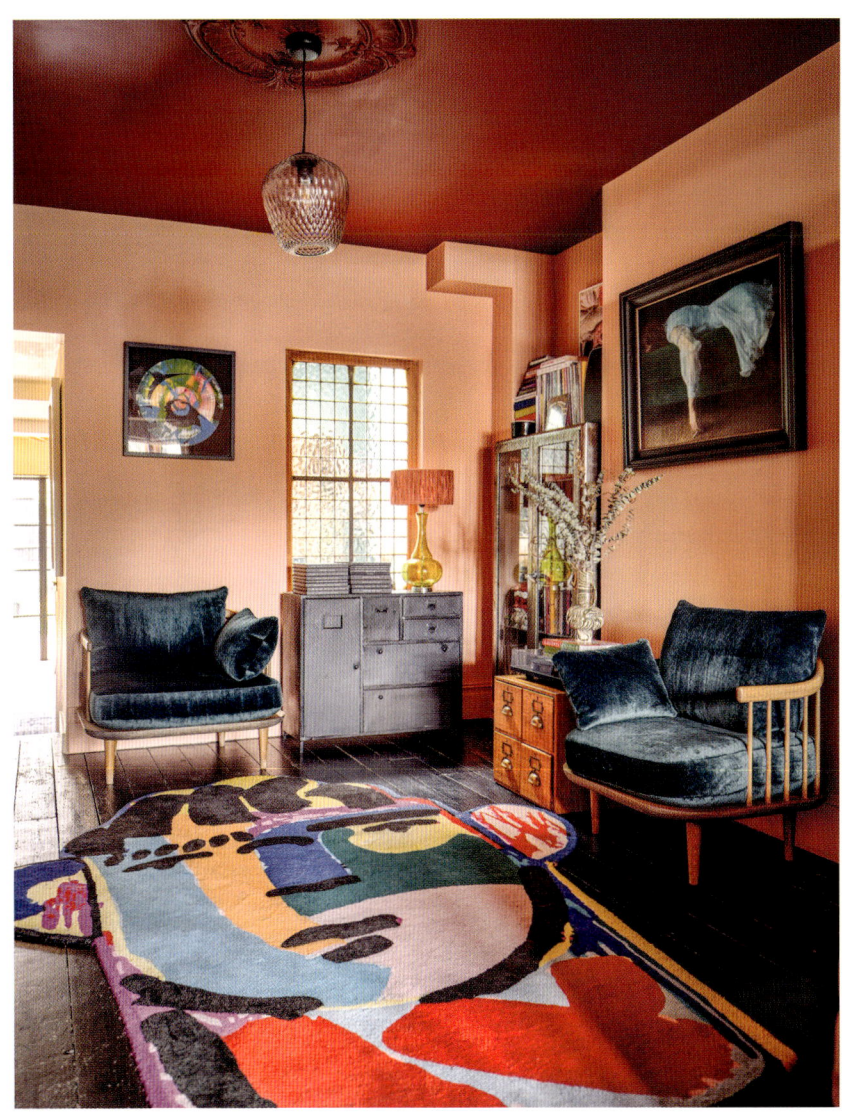

OPPOSITE
Fun and surprise are celebrated in unusual pieces that express individuality. This tall cabinet, which once belonged to a draper's store, was sourced from D&A Binder, a specialist dealer of antique shop fittings in north London's Holloway Road.

PLAYFUL PAINTBOX

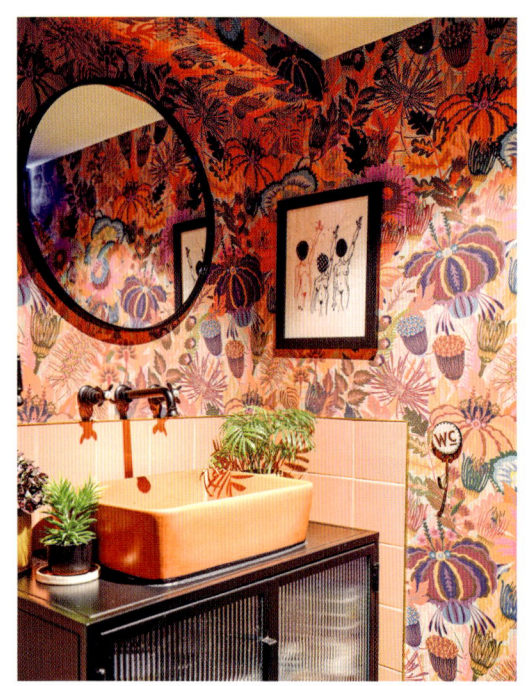

The kitchen was created as a space for daytime relaxation, with an earthy pink-red base, lush foliage greens and ochre yellows. It is a friendly and inviting space, with an overwhelming sense of being on holiday thanks to the bright pops of warm colour. By contrast, the living room is set for evening downtime, with more muted tones that encase and envelop the room in softness. A darker pink colour can be seen overhead with a slighter lighter shade on the walls, creating the illusion of a lower ceiling for a cosy, cocooning atmosphere.

The use of colour has been a learning curve for the couple, with braver choices made as the design progressed. The living room slowly became darker and now features walls with different colours to create zones and add interest.

ABOVE
The smallest room in the house features the strongest and boldest statement with a fun foliage wallpaper design and jewel-coloured sanitaryware in this hidden WC. A spotlight, reflected in the mirror, illuminates and captures the vibrant hues in the absence of windows.

RIGHT
The original glazing in the pantry marks where the old house shifts into the later extension. Like a stained-glass window, it offers a romantic link between the old and new. The pantry walls are painted in Aquamarine by Little Greene.

OPPOSITE
A holiday-at-home vibe defines the kitchen, with colours inspired by travels abroad. On the walls, sunny Ringwold Ground by Farrow & Ball and mustard tiles by Claybrook carry a cosy vibe from dawn to dusk. The Kent & London cabinets are painted in dark Alpine View by Dulux, with surfaces by Smith & Goat.

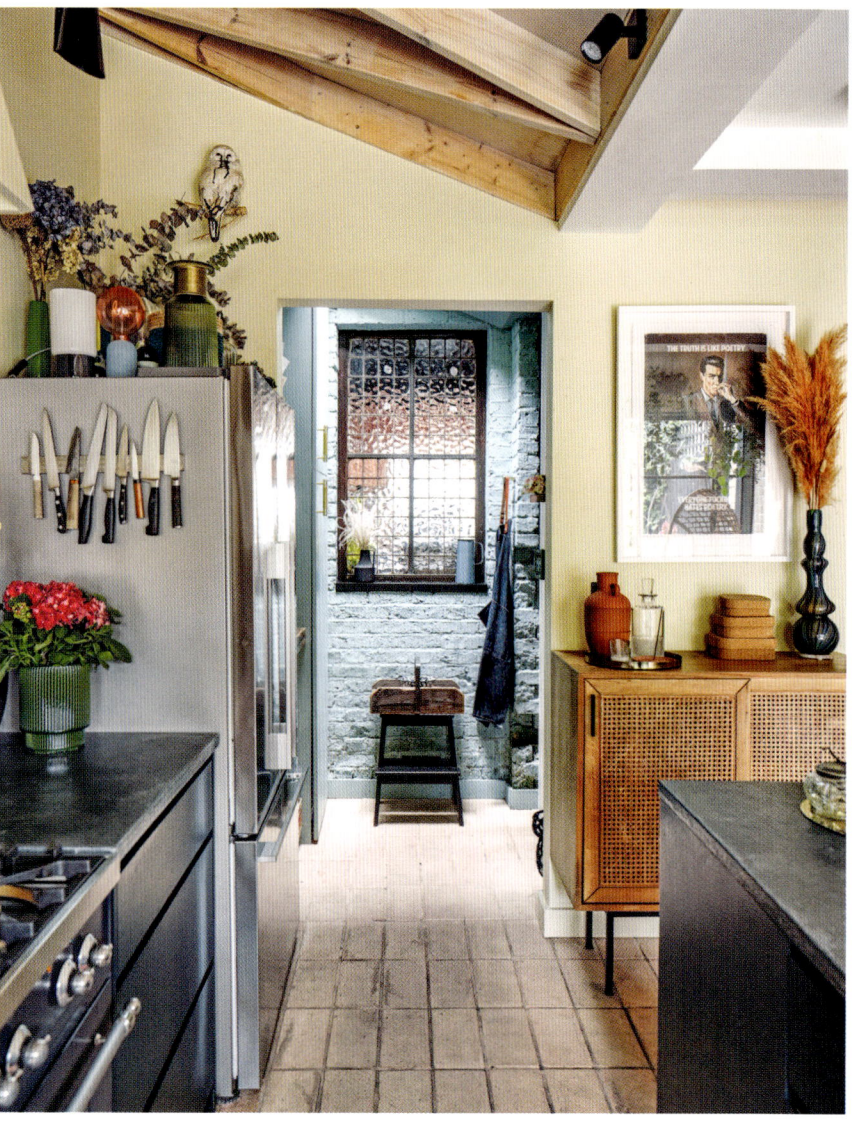

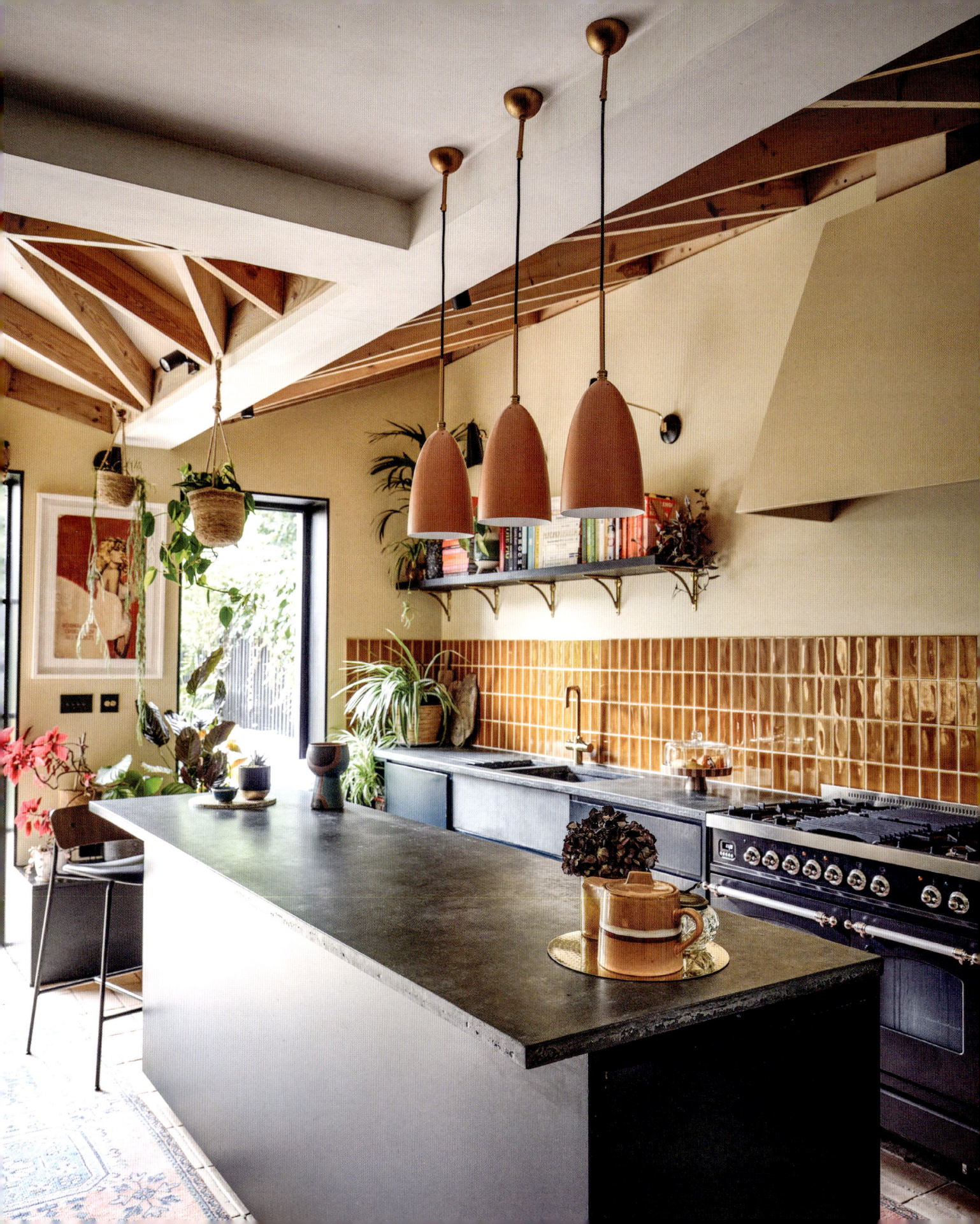

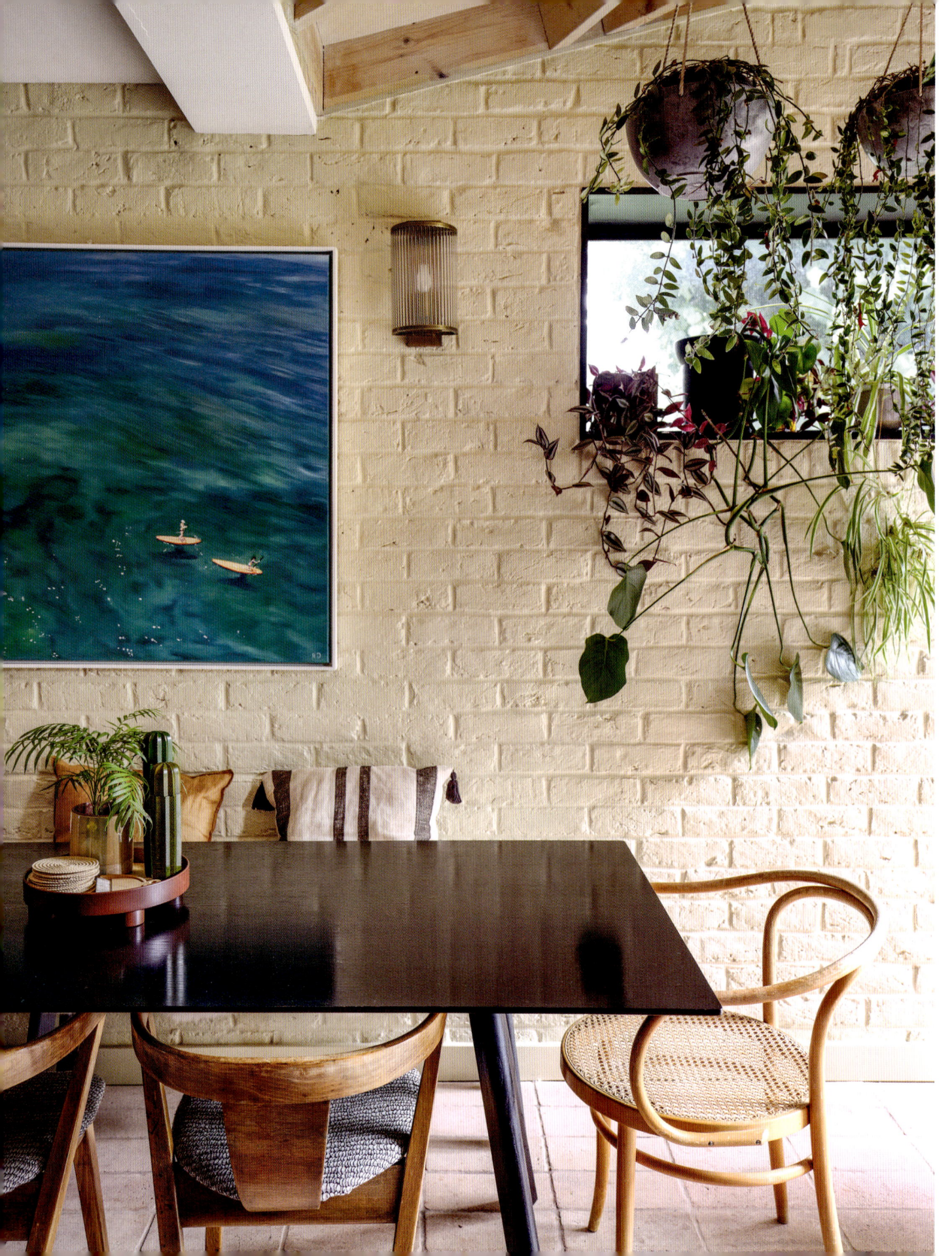

OPPOSITE, RIGHT & BELOW
The dining area is a flexible space, used for mealtimes and as a sociable work-from-home setting. There is always more room around the table, which expands to suit the crowd (opposite). Plants and foliage suspended from the ceiling suggest a rainforest canopy (right). A hanging rattan chair from Rose & Grey continues the jungle theme. The earthy terracotta floor tiles are from Solus (below).

The colours shift and change as day turns to evening, with lamps highlighting different shades meeting at corners or cornicing. Deep shades have a lighter counterpart to make more impact, for instance the ochre kitchen tiles against the paler peach paintwork.

Colour has been used to create identity upstairs, too. Favourites from the three-colour spectrum have been chosen for bedrooms, one of which has the striking combination of dark teal walls and white flooring. The family bathroom represents a meeting of minds, with daughter Bibi helping to create the look.

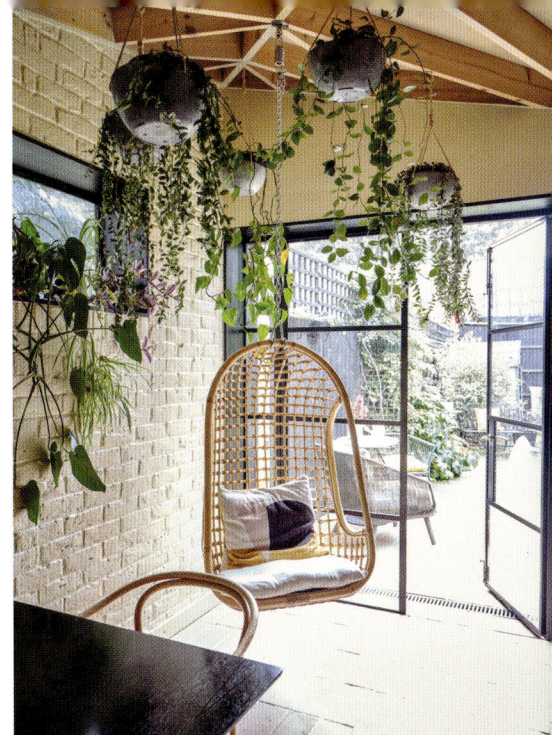

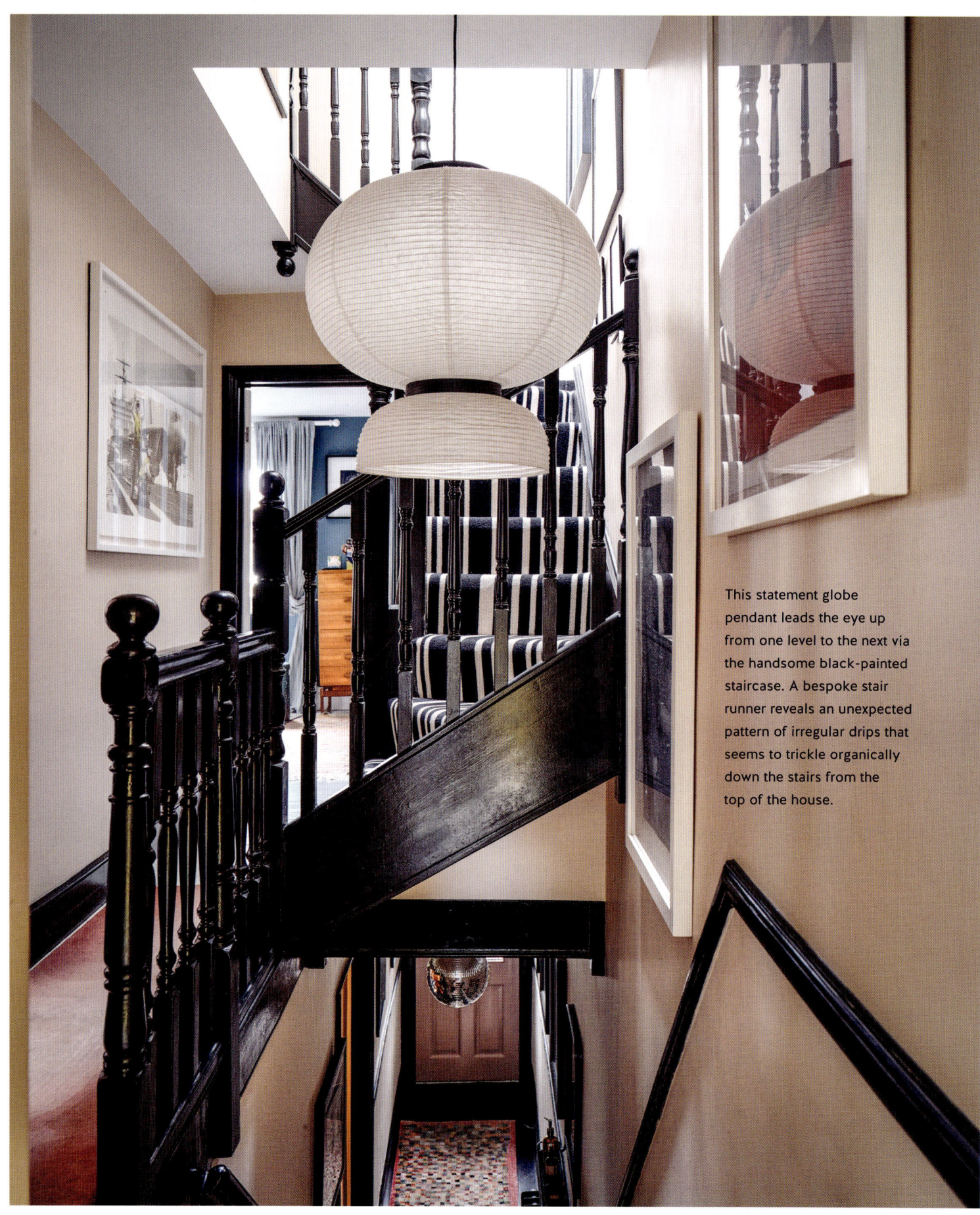

This statement globe pendant leads the eye up from one level to the next via the handsome black-painted staircase. A bespoke stair runner reveals an unexpected pattern of irregular drips that seems to trickle organically down the stairs from the top of the house.

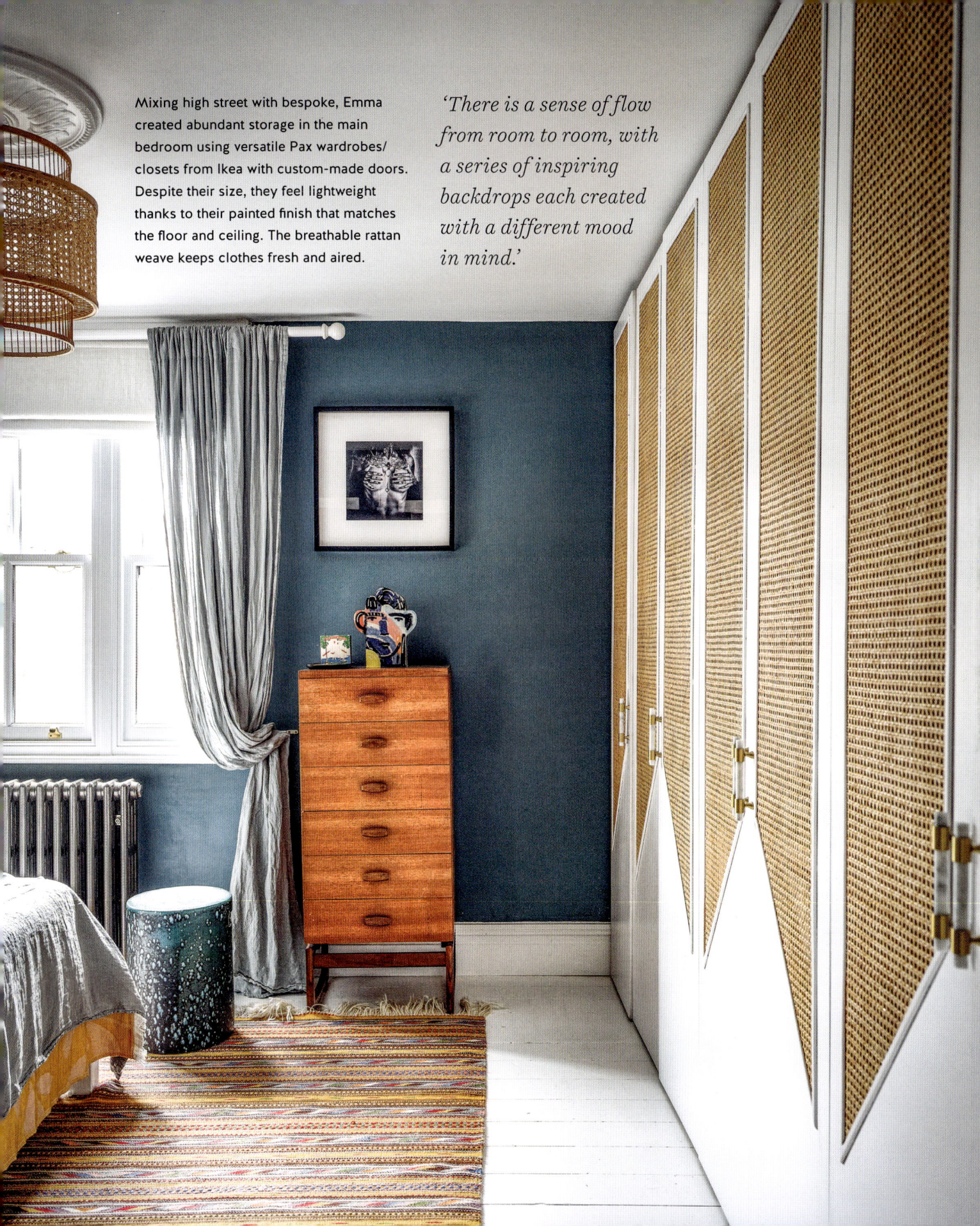

Mixing high street with bespoke, Emma created abundant storage in the main bedroom using versatile Pax wardrobes/closets from Ikea with custom-made doors. Despite their size, they feel lightweight thanks to their painted finish that matches the floor and ceiling. The breathable rattan weave keeps clothes fresh and aired.

'There is a sense of flow from room to room, with a series of inspiring backdrops each created with a different mood in mind.'

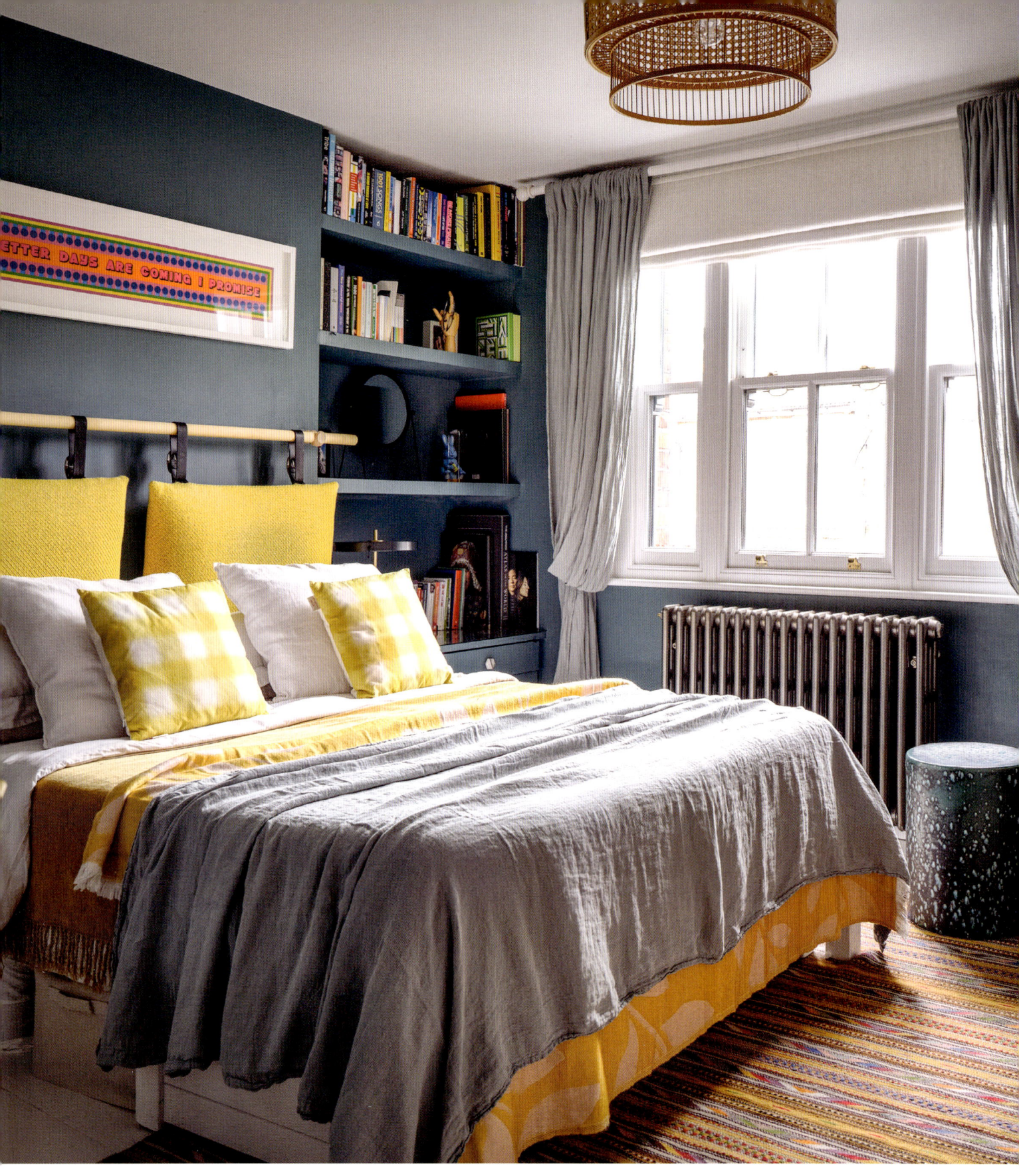

It is room to remind everyone that design shouldn't take itself too seriously: the tiling layout is playful and fun, and a surprising pink bathtub takes pride of place.

Throughout the house, paint has been taken onto the woodwork and skirting/baseboards to give a polished feel, and also to give the colours free rein rather than curbing their intensity with white. Under Simon's expert eye, rugs have been the ideal canvas to introduce and experiment with differing shades. Bringing colour on board in a contained way, the rugs make a moveable layer that's interchangeable over time.

Tones have been used to work with and support the seasons according to the orientation of each room. Cold north-facing spaces now feature warming summery shades and the house dresses up or down for winter and summer settings with vibrant textures that can be exchanged as needed. Cooler and silkier greens are in evidence during the warmer months, before making way for plusher and luxurious pink piled weaves as the nights draw in.

Many shared collections of homewares and memorabilia hinting at mutual interests are evident throughout the home, but above all it is Emma and Simon's love of travel that sets the mood and introduces characterful colour.

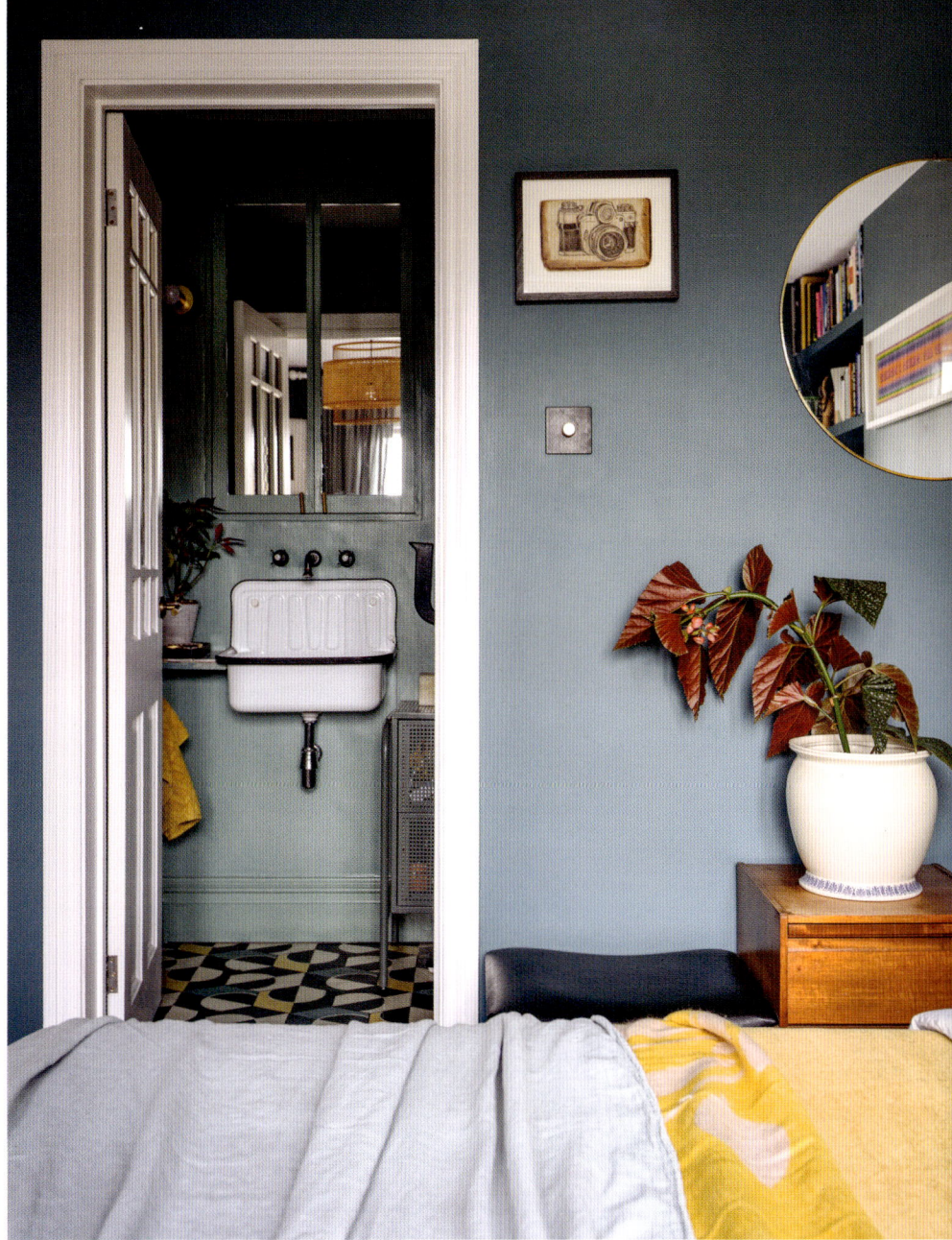

OPPOSITE
The bedroom dips into the yellows and blues of downstairs but offers a distinctly fresher and upbeat feel. The walls are painted in Tea with Florence by Little Greene and the golden headboard fabric (teamed with a wooden curtain pole and faux leather straps) is from Kvadrat. It is a zingy colour combination to wake up to, yet tonally adjusted to a room that receives so much natural light.

ABOVE
Emma and Simon have given their ensuite a bijou bespoke treatment. The beautiful floor tiles were designed by Anna Hayman for London Encaustic. Indulging a small room with luxury or designer touches is a balanced method of introducing distinctive or exclusive looks into a scheme.

PLAYFUL PAINTBOX 143

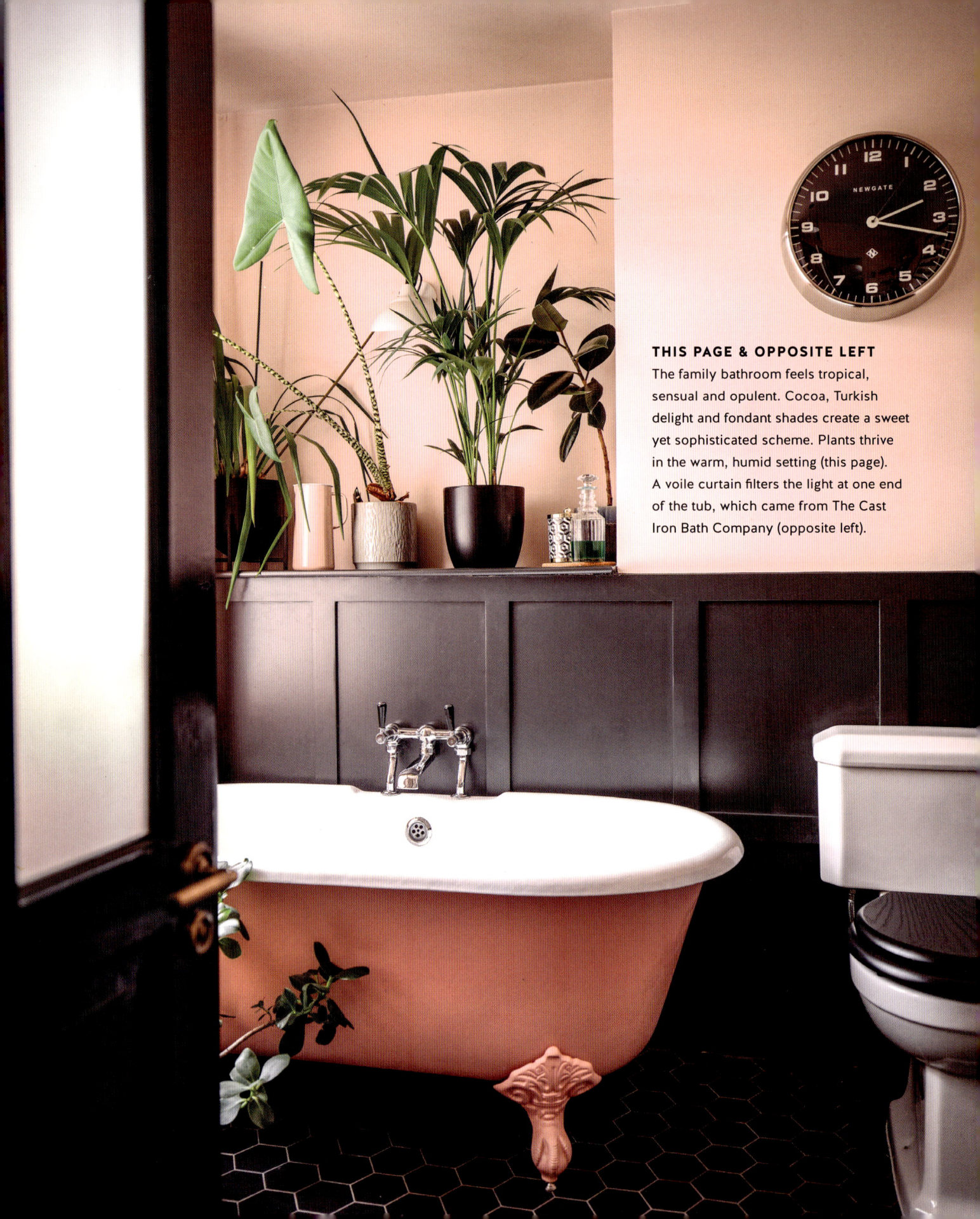

THIS PAGE & OPPOSITE LEFT The family bathroom feels tropical, sensual and opulent. Cocoa, Turkish delight and fondant shades create a sweet yet sophisticated scheme. Plants thrive in the warm, humid setting (this page). A voile curtain filters the light at one end of the tub, which came from The Cast Iron Bath Company (opposite left).

RIGHT
Emma and Simon's daughter Bibi chose and arranged the Tom Pigeon tiles for the shower. The colourful, free-flowing design is energizing and fun: it suggests style taking itself not too seriously while still delivering on functionality.

The palette draws on the deep and intense hues associated with the southern Mediterranean. Signature interior steals from Spain and Morocco allude to how these countries celebrate colour: vernacular designs, warming textures, handmade pottery and tropical planting, all of which now adorn the couple's home.

Colour is integral to the family's wellbeing. The pinks, greens and yellows are joyful, feel-good colours and are part of the family make up. The home palette reflects who they are as people and voices their personalities and preferences. It is playful and welcoming. There are calm corners, energizing features and celebrations of individuality. They have also recognized that character can be revealed in the smallest of surprises, including painted furniture, tiles and stair runners.

Emma and Simon's home successfully shows how one palette can be used to make bold but cohesive choices for the home. Just like the weaving process, these base colours act as a backing for other shades to interlace and criss-cross within. Robust, welcoming, able to wear and tear over time, their home's history is shown in colour. It is a home well lived in and designed to be loved.

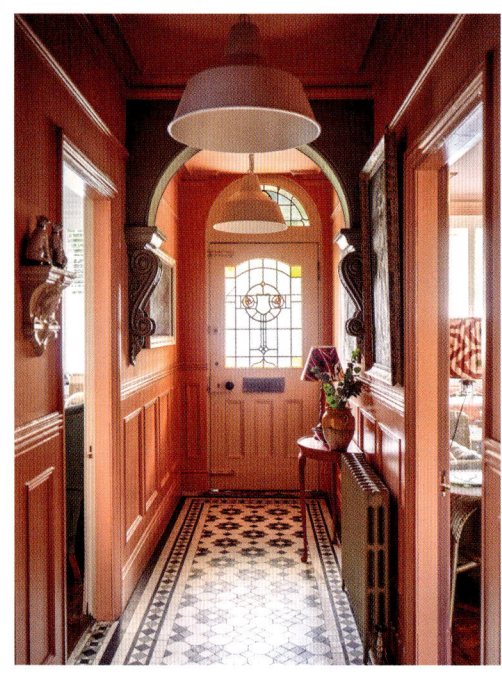

ZEST *for life*

Designer Sarah Davenport's family home in Lincolnshire provides a bright and vibrant backdrop for day-to-day living. Surrounded by her favourite colours and meaningful objects, she lives out her uplifting ethos of self-expression as the director of her thriving interiors business That Rebel House. Above all, her home is a place where she can be truly herself.

OPPOSITE
Fruity shades supplement the moody pinks in the living room. Furniture is draped in shawls and throws as a laidback alternative to fixed upholstery. Sarah's own tapestries, weaves and velvets, seen in the form of rugs and cushions/pillows, bring comfort, soften hard surfaces and muffle noise from outside in the absence of curtains.

ABOVE
Pretty and practical, pink paint in the hallway provides a cheery and robust welcome for this busy thoroughfare. The walls are painted in Brick and the decorative moulding in Drab Green, both from Edward Bulmer, whose paints were used throughout.

RIGHT
Sarah has gathered pictures from antique fairs, which are displayed alongside old books and lampshades. They have been arranged to feel like a gallery or museum scene where her various acquisitions jostle for space and deliver colourful views alongside eclectic homewares from Sarah's own company That Rebel House.

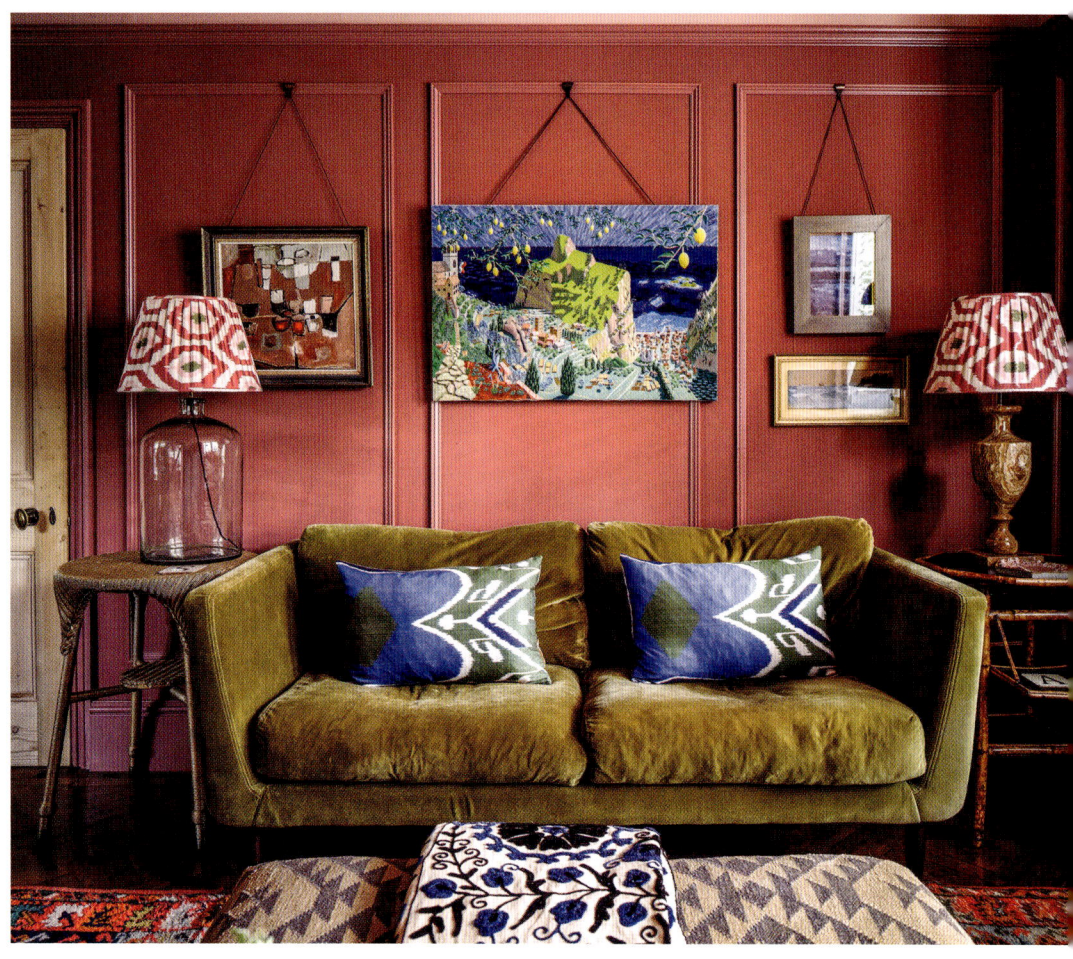

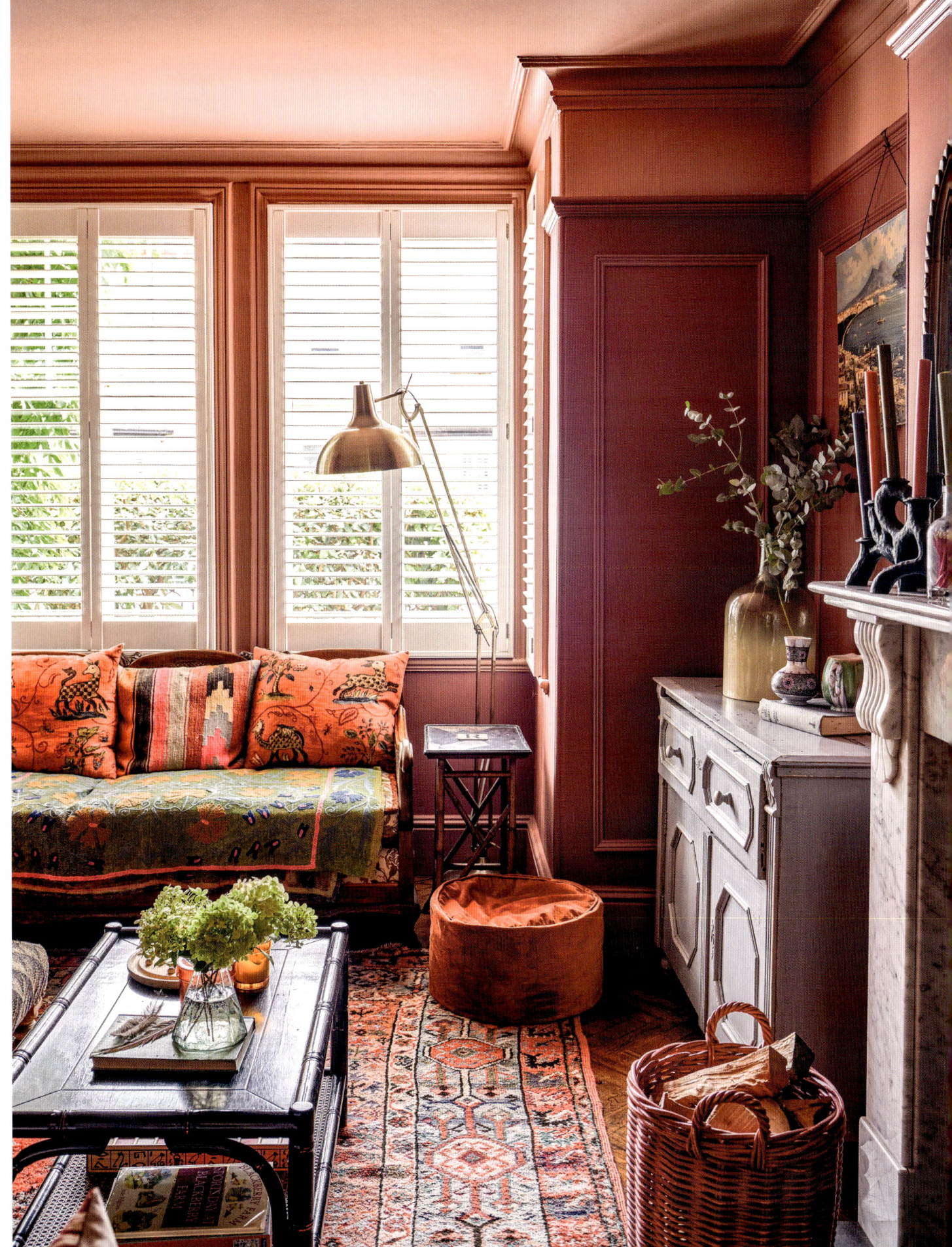

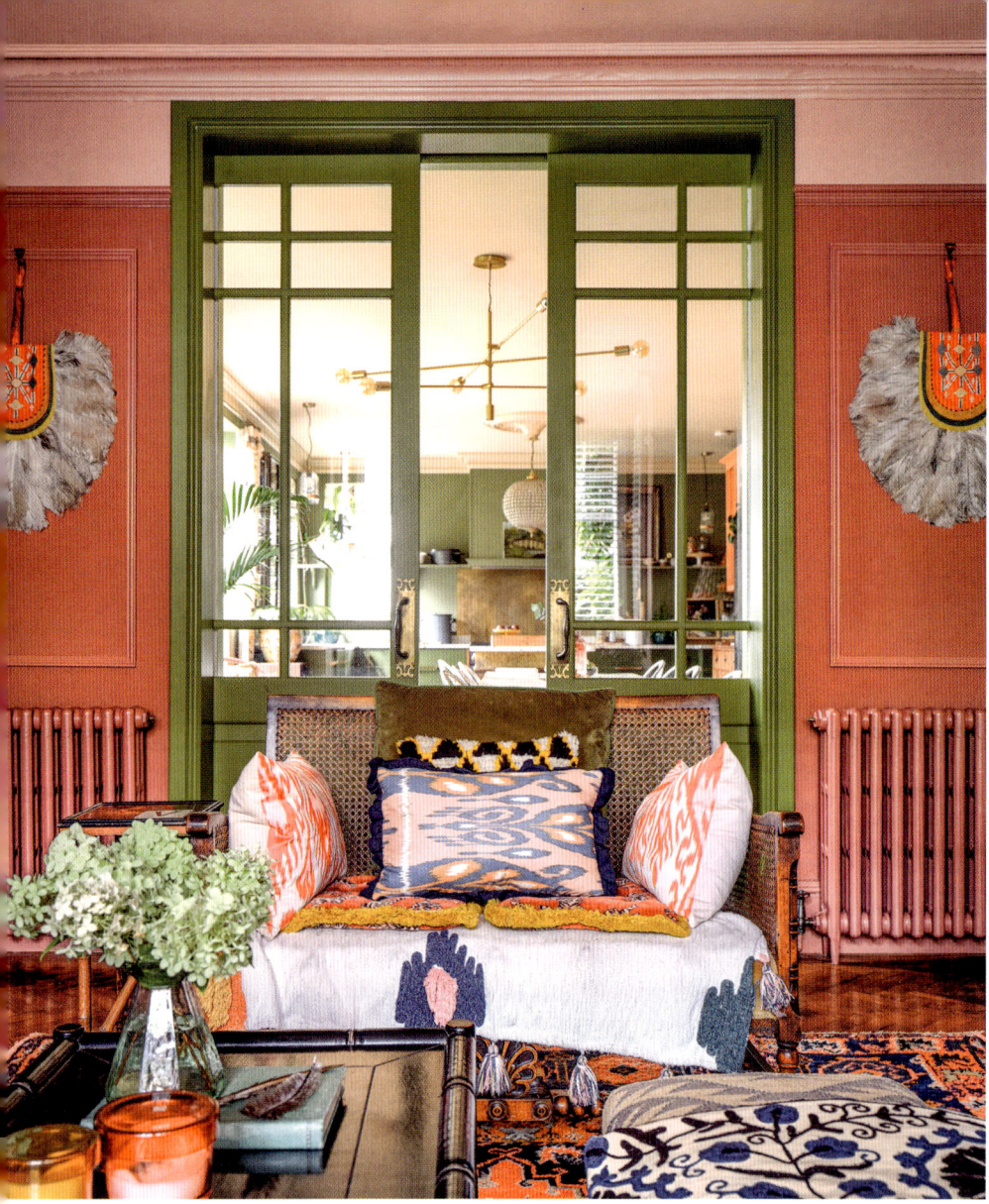

The house where Sarah lives with her husband Ross, their daughters April and Verity and their dog Walter is bold, exciting and a treat for the eyes. The uplifting decor is ideal for entertaining and promotes mental wellbeing. At the heart of Sarah's interiors style is the belief in creativity and being true to yourself, something she advocates in her work. Her home is filled with colour, pattern and texture, with hand-picked treasures that reflect the people who live there. Sarah has also referenced her wider family, her circle of friends and her business – all the strands that make up the tapestry of her life.

The original footprint of the home has been extended to add more bedrooms and a bathroom, so there was a need for a cohesive palette in order to connect the new rooms to the old. Sarah selected a few core colours, which appear throughout: greens, terracottas and pops of her favourite yellows prevail, with grounding brown textures and accent hues that appear sometimes for a season or other times as a fleeting highlight.

As the interiors have grown organically over time, Sarah has embraced the joy of change and impermanence. In turn, this has enabled her to put together new looks, make braver choices and bring different styles together in unexpected combinations.

ABOVE
An internal glazed door in the living room leads the eye into the green kitchen beyond. Olympian Green is the vibrant springlike shade that links the two spaces. A vintage cane sofa is dressed with Sarah's own cushions/pillows to bridge the gap between east and west.

OPPOSITE
A paintbox palette of vibrant and delightful shades flows from floor to ceiling throughout Sarah's home to make a continuous connection with colour. The living room is drenched in tonal tropical shades, including Pompadour on the walls and Nicaragua overhead. An overmantel mirror reflects and repeats the decor, doubling up on the details.

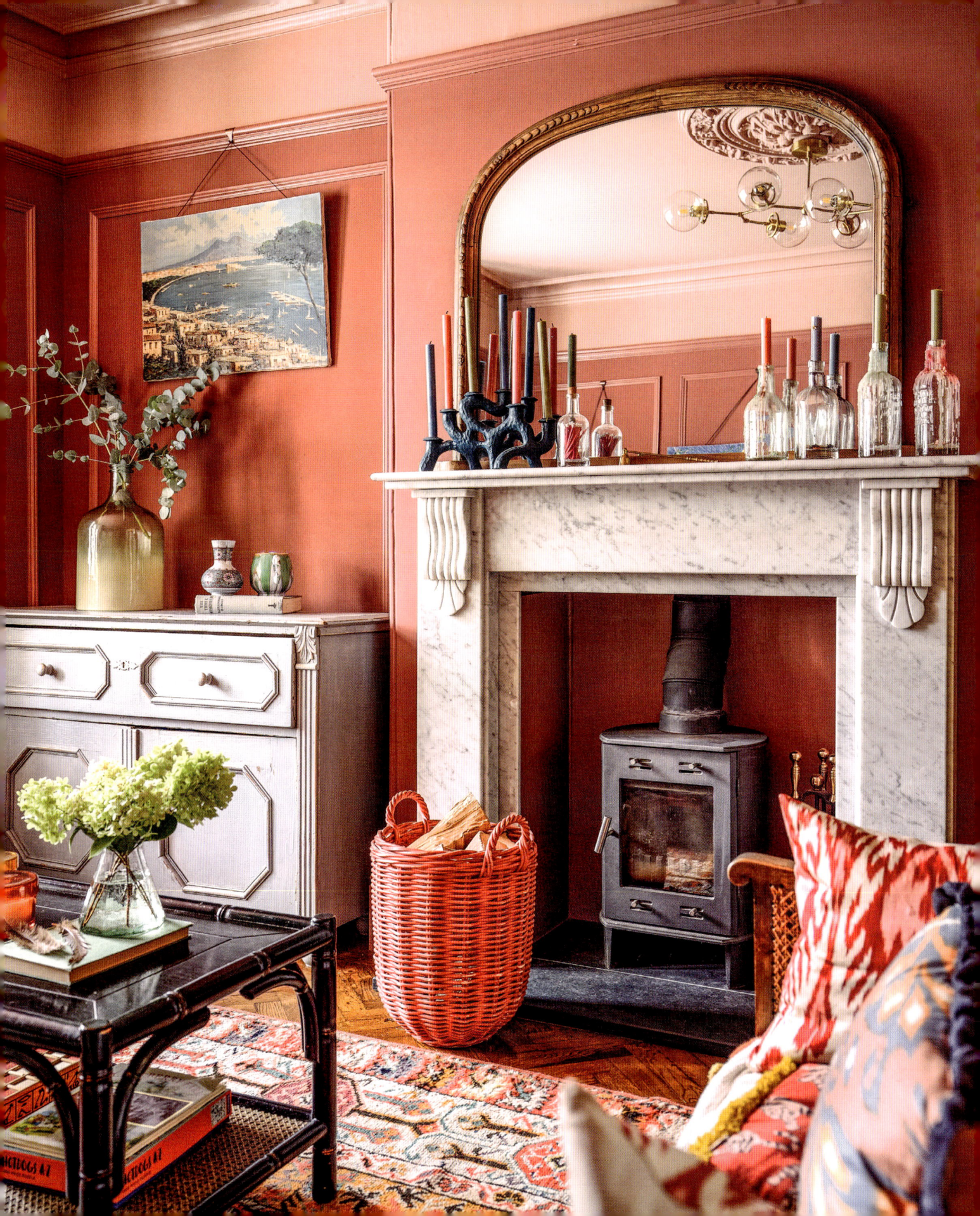

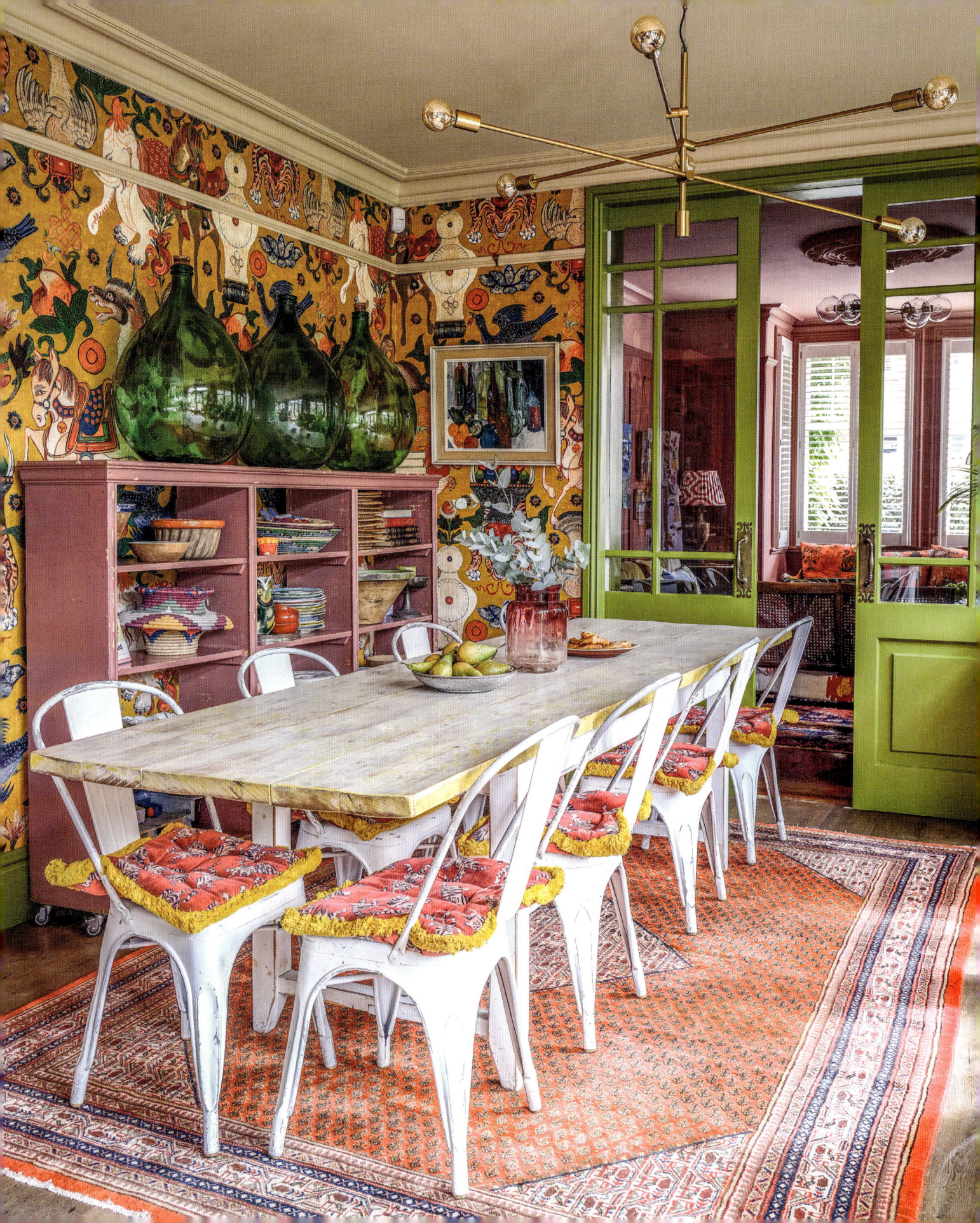

OPPOSITE & ABOVE
Sarah has played with scale throughout, often bringing in oversized pieces such as these green glass vessels in the dining area. When sourcing vintage pieces, it's rare to find perfectly matching sets – this can loosen up the styling and introduce a few happy accidents.

RIGHT
Sarah has embraced the 'unexpected red' theory with this cheery bistro setting in a corner of the room. Drawing the decor together, it adds an element of surprise and an air of cheerful creativity.

However, far from taking a throwaway approach to design, she has always prioritized sustainability and creative reuse. Many inherited, upcycled and already bought items have found a new lease of life through these changes, in which the whole family has been able to participate.

Sarah has used her rich palette to create engaging schemes with varying levels of intensity. In some rooms, vivid hues are colour drenched, while elsewhere they are used to accent, frame and zone. Colour provides a rhythm to draw visitors in and encourage flow from one room to the next. A detail on a doorway hints at what lies beyond or a change of tone supports a shift in atmosphere.

Colour also sets the mood for positive experiences. Imagine waking up to a favourite shade, then following a trail of colours that brighten daily tasks, bid farewell as you leave and welcome you home at the end of the day.

There is also the notion of wanting to surprise or delight visiting family and friends with a boutique hotel experience. In Sarah's home, guests can enjoy a unique room as their own for a few days, such as their own pink ensuite.

The origins of the various shades in Sarah's home are widespread and eclectic. Every corner entices with tales of travel, hobbies and happy memories. The whole family has a love of nature and Sarah has tapped into the rural landscape to lift the mood and provide biophilic benefits indoors. Mindful green dominates the kitchen and provides a link to the garden beyond. It flows onto wallpaper, frames internal doors and features on botanical artwork in the adjacent drawing room. The abundance of greenery inside and out brings a life-enhancing positive energy and vitality to the space.

Another source of inspiration was the family's appreciation of natural history museums with their cabinets of curiosities. With this in mind, Sarah has displayed objects in all manner of ways: not just on shelves but in frames, jars and pigeonholes. Flora and fauna motifs are key to this aesthetic, which reflects a keen interest in the natural world and an eye for foraged finds.

A no-rules attitude means articles are assigned to where they work best – a rug may serve as a wall hanging or a throw as a curtain.

RIGHT
Sarah has blended fitted with unfitted in her bespoke kitchen with great effect. She kept her kitchen cabinets and refreshed them with an apple green shade. On the right, a free-standing French military cabinet is paired with a wall-hung cupboard, which she made with old sash windows left over from the house renovation.

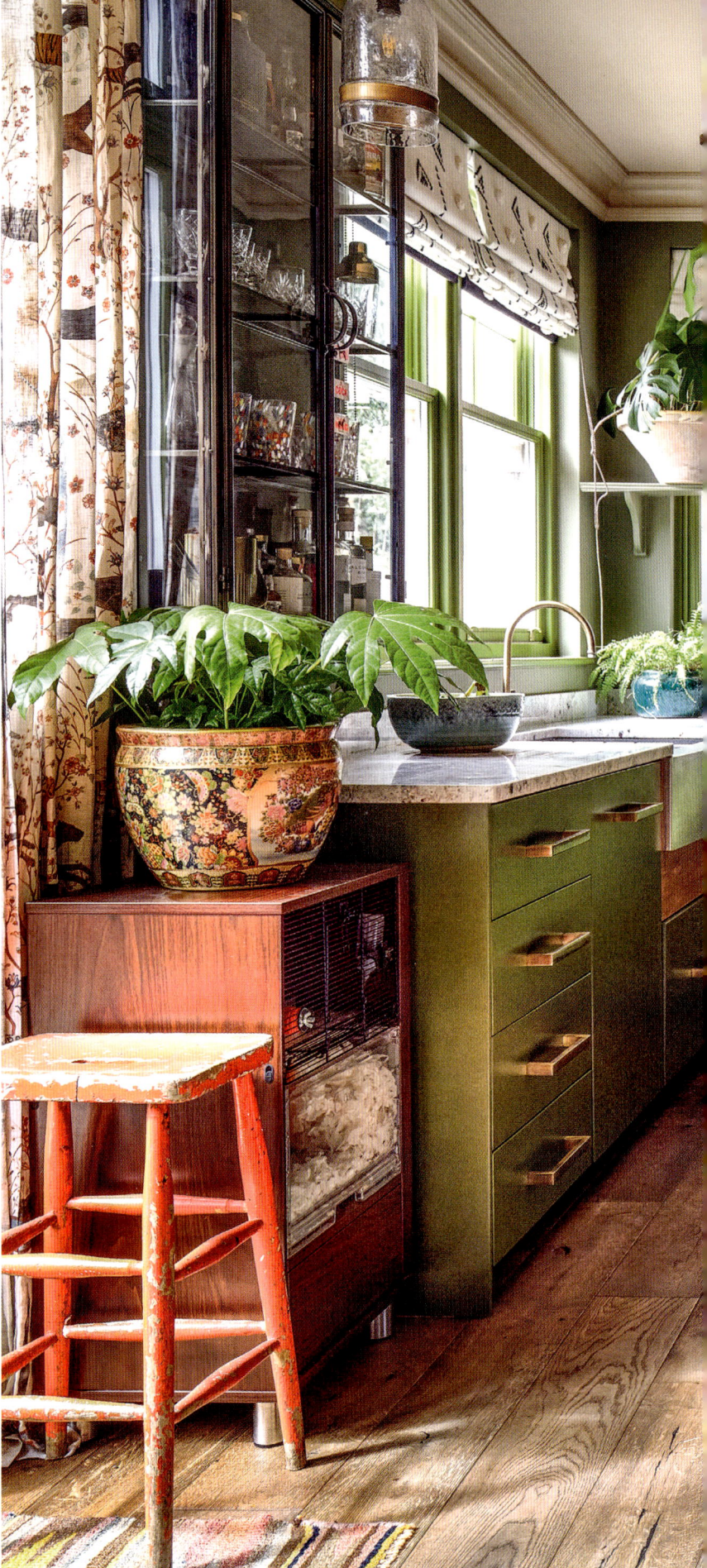

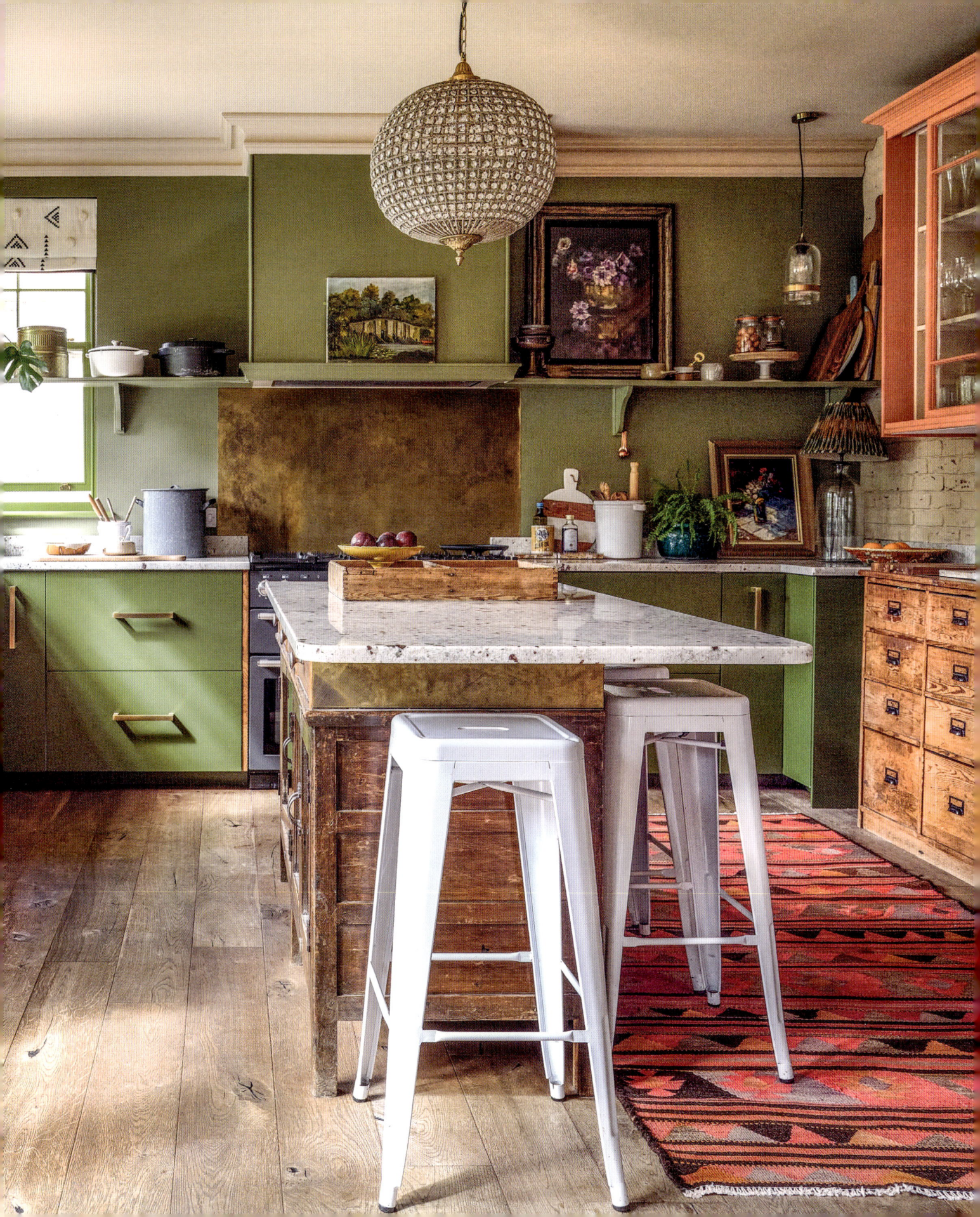

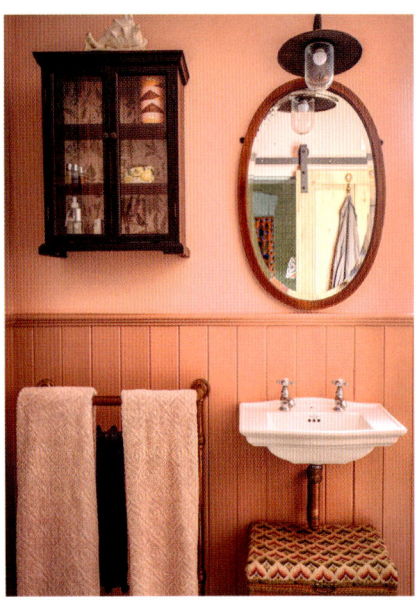

LEFT & ABOVE

Tapestries in the guest bedroom frame the entrance to the pretty pink ensuite, painted in Nicaragua and Rose. Sarah was keen to make sure that visitors could experience a kitsch bathing experience, even if only staying for a weekend.

OPPOSITE

The original brickwork of the exterior has been kept as a feature and lends a different surface texture to the room. The former window space was retained and is now used for built-in storage hidden behind a wall hanging. The walls are painted in Drab Green and the ceiling and accents in Aquatic.

Sarah has embraced the notion that things don't need to match or display symmetry. This makes it easier to bring new items into the home. Framed prints, cushions/pillows, vases and books can be changed or moved with ease.

There is a relationship between light and colour, especially at nighttime. In rooms where there is limited natural light, Sarah has shied away from greying pale shades, applying stronger colours instead. Her hallway is atmospheric and moody, and ceilings feature a striking shade for a cocooning effect in the evenings.

Sarah's home is an engaging social space that tells the inclusive, animated and articulate story of her family life. Through adventurous use of colour, Sarah and her loved ones have been able to express themselves, experiment and not take things too seriously in great comfort, while taking enormous pride in their surroundings.

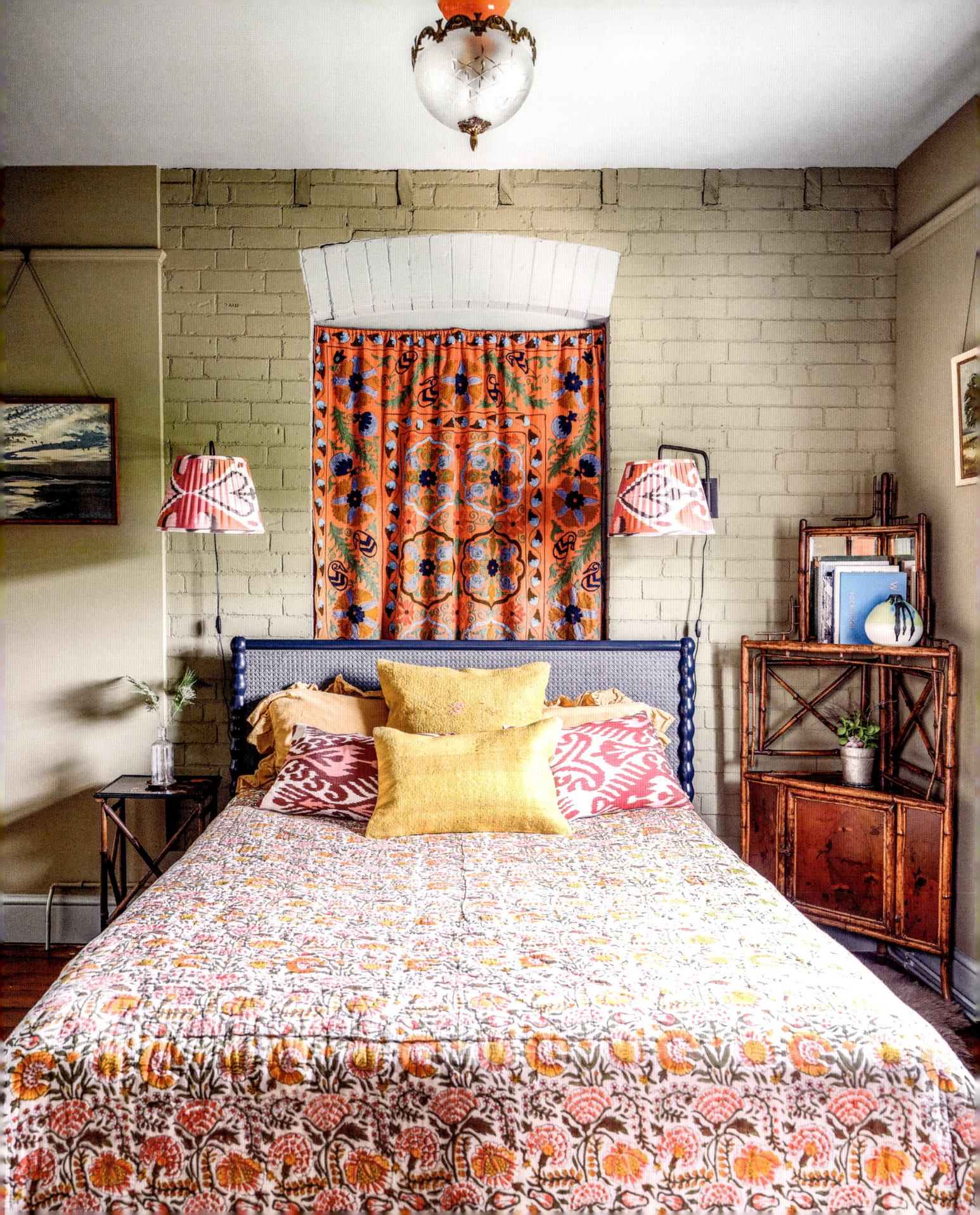

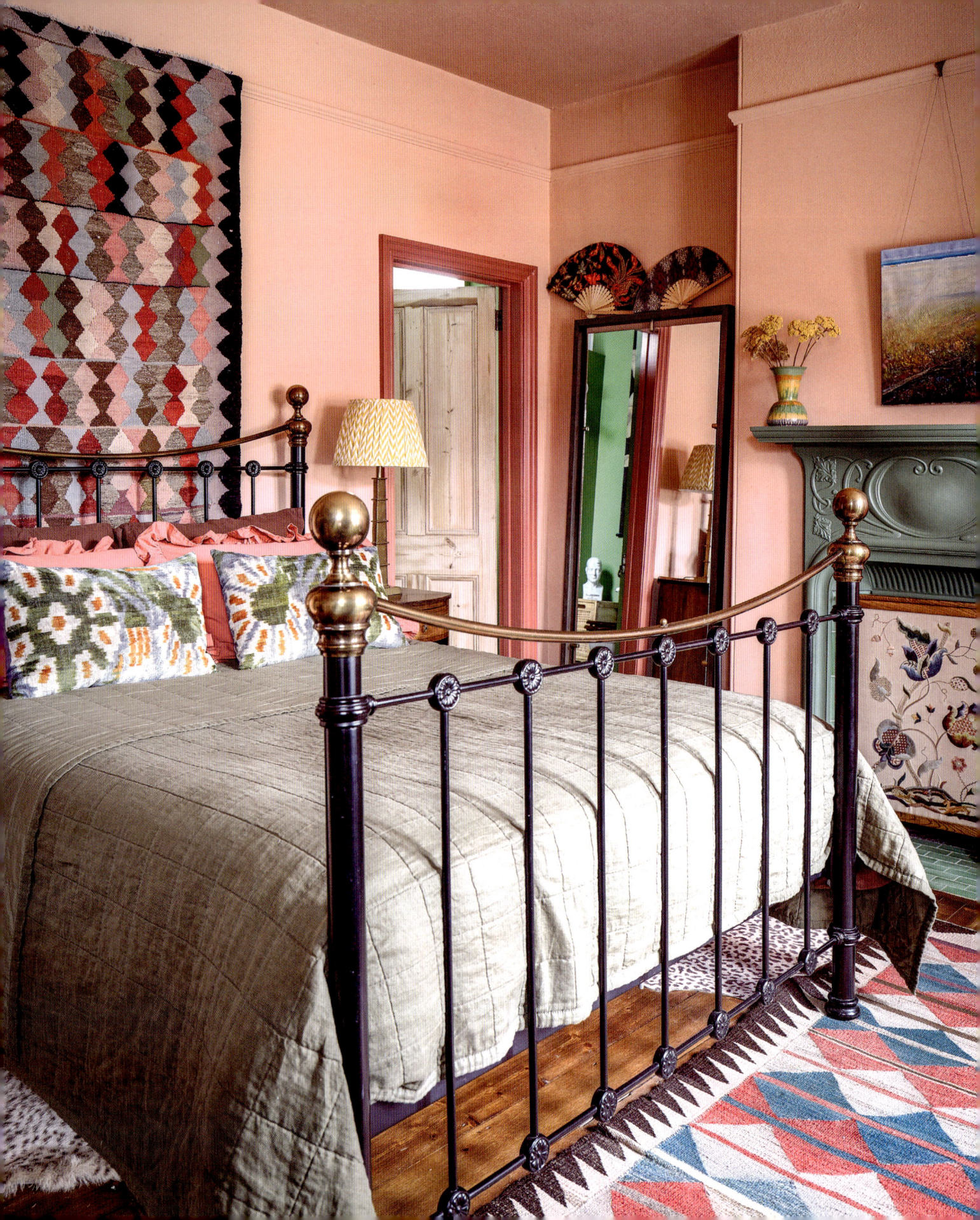

OPPOSITE
A bed more than 20 years old is described fondly by Sarah as 'almost vintage'. One of her very first purchases as a new homeowner, it now sits between a pair of bedside tables/nightstands inherited from her grandparents. A rug has been repurposed as a wall hanging behind the bed.

BELOW
This small green ensuite is attached to the main bedroom. Sarah has added a mirror over the sink, a practical feature which also creates an optical illusion that appears to double the room's size.

RIGHT
Playing with shape and styling, pendant lamps have been hung with whimsical asymmetry. Artworks and mirrors in wooden frames line the walls.

BELOW RIGHT
To complete the look, a pair of green leather Italian lounge chairs creates an inviting place to sit and relax in the bedroom. A big fan of multi-tasking in rooms, Sarah has created comfortable and versatile seating areas in various corners of her home, so that spaces can be used throughout the day.

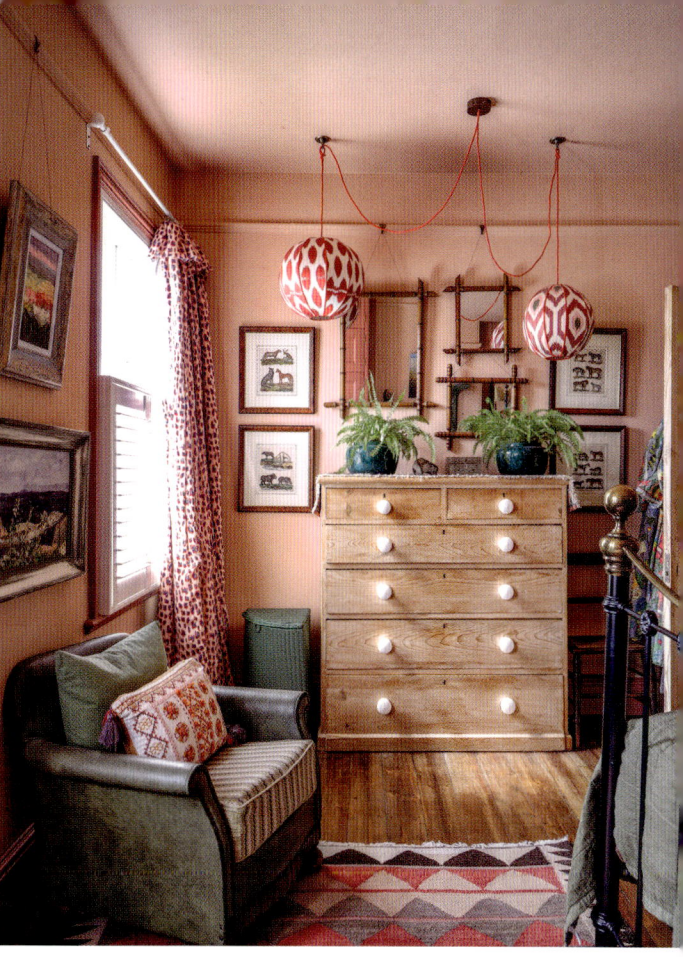

'Imagine waking up to a favourite shade, then following a trail of colours that brighten daily tasks, bid farewell as you leave and welcome you home at the end of the day.'

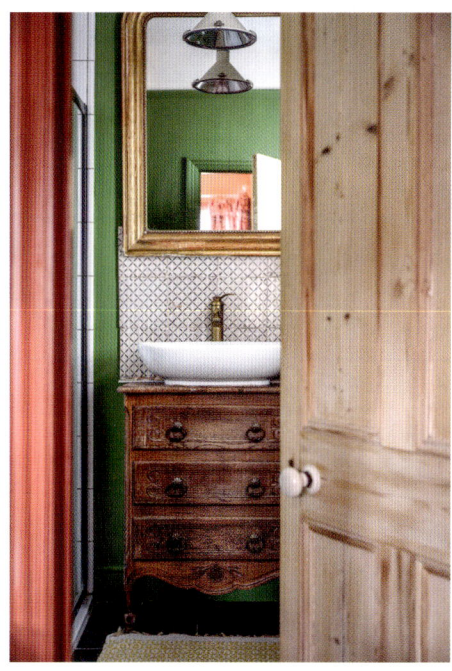

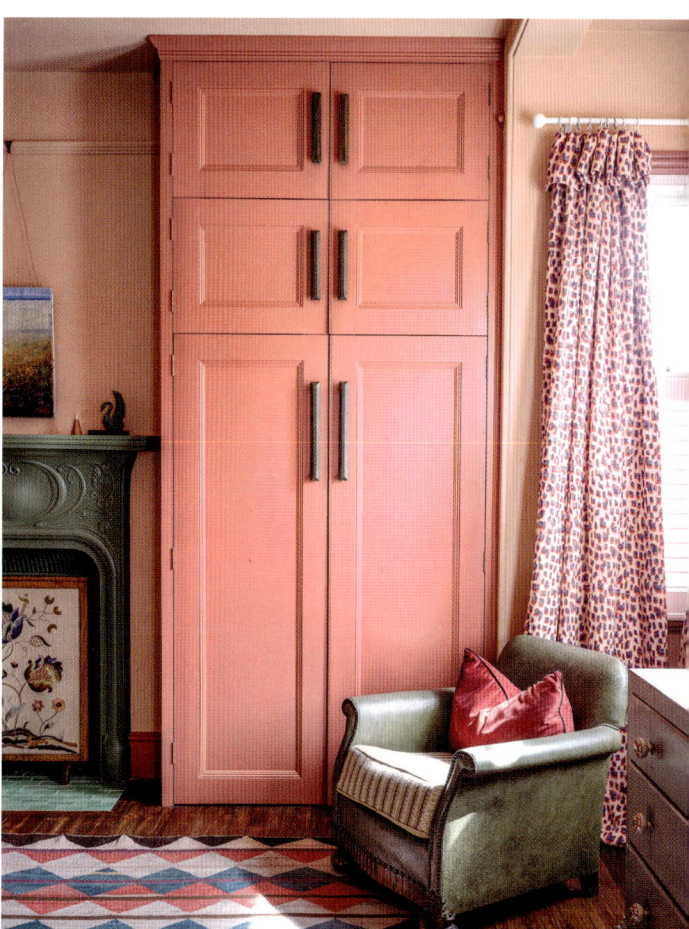

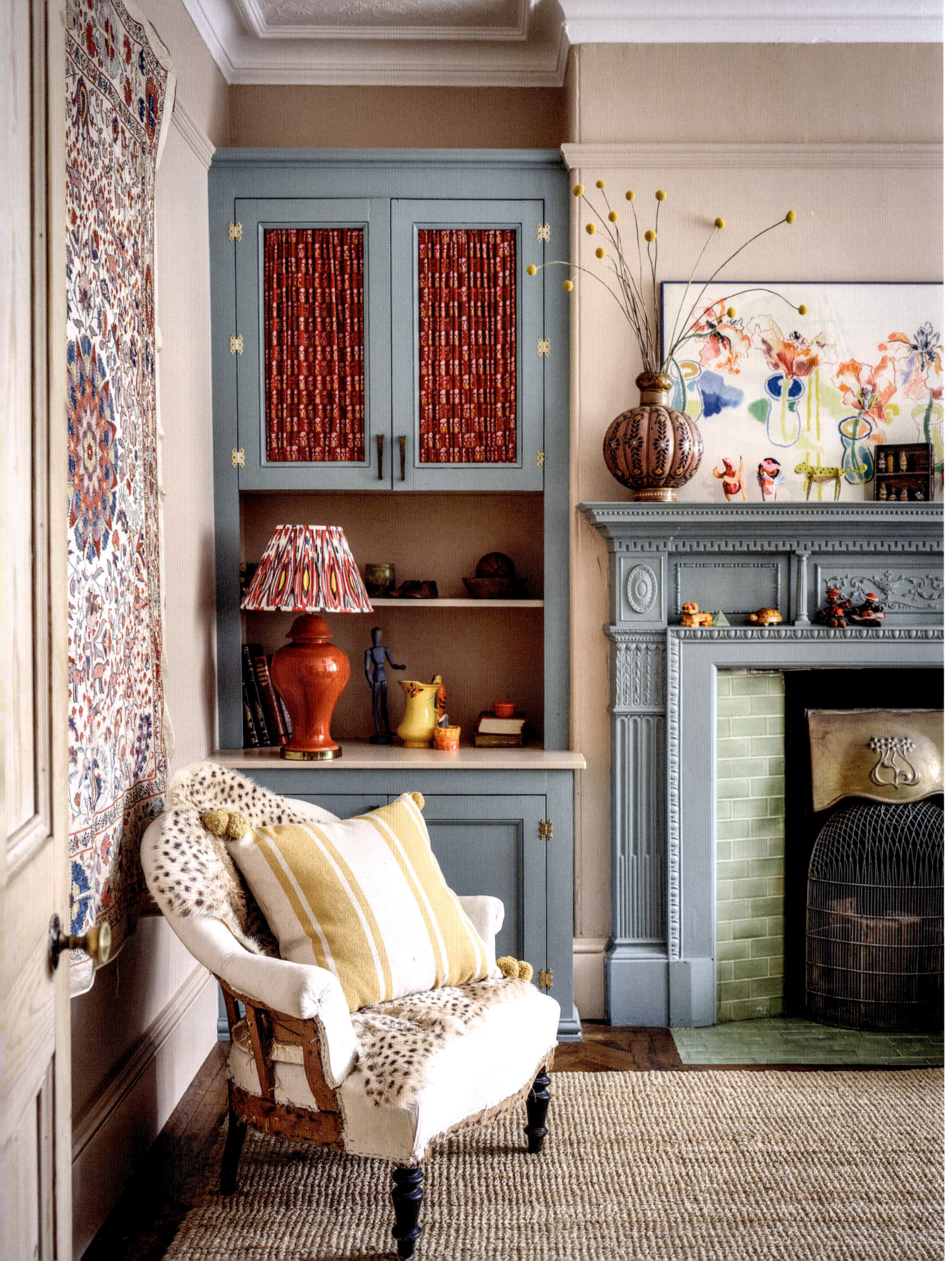

OPPOSITE
Within the overarching vision of Sarah's home colour palette, many other tones have found a home. Changing with the seasons or simply as a home develops, these additional hues lend a bespoke character and layers of personality to every room.

ABOVE
An aquatic blue is used on the walls of this bedroom to tap into a love of nature and the undersea world. A naturally spacious colour, blues recede from the eye and make a small space feel much larger.

RIGHT
As a complete change from the rest of the home, the downstairs WC has been left white. Far from dull or clinical, the room is full of foraged finds, heirlooms and vintage pieces.

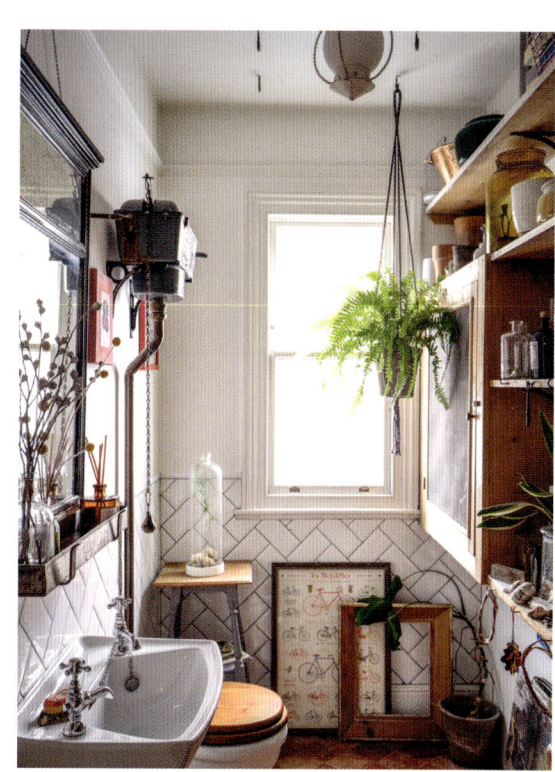

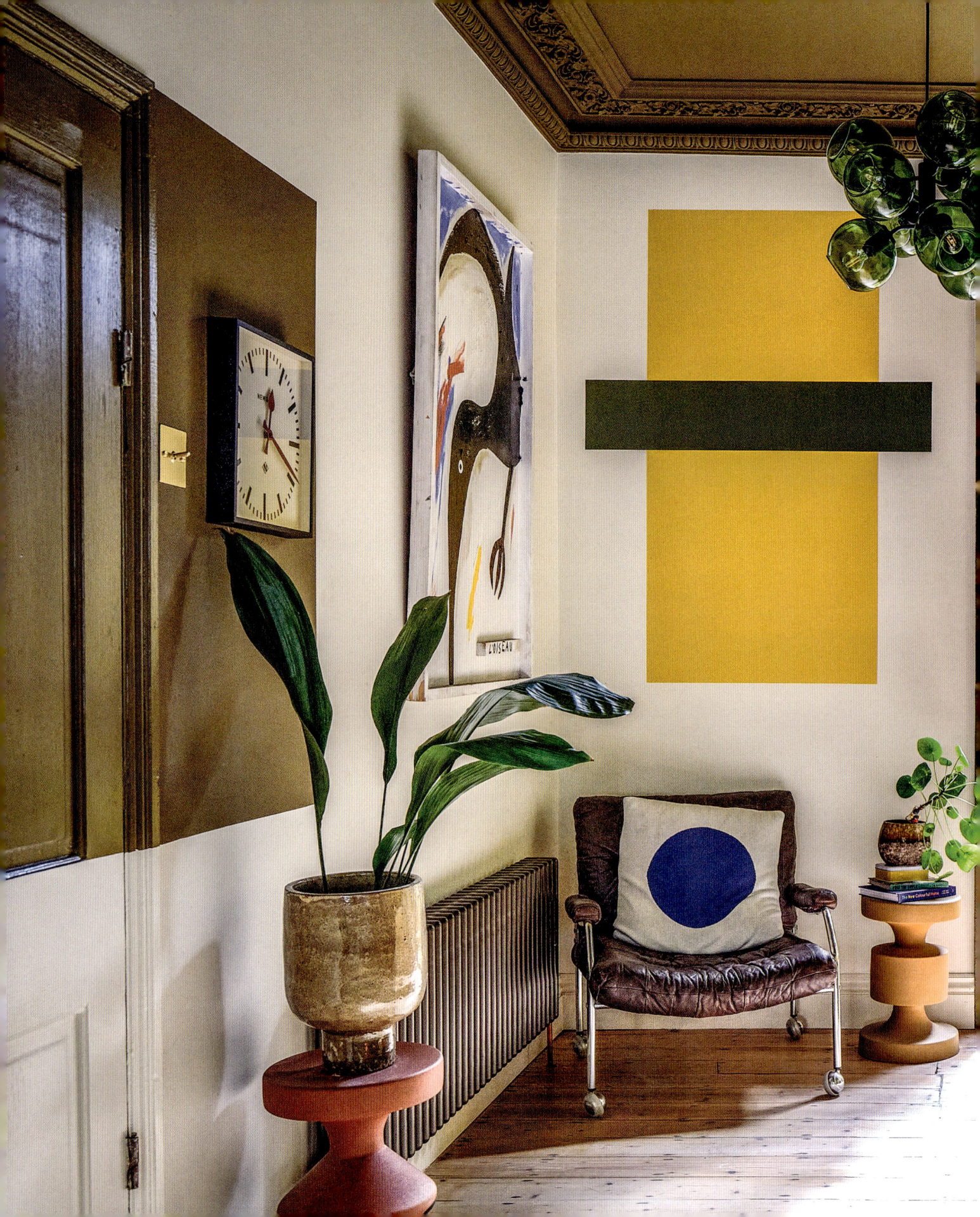

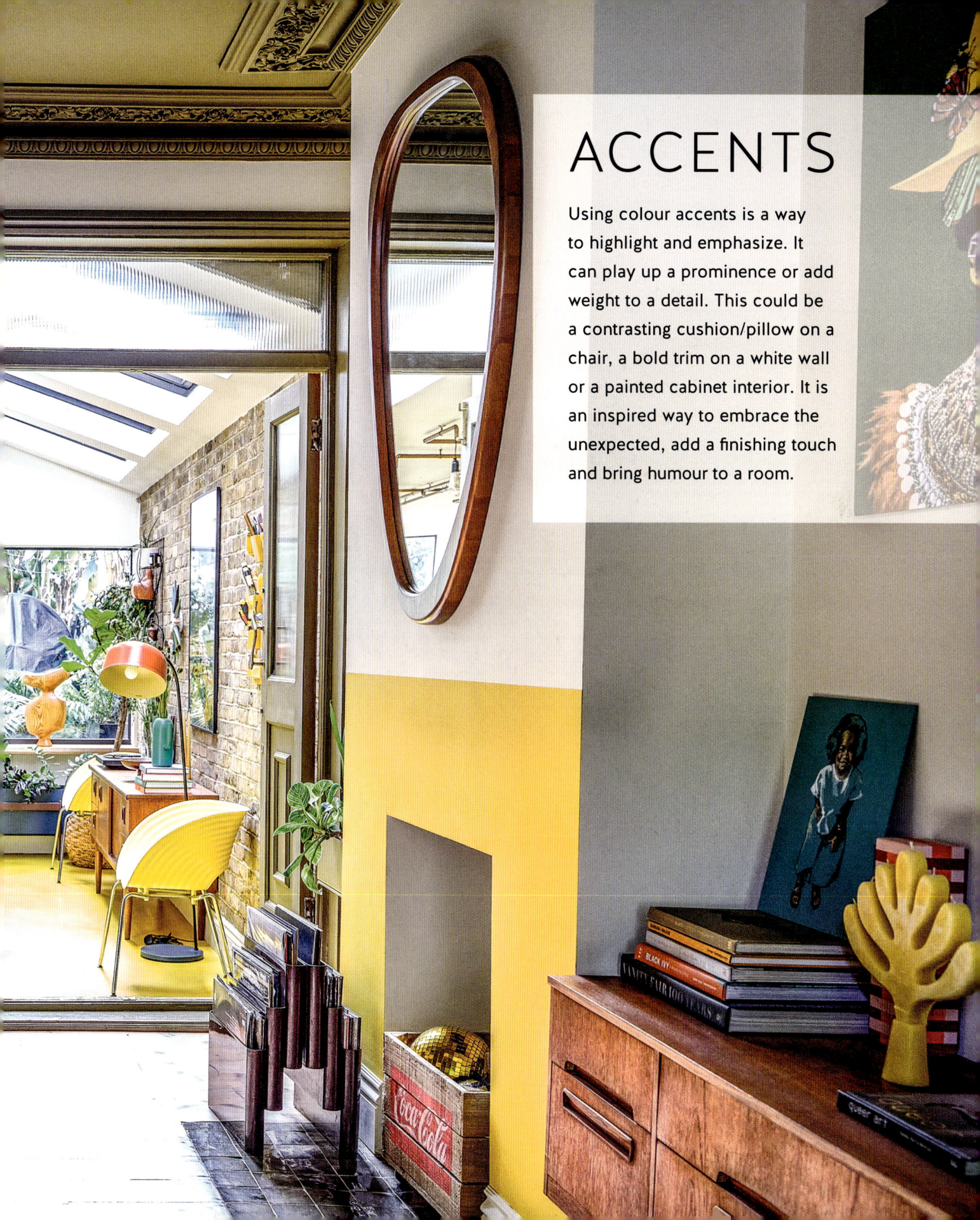

ACCENTS

Using colour accents is a way to highlight and emphasize. It can play up a prominence or add weight to a detail. This could be a contrasting cushion/pillow on a chair, a bold trim on a white wall or a painted cabinet interior. It is an inspired way to embrace the unexpected, add a finishing touch and bring humour to a room.

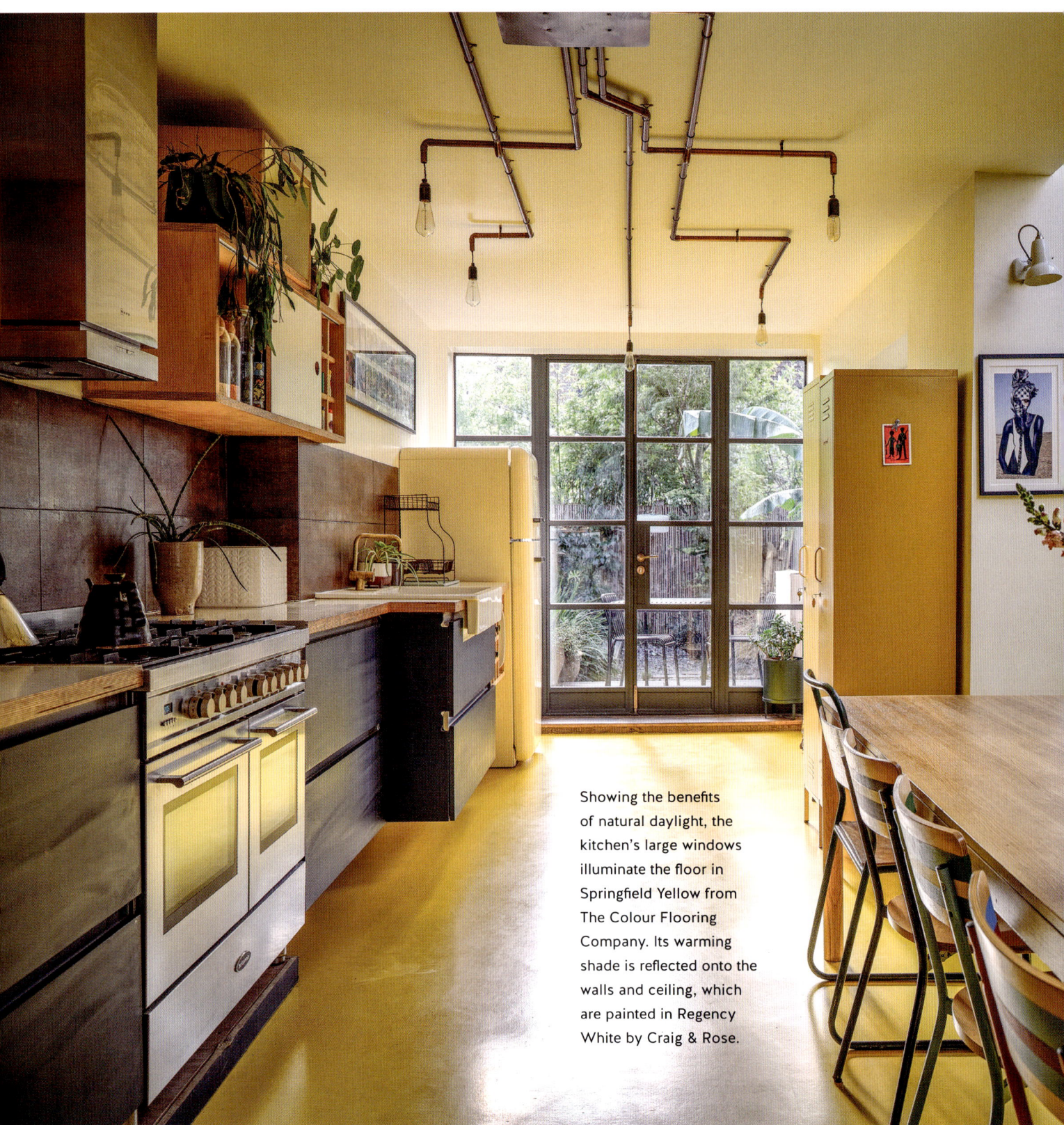

Showing the benefits of natural daylight, the kitchen's large windows illuminate the floor in Springfield Yellow from The Colour Flooring Company. Its warming shade is reflected onto the walls and ceiling, which are painted in Regency White by Craig & Rose.

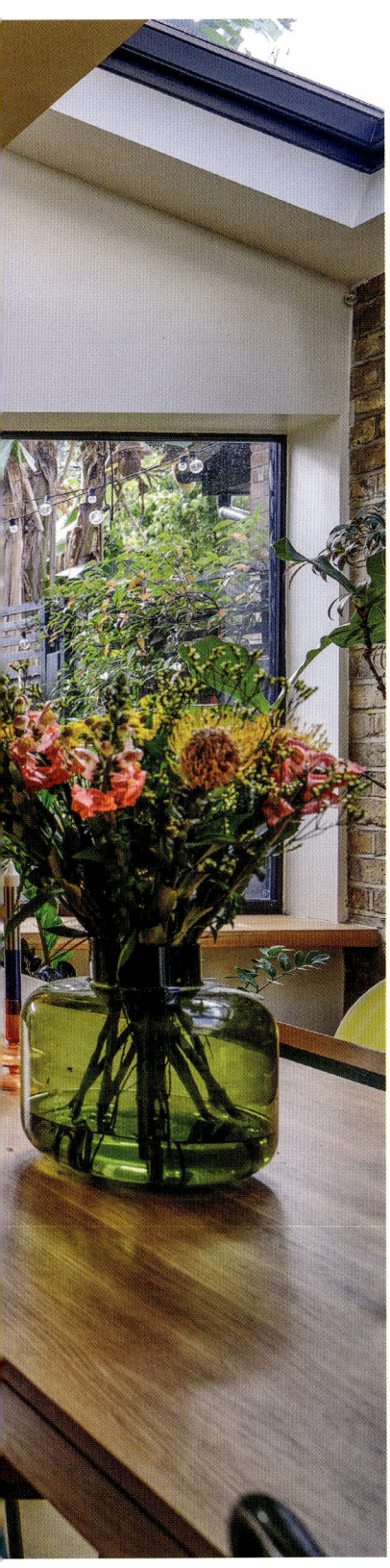

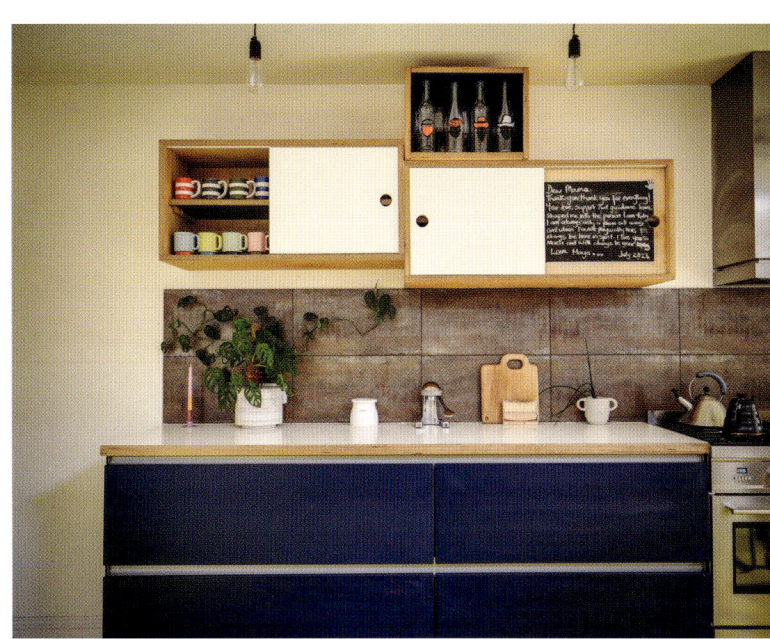

RIGHT
Natasha installed a mix of open and closed storage with sliding doors so that items can be displayed or hidden away as needed. White and navy cabinetry provides a smart contrast to the sunny yellow flooring. An earthy tiled splashback grounds the scheme.

INNER *rebel*

Creating a characterful home via colourful accents was an unscripted and organic experience for interior designer Natasha Landers, whose vibrant Victorian home in London is effortlessly crafted to demonstrate individuality and surprise at every turn. Tapping into her personal style and Caribbean roots, she has turned conventional room recipes on their head with a flair for the unexpected.

Natasha's home was always going to be a cacophony of colour, inspired by her early years and her mother's modern take on Caribbean interiors. Since then, she has brought in other influences from the arts, travel, wellness and nature, all of which have contributed feel-good hues to her palette. Greens, yellows and earthy shades have always been particular favourites and are now the mainstay of her home, appearing on many different surfaces. These vibrant colour blocks work alongside natural textures and materials to bring a comfortable and comforting feel to the space.

Many of the original 19th-century features had been stripped out of Natasha's home by previous owners.

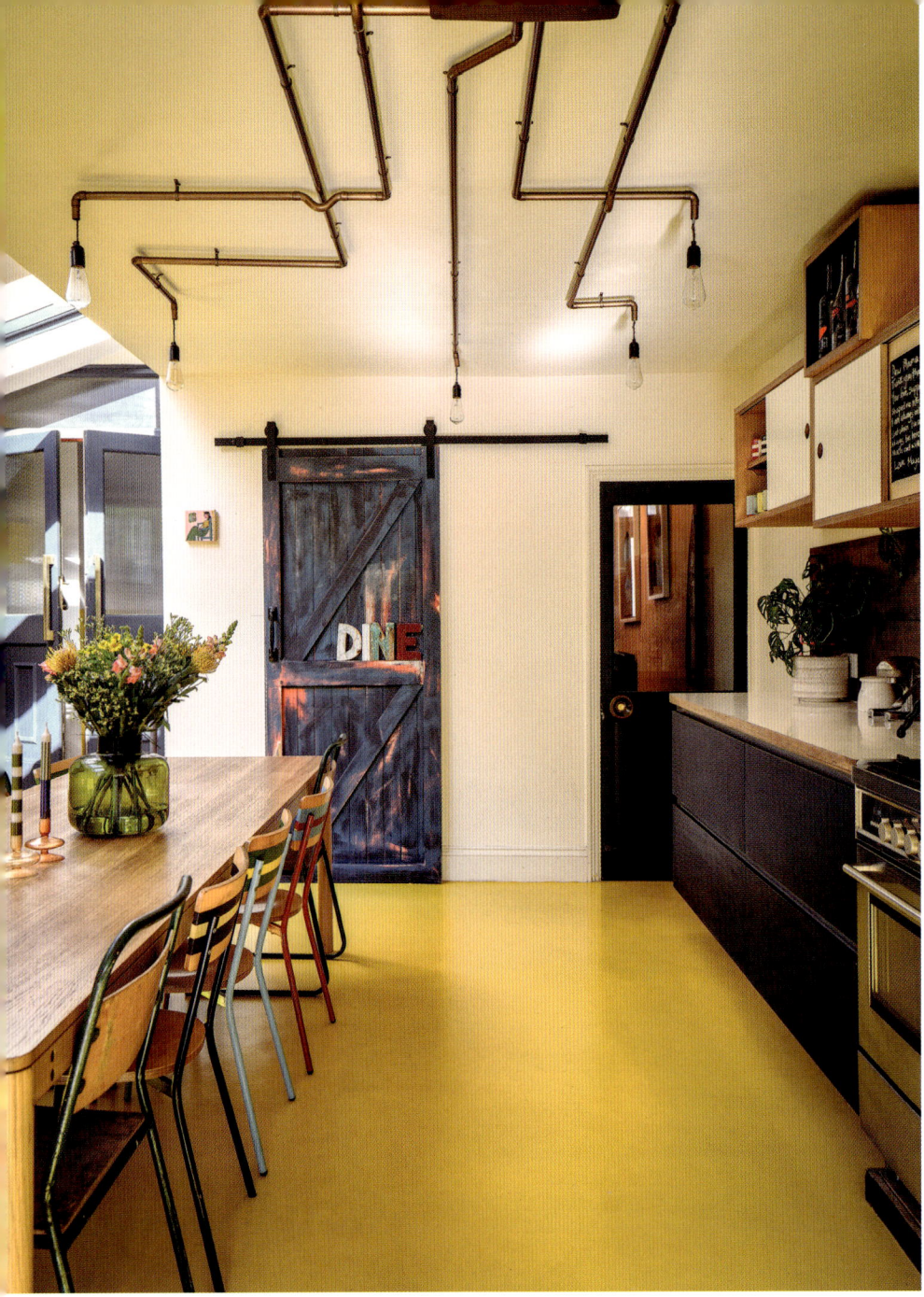

Restoring a sense of authenticity gave her the chance to be creative with every detail. She took a spontaneous approach, beginning the decoration without a clear plan and making decisions along the way. Her application of colour has been just as fluid and dynamic, and now takes the eye from the floor to the ceiling via a shutter, a door or a surface finish. Accents are used to highlight a room's identity and add a note of surprise.

Natasha's palette links different elements together, creating a cohesive yet unexpected design. Sometimes the ceiling provides the colour hit, while elsewhere she has boldly brightened the floor. Shaping and defining each area, three-dimensional blocks placed on corners, doorways and around walls lead the eye deeper into the house. Unrestricted by thresholds and boundaries, they flow from one room to the next like components of a unique art installation on permanent display. They highlight and mirror Natasha's many other collections of pictures and accessories.

Decorating via colour accents was a conscious choice, derived from Natasha's interest in fashion. Clothing has always been an outlet through which she can express her thoughts, feelings and identity, so it was only natural that she would take a similar approach to her home.

ABOVE
The dining table from Very Good & Proper is surrounded by mismatched vintage and high-street chairs. Natasha painted the new ones with accent stripes to lend them a personal touch.

PAGES 166 & 167
Natasha has used pops of yellow throughout her home with accent homewares and accessories. This chair from Vitra is lightweight enough to be easily moved from room to room (page 166). Here it finds an echo in a wall-mounted tool storage rack from House of BLOC (page 167).

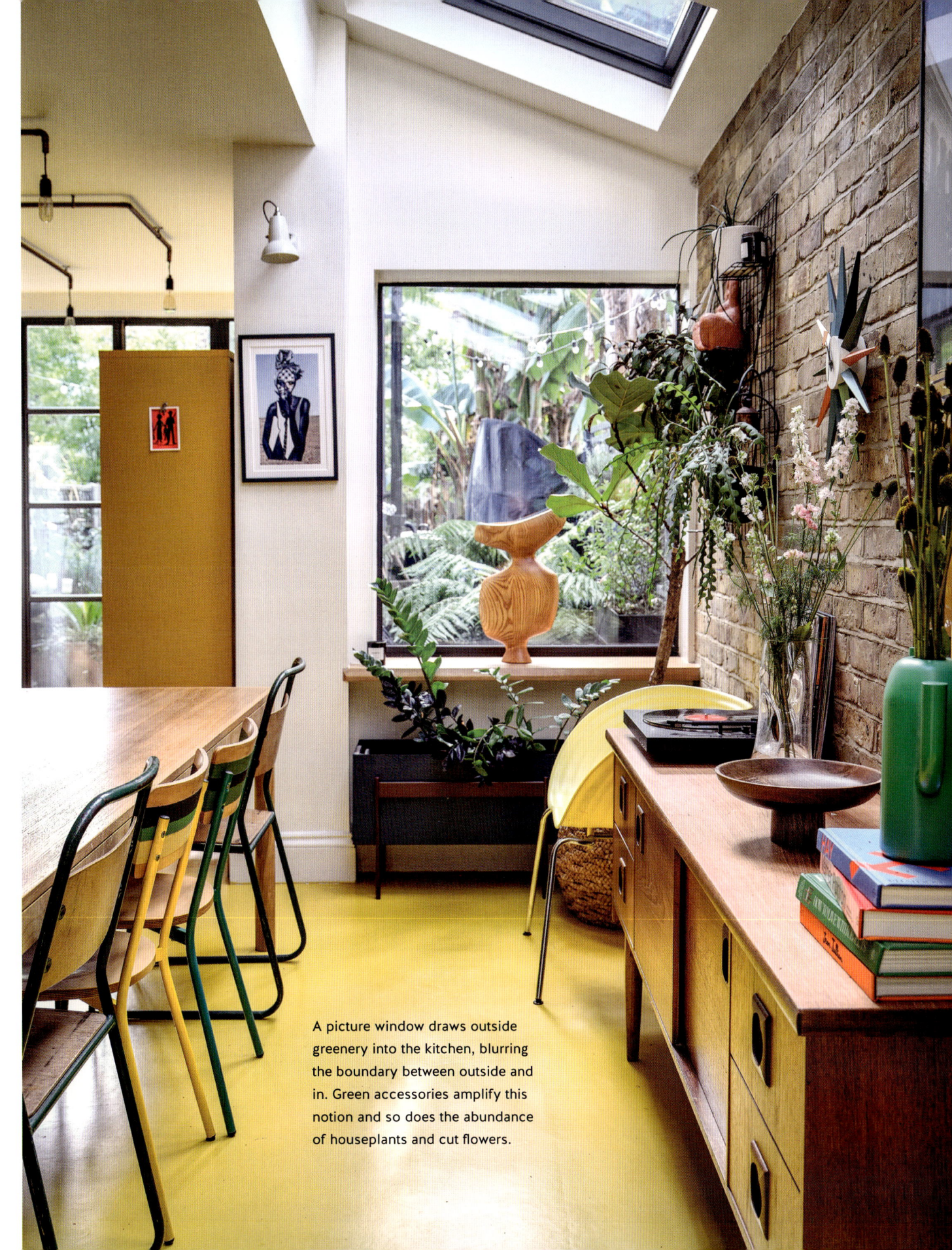

A picture window draws outside greenery into the kitchen, blurring the boundary between outside and in. Green accessories amplify this notion and so does the abundance of houseplants and cut flowers.

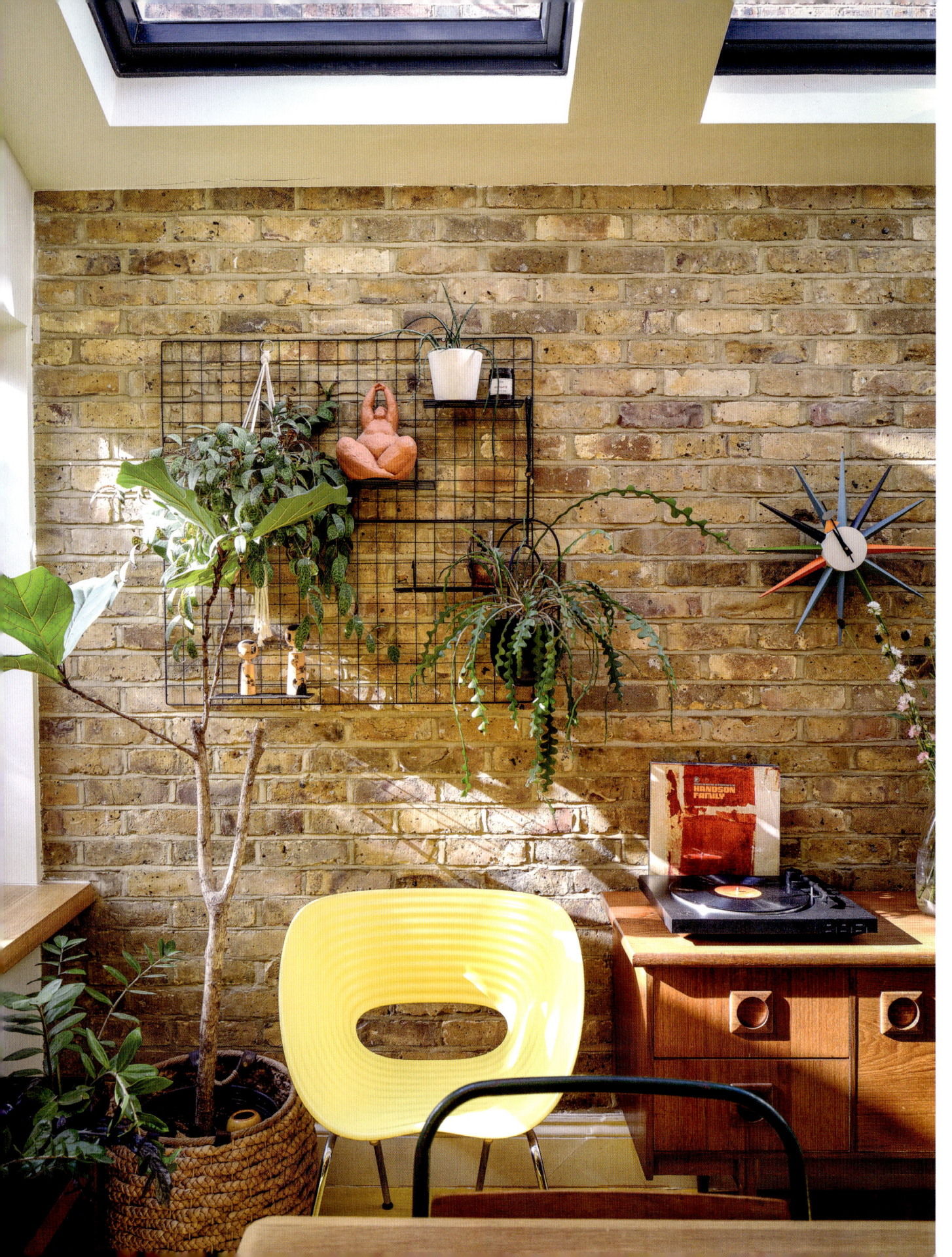

Each room has come together like the perfect outfit, with every piece chosen to suit the occasion and the mood of the space. When the season changes, new accessories can be added to refresh the look. With this in mind, Natasha has also chosen to use accent shades on small freestanding lamps, books, vases and other decorative objects. Easy to move around and update on a whim, these smaller homewares bring their own personality and are go-to updates for mood-changing moments.

As an interior designer, Natasha is constantly playing with ideas. Shopping from her home for a new look allows her to update without a repaint. The house is a testing ground where she can try out her schemes before she presents them to clients. Furniture and homewares can be refreshed, reupholstered, remodelled and moved around.

ABOVE
Expect the unexpected in Natasha's no-rules home, as accent shades cross surfaces without containment. Suggesting movement and shape shifting, this is a great way to disrupt plain walls and bring in creative charisma.

LEFT
Big and bold colour blocks are balanced by smaller details in subtle, sometimes hidden areas. Here, the doors between the kitchen and living room reveal a flash of pinky red only when open. The paint colour is Charlotte's Locks by Farrow & Ball.

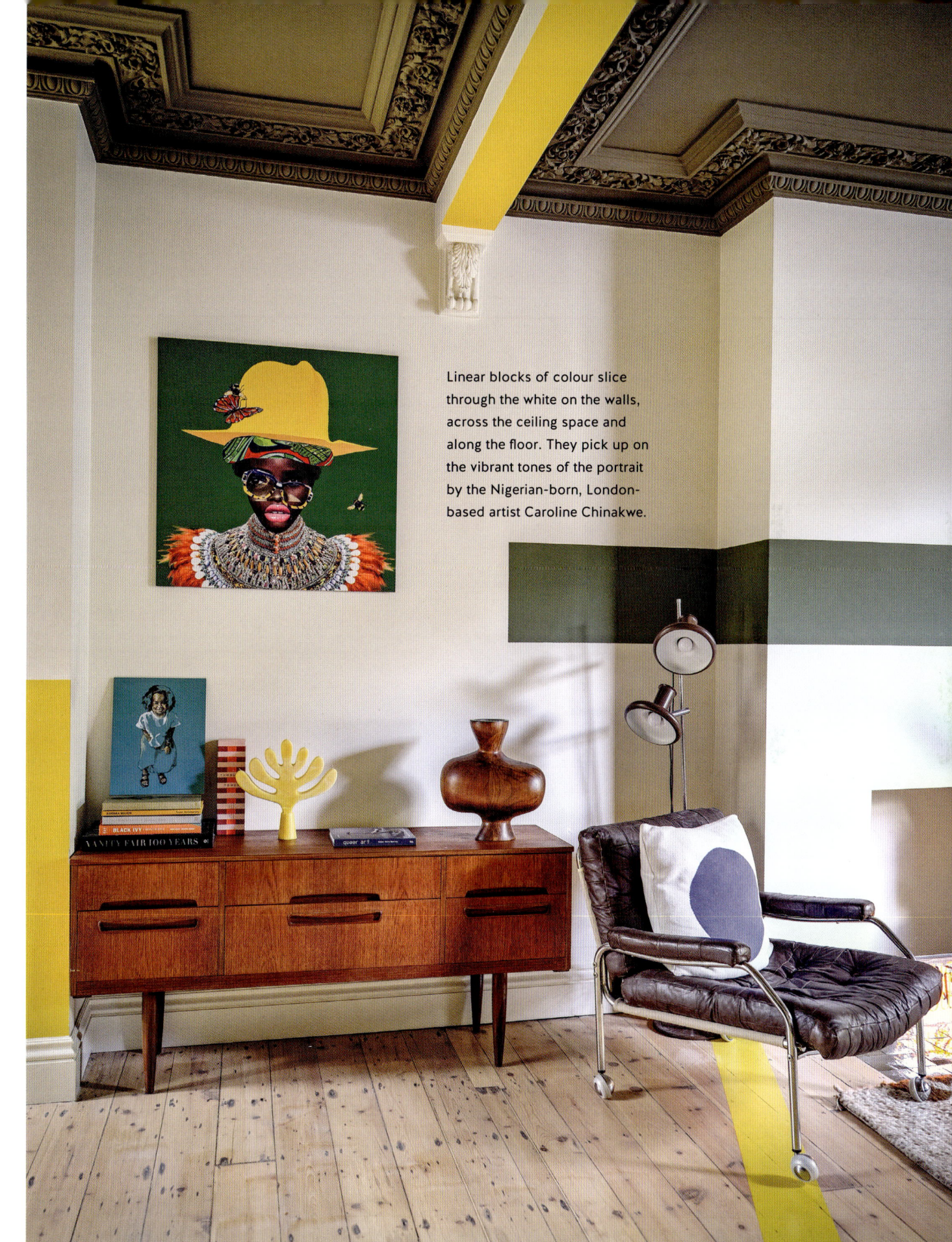

Linear blocks of colour slice through the white on the walls, across the ceiling space and along the floor. They pick up on the vibrant tones of the portrait by the Nigerian-born, London-based artist Caroline Chinakwe.

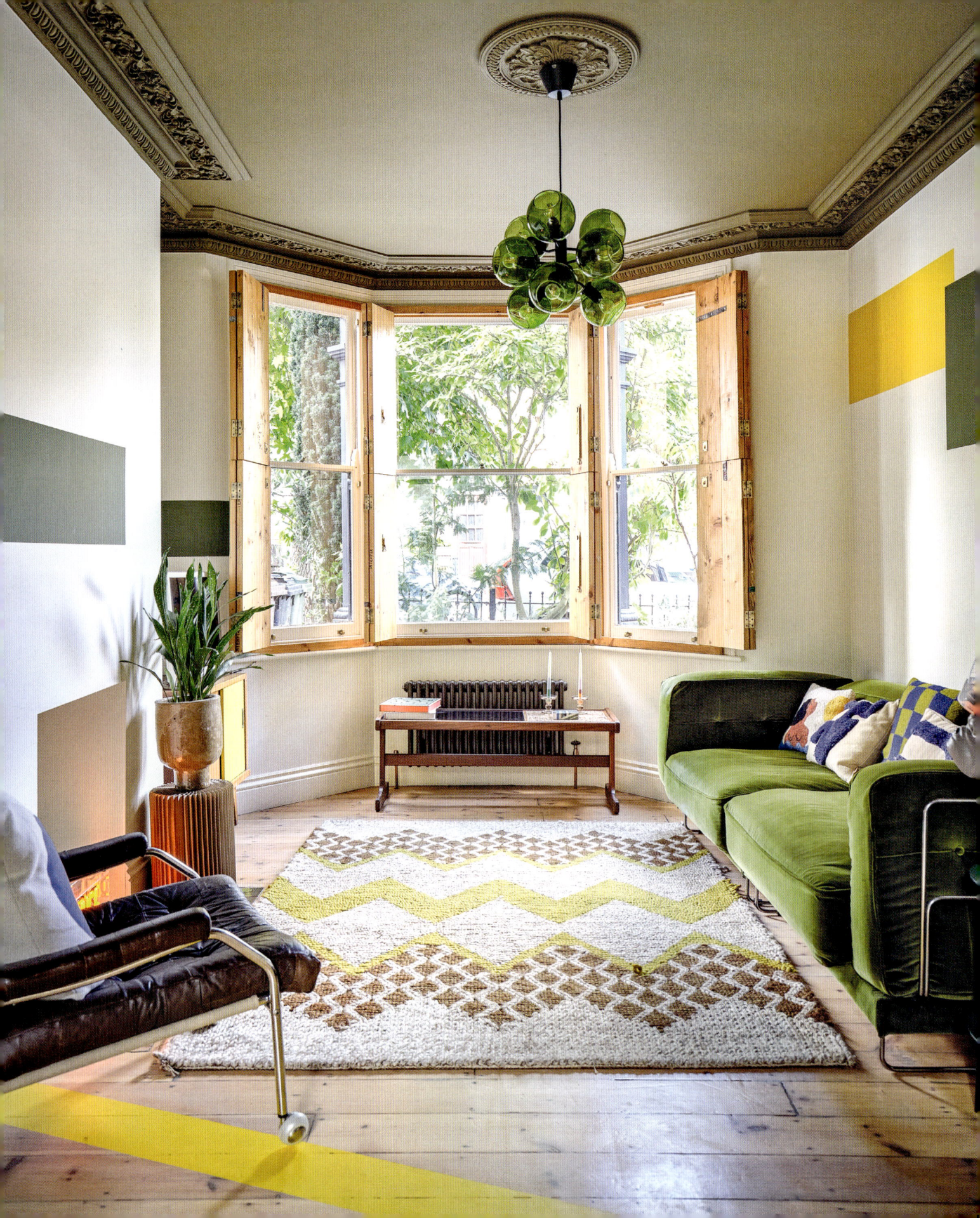

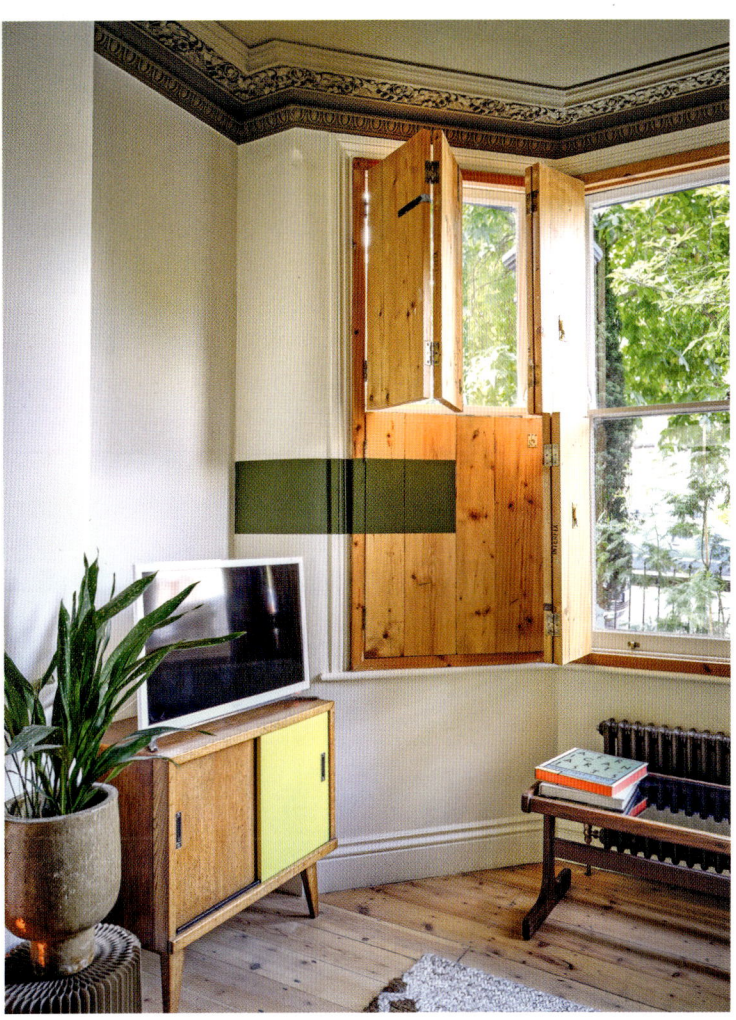

It's the perfect way to keep decor boredom at bay, not just for professionals like Natasha but also for renters or those who enjoy change and variety. Life isn't static and Natasha has mined this ability to move and keep up with the fast pace of life without overspending by rearranging the pieces she already owns.

Recognizing the link between light and colour, particularly in cooler climes, Natasha has opted for highly pigmented hues that glow even on the dullest London days. Important for mood and wellbeing, paints and dyes with premium recipes and high levels of pigment offer the best choice for year-round vibrancy. In the living room, the well-placed table and floor lamps react with the shades to bring atmospheric warmth. In the kitchen, the most used space, a sensational yellow floor fills the room with the suggestion of sunshine. On overcast days, the colour is gently uplifting, and in full sun it sings with warmth and happiness. The biophilic connection to the outdoors is enhanced by the view of Natasha's garden plants and greenery, so that the whole room feels hearty and health-giving.

OPPOSITE
A darker colour overhead, Light Bronze Green by Little Greene, draws the living room ceiling downwards for a cosy feel. The patchwork hues on the walls and floor are Mister David and Olive Colour from the same brand. The former is echoed in the Donna Wilson rug from SCP, the latter in the sofa and in the green glass pendant from Nordic Nest.

ABOVE LEFT & ABOVE
A wooden shutter allows control over the levels of natural light (above left). Together with the timber flooring and tiled hearth, it also brings warmth to the decor (above).

INNER REBEL 171

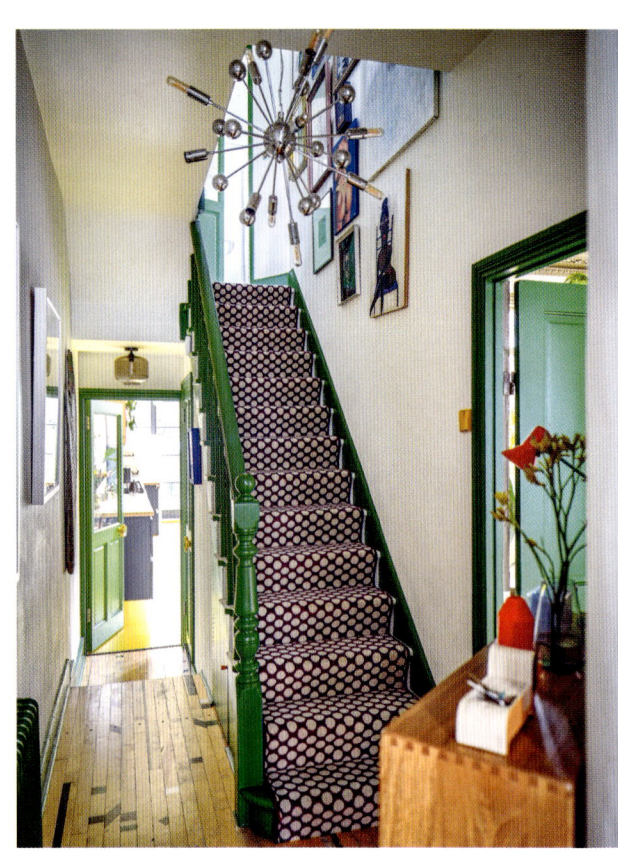

LEFT
White walls brighten the hallway. The flooring, reclaimed from an old gym, features broken-up court markings – these are scattered along the length of the space, creating their own freestyle pattern.

BELOW
Brilliant Green by Little Greene has been used along the hallway as a signature colour to mark entrances, exits and access routes, pointing where to go in Natasha's home.

OPPOSITE
Natasha has painted her bathroom a softer shade of green to aid relaxation at bath time. Houseplants provide living decor and biophilic benefits with their tonal foliage.

While it is mostly plain, matt shades that provide the backdrop to her home, Natasha has explored elements of texture and pattern to shake things up. The rubber flooring and glossy door paint offer a special sheen against the luxury and timeless feel of flat matt. Small repetitions bring a subtle change of pace to define and underline.

One of the cleverest tricks Natasha has brought to her home is knowing how to source and style the smallest details, using her artistic eye so that the results are tailored to her taste. High-end sits next to high street and antique next to upcycled. There is no need for matching sets or an abundance of designer labels. Going with what she loves and making her own place rather than following the pack, Natasha's strong visual identity has given her the freedom to break as many rules as she dares.

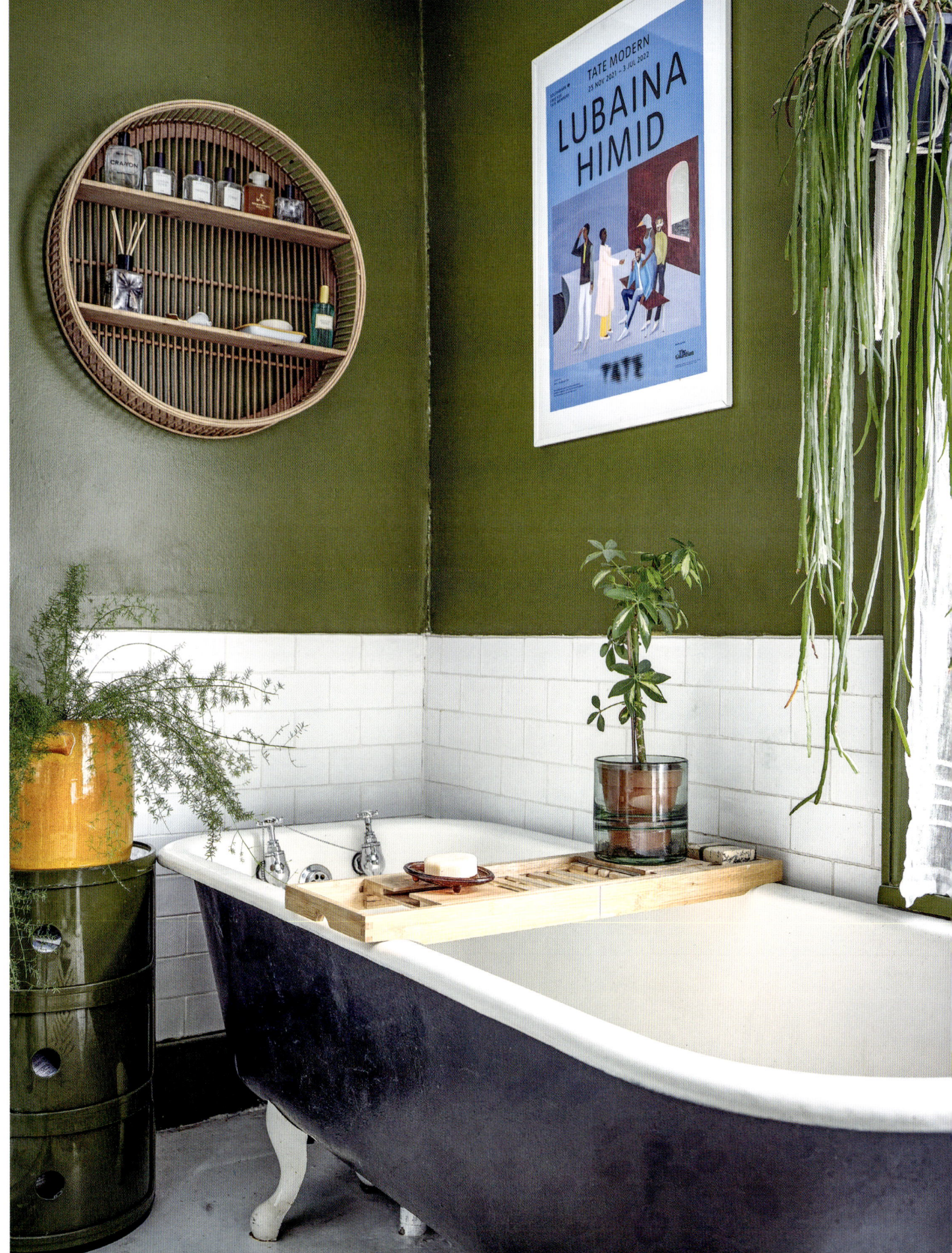

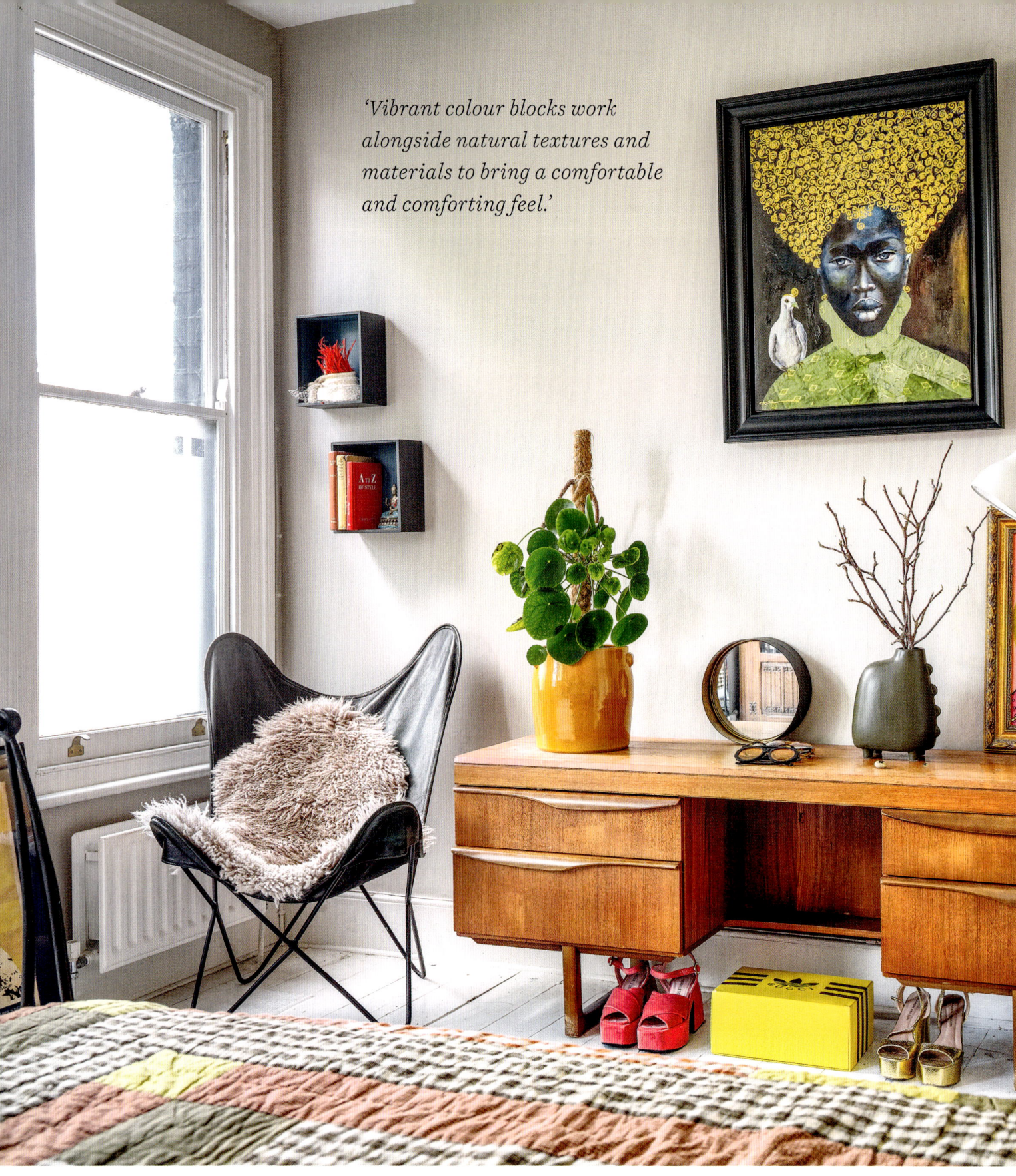

'Vibrant colour blocks work alongside natural textures and materials to bring a comfortable and comforting feel.'

THIS PAGE & RIGHT
In a contrast to all the bold colour downstairs, Natasha has chosen a restful and calming palette for her bedroom (this page). The very palest greyed pink shade, Elephant's Breath by Farrow & Ball, has been used for its misty and soothing quality. It is also a grounding hue for eclectic homewares and fashion accessories, some of which are displayed on the dressing table/vanity (right).

BELOW
Contrasting colours provide a vibrant clash in this sunny back bedroom belonging to Natasha's daughter. The walls are painted in Light Gold by Little Greene. The blue cabinet is from Hits The Light.

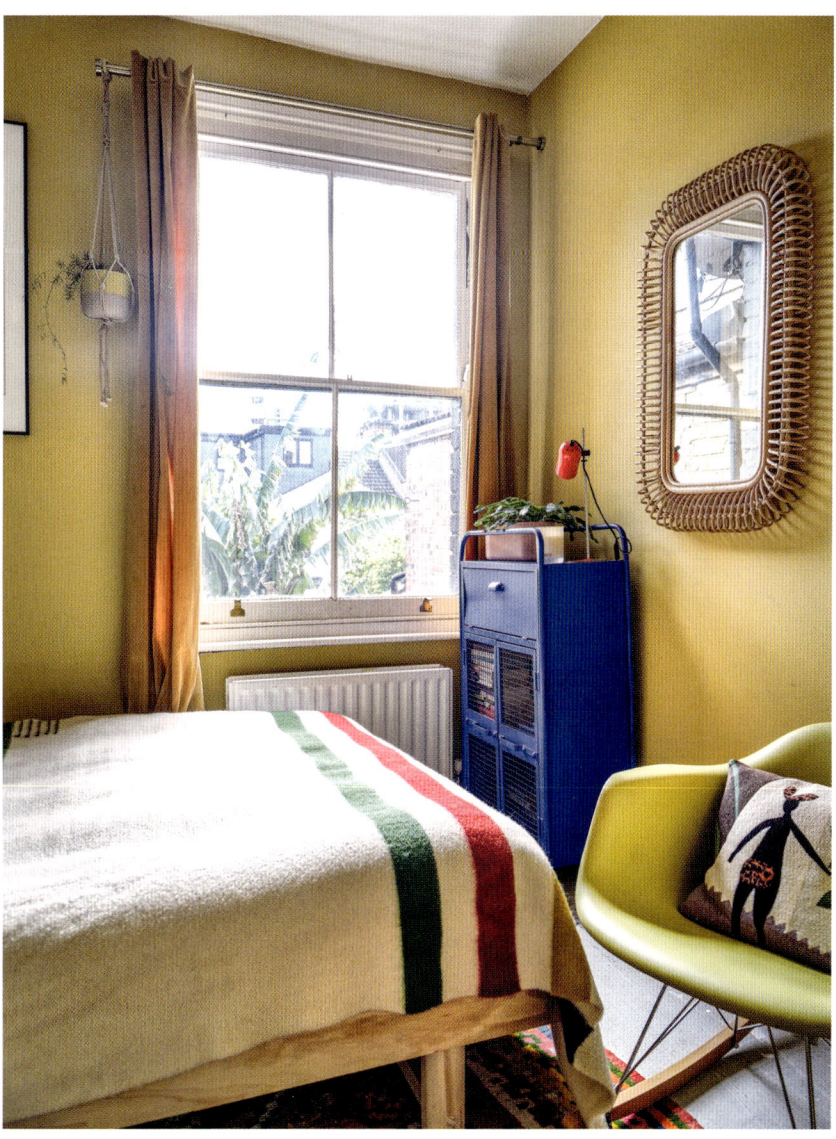

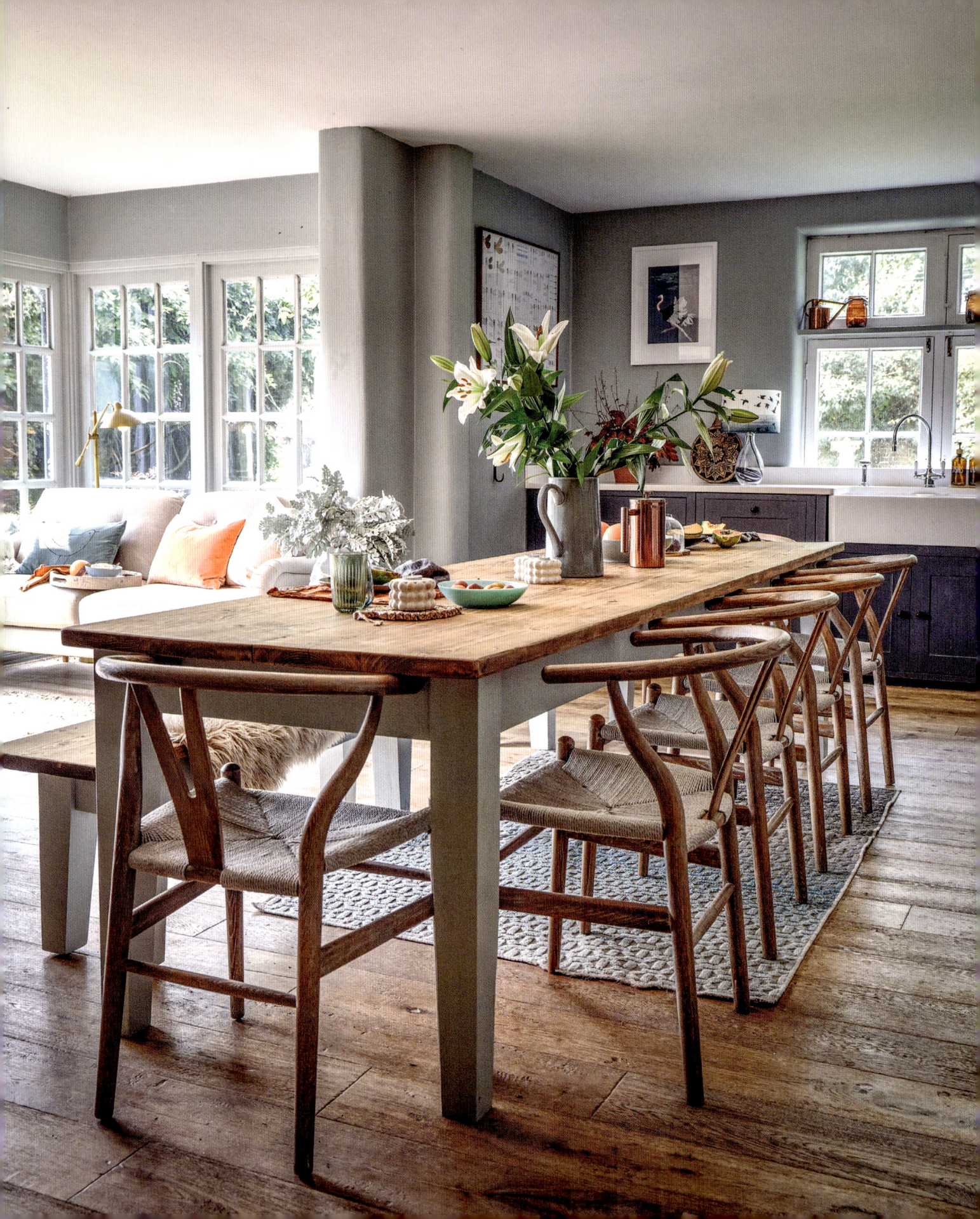

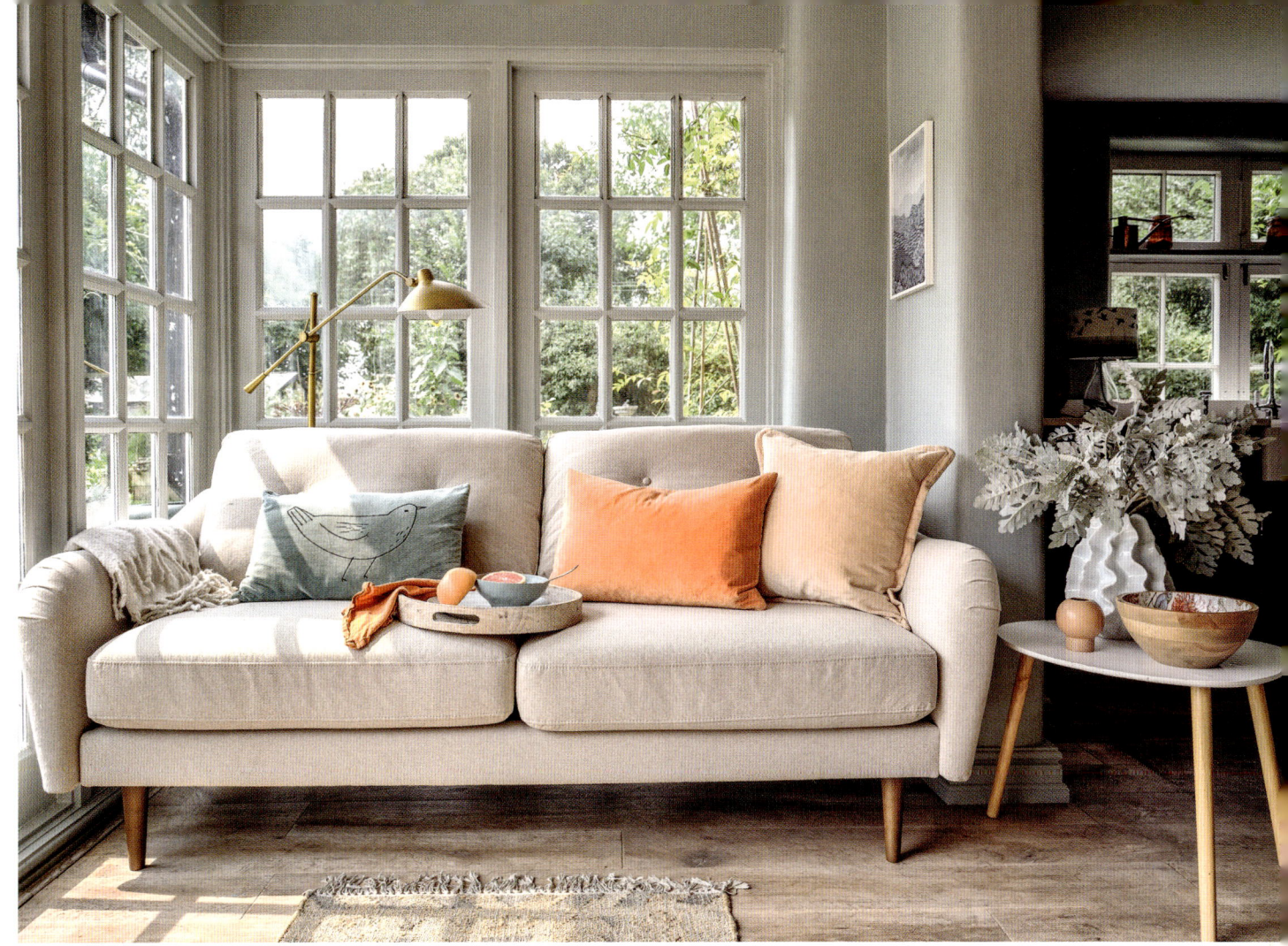

COLOURFUL *care*

In rural East Sussex, colour expert Anna Jacobs and filmmaker Andrew Ruhemann have combined simple style solutions and expertly crafted details to create a peaceful and nurturing haven for family and friends. Skilfully illustrating how to create a restful retreat so soon after move day, they have used well-honed decorating habits to speedily and soulfully make a mindful home to share with their loved ones.

OPPOSITE
A central table connects the family sitting room and kitchen. Blues dominate, with complementary orange highlights dotted throughout to connect both sides of the open-plan space.

ABOVE
Natural light dances over a sofa from Snug, which is perfectly positioned in a sunroom corner with windows on two sides. Turquoise, orange and peach-toned cushions/pillows from high-street brands enliven the neutral upholstery.

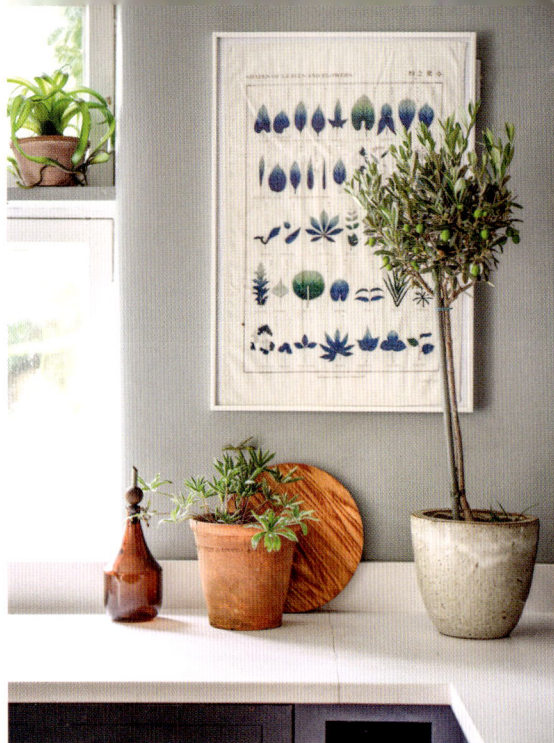

ABOVE
Anna has plenty of plants in her home. In the kitchen, herbs and miniature fruit trees have a practical purpose and also bring their scent and colour to the space.

RIGHT
Having inherited a perfectly useable Neptune kitchen in a colour that did not suit her chosen palette, Anna repainted the cabinets in Charcoal from the same brand. The wall colour is Museum by Mylands.

Designing a beautiful and considered home in a new environment is always a balancing act, especially if you want to establish a backdrop that will evolve gradually over time. However, thanks to Anna's well-honed eye for interiors, it did not take long after she and Andrew moved in for this house to become a soulful home. Planning the new interior scheme and creating a personalized feel-good palette became a collaborative experience for the entire family to share.

Surrounded by trees, ponds and a prairie-style paddock, the house has a natural indoor-outdoor ambience. To ease the transition from new home to forever space, Anna chose to delicately blend these landscape colours with firm family favourites. Field and forest hues create a direct biophilic connection with the countryside beyond and sit comfortably with much-loved green-blues and earthy oranges – a combination that is warm, soothing and inviting.

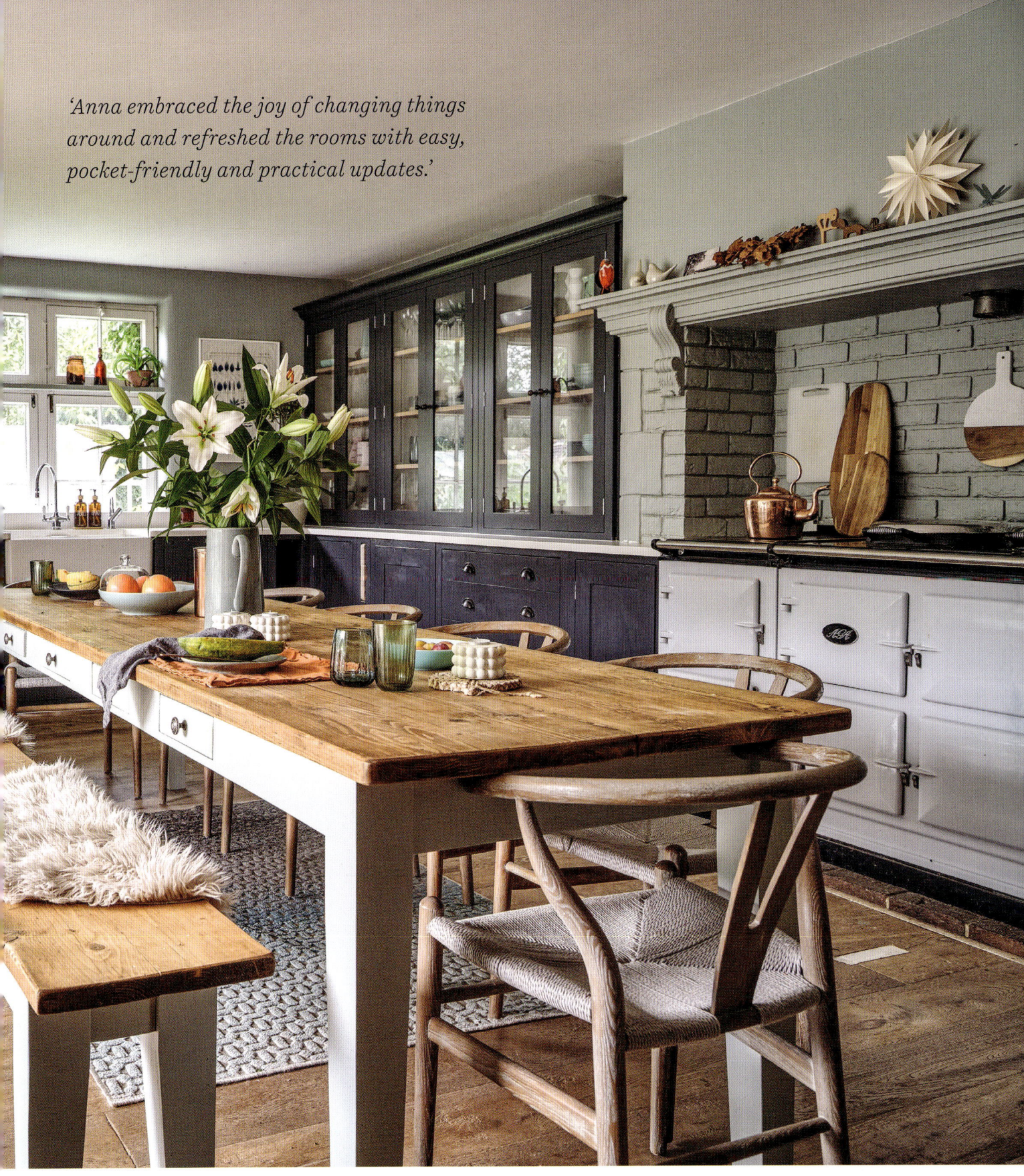

'Anna embraced the joy of changing things around and refreshed the rooms with easy, pocket-friendly and practical updates.'

BELOW
Anna has painted an organic plant mural on one of the walls. The foliage almost appears to move, suggesting growth and a biophilic connection to nature. The painted stems emerge from a real terracotta pot, but this vessel can be moved or replaced.

RIGHT
Anna's home is located within a pond and prairie landscape, which is filled with all kinds of wildlife. This is something that she was keen to illustrate inside the home with murals and other artworks. Watery blue-green walls are a further link to the outside world.

BELOW RIGHT
Behind closed doors, the pantry has been given a textural feel with a plaster-inspired paint finish. Anna created her own shade by mixing colours from Farrow & Ball and Craig & Rose.

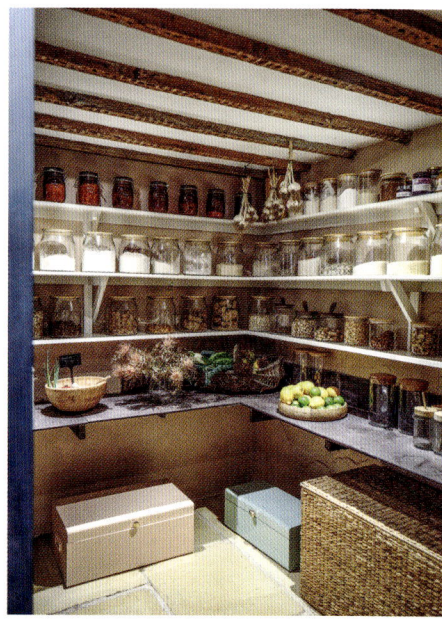

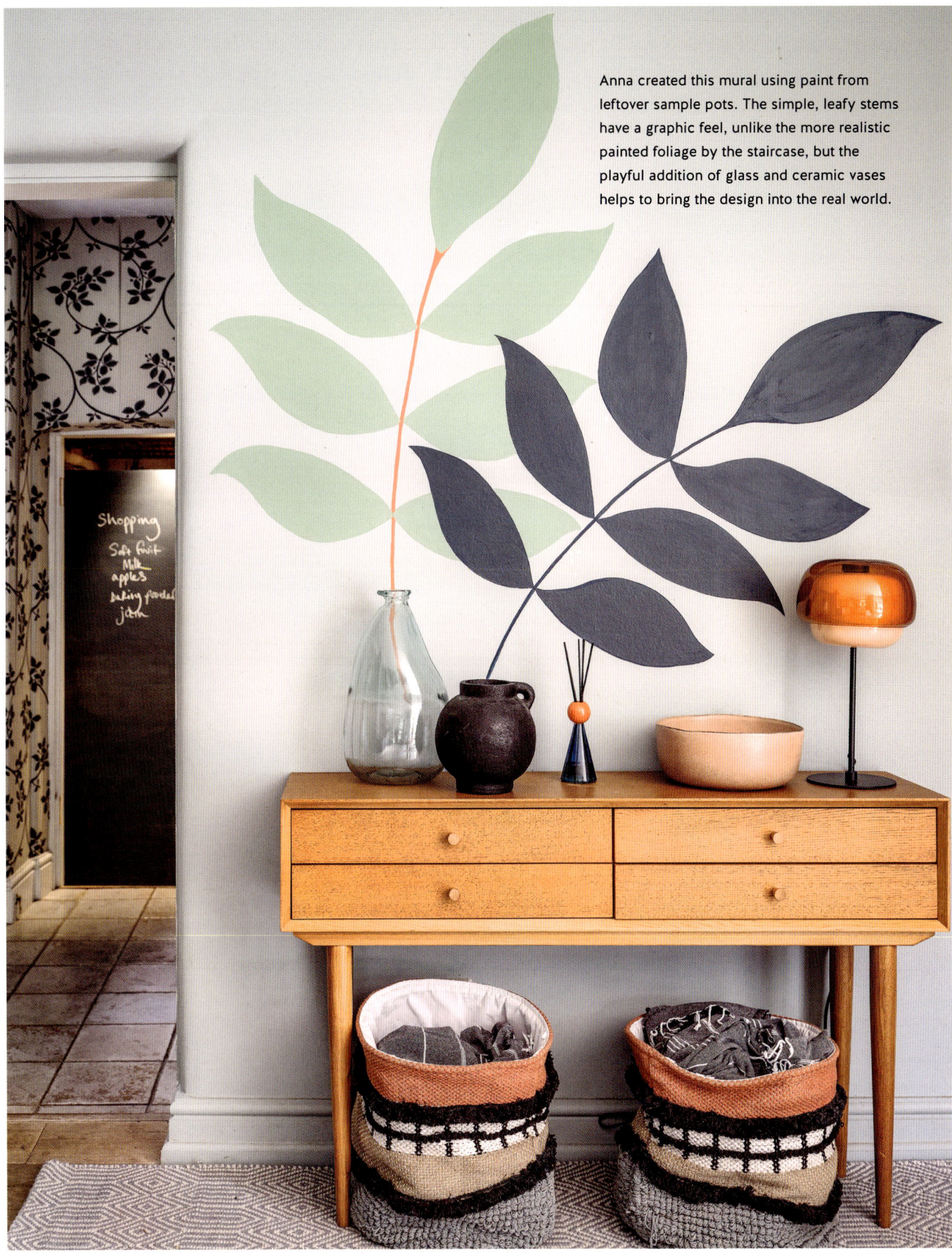

Anna created this mural using paint from leftover sample pots. The simple, leafy stems have a graphic feel, unlike the more realistic painted foliage by the staircase, but the playful addition of glass and ceramic vases helps to bring the design into the real world.

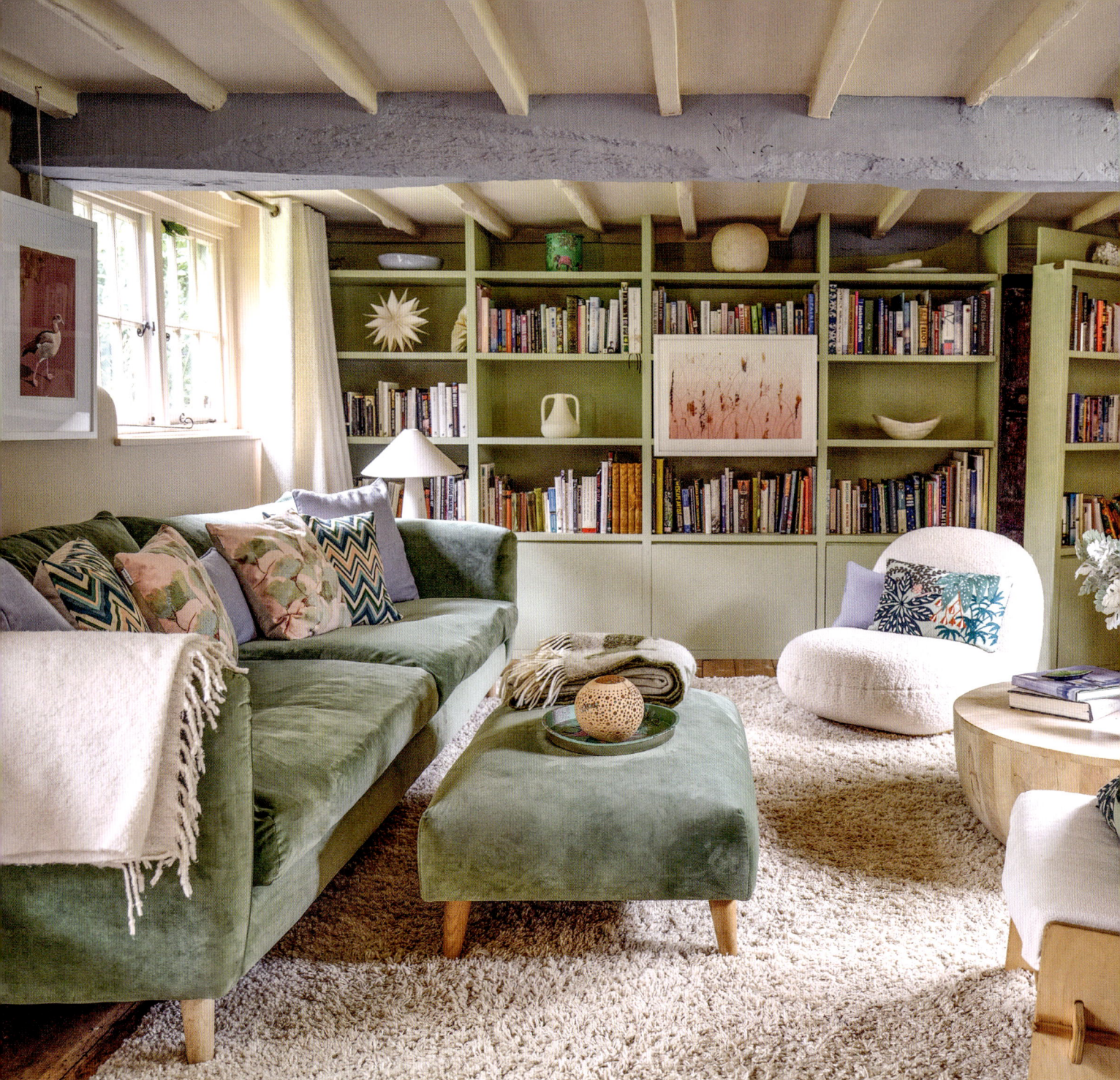

Anna has used colourful accents throughout to bring structure and spirit to the scheme. Wall surfaces have been broken up with bands of colour blocking, while ceiling beams introduce shaded stripes overhead. These fragments of different hues add pace, definition and a hint of the unexpected when you enter each room. The house was destined to be a retreat for a wider audience as soon as the moving boxes were unpacked and friends began to visit, so these moments of discovery can be experienced by everyone who walks through the door.

LEFT
Anna has made bold choices elsewhere in her home, but the main living room has a calming pastel palette. Greens and soft pinks prevail on furnishings and fittings. Textiles draw from both shades to create a cohesive colour direction, with warmer corals seen on cushions/pillows, paintings and book bindings.

RIGHT
On the walls not covered by bookshelves, Setting Plaster by Farrow & Ball provides gentle warmth in the daytime. Come evening, the colour leaps into life as the fire is lit, reflecting glowing ember shades back into the room.

BELOW
Anna has added a freestyle fresco with sculptural details under the side window. To create a similar design, try using large floral stencils or relief mouldings.

COLOURFUL CARE 183

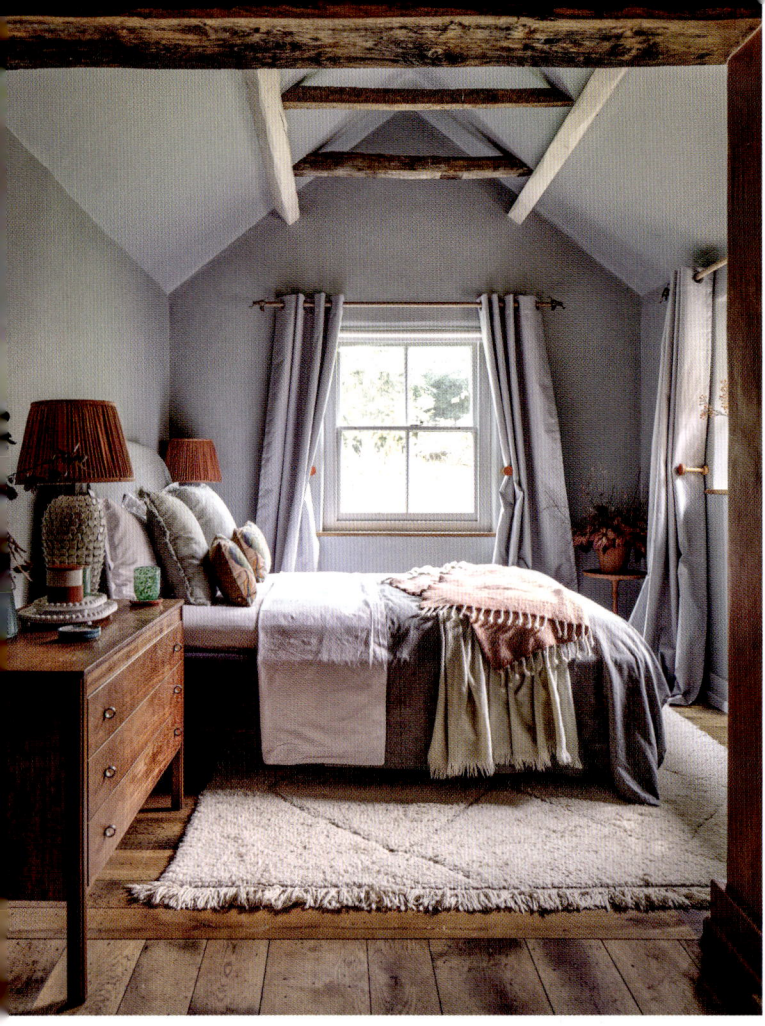

Colour psychology and natural light both came into play with the creation of the main palette. The house mostly faces east, south and west, with the light lending itself to a warm and cheery mood. Anna took her time to observe the orientation of each room in relation to the sun to pick the best shade. Easterly rooms enjoy serene early daybreak moments, so calming green hues prevail, whereas westerly spaces are reserved for golden tones that glow at sunset. The two boutique-chic guest bedrooms have been immersively drenched in green and blue respectively, giving each its own identity and presenting an instant and cohesive colour splash for guests to enjoy.

OPPOSITE
Decorated to align with the adjacent bedroom, the guest ensuite offers a shared colour experience with a rich palette of blues and oranges. The copper bathtub adds to the luxury spa experience, especially with a Tropical Bellewood wallpaper mural by Rebel Walls as its backdrop.

ABOVE, RIGHT & FAR RIGHT
This beautiful and calming downstairs bedroom at the back of the house is a sublime escape for guests to retreat to (above). Pastel blues cover the walls and ceiling, which were painted in Museum by Mylands, and are also seen on the bed linen (right). On one side, a wall painted in Red Sand by Dulux Heritage frames the entrance to the ensuite (far right).

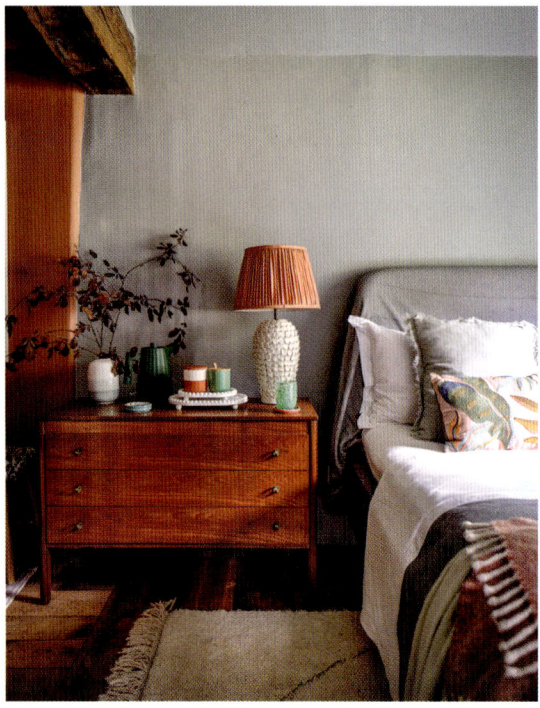

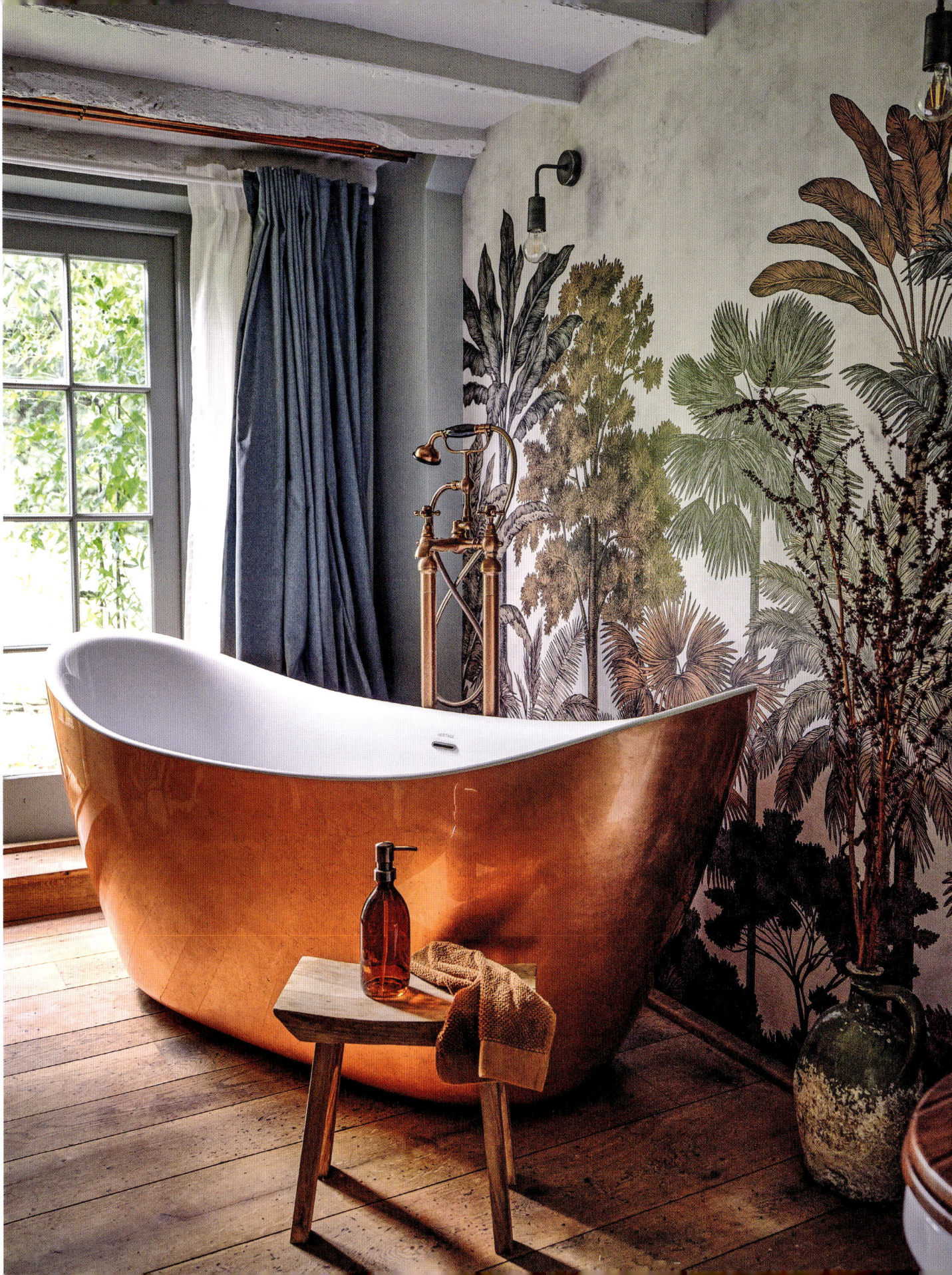

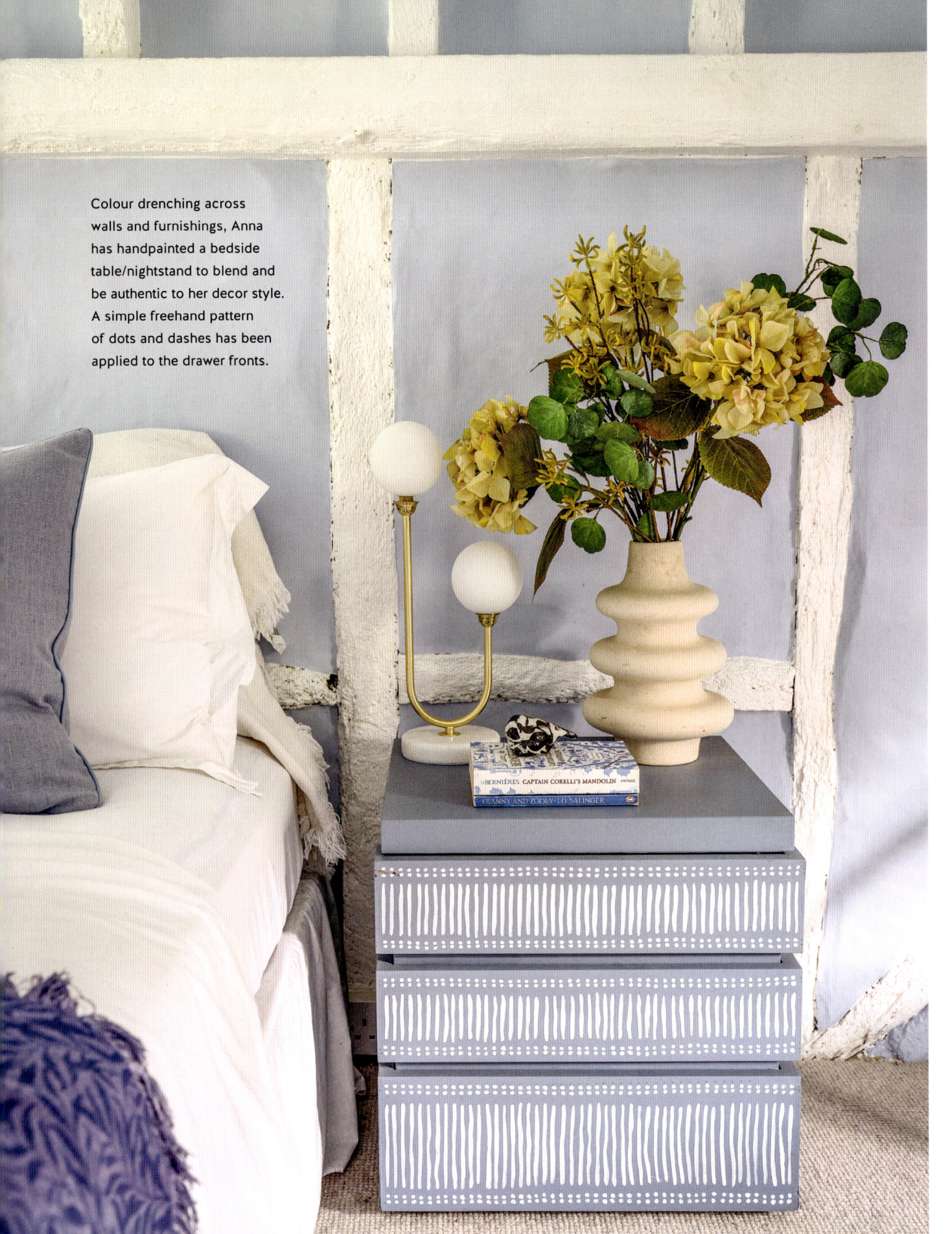

Colour drenching across walls and furnishings, Anna has handpainted a bedside table/nightstand to blend and be authentic to her decor style. A simple freehand pattern of dots and dashes has been applied to the drawer fronts.

ABOVE
The beams in the bedroom have been painted white to contrast with walls in Atlantic Surf 5 by Dulux. Showing how period features can sit alongside modern furniture, they provide a foil to the Acapulco-style chair in a deeper shade of blue.

RIGHT
Anna has chosen tonal shades throughout in the bedroom, with foliage reflecting the seasons in a changeable display.

Practicalities aside, Anna has made sure there is plenty of playfulness dotted around the home. Wanting the space to feel instantly familiar, she also employed some tricks she had picked up along the way when living in rented housing. As a tenant, she had learned to put down roots via decorative updates, which brought a sense of fulfilment and creative expression even in a temporary setting. In this new space, Anna embraced the joy of changing things around and refreshed the rooms with easy, pocket-friendly and practical updates. These included small-scale surface treatments and pops of colour such as repainting cabinet doors, creating a feature wall, installing a panel or arranging personal treasures on open shelving.

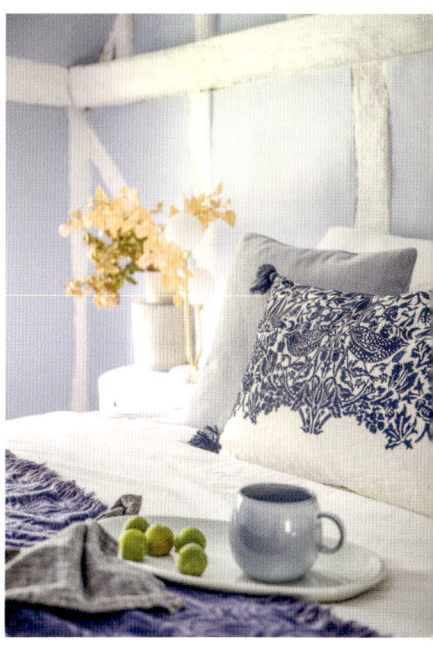

COLOURFUL CARE 187

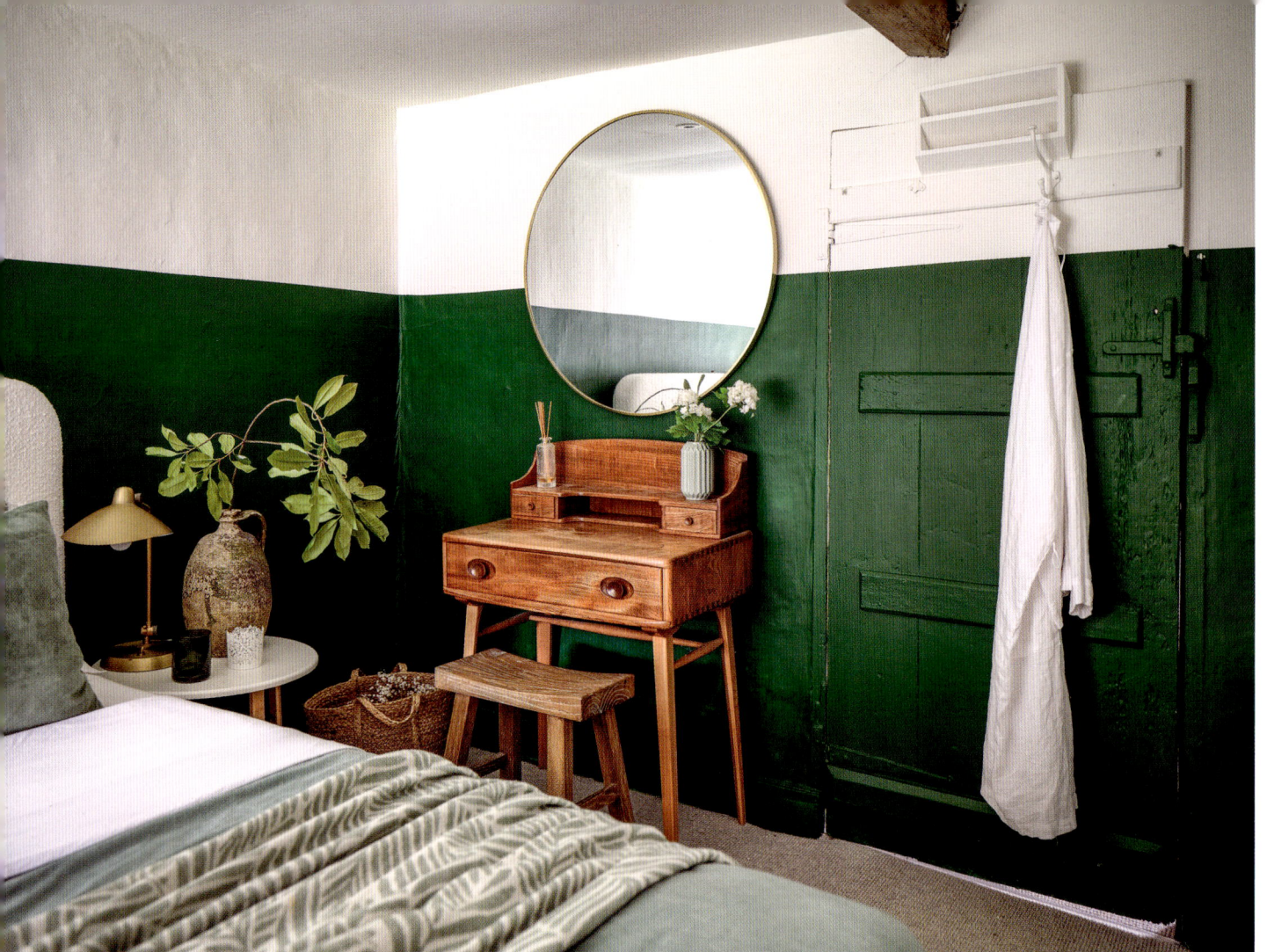

The couple both have a background in visual storytelling and the house has a creative flow and lyrical rhythm throughout, with charming details, uplifting moments and the odd surprise. The romance of not knowing what is around the corner not only raises a smile but also heightens the experience of walking from room to room. Travel, wildlife and bird images can be found as painted motifs. Foliage murals applied by hand bring movement and dynamism to the scheme and colour is used to draw the eye to unexpected vistas, adding layers of descriptive detail.

At this point in time, Anna has set up a slow-living haven with speedy success for all to enjoy. With cathartic colour at its heart, her home is a retreat for friends, family, children and pets to disengage from everyday life. Anna herself is living mindfully in the present, but already setting her sights on the next chapter of the decorative transformation. Her home has warmed to change and offers peace with every tonal transition.

ABOVE
In this guest room, a mix of Forest Green and Pine Green by Dulux has been used on the lower part of the walls to anchor the space. The small wooden desk is a mid-century modern design.

OPPOSITE
To retain a natural element, the beams have been left in their original light wood finish against the green and white paintwork. The feeling in the room is deeply connected to the outside world, with a refreshing note that sits well with changing landscape outside.

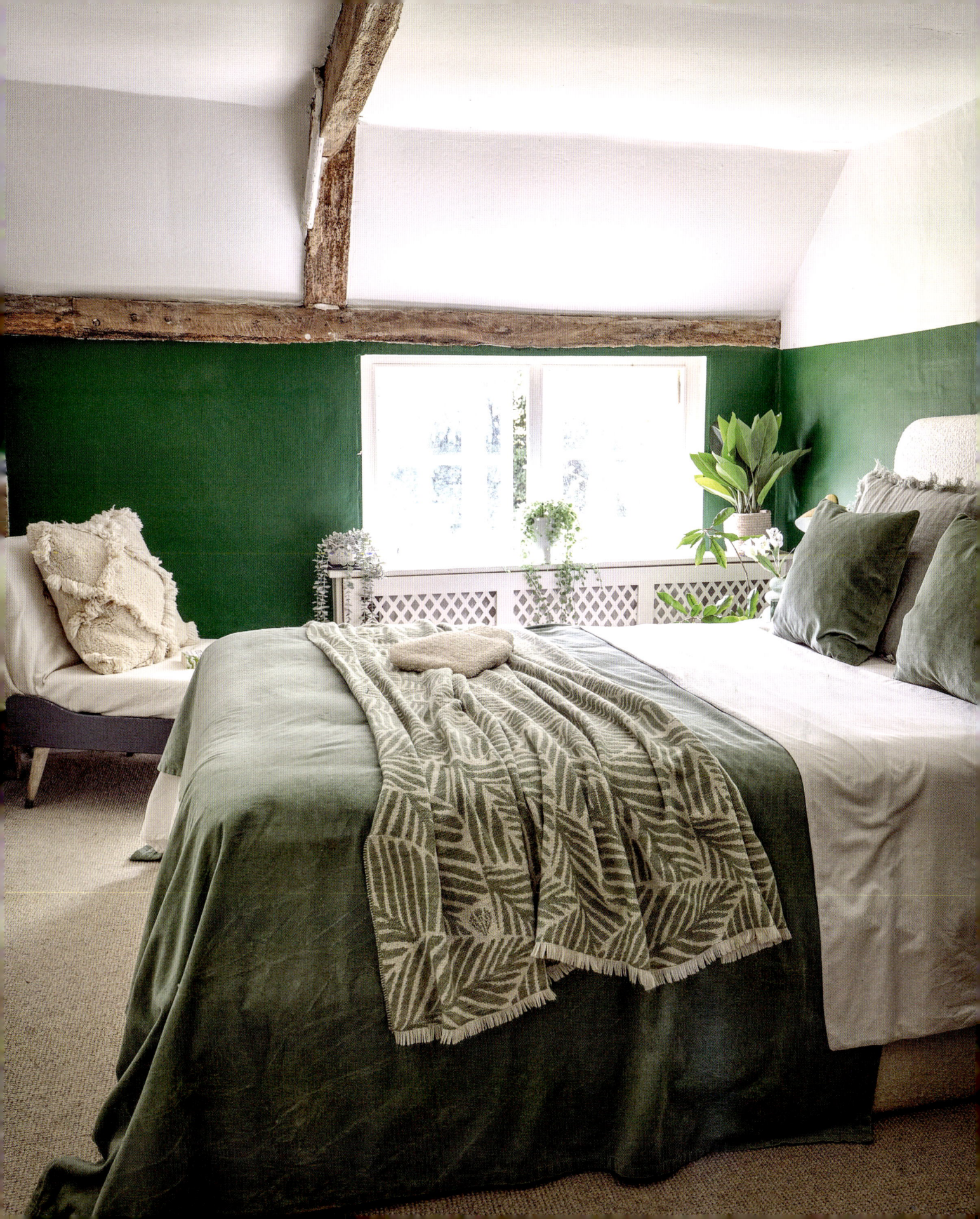

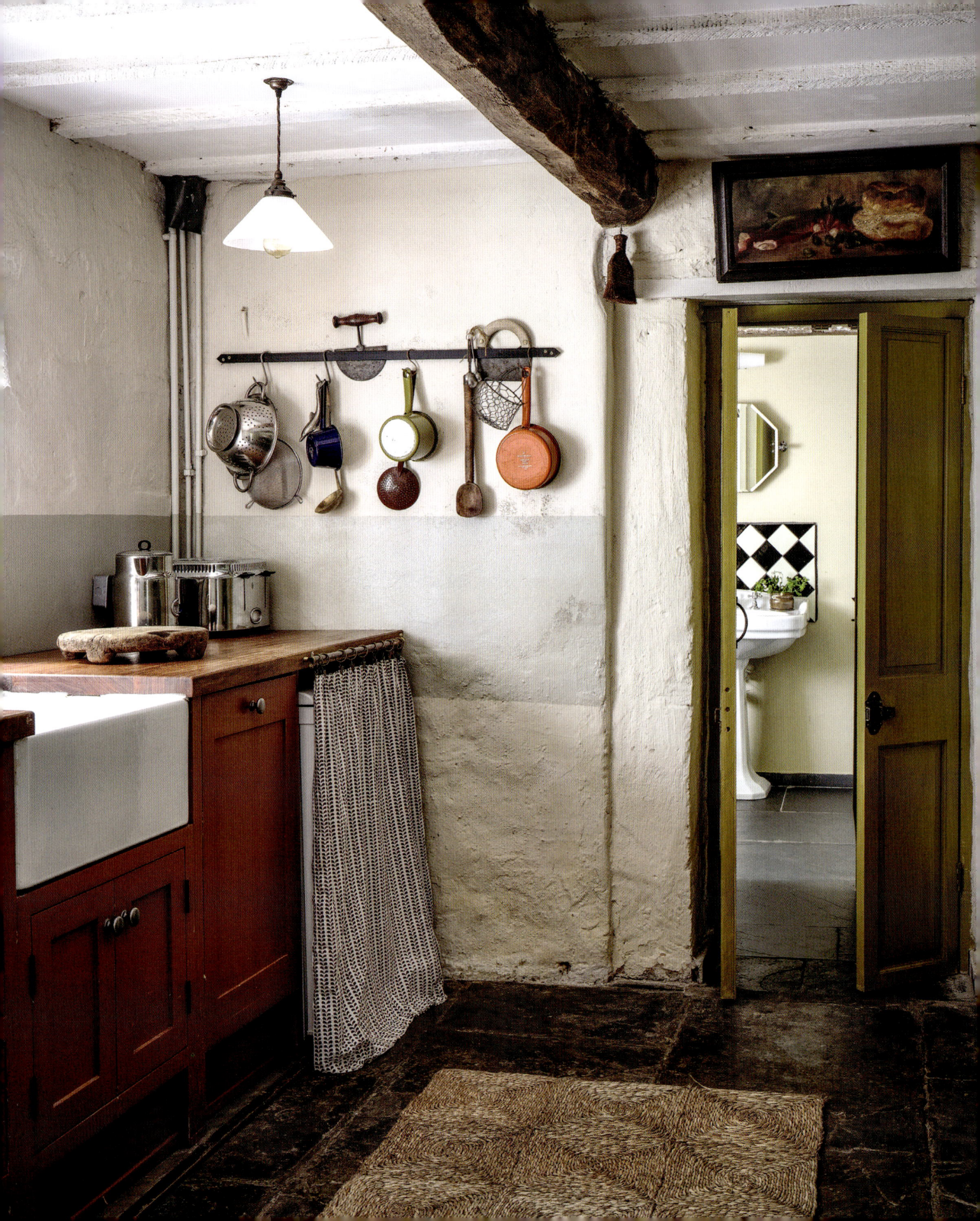

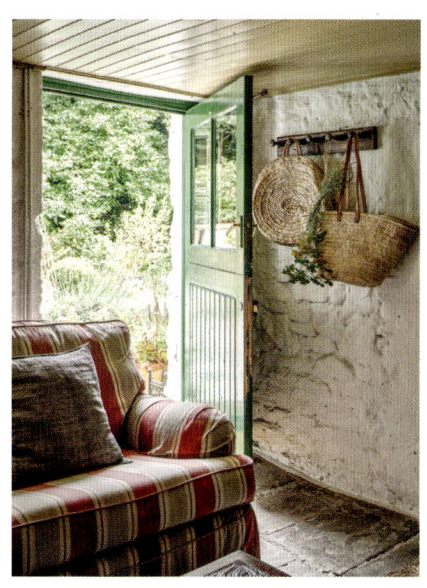

OPPOSITE
To highlight the traditional plasterwork in the cottage kitchen walls, Hayley has painted the walls in lime-based colours. The powdery matt finish lends a textural note to the dappled surface. A slight shift of colours along the wall creates the illusion of a splashback around the sink. This simple colour blocking is a great way to designate a functional space – choose a washable kitchen paint for the most durable finish.

LEFT
Vivid green paint on the front door creates an evocative connection to the world outside. It extends a fresh and inviting welcome across the threshold.

BELOW
The kitchen also incorporates a farmhouse-style dining table surrounded by rustic chairs. A white fabric pendant shade overhead brings in a note of cottage charm and whimsy.

FLYING *colours*

Celebrating the character found in their charming former mill in Wales, Hayley Caradoc-Hodgkins and Leo Todd have cleverly connected different floors and features by peppering their home with uplifting hues.

Positioned in a peaceful riverside setting, Hayley and Leo's holiday hideaway is a picturesque collection of old buildings in the heritage-steeped town of Abergavenny. It is a heart-warming place, with stunning scenery in easy reach and the restful sounds of the River Gavenny running past outside. Inside, rustic textures and artisan crafts are perfectly paired, but it is the skilful application of a folk-inspired colour scheme running throughout that makes the unique decor such a delight.

The former mill has been sensitively converted and repurposed to create a welcoming three-storey retreat that is sympathetic to its humble beginnings.

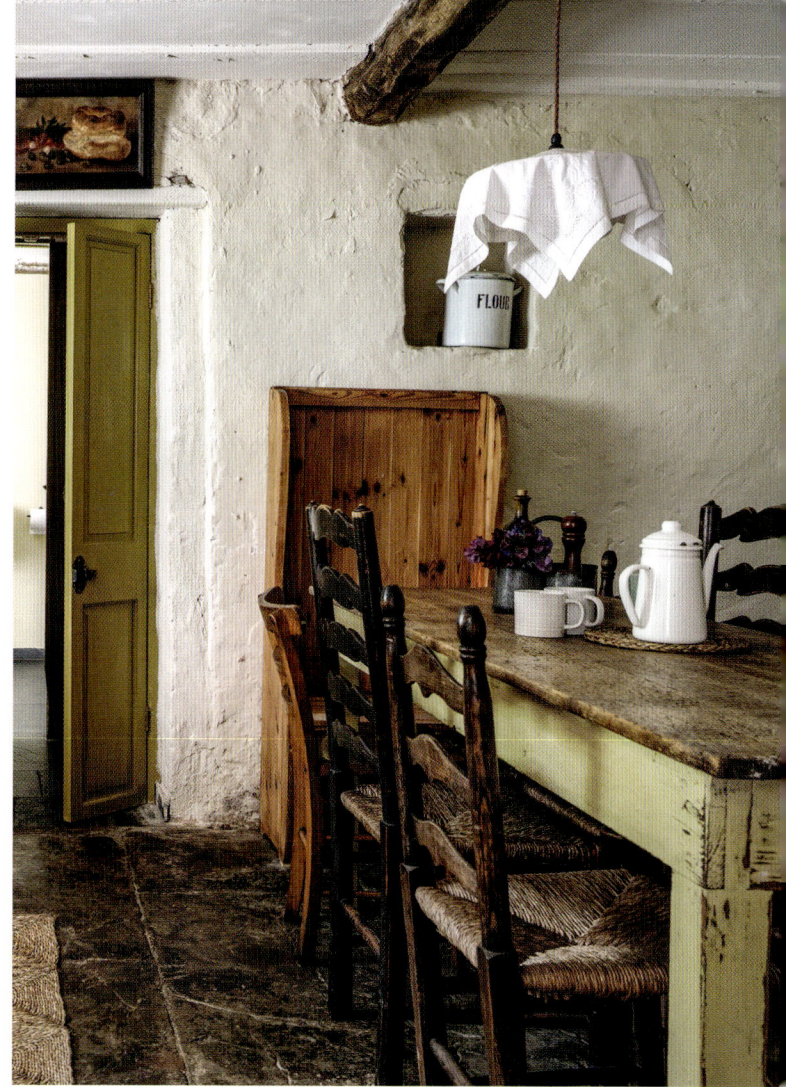

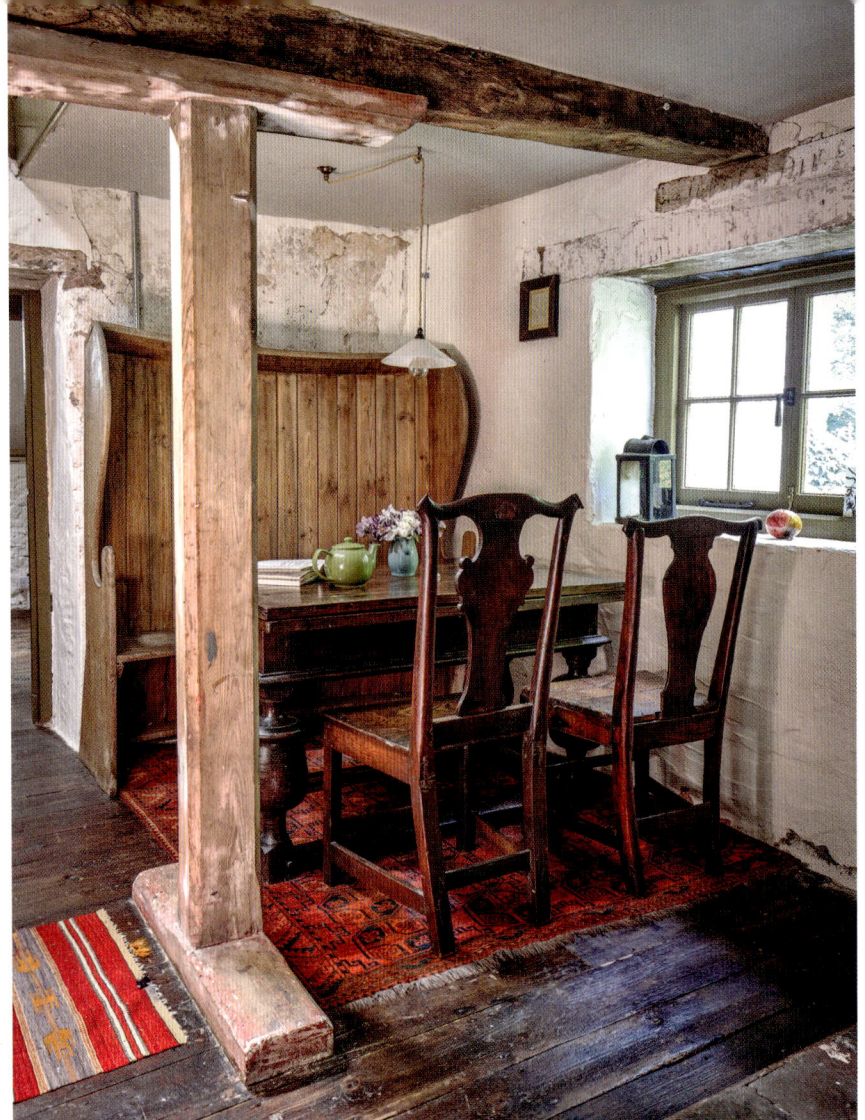

LEFT
A jolly rug on the floor holds court to mark out just enough space for a table and chairs in this cosy window nook, which harmonizes with the warmth and texture of the original beams.

OPPOSITE
Simple colour blocking, accents from nature and timeless styling bring out the humble character of the home. Every detail has its own charm: open shelving, undercounter curtains, collected ceramics and copper kitchenalia. Celebrating the practical and seasonal brings a wealth of wonder to a home, bestowing a magical lived-in quality.

'The pastoral palette with simple cottage and folk-inspired styling makes for a year-round creative holiday retreat.'

Certain areas of the property can be arranged and configured so as to feel separate from the main living space, yet everything remains connected thanks to the distinctive accents running throughout.

Drawing inspiration from the age of the property, parts of which date back to the late 17th century, the couple opted for a muted mid-tone palette to bring a timeworn and authentic feel. From the moment you step over the main threshold, through a green doorway inspired by the surrounding forest, different shades subtly take you on an interior journey. More doorways provide a processional experience, with a series of decorative frames enticing and drawing you further inside. The romantic effect is heightened by the fact that entrance to each room is slightly offset. Finished in different shades, the paint pleasingly wraps around both sides of the door before closing behind and revealing the next surprising hue.

The rooms take striking decoration in their stride, with monochromatic tiling, bohemian rugs, cottagecore patchwork and pastoral stripes all sitting comfortably together. Wood cabinetry and boarding is also a vehicle for colour throughout the mill, with each plank and panel being used to anchor decorative elements into the design. In the children's room, bespoke wooden bunks have been painted a rich shade of brown for a cosy bedside nook. In another bedroom, vivid green flooring suggests nature underfoot.

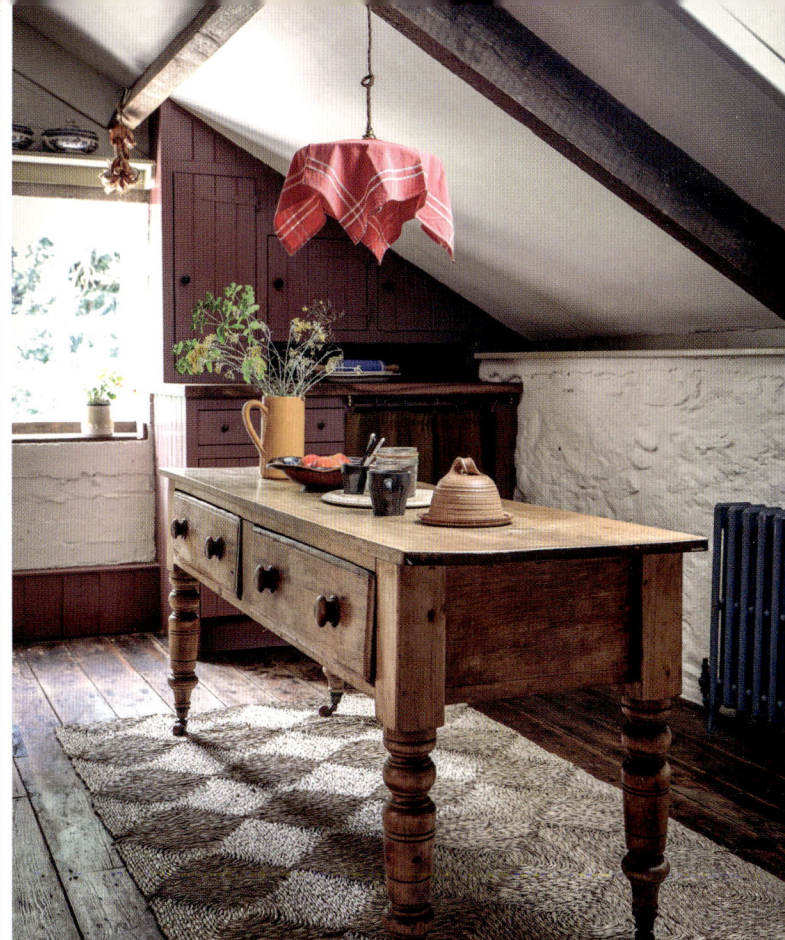
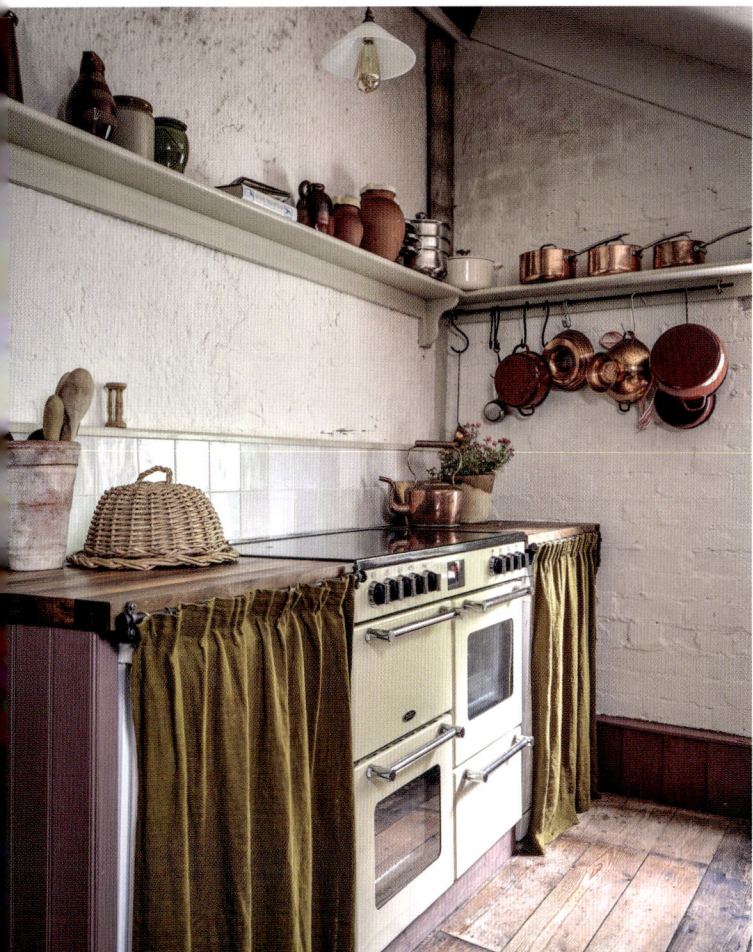
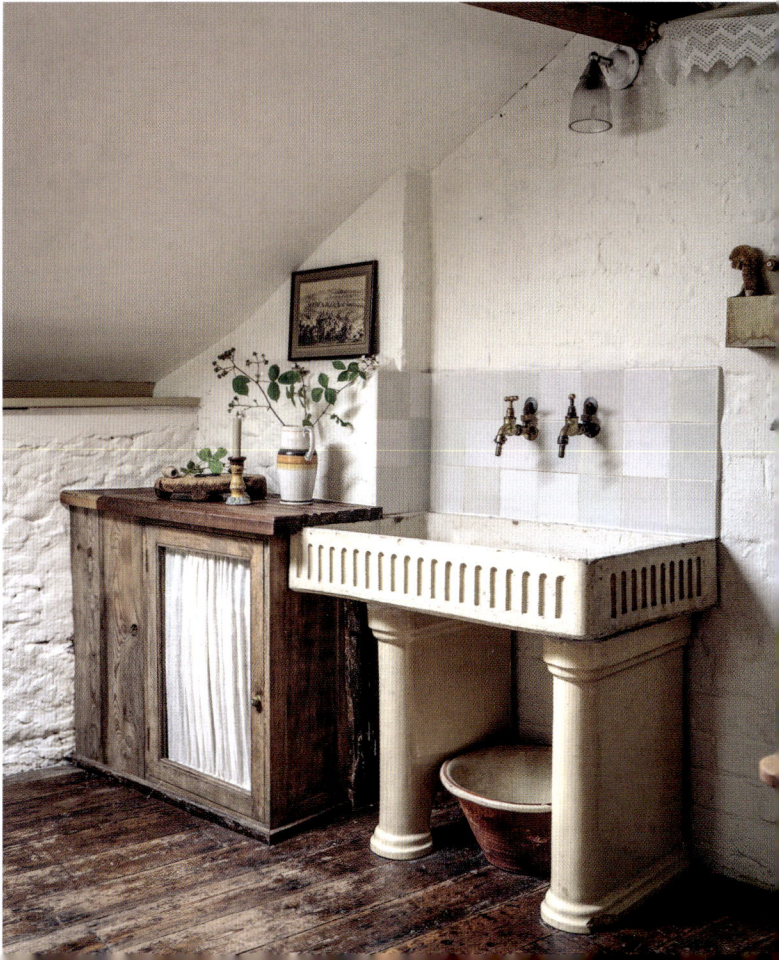

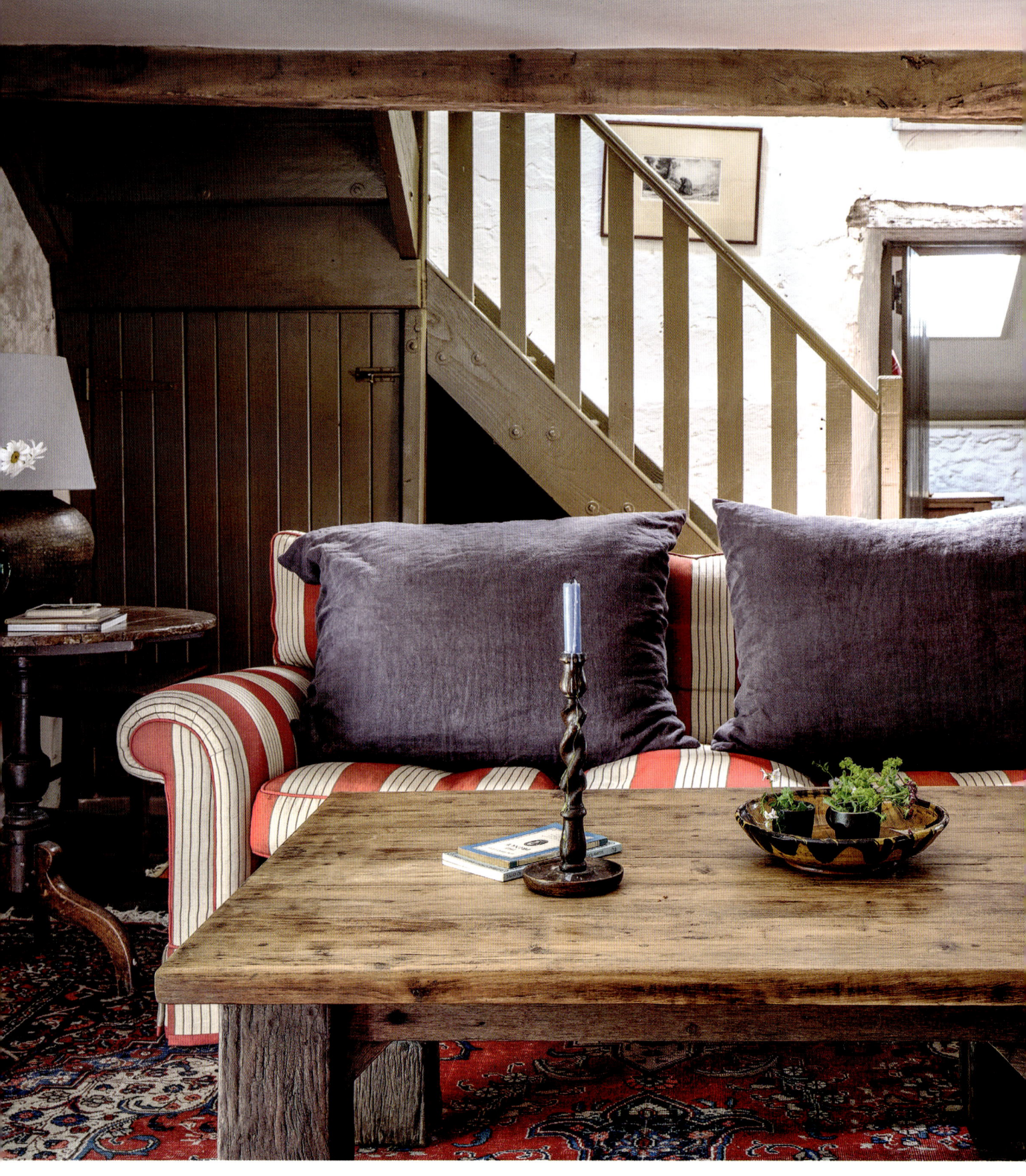

LEFT
Hayley has turned to classic patterns to bring a timeless quality to the interior. Ever-stylish stripes are combined with a succession of plains in seasonal colours. The sofa's rich raspberry-hued upholstery is the mainstay against the mossy painted backdrop.

RIGHT
An easy update for armchairs like these is to combine white slipcovers with cheerful seat pads. The mix-and-match effect is relaxed and uplifting, with changes over time as the fabrics are worn and washed.

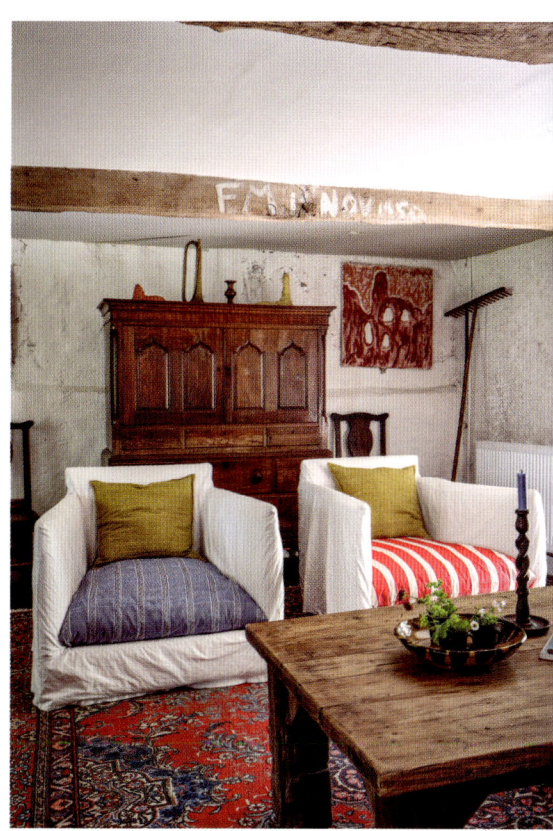

To balance and harmonize all the different shades, the house features plenty of white and cream. As in a multi-aperture picture frame, these pale neutrals provide breathing space between the colour pops and areas of bold pattern. There are subtle shade variations used here, too, with a tint change for a splashback wall panel or worn layers of paintwork on wall boards. Equally, the washed and whitened shades have been used to showcase different surface finishes. Glossy cream painted ceilings reflect the light and make low-ceilinged rooms feel larger and taller, while matt powdery white reveals the soft, uneven texture of the hand-finished plaster walls with their dimpling and depressions.

Hayley and Leo have used dyed, woven and handsewn textiles with ease to add impact and draw the eye to details throughout the interiors. From large one-colour blanketing to exquisite appliqué samples and piecework, the wealth of linen layers offers homely hues and softens hard lines. Cheery striped yellow drapes around a bed invite daytime rest and relaxation as much as nighttime sleep.

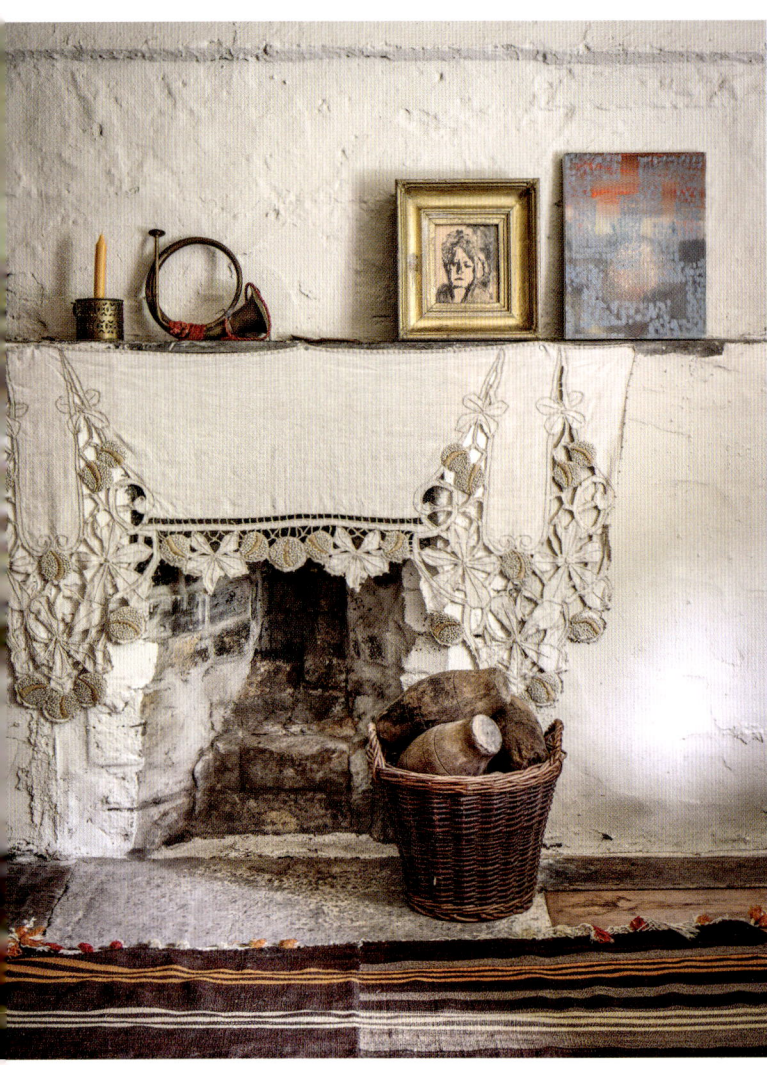
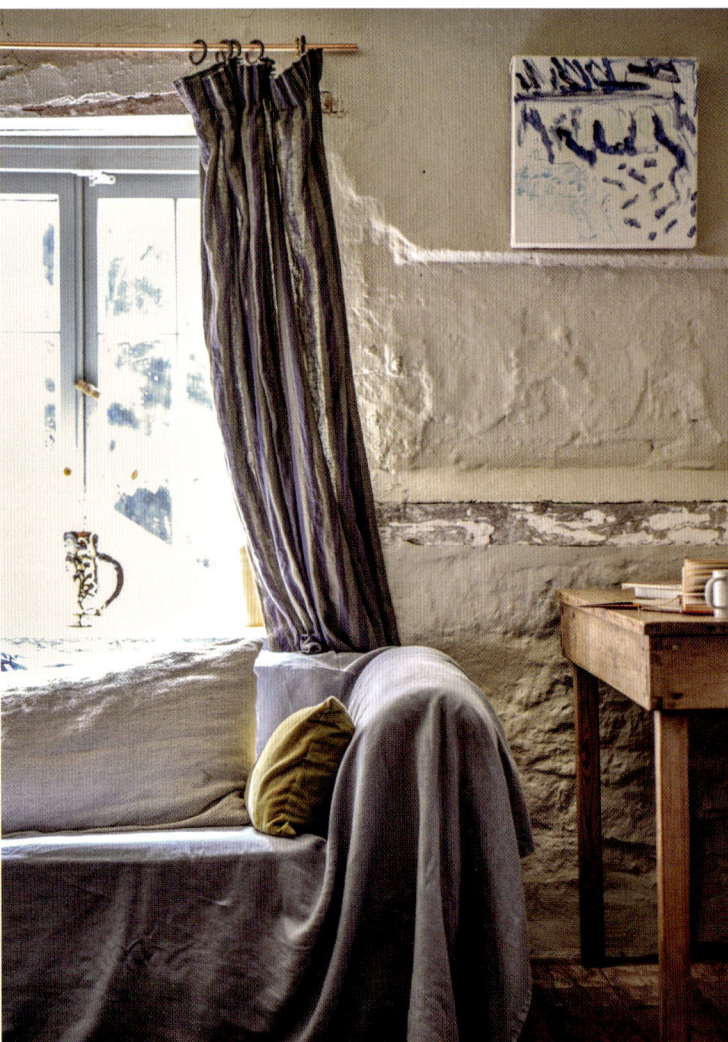

Bright cushions/pillows make for comfortable seating. Under-counter curtains screen kitchen clutter and coverlets have been cast over old furniture for an instant uplift. Even unassuming lighting has been enlivened with the addition of dainty fabric lampshades above tables and seating areas.

Although the walls, floors and furniture do the bulk of the colour trailblazing, there is still room for surprising and playful details on accessories. Hanging planters, charming china, framed prints and vintage bound books can be moved around on a whim or season and carry happy hues from room to room. Sourced to scatter shades throughout, these familiar elements have fresh appeal when seen in a newly shuffled reading stack or shelf line-up.

ABOVE LEFT & LEFT
This fireplace has become a decorative focal point, with artworks and objects arranged on the mantel (above left). A blue doorway frames the entrance to the room, foreshadowing the soft furnishings in the same hue to be found within (left).

ABOVE
Slipcovers are a quick, effortless and easy update for furniture. Here, the blue fabric adds a splash of a desired shade without the need for new upholstery.

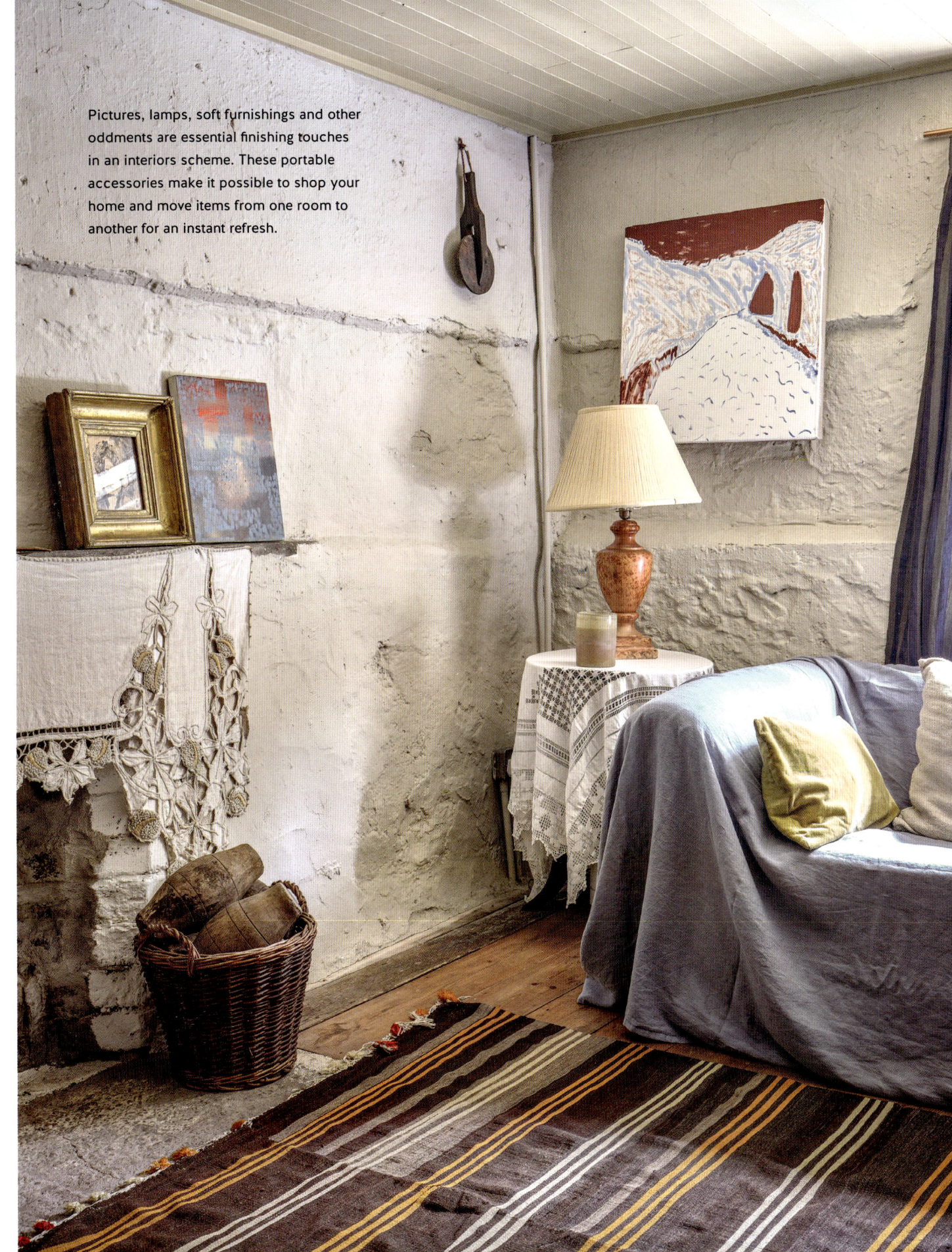

Pictures, lamps, soft furnishings and other oddments are essential finishing touches in an interiors scheme. These portable accessories make it possible to shop your home and move items from one room to another for an instant refresh.

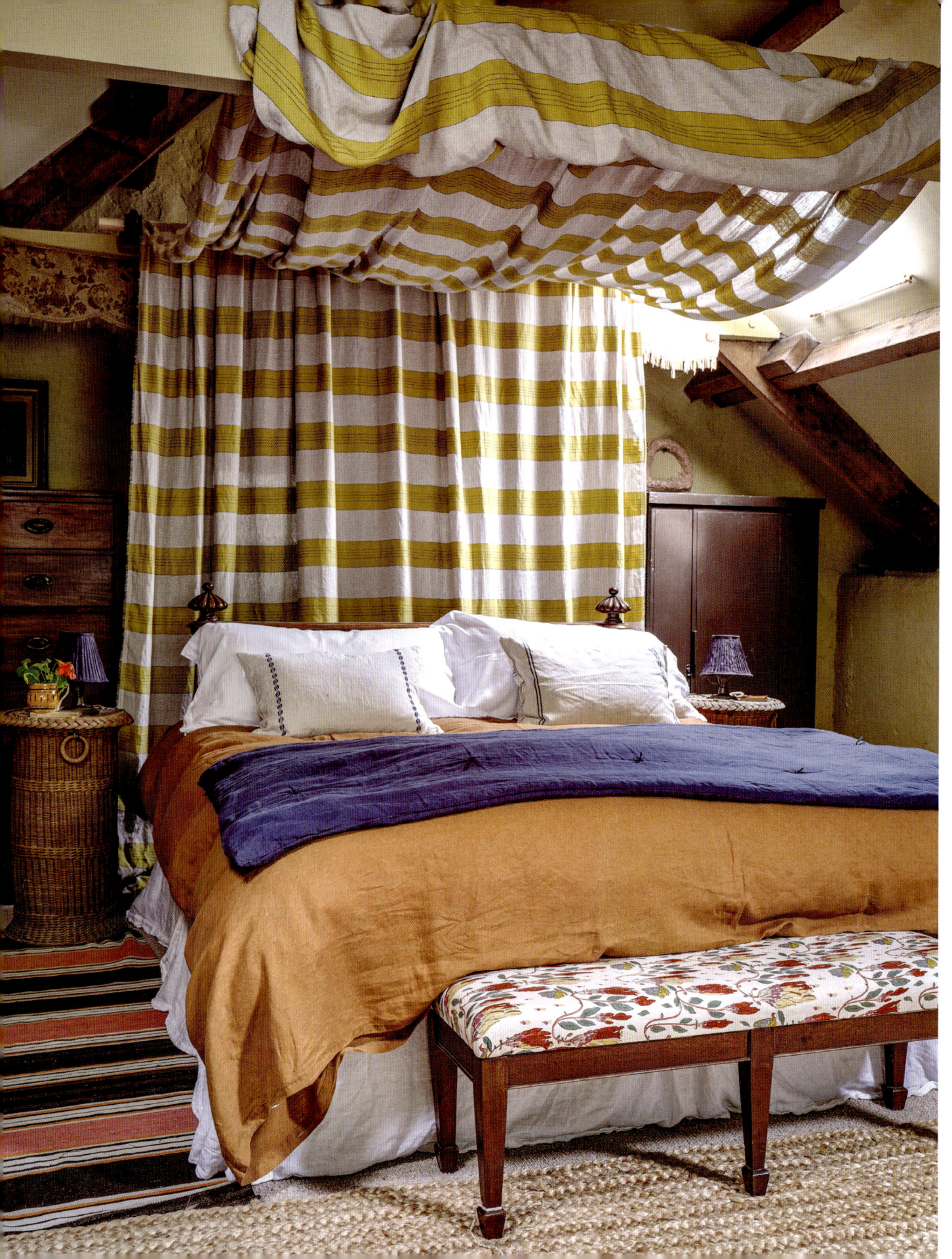

The soulful decor of the mill has been designed to entice and invite from inside out. The pastoral palette with simple cottage and folk-inspired styling makes for a year-round creative holiday retreat in which to linger and make memories with loved ones. In an engaging and enticing jostle of paints, textures and unusual finds, the use of happy-go-lucky and optimistic colours exudes a carefree and soulful spirit.

OPPOSITE
The ceiling provides a 'fifth wall' on which to add colour within a room. Here, striped fabric has been draped over the bed as a wonderful wake-up to witness in the morning.

LEFT
The importance of being seasonal is a highlight of Hayley's home, especially when welcoming family and friends. Plants and flowers bring life and colour to every room of the house.

ABOVE
Raspberry rugs and cushions/pillows designate a daytime seating area in this bedroom. Introducing another colour in this way can establish a 'room within a room' and create space for activities beyond the primary function of a space.

FLYING COLOURS 199

BELOW
The title of best bed in the house is reserved for the children's bunk space, contained by a structure of bespoke panelling. The experience of being within is cocooning and comforting. Chosen to provide year-round warmth whatever the weather, the cinnamon paint shade mimics wood tones and provides a vibrant backdrop to the more muted bed linens and curtains.

RIGHT
Many of the textiles are sourced from local artisan makers in and around Wales. Inspired by the colours of the local landscape and traditional patterns handed down over time, these vernacular homewares ground the old mill in its picturesque setting.

BELOW RIGHT
Mirrors are used in small rooms such as this throughout the home to reflect light and create the illusion of a larger space.

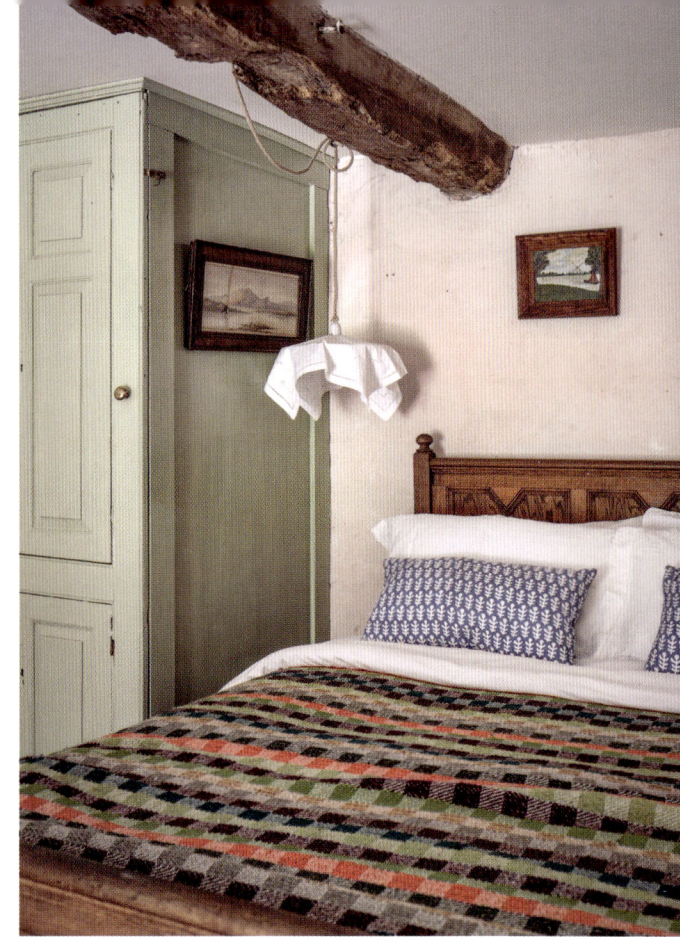

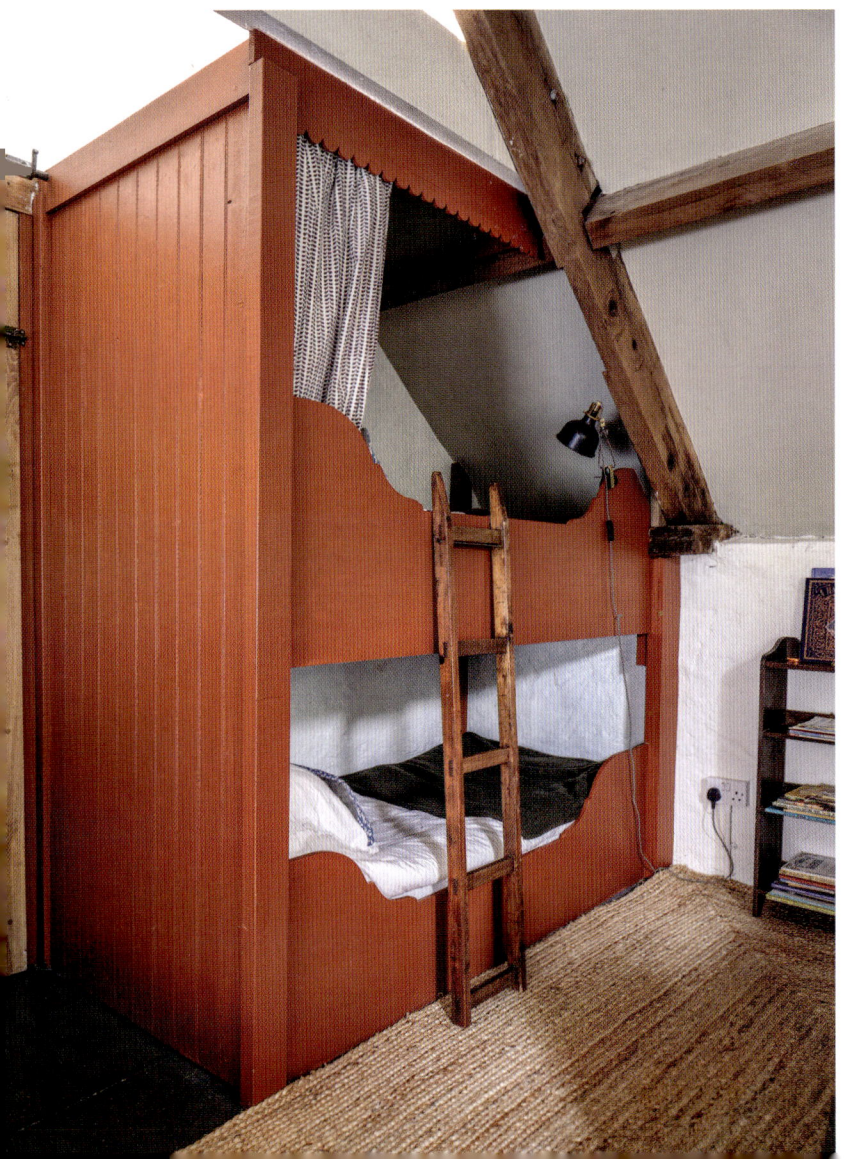

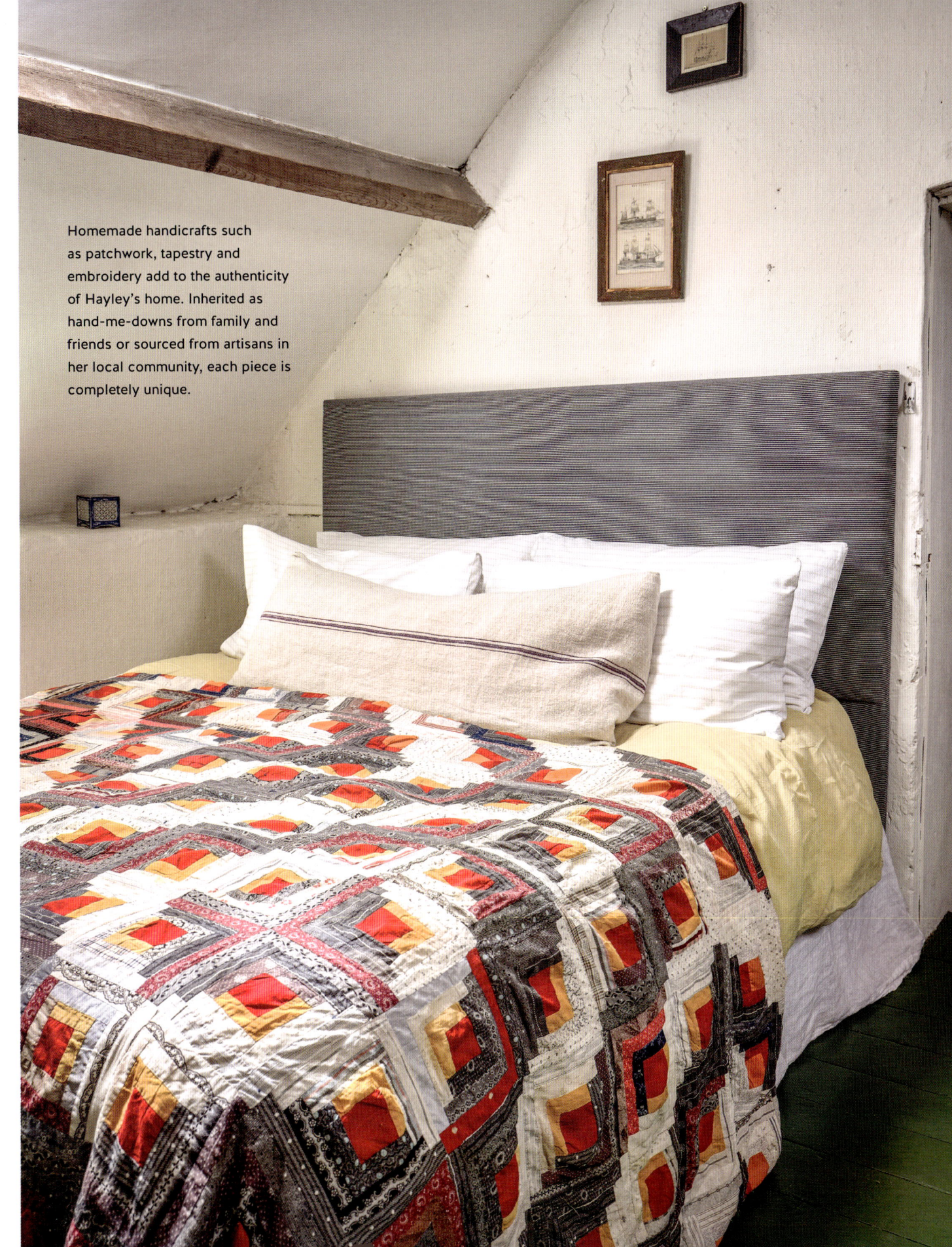

Homemade handicrafts such as patchwork, tapestry and embroidery add to the authenticity of Hayley's home. Inherited as hand-me-downs from family and friends or sourced from artisans in her local community, each piece is completely unique.

SOURCES

PAINTS

AIRLITE
www.airlite.com/en
Makers of breathable and beautiful antibacterial paints that purify the air by neutralizing pollutants such as nitrogen dioxide.

ANNIE SLOAN
www.anniesloan.com
The original inventor of non-toxic, water-based, virtually odour-free Chalk Paint, which can be applied to most surfaces without the need for primer.

BAUWERK
www.bauwerkcolour.co.uk
Environmentally friendly vegan-formula clay paint made using 100% renewable power in the production process.

BENJAMIN MOORE
benjaminmoore.com
www.benjaminmoorepaint.co.uk
Makers of beautiful, professional-quality paints that meet the criteria for zero-VOC classification in the US.

CROWN
www.crownpaints.co.uk
The first UK paint company to be vegan certified, with trace VOC classification and 100% recycled packaging.

EARTHBORN
www.earthbornpaints.co.uk
Makers of VOC-free clay paint that is breathable and safe to use throughout the home, including in children's rooms, and has been awarded the EU Ecolabel.

FARROW & BALL
www.farrow-ball.com
Safe, water-based paints with trace levels of VOCs and recyclable cans, delivering a delectable range of colours.

FENWICK & TILBROOK
www.fenwickandtilbrook.com
Family-run paint company producing premium, high-performance, pigment-rich products in countryside hues.

FRANCESCA'S PAINTS
www.francescaspaint.com
Exclusive and elegant paint company producing limewash and plastic-free Eco-Emulsion in colours inspired by art, travel and nature.

GRAPHENSTONE
www.graphenstone.co.uk
Breathable, solvent-free paints that absorb carbon dioxide from the air to create a purified atmosphere in your home.

LAKELAND PAINTS
www.lakelandpaints.co.uk
Naturally solvent-free and organic paints created in the UK and available in 372 colours.

LITTLE GREENE
www.littlegreene.com
Tinted to order, water-based and sustainable vegetable oil-based formulas, including the Re:mix collection made with recycled paint.

MYLANDS
www.mylands.com
Heritage paint company that uses natural pigments for its paint ranges, including the Upcycled collection made with surplus paint that would otherwise go to waste.

PAINT 360
www.paint360.co.uk
Creators of bespoke and added-value paint solutions from waste paint.

FABRICS & TEXTILES

THE BRISTOL WEAVING MILL
www.bristolweavingmill.co.uk
Micro mill uniting traditional weaving, innovative design and sustainable, traceable materials.

IAN MANKIN
www.ianmankin.co.uk
Curtain and upholstery fabrics woven from natural, recycled and certified organic fibres, including the colourful Paint Pot collection.

LARUSI
www.larusi.com
Natural hand-dyed and variegated textiles, weaves and rugs from tribal and traditional African artisan makers.

LINENME
www.linenme.com
Mindful shopping for household cloths and home linens, all made to order with batch-dyed hemp cloth.

LOOM & LAST
www.loomandlast.com
Worldwide sourcing from heritage suppliers for timeless, hand-finished household linens suitable for bedrooms, drapery and homewares.

MELIN TREGWYNT
www.melintregwynt.co.uk
Traditionally woven Welsh textiles in colours inspired by the landscape and seasons.

PARNA
www.parnaramarama.com
Vintage and reclaimed textiles and fabrics from Central and Eastern Europe, including linens, embroideries, grain sacks and sheeting.

THE PURE EDIT
www.thepureedit.com
Curators of natural, recycled, reclaimed and repurposed textiles, bedding and furnishings – including Repreve yarns made from plastic bottles – and PVC-free wallpapers.

VOLGA
www.volgalinen.com
Heirloom quality sustainable linen company using 100% flax in its beautiful designs.

SURFACES

CEMENT TILE SHOP
www.cementtileshop.com
Creators of earth-born based and pigmented tiles. Made to artisan recipes, the designs can be shipped anywhere in the US, Canada and the UK, with delivery to other countries available on request.

CLAYWORKS
www.clay-works.com
Producers of natural, beautifully pigmented and breathable clay plasters in Cornwall.

ECOHARDWOOD
www.ecohardwood.co.uk
Sustainable engineered oak flooring, staircases, doorways and panelling made using non-toxic materials. Founded by a former forester, the brand uses only FSC-certified timber and replants oak trees to give back to the environment.

LASSCO
www.lassco.co.uk
This unique company sources and supplies salvaged exterior and interior antiques, architectural fixtures, ornaments and curiosities.

RECLAIMED FLOORING CO
reclaimedflooringco.com
Restored and reclaimed wood flooring and new solid and engineered boards made with oak from FSC-certified forests. The company has offices in the UK and US.

TRIBAL COLLECTIONS
www.tribalcollectionscarpets.com
Rugs, kilims, carpets and cushions/pillows, all made by hand and naturally dyed, with global shipping from Turkey.

WEITZNER
www.weitznerlimited.com
Paper wallcoverings, including some upcycled from old maps, newspapers and magazines.

WOVEN IMAGE
www.wovenimage.com
Creators of sustainable and characterful interior wallcoverings and partitions for decorative and acoustic purposes, some made using recycled waste plastic.

FURNITURE & LIGHTING

BAILEYS HOME
www.baileyshome.com
Timeworn antiques, treasures, textiles and preloved furniture and furnishings.

COLOURED BATHROOMS
www.colouredbathrooms.co.uk
Colourful sanitaryware, including discontinued designs from various brands in over 90 different shades.

COTSWOLD COMPANY
www.cotswoldco.com
Beautiful, useful and responsibly made furniture from a company with fully traceable timber sourcing and Zero Waste to Landfill certification.

HAY
www.hay.dk
Modern furniture in colourful finishes made using recycled materials, water-based lacquers and natural textiles.

IKEA
www.ikea.com
Known for its colourful, budget-friendly and hackable furniture and homewares, this Swedish brand is making the everyday sustainable. Many of its products are made with recycled materials and there is a buy-back scheme to prevent waste.

INDUSTVILLE
www.industville.co.uk
Designer-makers of decorative artisanal lighting and homewares, all made with both sustainability and style in mind.

LIGHTS4FUN
www.lights4fun.co.uk
Solar and LED lights in statement and subtle styles for all seasons and celebrations.

POTTERY BARN
www.potterybarn.com
Mindful of its eco footprint, this US brand creates sustainably sourced and artisan-made furniture and homewares.

RH
www.rh.com
This vast design emporium has stockists all over the world, selling a huge range of beautifully crafted pieces in neutral tones. Many products are Greenguard certified, meaning low levels of chemical emissions for higher air quality in your home.

ROCKETT ST GEORGE
www.rockettstgeorge.co.uk
Curators of upcycled, characterful and trailblazing furniture, homewares and accessories, including pieces made from recycled, reclaimed and renewable materials.

SALVO
www.salvoweb.com
Directory for reclaimed furniture, furnishings, architectural salvage and more.

SCARAMANGA
www.scaramangashop.co.uk
Carefully sourced retro, vintage and restored furniture with a wide selection of colourful painted pieces.

TALA
eu.tala.co.uk
On a mission to become the world's definitive zero-carbon lighting brand, Tala has a wide selection of characterful products that offer personality and low-energy illumination.

TIKAMOON
www.tikamoon.com
Creators of contemporary furniture and fittings in solid wood, wicker and bamboo, this company works with manufacturers worldwide to ensure sustainability and traceability.

VINTERIOR
www.vinterior.co
Expert-curated vintage online market showcasing all kinds of antique and period furniture.

WEST ELM
www.westelm.com
www.westelm.co.uk
A modern take on traditional patterned and colourful furniture and homewares, designed to last with e vergreen styling.

HOMEWARE & LIFESTYLE

BOHEMIA
www.bohemiadesign.co.uk
Personality-packed homewares and fashion accessories crafted by artisan makers all over the world. Colourful craftsmanship with sustainability in mind.

DESIGN VINTAGE
www.designvintage.co.uk
Scandi and tribal-inspired homewares and furniture made by artisans from authentic and sustainable materials.

THE FUTURE KEPT
www.thefuturekept.com
Ethically souced, mellow-hued and harmonious items for the well-considered home.

NKUKU
www.nkuku.com
Ethical and authentic products in a naturally inspired palette. The company is a certified B Corp and supports the maker as well as the marketplace.

PIGLET IN BED
www.pigletinbed.com
Creators of luxury bed linens – part of their Piglet Promise is a partnership with the Better Cotton Initiative to ensure sustainable and ethically sourced natural materials.

ROWEN & WREN
www.rowenandwren.co.uk
Timeless artisan-crafted heirlooms led by considered colour and design over trends.

SECRET LINEN STORE
www.secretlinenstore.com
Responsibly sourced bed linen, towels and home linens from a registered B Corp that supports local and global charitable causes.

TOAST
toa.st
Designers of functional and beautiful fashion and homewares, all sustainably sourced and responsibly made.

WEAVER GREEN
www.weavergreen.com
Leading rug and homewares company offering multi-hued products made from 100% recycled plastic bottles.

PICTURE CREDITS

All photography by Dan Duchars

1 The home of interior designer Natasha Landers of @untillemonsrsweet; *2–3 left* www.thatrebelhouse.co.uk @thatrebelhouse; *3 centre* The home of interior designer Natasha Landers of @untillemonsrsweet; *3 right* Felin, part of Little Mill Abergavenny, riverside Welsh cottages, available to rent littlemillabergavenny.com; *4* Alex Legendre; *5 above* www.thatrebelhouse.co.uk @thatrebelhouse; *5 below* The London home of Simon Goff of Floor_Story www.floorstory.co.uk and Emma Morley of Trifle* www.triflecreative.com; *6* The home of interior designer Natasha Landers of @untillemonsrsweet; *7* The London home of Simon Goff of Floor_Story www.floorstory.co.uk and Emma Morley of Trifle* www.triflecreative.com; *8–9* www.thatrebelhouse.co.uk @thatrebelhouse; *10* The former home of artist Sophie Wilson; *11* The Shropshire home of Karl Bauer and Amy Jones of brocanteliving.com; *12* www.thatrebelhouse.co.uk @thatrebelhouse; *14 above left* The London home of Simon Goff of Floor_Story www.floorstory.co.uk and Emma Morley of Trifle* www.triflecreative.com; *14 below right* The home of Swedish interior designer Lisa Bengtsson, studiolisabengtsson.se; *15* The former home of artist Sophie Wilson; *16–17* The Shropshire home of Karl Bauer and Amy Jones of brocanteliving.com; *18 above* Felin, part of Little Mill Abergavenny, riverside Welsh cottages, available to rent littlemillabergavenny.com; *18 centre* The Sussex home of film-maker Andrew Ruhemann and artist and designer Anna Jacobs annajacobsart.com; *18 below* Landgate House, (available to rent via landgatehouse.com); *19* The Palmhouse, N8; *20 above* The Sussex home of film-maker Andrew Ruhemann and artist and designer Anna Jacobs annajacobsart.com; *20 below* www.thatrebelhouse.co.uk @thatrebelhouse; *21 above* The home of interior designer Natasha Landers of @untillemonsrsweet; *21 below* The Sussex home of film-maker Andrew Ruhemann and artist and designer Anna Jacobs annajacobsart.com; *22* Landgate House, (available to rent via landgatehouse.com); *23 above* The Palmhouse, N8; *23 centre* The former home of artist Sophie Wilson; *23 below* The Palmhouse, N8; *24* www.thatrebelhouse.co.uk @thatrebelhouse; *25 above* The Shropshire home of Karl Bauer and Amy Jones of brocanteliving.com; *25 below* The home of interior designer Natasha Landers of @untillemonsrsweet; *26 above & centre* The former home of artist Sophie Wilson; *26 below* www.thatrebelhouse.co.uk @thatrebelhouse; *27* The former home of artist Sophie Wilson; *28 above* Landgate House, (available to rent via landgatehouse.com); *28 below left* The former home of artist Sophie Wilson; *28 below right* The Sussex home of film-maker Andrew Ruhemann and artist and designer Anna Jacobs annajacobsart.com; *29* The home of interior designer Natasha Landers of @untillemonsrsweet; *30* The Sussex home of film-maker Andrew Ruhemann and artist and designer Anna Jacobs annajacobsart.com; *31 above* Landgate House, (available to rent via landgatehouse.com); *31 centre* The former home of artist Sophie Wilson; *31 below* The Palmhouse, N8; *32 above* The Palmhouse, N8; *32 below* Landgate House, (available to rent via landgatehouse.com); *33* The Sussex home of film-maker Andrew Ruhemann and artist and designer Anna Jacobs annajacobsart.com; *34 above* The Palmhouse, N8; *34 centre* www.thatrebelhouse.co.uk @thatrebelhouse; *34 below* Felin, part of Little Mill Abergavenny, riverside Welsh cottages, available to rent littlemillabergavenny.com; *35* The Palmhouse, N8; *36* Alex Legendre; *37 above* The Sussex home of film-maker Andrew Ruhemann and artist and designer Anna Jacobs annajacobsart.com; *37 below* The Manchester home of Hannah and Nelson Beaumont Laurencia of Beaumont Organic, www.beaumontorganic.com; *38* www.thatrebelhouse.co.uk @thatrebelhouse; *39* The Palmhouse, N8; *40–53* The former home of artist Sophie Wilson; *54–65* The Palmhouse, N8; *66–79* Landgate House, (available to rent via landgatehouse.com); *80–93* The Manchester home of Hannah and Nelson Beaumont Laurencia of Beaumont Organic, www.beaumontorganic.com; *94–105* The Shropshire home of Karl Bauer and Amy Jones of brocanteliving.com; *106–117* Alex Legendre; *118–131* The home of Swedish interior designer Lisa Bengtsson, studiolisabengtsson.se; *132–145* The London home of Simon Goff of Floor_Story www.floorstory.co.uk and Emma Morley of Trifle* www.triflecreative.com; *146–159* www.thatrebelhouse.co.uk @thatrebelhouse; *160–175* The home of interior designer Natasha Landers of @untillemonsrsweet; *176–189* The Sussex home of film-maker Andrew Ruhemann and artist and designer Anna Jacobs annajacobsart.com; *190–201* Felin, part of Little Mill Abergavenny, riverside Welsh cottages, available to rent littlemillabergavenny.com; *205* The Sussex home of film-maker Andrew Ruhemann and artist and designer Anna Jacobs annajacobsart.com; *206* The home of Swedish interior designer Lisa Bengtsson, studiolisabengtsson.se; *208* www.thatrebelhouse.co.uk @thatrebelhouse.

BUSINESS CREDITS

ALEX LEGENDRE
@alexlegendre.interiors
&
St Mary's View Developments Ltd
4; 36; 106–117.

AMY JONES
brocanteliving.co.uk
@amy_brocanteliving
11; 16–17; 25 above; 94–105.

ANNA JACOBS
@annalysejacobs
18 centre; 20 above; 21 below; 28 below right; 30; 33; 37 above; 176–189; 205.

BEAUMONT ORGANIC
www.beaumontorganic.com
37 below; 80–93.

FLOOR_STORY
www.floorstory.co.uk
&
TRIFLE*
www.triflecreative.com
5 below; 7; 14 above left; 132–145.

LANDGATE HOUSE
www.landgatehouse.com
18 below; 22; 28 above; 31 above; 32 below; 66–79.

LAURA STEPHENS INTERIOR DESIGN
www.laurastephens.co.uk
E: interiors@laurastephens.co.uk
T: 07970 072525
19; 23 above; 23 below; 31 below; 32 above; 34 above; 35; 54–64.

LITTLE MILL ABERGAVENNY
www.littlemillabergavenny.com
E: themillabergavenny@gmail.com
3 right; 18 above; 34 below; 190–201.

NATASHA LANDERS INTERIOR DESIGNER
Until Lemons R Sweet
&
Havant House 53
Location House
www.untillemonsrsweet.com
@untillemonsrsweet
E: natasha@untillemonsrsweet.com
1; 3 centre; 6; 21 above; 25 below; 29; 160–175.

SOPHIE WILSON
www.1690store.com
10; 15; 23 centre; 26 above; 26 centre; 27; 28 below left; 31 centre; 40–53.

STUDIO LISA BENGTSSON
www.studiolisabengtsson.se
14 below right; 118–131; 206.

THAT REBEL HOUSE
www.thatrebelhouse.co.uk
@thatrebelhouse
E: sarah@thatrebelhouse.co.uk
T: 01780 844425
M: 07717 436345
2; 3 left; 5 above; 8–9; 12; 20 below; 24; 26 below; 34 centre; 38; 146–159; 208.

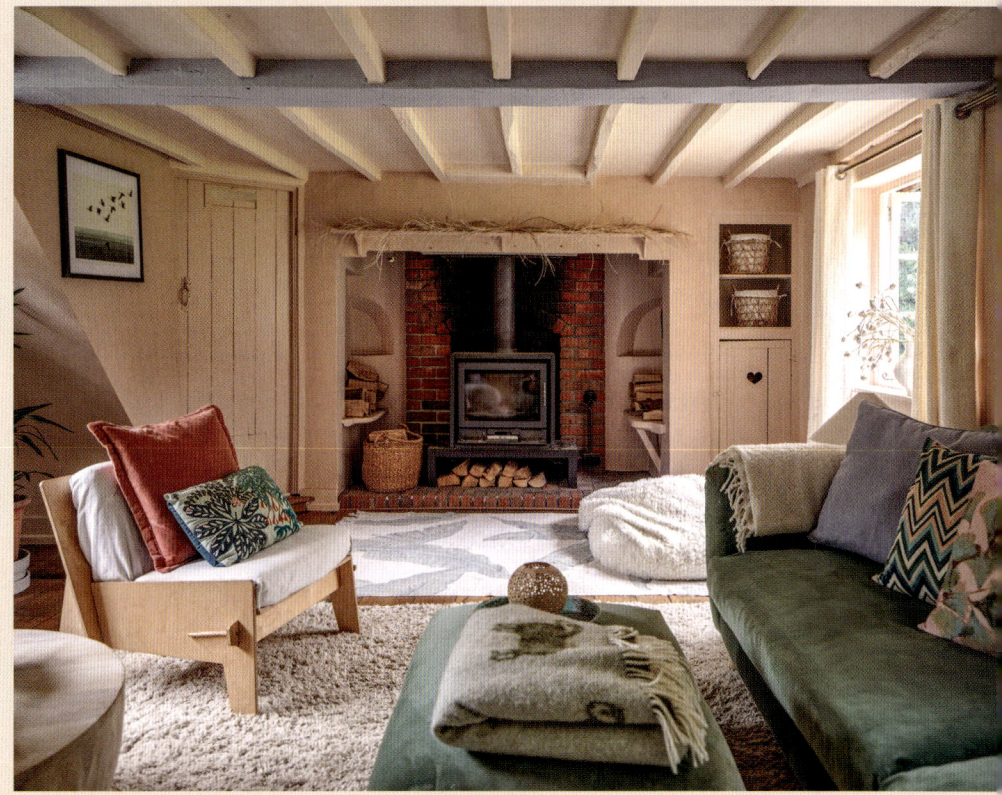

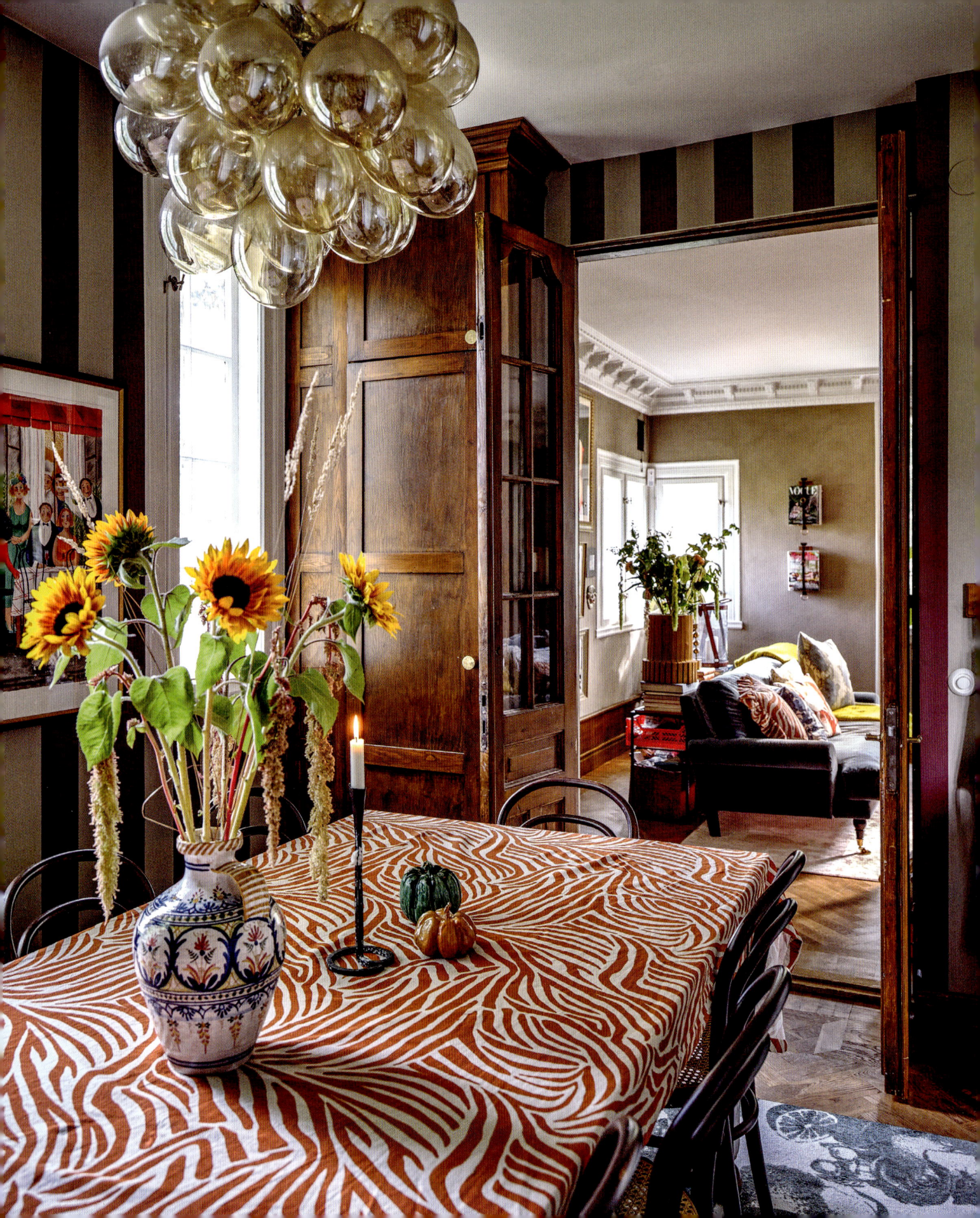

INDEX

Page numbers in *italics* refer to the illustrations

A
accents 18, 29, *36*, *37*, *73*, 160–201
Adler, Jonathan 120, *121*
The Albion Bath Co 93
analogous shades 13
application of colour 18–21, 25
 artwork *63*, *75*, *127*, *146*, *157*, *180*, *181*, *183*, *197*
Atelier Ellis 52, *53*

B
Baker, Amber and Jonathan 66–79
balance 13, 18, 44
bathrooms: accent colours *173*, *185*
 maximal 139, *144*, *145*, *154*, *157*
 minimal 92, *93*, *104*, *105*, *116*
 natural 52, *53*, *64*, 77, *79*
 paint finishes 23, *25*
Bauer, Karl 94–105
Bauwerk Colour *104*, *114*, *115*
Beaumont-Laurencia, Hannah 82–93
Beaumont Organic 82
bedrooms: accent colours *175*, 184, *184*, *186–9*, *192*, *200*, *201*
 maximal *128–31*, 139, *141*, *142*, *154–6*, *159*
 minimal 90, *93*, *102*, *103*
 natural *50–1*, *60–1*, 61, *62*, *63*, *65*, *76*, 77, *77*
Bengtsson, Lisa 120–31
Beni Rugs 58, *59*
biophilic design *37*, 61, 77, 152, *171*, *173*, *178*, *180*
blues 34, *37*, 41, *159*
BoConcept 88
Bombay Sprout 54
brickwork 87, 92, 93, 96, 98
Broughtons 84, *85*
By Rydéns *125*

C
Caradoc-Hodgkins, Hayley 190–201
The Cast Iron Bath Company 145
ceilings 21, *21*, *198*
chalky paints *33*, 84, 103
Chinakwe, Caroline *169*
chroma 13, 29
Claybrook *137*
The Coach House *91*
Collier Campbell 44
colour: application of 18–21
 colour blocking 18, *21*, *168*, *174*, *182*, *190*, *193*
 colour drenching *15*, 18, *50–1*, *60–1*, 74, 82, *186*
 colour theory 12–17
 finishes 22–5
 and light 26–9, 171
 and wellbeing 34–7, 171
The Colour Flooring Company *162*
complementary colours 13, 44
cool colours 21, 26
Craig & Rose *132*, *162*, *180*
Crazy Cat Lady *127*
curtains 95, *103*, *105*, *111*, *145*, *152*, *196*
cushions/pillows *48*, *63*, *147*, *148*, *154*, *161*, *177*, *196*, *199*

D
D&A Binder *134*
Davenport, Sarah 146–59
dining areas: accent colours *164*
 maximal *124*, *125*, *126*, *127*, 138, *139*
 minimal *106*, *107*
 natural 68, *69*, 74
Ducaroy, Michel *132*
Dulux *137*, *184*, *187*, *188*
dyes, natural 31

E F
East London Cloth *76*
eBay 73
Edward Bulmer *146*
eggshell 23
emotions, effect of colour on 34, 37
family rooms, natural 58, *59*
Farrow & Ball *54*, *62*, *63*, *73*, *79*, *88*, *89*, *137*, *168*, *175*, *180*, *183*
finishes, colour 22–5
Fired Earth 84, *85*
fireplaces *87*, *123*, *196*
Floor Story *132*
flooring: painted 23, 68, 74
 poured concrete *83*
 tiles *43*, 51, *54*, *64*, 96, *138*, *139*, *143*
flow 56, 93, 108, 128, *151*, *164*
flowers *63*, *117*, *165*, *199*
The French Depot *76*
French Loft Antiques *116*

G H
G Plan *78*
Georgian style *43*, 44, *48*, *49*
gloss paint 23, 25, 26, 195
Goff, Simon 132–45
Graham & Brown 66–7
greens 34, *37*, 41, *46*, *47*
Hadeland Glassverk *89*
hallways: accent colours *172*
 maximal *127*, *128*, *146*, *154*
 natural *43*, 51, *52*, *54*, *66–7*, 70
 paint finishes 25
Hayman, Anna *143*
home offices *63*
House of BLOC *167*
hues 13, 34, 70

I J
Ikea *141*
Jacobs, Anna 176–89
Jones, Amy 94–105
Julie Adams Curtains *114*

K
Kent & London *137*
Kime, Robert 57
kitchens: accent colours *162*, 171, *176*, *178–9*, *190*, *191*, *193*
 maximal 136, *152–3*
 minimal 82, *83*, *84*, *85*, *108*, *109*, *110*
 natural 44, *45*, 51, *55*, *56*, 68, *70–1*
 paint finishes 23, *24*, *190*
Kvadrat 142

L
Lacanche 84
Landers, Natasha 162–75
Legendre, Alex 106–17
Levenshulme Antiques Village 93
light/lighting: and colour 26–9, 171
 natural light 26, *26*, 29, *29*, *52*, *66*, 68, 70, *113*, *114*, *128*, 171, *184*
 reflected light *73*, *78*, *200*
 pendant lights *45*, *86*, *87*, *89*, *108*, *125*, *128*, *131*, *140*, *157*, *191*
Lighting By Stacie *108*
Ligne Roset *132*
lime paints 96, *98*, *104*, 190
Little Greene 58, *59*, *136*, *142*, *170*, *172*, *175*
living rooms: accent colours *170*, *171*, *176*, *182–3*
 maximal *120–1*, *123*, *127*, *132*, *136*, *148*, *149*
 minimal *86*, *87*
 natural *73*, 74
Loaf *59*
London Encaustic *143*

M
materials: natural *17*, *84*, *106*, *108*, *109*, *114*, *117*
 repurposed 94, 99, 100, 113
matt finishes 23, *23*, *24*, *26*, 190, 195
maximalism 118–59
Melimeli *120*, *121*
Merchant & Mills 77
mirrors *78*, *92*, *111*, *157*, *200*
Mogensen, Børge *48*, *49*
monochromatic looks 13
mood *26*, 29, 37, 70, 171
Morland Bathrooms 92
Morley, Emma 132–45
Morris, William *46*, 47
Mylands 178–9, *184*

N O
Naked Kitchens *56*
natural 31, 40–79
Neptune 178–9
neutral schemes *16*, *17*, 26, 37, 195
Nordic Knots *57*
Nordic Nest *170*
ochre 31, 41
oranges 34

P
Paint & Paper Library *55*
paints: finishes 22–5, 195
 sustainable 31–3
patterns 61, *120*, *121*
pearl finishes 23
pigments 31, 171
pinks 34
plants 74, *84*, *85*, 88, 90, *113*, 117, *139*, *144*, 152, *165*, *173*, *178*, *199*
Pooky *108*
primary colours 13
purples 34

R
Rainbows Furniture 84, *85*
Rebel Walls *185*
reds 41
Rose & Grey *139*
rugs *48*, 84, *91*, *128*, *132*, *135*, *143*, *147*, *152*, *156*, *170*, *192*, *199*
Ruhemann, Andrew 176–89
The Rye Emporium *78*

S
satin finishes 23, 25
saturation 34, 47
Scandinavian design 88, *89*
SCP *170*
secondary colours 13, 18
semi-gloss paint 25
Sir Grace *120*, *127*
Skipper, Svend *73*
Smith & Goat *137*
Snug *177*
The Socialite Family *57*
sofas *46*, *48*, *49*, *59*, *72*, 74, *99*, *113*, *131*, *132*, *148*, *177*, *194–5*
Soho Home 74, *132*
Solus *139*
staircases *43*, *52*, *116*, *140*
Stephens, Laura 54, *54*, 56, 63
storage *68*, *70–1*, 77, *163*
Stripe Forward *124*, *125*
stripes *61*, *194–5*
Studio Lisa Bengtsson *120*, *121*
sustainability 30–3
Switch to Wood *115*

T
tadelakt 25
textiles and fabrics *48*, *64*, *65*, *84*, 99, *99*, 100, *195*, *200*
texture *17*, 23, 32, *36*, *37*, *81*, *86*, *87*, *91*, *127*
That Rebel House *146*, 146
tiles: floor *43*, 51, *54*, *64*, 96, *138*, *139*, *143*
 wall *61*, *64*, *145*
Todd, Leo 190–201
Tom Pigeon *145*
tonal shades 13, *14*, *17*, 18, 21
Tudor-Jones, Lisa 54–65

U V
upholstery *111*, *147*, *196*
Valspar *132*
Very Good & Proper *164*
Victorian era 82, 163
vintage pieces *30*, *31*, 47, 82, 94, 100, *103*, *150*, *151*
Vitra *166*

W Y Z
walls: brickwork *87*, *92*, 93, 96, *98*
 panelled *61*, *79*
 tiled *61*, *64*, *145*
warm colours 21
wellbeing 34–7, 171
whites 34, *37*, 84, 93
Wilson, Sophie 42–53
Wren Kitchens *109*
yellows 41
Zoe *127*
zones 18, *83*, *96–7*, 99, *136*

ACKNOWLEDGEMENTS

One of our favourite things to explore in design and decor is colour and we are excited to focus on this in our latest book, *Colourful Homes for the Soul*. Teaming up with the fabulous Ryland Peters & Small team once again, we thank them for all their continued help and support.

Also enabling us to make this book were the amazing designers and decor-makers who invited us into their gorgeous interior spaces. Creating the most exquisite of settings, each project resonated with homely hues presenting mindful delights and insights with every tonal pairing and layer. Thank you so much for your time and hospitality.

Hearing stories of how and why a home can inspire is always a delight and we are grateful to our likeminded friends and followers who continue to engage with us on all our social media platforms. Do continue to keep in touch, comment and share ideas with us via @thecontentednest and #colourfulhomesforthesoul .

A last word goes to all the behind-the-scenes backing we receive from our wonderful families, whose encouraging words and patience have made this book possible. It is with them we probably converse with the most in making our own colourful decor decisions in all their spectrums, styles and guises. Crafting, we hope, a setting rich in significance and abundant with soulful shades making our own bespoke backdrop.

We hope you enjoy delving into this book as much as we adored creating it.

With love
Sara and Dan
The CONTENTed Nest

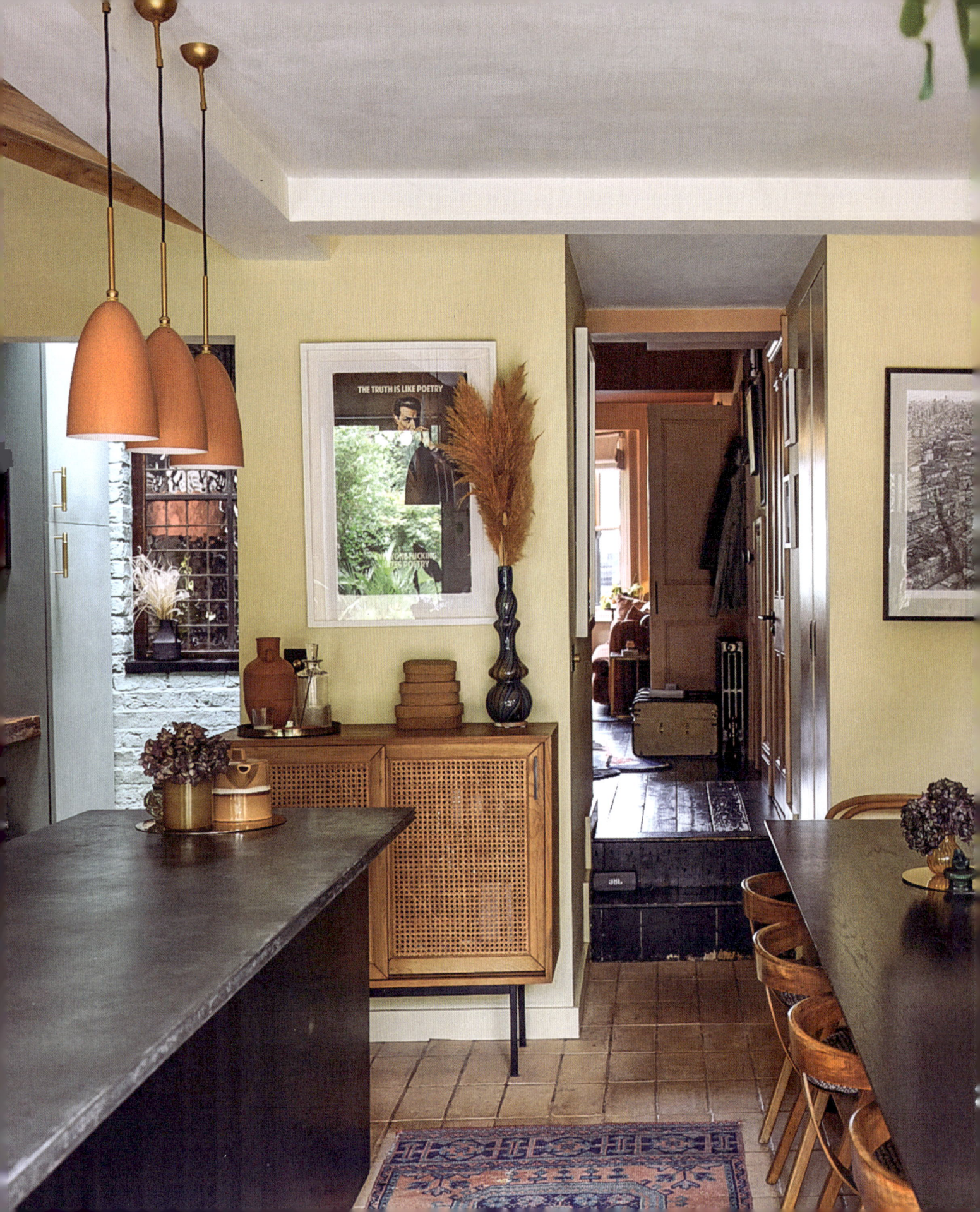